Photocommunication

a guide to creative photography

DAVID H. CURL
Western Michigan University

Photocommunication

macmillan publishing co., inc.
New York

collier macmillan publishers
London

Macmillan Publishing Co., Inc.
866 Third Avenue, New York, New York 10022

Collier Macmillan Canada, Ltd.

Library of Congress Cataloging in Publication Data

Curl, David H
 Photocommunication.

 Bibliography: p.
 Includes index.
 1. Photography. I. Title.
TR145.C977 770'.28 76-19049
ISBN 0-02-326350-4

Printing: 2 3 4 5 6 7 8 Year: 9 0 1 2 3 4 5

on vision

So
you've come
to ask me
to teach you photography.

By means of the tools
I shall oblige;
for son,
the mechanics
may be easy.

But,
once you have
mastered these,
 please,
do not return
to ask me
 for vision.

For
you must first
learn of yourself
and life in others,
before
you learn
to see.

Judith Baker Martin

Many people must share the credit for any success that this book may have as a teaching tool. I am proud that my teachers have included such giants of photography as Ansel Adams, Clarence White, Jr., Henry Holmes Smith, and Jerry N. Uelsmann. Many others have shared with me both insight and information; some, such as Ed Farber, may recognize some of their ideas rephrased.

Most of the photographs used to clarify concepts within the text are representative of the inspired and technically competent work that can be expected from college students; these photographs were actually made by my students for class assignments during the last few years. I have given credit to each photographer in the appropriate caption. The photograph by Brian Lanker on page 24 is reproduced by courtesy of the Topeka Capital-Journal. Many of the ideas for line drawings in Chapter Seven were originated by James A. Nemsik, while the final line drawings that appear throughout the book are the work of ECL Art Associates.

The numerous quotations punctuating and illuminating the text came from various sources, many of which, unfortunately, must remain undocumented. To Scholastic Magazines, Inc. and to the International Fund for Concerned Photography, I am most deeply indebted for permission to quote frequently the words of great photographers as spoken in the remarkable *Images of Man* series of slide/tape presentations. *The Daybooks of Edward Weston,* published by Horizon Press and George Eastman House, provided many significant short quotations, as did Ansel Adams' *Basic Photo Series*, published by Morgan & Morgan.

Lloyd C. Chilton and many others at Macmillan provided encouragement and the publishing skills necessary to see the project through. Because of his intense interest in subjects photographic, Dave Novack was the natural choice for assignment as production supervisor. Credit for the innovative design of the book should go to Andy Zutis.

Professors James Fosdick of the University of Wisconsin and Wilmer Counts of Indiana University supplied constructive criticism that helped to make this book better. To all of the many people who encouraged me and who assisted me in so many ways, I offer a humble and sincere *thank you!*

D. H. C.

acknowledgments

contents

6 film development
115

7 making fine prints
141

print finishing and display
173

photographing people and things
183

10

the surreal and the bizarre
213

11

photography as a profession
245

self-assignments
269

art and science

Many people are intrigued with the technical aspects of photography. To some, there is great pleasure in testing the latest cameras and lenses and concocting and comparing developer formulas. It seems that most photo courses are organized around the physics and chemistry of photography or based on the history of the medium, with instructors teaching *about* photography in the hope that students somehow will be able to apply this basic knowledge to their work.

But to more and more people, photography is more of an art than it is a science. For fifteen years I taught photography as if it were not an art form at all, but as if it were a scientific, academic subject. To my surprise, I discovered that some of my students were becoming effective communicators not so much because of what I had been teaching them, but because of their own terrific internal urge to create—to communicate. My students taught me that no one can be *taught* photography—that you have to learn it by yourself.

communication first

I no longer teach the way I began teaching. Instead, I have learned to encourage each student to photograph first and to ask questions later. The technical processes, I have concluded, are merely means to an end—means to creating an image that communicates something to someone else or expresses the photographer's feelings or impressions of a situation or subject. Although technique—the *craft* of photography—is important enough to be stressed in this book and in my course, I believe it is a mistake to treat technique as if it were an end in itself.

To my surprise I have found that this simple system works especially well with beginning photographers—those who are as yet unbound by what they may have assumed to be the "limitations" of the medium. Students blossom rapidly within a nonthreatening, nontechnical environment in which they are com-

I try to encourage in the student photographer a sense of freedom and dependence on himself that will permit him to face whatever challenges and opportunities may confront him as the result of either his future development or lack of it . . .

Henry Holmes Smith

Art is the affirmation of life.
Alfred Stieglitz

Life, or its eternal evidence, is everywhere.
Ansel Adams

Photography is at once a science and an art, and both aspects are inseparably linked throughout its astonishing rise from a substitute for skill of hand to an independent art form.
Beaumont Newhall

Technique is simply the means of conveying to the printing paper what the photographer has seen so that someone else might see it too.
Margery Mann

introduction

Study esthetics in terms of photographs and techniques in terms of esthetics, and arrive at photographs deserving to be called Art and a personal life deserving to be called Living. Esthetics describes the proper ends for the photographic art; technique provides the means for reaching these ends. Either subject studied alone, however, will lead to sterility and unhappiness. The proper mood in which to study the two is emotional, tho intellect serving a checking or guiding function.
Ralph Hattersley

The greatest gift we can give is to help those who want to learn, find out what they love to do.
Richard Bach

Photography is an adventure, just as life is an adventure. If man wishes to express himself photographically, he must understand . . . his relationship to life.
Harry Callahan

peting only with themselves. They see more, they see it much sooner, and they are more able to talk with conviction about what they have seen and why they felt it was worth photographing.

Not that technique is unimportant in photography—but motivation and self-confidence should come first. I have found that nearly all of the technical problems that I would have "covered" in lectures will come out through print critiques. These problems usually appear in the form of questions that are asked when the learner is ready for the answers and really wants to know.

using a textbook

To help persons learn a mechanical operation, don't give them a lecture full of directions. . . . Get them started doing the very thing they want to learn.
Kenneth Macrorie

It is more important to generate enthusiasm than to convey knowledge. Knowledge is easily forgotten, while enthusiasm makes anything possible.
Harold Allen

This book is intended to be a stimulus to students and a basic guide, but there should be additional reference sources readily available to students when they need help (I have suggested several of these in the Selected References beginning on page 295.) And when students are working together in a communal darkroom, the instructor or a humane and experienced assistant must be on hand to assuage anxieties, to alleviate technical crises, and to give on-the-spot praise and enlightened criticism.

I used to think that one had to master the fundamentals of technique before he or she would be able to communicate. But now I realize that was a very old-fashioned idea. It's like saying that before a young child can write an exciting story about something that interests him, he must first memorize all the rules of perfect punctuation, spelling, and grammar. I believe you should first get turned on to photography—or turned on to writing—by photographing or by writing. Once you get to doing a thing, you'll discover "how to" soon enough.

the importance of criticism

Criticism . . . is the analysis of a product or performance for the purpose of identifying and correcting its faults or reinforcing its excellences. . . . Criticism lies at the very heart of education. To learn is to submit oneself to the discipline of a standard, *even if the standard is self-created and self-imposed.*
Robert Paul Wolff

It's possible to teach photography to yourself privately, but most photographers crave response to their work, and most artists in other media will readily admit their dependence on criticism.

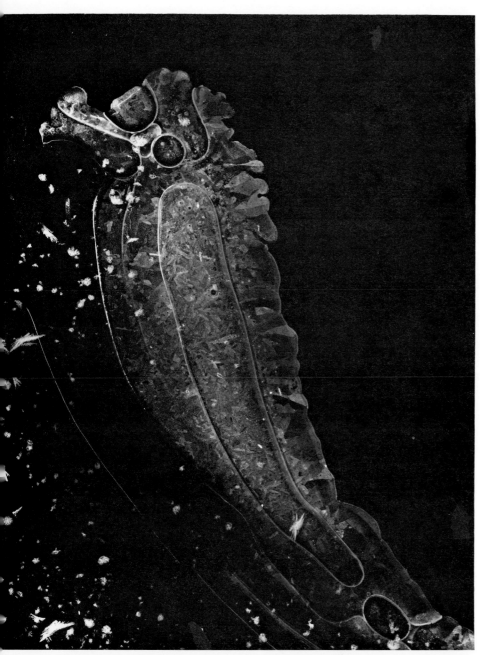

RAIMONDS ZIEMELIS *Abiguity*
What is it—a seahorse? Or is it a photomicrograph of an amoeba or an aerial view of a glacier? Actually, it's a few inches of ice along the edge of a small puddle, but ambiguity of scale creates a provocative puzzle.

JIM NIXON *Mom at Home*
Is this a *snapshot* or a *photograph?* Can it be both? Does it make a statement about suburban life in America while presenting some interesting elements of design?

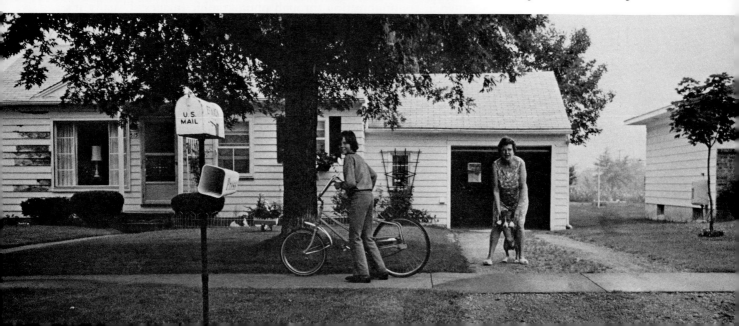

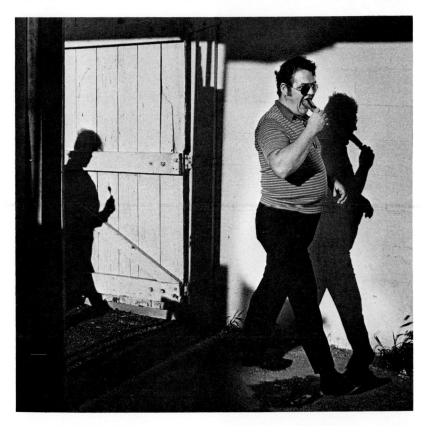

JIM NIXON *Man with Popsicle*
Was your first impulse to laugh
when you saw this photograph?
But, upon second examination, are
there sinister elements? Notice the
graphic impact achieved through
repetition with variation and con-
trast both of value and of line.

The truest test of independent
judgment is being able to dislike a
photograph made by someone you
admire—and to admire qualities
about a photograph you dislike.

Author unknown

Not only is it intriguing to discover what other people see in your
pictures, but it's most important to find out whether what you're
trying to say with your photographs is getting across to others.
Praise is pleasurable and ego satisfying, but it's vital that you real-
ize when personal recollection evoked by some of your photo-
graphs works so strongly in your own mind that you can't possi-
bly be objective about the image itself. It's important, too, to
become aware of unforseen communication barriers that may be
present in your work.

Those who critique your photographs should be knowledgeable
and sensitive—peers, hopefully—with an interest as keen as your
own in communicating through photographic images. Usually it's
helpful to have your instructor or another empathetic "expert" on
hand at critique sessions as catalyst and moderator—to keep the
comments flowing and to help unravel the technical mysteries as
they appear.

Seeing means perceiving the visual
relationships that exist in the
world. *Visualizing* means perceiv-
ing visual relationships . . . as
they will exist as translated into a
photographic print.

Phil Davis

what about technique?

Don't worry too much about the mechanics of photography.
Actually, the technical side is the easiest to learn—the hardest
part is learning to *see* and to *visualize*.

Let's take the technical details in small doses and save the most

difficult until you're so excited about photography as a medium that you're really ready to master the techniques. Did you know that some superb photographic communicators practice only the very rudiments of technique? Many professional photographers, in fact, don't do any of their own darkroom work. Paradoxically, there are thousands of competent technicians who rarely produce any photographs worth looking at.

color or black and white?

We will deal in the text with some of the unique aspects of both color and black and white photography, but you will be directed elsewhere for a thorough treatment of color theory and processes.

Begin with black and white photography and stay with black and white for a while before you allow yourself to be consumed with the glamour of color. Although color prints and transparencies can have stunning impact, color photography is in some ways a less versatile medium than black and white. Black and white is more abstract. When you're working in black and white you have to perceive and reproduce the essential elements of the

Photography can be an extra sense, or a reservoir for the senses. . . . Photography can teach people to look, to feel, to remember in a way that they didn't know they could.

Edwin H. Land

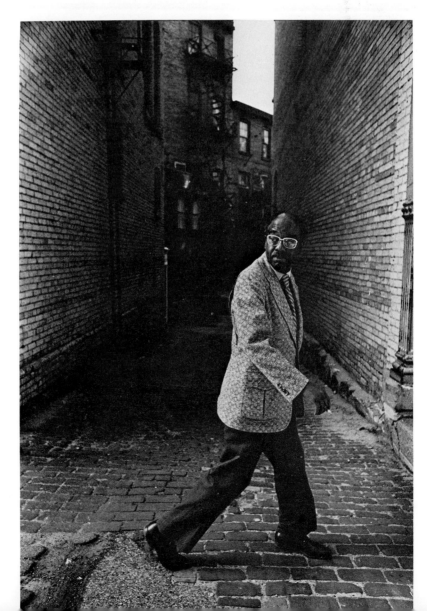

GARY CIALDELLA *Man and Alley*
Do you wonder why this man is looking back over his shoulder? What is the effect of the converging walls on your interpretation of this photograph?

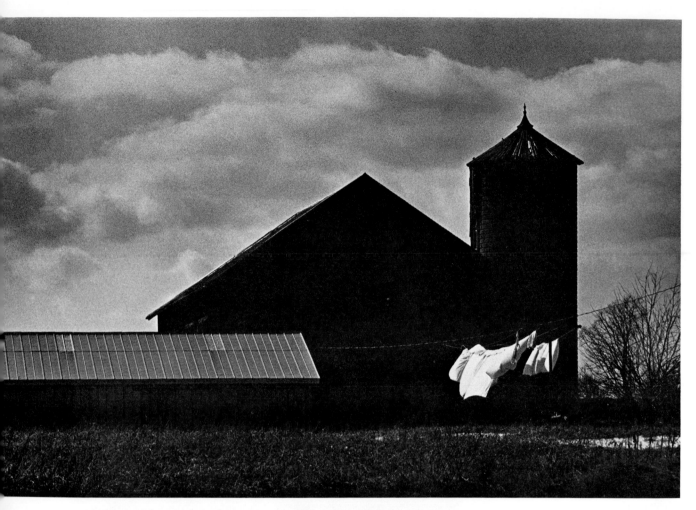

JIM NIXON *Barns and Washing*

It is gratifying to me that so many young men and women are deeply involved in the many aspects of the medium of photography. They are exploring new worlds, realizing new visions, and experiencing new dreams. . . . We must encourage rather than scorn the sincere explorations at the edge of the present and well into the future. . . . I can see no limits to the potentials of the great communicative art form of our age—photography.
Ansel Adams

subject or event, whereas color often excites the eye with its sheer dynamic force alone. That's why the early color photographers often placed a model wearing a bright red sweater in the foreground of each picture. First, master black and white photography—learn to see the essentials of the image—then you can become a master of color. As color printing processes become less complex and less expensive, so the transition to color from black and white will become easier for everyone.

I hope you will use this book as it was intended: as a stimulus to heighten your own awareness and sensitivity; as a guide—as you have need of it—to some of the inescapably basic fundamental information; and finally, as a source of comparison, so that you can intelligently and constructively criticize your own work and the work of other photographers.

communicating through photography

Photography is the closest thing we have to a universal medium of communication. Although there are some cultural variations in the way people respond to them, photographs transcend most traditional social and literary boundaries. Photography reaches people on many levels—most of which cannot be classified as art. Photography informs and educates. Much of what we know about the world we have observed in the photographic images presented to us on television and movie screens and on the pages of magazines and books. Photography tempts us and persuades us. Photographs sell us food, furniture, clothes, cars, cosmetics, and candidates. Photography entertains us through motion pictures and television. Photography works for us behind the scenes in countless unapparent ways as an extension of the human eye and the human mind in scientific research, engineering and medicine. Photography for millions of people is a diary for preserving moments of fleeting time. And photography for increasing numbers is becoming, in the words used by Alfred Stieglitz to define art, "an outer expression of inner growth."

Photography is rooted in reality. Nothing is more important to mankind than the transfer of ideas from one person to another. In this process, which we call communication, lies the potential for governments and for individuals to overcome ignorance and misunderstanding. Because it is realistic and therefore believable, photography can be one of the most potent means of communication.

Photographs can preserve the present and immortalize the past. Photographs can take us traveling to distant places or to places that have never existed. Photographs can add life and excitement to the words of the teacher and the journalist. Photographs can supply information. Photographs often arouse deep feelings and intense emotions. Photographs can stimulate curiosity.

Photographs often help to correct mistaken ideas people have. But because photography is so believable, a careless or unscrupulous photographer or editor can misrepresent events or situations, or may even use photography to tell deliberate lies. This possibil-

Photography is a language with which a knowledgeable photographer can produce records, reports, essays, diary-entries—even poetry!

Ansel Adams

I believe that photography can be one of the most powerful means of sharpening human awareness—one of today's most faithful, permanent, and universal means of communication. Through it we can provide an accurate and believable mirror of the human condition—a mirror that mankind must finally face.

Cornell Capa

The mission of photography is to explain man to man and each man to himself.

Edward Steichen

There were two things I wanted to do. I wanted to show the things that had to be corrected. I wanted to show the things that had to be appreciated.

Lewis W. Hine

I photograph nature . . . because I believe nature is terribly important.
Ansel Adams

A good photograph says something so well that it cannot be said better in any other way. It may be factual or poetic; but always it will be so true that from it we can learn of life.

Beaumont Newhall

photography is a language

7

ABIGAIL PICKETT *Whispering*

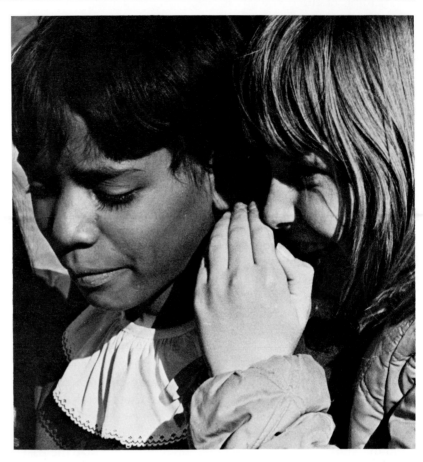

ity is made more acute because the very presence of press and TV cameras at an event can make that particular event seem a thousand times more important than other events not covered by the visual media.

Because photographs are so believable, we must learn to react to the language of visual stimuli as we should react to written and spoken words. We must learn to ascertain the photographer's or editor's intentions and to recognize the impact of each medium. We must be able to tell when a photographer is speaking to us with facts and when he is speaking to us in visual simile or in visual metaphor.

visual literacy

The grammar of photography is often very closely related to that of verbal language. Visual literacy has become as important in modern times as its verbal antecedent, as explained by Fransecky and Debes: "As might be expected, visual behavior is analogous to verbal behavior. A visually literate child can 'read' visual language with skill. He can 'write,' that is, compose visual statements with skill, perhaps with eloquence. He can translate from

The best pictures are made by those photographers who feel some excitement about life and use the camera to share their enthusiasm with others. The camera in such hands is a medium for communicating vital experience.
Roy Stryker

Television *cannot* present the trivial. By *being presented* even trivia becomes of enormous importance.
Jay Chidsey

I always wanted to take the best picture I could, one that would satisfy me. But at the same time I wanted to take pictures that would influence people. I wanted to show people that the natural world was valuable for them. This was in a sense propaganda. But I don't think there is anything wrong with certain kinds of propaganda.
Eliot Porter

the visual language to the verbal and vice versa. He has a basic understanding of the grammar of visual language and some realization that it parallels verbal language. He is familiar with and somewhat skilled in the use of the tools of visual communication. And, finally, of course, he is developing a critical sensibility toward visual communication."*

The mass media, commercial TV and film, have, as Marshall McLuhan has suggested, pushed written English toward the spontaneity and freedom of the spoken idiom. At the same time, the media have made us intensely aware that words often cannot communicate true feelings as effectively as facial expression, tone of voice, and body gesture. And there has been widespread fear that literate culture will somehow be "cheapened" by the visual media—a point spoken to by McLuhan: "If these 'mass media' should serve only to weaken or corrupt previously achieved levels of verbal and pictorial culture, it won't be because there's anything inherently wrong with them. It will be because we've failed to master them as new languages in time to assimilate them to our total cultural heritage."*

*Roger B. Fransecky and John L. Debes. *Visual Literacy: A Way to Learn—A Way to Teach* (Washington, D.C.: Association for Education Communications and Technology, 1972), p. 7.
*Gerald E. Stearn (ed.), *McLuhan: Hot & Cool* (New York: The Dial Press, 1967), p. 120.

ROBERT ROWAN *Wil*

The very sharpness and verity of the photographic image leads to the use of the photograph for the significant; its inherent quality of believableness is a challenge to the user's sense of truth.
John R. Whiting

My aim as a nature photographer has been to find the leaf that stands for all leaves and the perfect moment to photograph it.
Larry West

The knowledge of photography is just as important as that of the alphabet. The illiterate of the future will be a person ignorant of the use of the camera as well as the pen.
László Moholy-Nagy

One picture is not necessarily worth a thousand words. But pictures, plus related facts, plus visual presentation, do constitute the language of photography.
John R. Whiting

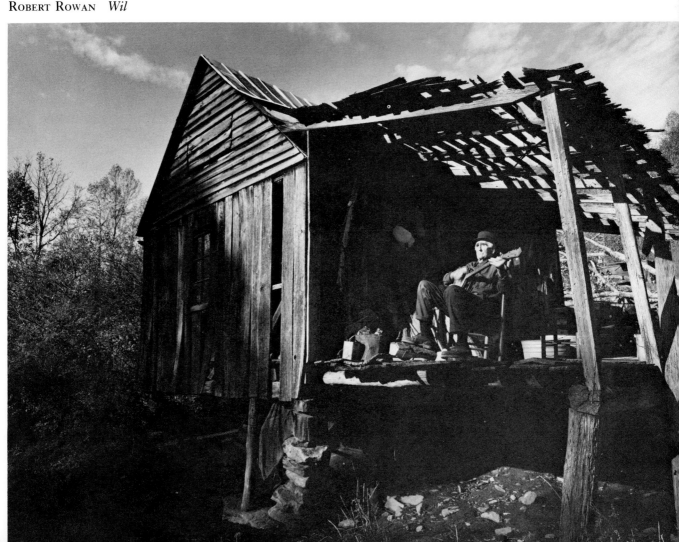

There is no greater esthetic power than the conversion of the familiar into the unbelievably new.
Edwin H. Land

Don't merely record what you saw, but tell others how you felt about what you saw.
Susan Wood

Facts are not interesting. It's a point of view on facts which is important . . .
Henri Cartier-Bressen

the meaning of photographs

The basic purpose of photography usually is to reproduce objects and events realistically. But the meaning a photograph is to have for the people who see it can be altered simply by allowing differences in the way the picture is taken. The weather, for instance, or the time of day can affect the subject being photographed. The point of view or type of lens chosen by the photographer can make one object seem larger or smaller in relation to the size of other objects. The photographer directs or diverts the viewer's attention by choosing what is to be included or excluded in the camera's field of view.

LOWELL McCOY *Daisy Pool*

The photographer's use of light may mean the difference between a natural-looking picture or one that appears contrived. Light can make the scene appear bright and happy; its absence can make it appear dark and sad or mysterious. When more light is allowed to fall on one part of a subject, people tend to pay more attention to that part of the photograph.

The photographer has a responsibility to use his technical knowledge and creativity to make pictures that will be of greatest interest and greatest significance to the people who see them. Making pictures that communicate can be an active, satisfying experience.

Gary Cialdella *Conveyer*
What's going on here? Is this a humorous photograph, or is it frightening? Are these postal workers on the conveyer or have they become part of the machines they operate?

Writing about a visual medium tends to make the simple complex. If you want to make photographs, all you do is point the camera at whatever you wish; click the shutter whenever you want. If you want to judge a good photograph, ask yourself: Is life like that? The answer must be yes and no, but mostly yes.

Charles Harbutt

There is a certain exchange going on between a good photograph and the person looking at it.
William Albert Allard

PHOTOGRAPHY IS A LANGUAGE 11

Photography, to me, is simply a way of showing to someone else someone or something that has excited me.

William Albert Allard

By revealing my own fantasies, I'm also exposing yours!

Kurt Oldenbrook

90 per cent of a successful picture comes from within the photographer himself.

Willard D. Morgan

looking at photographs

GARY CIALDELLA *Portent*
Does this photograph make you feel as though something terrible is about to happen? If so, is it because of the subject matter or because of experience that you bring to the photograph? Have you seen the Alfred Hitchcock movie *The Birds* or read the original short story by Daphne du Maurier?

Looking at pictures can be an active and satisfying experience for the viewer. When a photograph appeals most strongly to you, it may not only reveal an accurate visual record, but it may also excite your imagination and stimulate your thinking by reminding you of personal experiences or desires or by challenging you to think thoughts that you've never thought before.

Many strong photographs stand by themselves as visual experiences, without benefit of caption, context, or title; at other times words and pictures work together most effectively to communicate ideas. Photographs can provide information or stimulate

interest when words alone might fail; written captions, however, are often required to clarify facts, to place a photograph or series of photographs into context, and to call attention to details that might be overlooked by the casual viewer. Some successful photographs need no words at all. Such photographs appeal to nearly everyone.

think before you shoot!

A photograph is only as good as the thinking that goes into it. You cannot communicate your ideas if you have nothing to say; nor can you effectively communicate someone else's ideas if you have no feelings about the subject or about the audience.

Even the aloof artist who claims not to be attempting to communicate any message at all is actually saying quite a bit about himself to anyone with whom he shares his photographs. Those of us who consciously attempt to communicate with others need to take a hard look at what we are doing and think about ways to be more articulate. I urge you to consider the advice in the five following sections:

1. *Decide First What You Are Trying to Say or Convey to Others.* Do you want to *present information or facts, create emotional impact,* or *provide esthetic satisfaction?* Although a "good" photograph can fulfill any one of these functions, most truly great photographs operate on all three, or at least two, of the three levels simultaneously. See what purposes you perceive in "great" photographs that you see.

2. *Previsualize the Essentials of the Image.* A photograph communicates with *subject matter, lighting, perspective, composition,* and *technical quality.* All of these elements make up your photographic vocabulary; how well you communicate depends on how well you use your vocabulary. Seldom do these factors combine themselves by accident into an effective photograph.

3. *Study Every Image You See.* Look at photographs, paintings, movies, and more photographs. When you react strongly to a picture or a movie or TV shot that has real impact, try to analyze the

That's a very important part of my photography—not knowing why—being attracted to a world, exploring it, finding myself, finding truth, and finding meaning inside a world I didn't know.
Bruce Davidson

Any . . . photograph that fails to move the viewer and to leave him different than he was before has failed as art because it has failed as communication.
Harold Allen

By seeing things I could be seen. And by feeling things and capturing those feelings on film I could be felt.
Bruce Davidson

I think once you get interested in photographing it makes you very alert to the environment around you. You see much more than if you don't think in terms of photography.
Eliot Porter

My photographs are the result of intense reaction to my daily experiences. I do not wish to record, but to search for the elusive fragments of meaning according to my perceptiveness and awareness of the universe. . . . As in a mirror, the responsive observer will discover not only the artist's reflection in his work, but his own image as well. This way we share our findings with others, communicate and fill a deep human need.
Ruth Bernhard

I am the adventurer on a voyage of discovery, ready to receive fresh impressions, eager for fresh horizons
Edward Weston

You're always looking for the picture that sums it up, the picture that makes a point.
Brian Lanker

Discovery consists of seeing what everybody has seen and thinking what nobody has thought.
Albert Szent-Györgyi

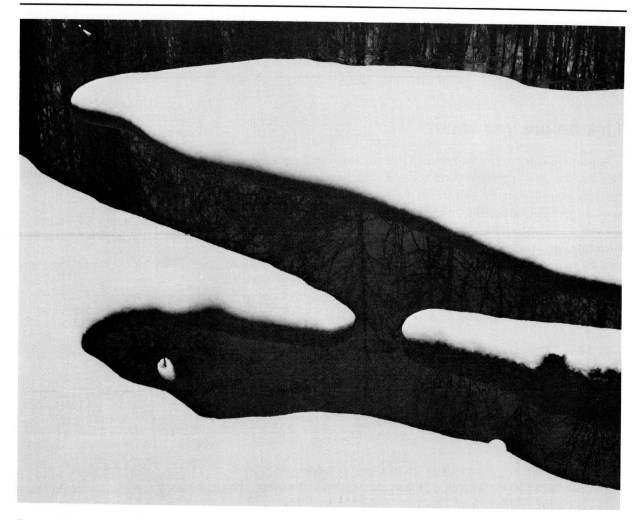

ROGER HANSEN *Snow and Water* When viewed from a distance, this winter landscape becomes an interaction between abstract forms of white on black—or is it black on white? Which form is foreground and which is background?

My favorite thing is to go where I've never been.

Diane Arbus

I don't take pictures, pictures take me. I can do nothing except have film in the camera and be alert.

Charles Harbutt

The first impression is essential. The first glance, the shock, the surprise.

Henri Cartier-Bresson

treatment of subject matter in terms of lighting, perspective, composition, and technique to see just why it succeeded. Study your own pictures to determine just how each one could be improved. Seek advice from others who are knowledgeable, but most of all be your own severest critic. Look at all the newspapers, magazines, and photographic books you can get your hands on. Study their pictures and their layout. See how the photographs hold your attention (or fail to). Don't copy others' work exactly, but never hesitate to adopt good technique or to adapt good ideas that have meaning for you. Improve on other photographers' successful pictures, but don't repeat their mistakes.

4. *Discover the World Around You*. Try to see things the way a camera does. Jacques Henri Lartigue wrote that, as a boy, when he ran out of film he would aim his head at a subject he wanted to preserve, close his eyes for a few moments, and then blink his eyelids open and then quickly close them again. Then he would go home and draw with pencil and crayon the "photographic" image he retained in his mind.

The camera lens sees things in a circumscribed way, and the

camera shutter determines the impression that is to be retained of movement. When you are *being a camera*, notice how every familiar thing changes its appearance under varied lighting conditions and when seen from different points of view. Challenge yourself to notice new things in your everyday environment and to examine familiar things in new ways. Enjoy the new textures, forms, and relationships you discover, but don't limit yourself to photographing inanimate objects. Most of all, don't be afraid to photograph people.

5. *Develop your Interest in People.* Go to shopping centers and supermarkets; attend concerts, picnics, meetings, plays, and social and sporting events. Watch people at these places and activities and watch them at their work. Watch how they sit, lean, laugh, or cry. Watch how they argue, walk, or run. Most people are interested in pictures of other people, especially people who are somewhat like themselves. Photographing people in meaningful and insightful ways takes a lot of empathy, patience, and persistence, but this skill is vital to being an effective visual communicator.

communication as participation

Communication is often described as a one-way process originating with a sender (speaker, writer, or visualizer) through a medium (speech, written word, photograph, or painting) to a receiver (listener, reader, or viewer). Communication is thus seen as a linear process rather than a circular or continuous one. Edgar Dale explained that "in one-way communication, the sender assumes that the receiver is a target to be aimed at but with little or no provision for the 'target' to shoot back." In one-way communication there is, as Dale put it, no creative interaction between sender and receiver.

Communication can be defined in a broader sense to mean "to share in common, to participate in." An effective photograph can be the bridge by which people share common experiences. A photograph makes a literal statement: "This is what this object looked like at a certain moment in time"; or "these were the participants

I try to reveal but not to interpret. I observe but do not intrude.
Henri Cartier-Bresson

The photographer establishes an intimate relationship between himself and whatever he is photographing
Edward Steichen

The camera simply becomes a tool to introduce a person to you To record the kinds of things that surround him. The kind of country he lives in. The way he lives. The way he works. Hopefully, if the photograph is good, it might even tell you a little bit about the way he thinks. And what he likes to do.
Willaim Albert Allard

Talk to people, but listen to them more. Cultivate a genuine interest in everyone's problems, troubles, successes, and achievements, no matter how small. Learn to take everyone for what he is worth. Learn to meet every type of person on his own level. In other words, learn to like people!
Ed Farber

The function of poetry is to awaken a mysterious and uniquely human power of seeing into the essence of things—to discover in each and every article that makes up our universe the truth which unites them all. It matters not what medium the poet uses, and photography can be as eloquent as any.
William Webb

I feel you have to strongly like or dislike a subject. You have to care one way or the other. You can't be indifferent.
William Albert Allard

To communicate is to take part . . . to partake in a joint effort which transforms those so engaged, reconstructs their lives a little and sometimes a lot.
Edgar Dale

Irresistibly, you share a photograph with someone who is with you, and he or she gets a deeper insight into you as well as what you discerned.
Edwin H. Land

a thought is not a thought unless it is one's own. There is all the difference between having something to say and having to say something.

John Dewey

Mere facile rendering of subjects, however beautiful the objects or the technique, has no particular significance. The attempt of an individual to . . . use his craft to make an intense, personal, and unique statement about *his* world and himself has much more value. Each viewer of a particular image would hopefully attempt to examine that image . . . with the idea of determining the intent, the intensity, and the possible meanings of that image in the mind of the photographer as well as . . . in his own mind.

Todd Walker

The terror of each fleeting season is softened by capturing a few of its exquisite moments.

John Schulze

Within each of us there is a spirit which is not seen by others. It lies silent in most of us all our lives. For some it emerges as the expression of the inner-self . . . in painting or weaving or dance or music. That spirit, that unseen part of us, is what makes human kind unlike all other creatures of the earth.

Author unknown

and this is the setting for an event that once took place." Or the photograph can say, "Share the excitement (or pain or joy or togetherness or aloneness) of these human beings." Or the photograph may speak eloquently of texture, line, mass, balance, light and shade, or color. "I was moved by this beauty," the photographer might confide to you through his image, "and I wanted you to share my pleasure." Or the photographer might be saying, "I was horrified and repulsed by what I saw—maybe if you, too, can be horrified, together we can start to change things." Or the photographer could say, "I felt strangely elated (or terrified) when I realized what this image contained—can you help me sort out its meaning?"

But to communicate with others we must first understand ourselves. We must recognize our strengths and frailties; our hopes and fears; our envies and prejudices. I know of no better means than photography to aid us in the better understanding of our world—and of ourselves.

what are you saying?

Deciding what to photograph isn't so much of a problem if you've developed the habit of *seeing*. Finding subject matter may not be so hard if you already have a lot to say in the way of social comment, or if there is specific information you have good reason to want to communicate to others. As we summarized earlier, you have to decide what you are trying to say—presenting information or facts, creating emotional impact, giving esthetic satisfaction, or stimulating the viewer's imagination. If you've decided *what* you want to do with photography and *why*, then you can begin to study the *how*.

The anonymous student asks a very good question. Later on in this book I will discuss some routine details, such as the temperature of your developer and the way you can control image contrast. But before we get into that business, I want you to be making photographs in your mind as well as in your camera. I want you to become so excited about what you're seeing that you can't wait to get it down on film and paper.

It's very helpful to study other people's photographs. In doing so you'll find yourself going through three stages of photographic awareness: first, noticing; then analyzing; and finally, reacting. When you first become interested in photography, you begin to notice photographs that you might not have paid any attention to before. As you learn a little more about visual language, you can't help but analyze every aspect of each image, from concept to quality in a way that a camera club or salon judge might analyze the same photograph. Before long you begin to allow yourself to experience real gut reactions, and you start analyzing why it is that you (and others) feel the way you do about certain images and why you don't feel the same about others. At this point, you can feel that you know what you're doing and need merely to mature. Don't hesitate to "borrow" ideas and styles until you evolve a style of your own. Emulation need not be the same as imitation.

2

I've been in places where the photographers were literally elbow to elbow. And yet everyone comes up with a different picture.
William Albert Allard

Let us first say what photography is not. A photograph is not a painting, a poem, a symphony, a dance. It is not just a pretty picture, not an exercise in contortionist techniques and sheer print quality. It is, or should be, a significant document, a penetrating statement, which can be described in a very simple term—selectivity.
Berenice Abbott

I can read in any photo book what the temperature of my developer is supposed to be. However, I want to know what makes a good photograph and the books fail me in that respect. What good is a perfect print of a rotten picture?
A student

Two may do the same thing, and it is not the same thing.
Publius Syrus (1st century B.C.)

selecting subject matter

The photographic image is different in form and meaning from any other image. It has its own grammar, vocabulary, and interpretation. When and if the student learns this language, he will be able to photographically translate his own thoughts.

Walter Civardi

Robert D. Havira
St. Louis, 1972
(*The Beautiful.*) Such images attract attention whether the subject matter is majestic mountains, fair flora, or pulchritudinous people. Repetition is the keynote in this delicately balanced composition. Notice the subtle variations as lines, forms and values are repeated.

the photographer's vocabulary

As I mentioned earlier, you have at your disposal all of the fundamental elements of visual vocabulary: subject matter, light, perspective, composition, and technique. In this chapter each of these major headings will be examined, except technique; see which

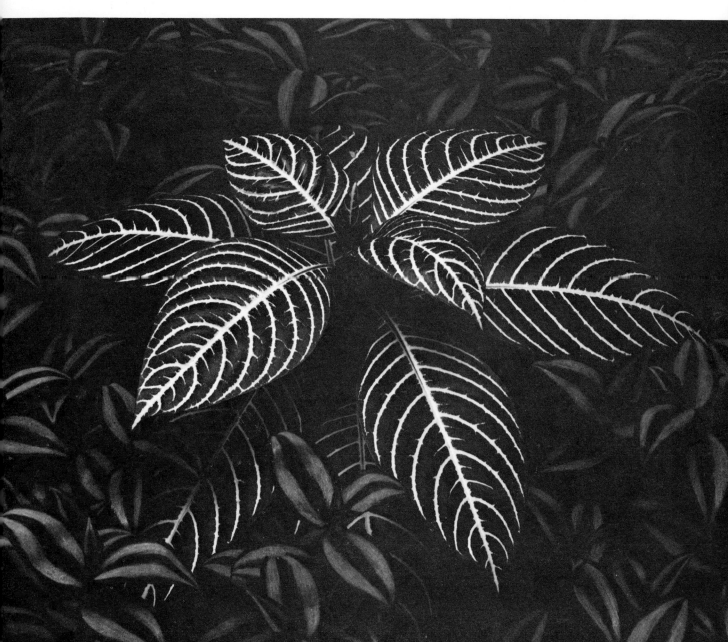

specific communication tools each category contains. In later chapters technique will be discussed.

subject matter

THE BEAUTIFUL

If you're hoping to win prizes at photo contests and art fairs and win acceptance and honors at the local camera club, you'll need to make the kind of pictures people like to see. If you intend to make a little moonlighting money in the calendar and greeting card market, you can count on success with picturesque pictorials, pulchritudinous women, charming children, exquisite flowers, and exotic landscapes. Sex, of course, has always had wide appeal, but the most universal formula for popular success is to unite beautiful children with appealing animals. You can be successful in a certain area of photography if you stick to The Beautiful and replicate the clichés with competence. Almost everyone admires pretty pictures that show life at its most pleasant—the way most people wish life would always be.

THE FAMOUS

The public is insatiably curious about the personalities and private lives of celebrities. A recognizably notable or notorious face will cause most people to stop, to look, to react—especially if the celebrity is caught in an unusual activity or bizarre pose. But famous people aren't everyday photographic fare. Unless you're a professional news hound or amateur snoop, don't depend on this category to make a living.

THE HUMOROUS

If you have a natural sense of humor, let it show in your photographs. People respond to a touch of whimsy in an otherwise somber scene, and a naturally comic situation always gets a spontaneous reaction. You can win photo contests and sell pictures to publications if you can skillfully place children, animals, and famous or emotive people into universally humorous situations or devise really clever visual puns and gags.

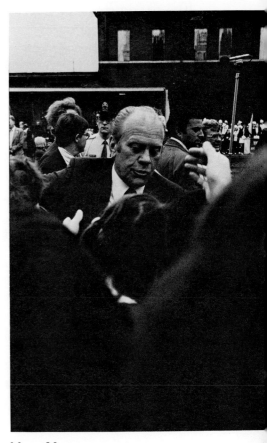

MARK NAMATEVS
Campaigning in Kalamazoo
(*The Famous.*) Would this photograph evoke any response if the main subject were not recognized as a familiar public figure or celebrity?

I believe in photography as one means of . . . affirming the enormous beauty of the world . . .
Ansel Adams

I like to take people in their environment . . . the animal in its habitat.
Henri Cartier-Bresson

Let other people see the world through your eyes.
Richard Shirk

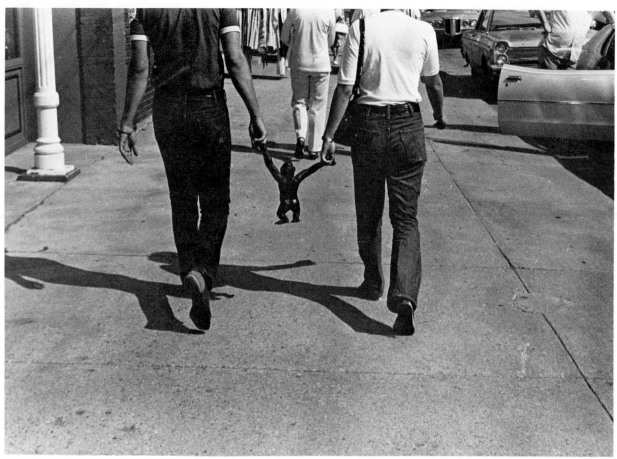

GARY CIALDELLA *Downtown Pentwater*
(*The Humorous.*) Does the sheer incongruity of this photograph make you chuckle? It is an instant in time—an image that could only be photographic—that succeeds, despite fracturing all the traditional rules of composition and previsualization.

MICHAEL SARNACKI *Music Festival*
(*The Unexpected.*) Would you quickly dismiss this photograph because of "sloppy" composition? Or would you be intrigued enough to study the image long enough to discover the unexpected surprise within?

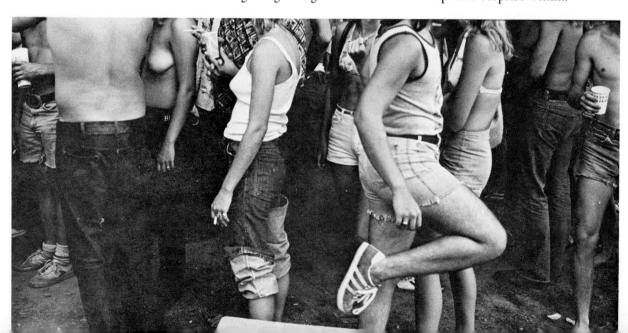

THE UNEXPECTED

People love to be surprised by the bizarre and the unusual. A strong reaction of either laughter or distaste can be achieved by deliberate distortion of the ordinary or by juxtaposition of unrelated things. If you can shock viewers into spending enough time with your photograph, you can reward them with serendipitous discoveries within the image. Try photographing an object not so much for *what* it is, but for *what else* it is.

THE SPECTACULAR

A dramatic vista, grandiose canyon, monumental mountain, or fantastic inferno will awe its beholder. Such a view grabs the attention of the viewer because of sheer scale and deviation from the ordinary. Capitalize on spectacular subject matter when you can. Employ all the technical skill you possess to emphasize the inherent grandeur and spectacle of your subjects.

KAREN ERICKSON *Fireworks*
(*The Spectacular.*) Dramatic photographs of fireworks, fires, wrecks, demolition, and disaster all capture the curiosity of viewers. In this case, the unsteadiness of a hand-held one-second exposure added interest to what otherwise would have been a routine burst of fireworks.

Nothing is ever the same as they said it was. It's what I've never seen before that I recognize.
Diane Arbus

To the man who knows nothing, mountains are mountains, waters are waters, and trees are trees. But when he has studied, and knows a little, mountains are no longer mountains, water is no longer water, and trees are no longer trees. Finally, when he has thoroughly understood, mountains are once again mountains, waters are waters, and trees are trees.
Zen philosophy, quoted by Edward Weston

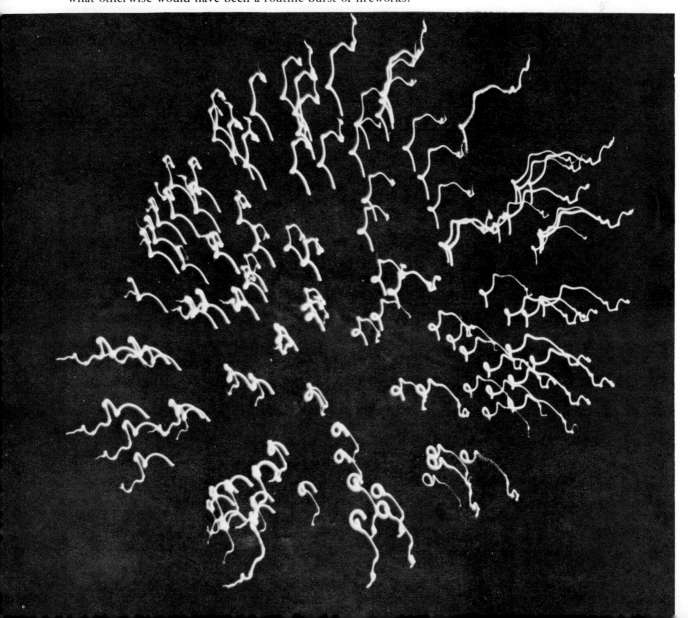

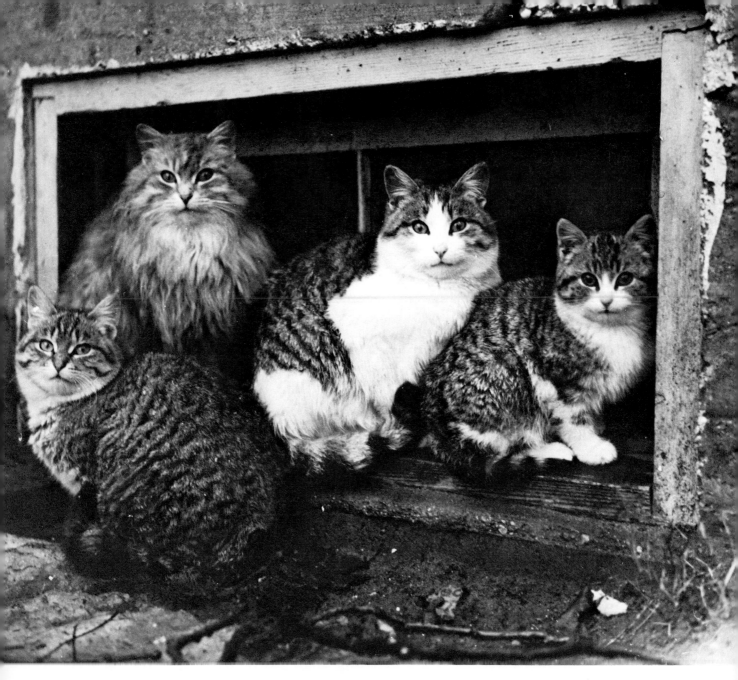

JOHN BARTOCCI *Cats*
(*The Familiar.*) Nearly everyone
notices and likes pictures of ani-
mals, children, and familiar sce-
nery. Notice that in this simple
photograph, however, the fun-
damental compositional device is
repetition with variation. Also
present are the elements of form,
line, tone, space, texture, rhythm,
and contrast.

There are no new ideas in the
world. There is only new arrange-
ment of things.
Henri Cartier-Bresson

THE FAMILIAR

Babies, animals, and landscapes are popular subject matter be-
cause they are familiar to everyone. Such pictures evoke sentimen-
tal memories of idealized childhood and idyllic experiences. Al-
though personal snapshots fulfill this purpose for millions of
people, many thousands will happily purchase professional "snap-
shots" to put on their walls, coffee tables, and bookshelves. The
skilful professional might even educate his customer a bit by
sneaking some quality and design into an otherwise ordinary
image.

THE GRAPHIC

Many people who claim not to like any kind of abstract art will
subconsciously be attracted to an image built on strong elements

of graphic design. Some people will be attracted to such an image without really knowing why. Those who do understand the visual vocabulary well enough to analyze and appreciate the quality of the underlying order and balance may receive distinct esthetic pleasure from the simple act of viewing such a work.

THE MYSTERIOUS

A "stopper" photograph is not always easy to understand. The secret of its success is in trapping the viewer into studying it long

JAMES M. RHODES *Railing* (*The Graphic.*) A simple, dynamic visual statement can attract a viewer's attention from across a room. Whether the photograph is great or not may depend on whether attention, once captured, can be held and rewarded by rhythms and detailed elements within the image.

The seeing process is primarily a purposive searching of the visual environment for instances of order.
Norman F. Carver, Jr.

I like to present a problematic situation and let the viewer in his inventive way come to grips with it on personal terms
Jerry N. Uelsmann

MICKEY HOWELL *White Hand*
(*The Mysterious.*) This photograph
makes my flesh crawl and sends a
chill up my spine. Does it have a
similar effect on you? Does the
murky, grainy tonality of the image
affect its psychological impact?

BRIAN LANKER
Automobile Accident
(*The Tragic*). What is there about
injury and death that appeals to
the morbid curiosity of the human
mind? Why are people fascinated
by the misfortunes of others—
could it be that we are secretly re-
lieved that it didn't happen to us?
Brian Lanker says, "People seem
to have something for tragedies.
When they go on in my town, I've
got to photograph them." (Photo
courtesy of Topeka Capital-
Journal).

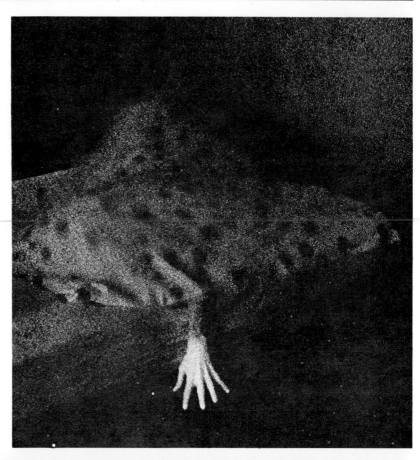

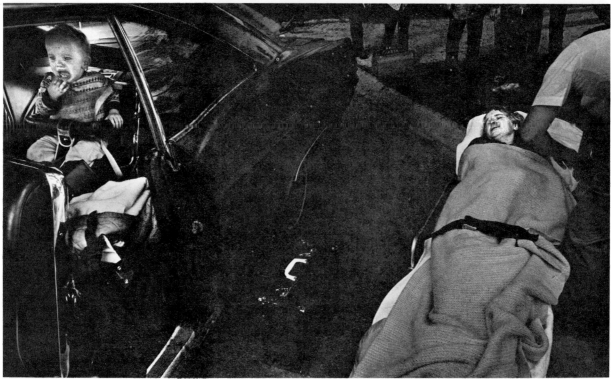

enough to commit himself to unraveling the visual puzzle or metaphor that the photographer so cleverly hid within it. You have to offer the viewer a challenge, in other words, that is so personal and so tempting that he can't refuse to accept your little intellectual game and play it seriously or for fun—but accept your challenge, nevertheless.

THE TRAGIC

As we have learned during recent wars and catastrophes, strong photographs can stir up emotions of sympathy, empathy, indignation, and anger. They can stimulate reactions of commitment and they can result in distrust and disgust. War photographs, for example, and photographs of starving children or accident victims often shake us to our emotional roots, as we identify with the plight of the people in the pictures.

THE SOCIAL LANDSCAPE

Many contemporary photographers have been turning away from pictorial subjects and toward recording moments of everyday reality—catching man unawares as he interacts with the environment he has created for himself. Bearing a superficial resemblance to the uninspired snapshot, such photographically immortalized instants in time sometimes make significant com-

If . . . my photographs could cause compassionate horror within the viewer, they might also prod the conscience of that viewer into taking action.

W. Eugene Smith

The visual soul of America is the highway, a hamburger joint, and a dime store. I love the loneliness and power and craziness of America. It is me.

Burk Uzzle

JOHN A. LACKO *Plainwell* (*The Social Landscape.*) Has this boy been sent from the restaurant for some obscene infraction of table manners? What has he done (if anything at all)? We'll never know, but the photograph poses a provocative problem for us as it records a moment of human drama.

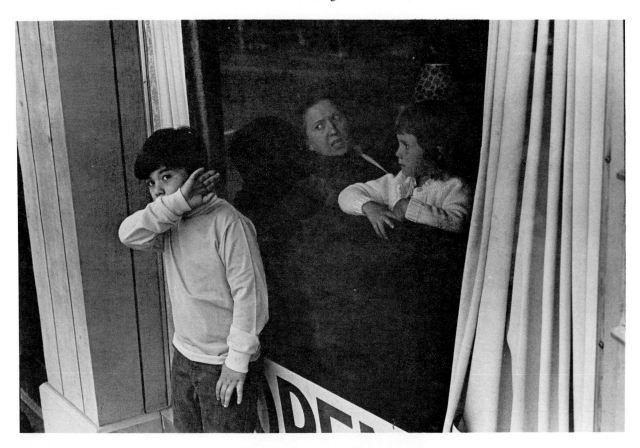

This mysterious quality of believability or implied truthfulness . . . raises to the level of art the simplest, most direct snapshot, when the process of selection is in the hands of a creative person.

J. H. Troup, Jr.

A photograph should sometimes be more of an intriguing suggestion than an obvious statement.

John Lacko

Photography combines those elements of spontaneity and immediacy that say this is happening, this is real, and creates an image through a curious alchemy that will live and grow and become more meaningful in a historical perspective.

Dan Weiner

Any photographer who takes the time to react to what he is photographing, as well as to aim the lens and push the button . . . will never feel the same about his subject after he has photographed it.

Margery Mann

ments about the state of man and his relationships and interactions.

So much for subject matter. I shouldn't have to point out that some photographs succeed on strength of subject matter alone. It's true that Pulitzer prizes have been awarded to photographers who had the good luck to be in exactly the right place at the right time and who had the nerve and the presence of mind to trip the shutter at the climactic instant of a newsworthy event. But you can carry a camera around your neck for a lifetime—everywhere you go—and never luck into such a situation. Most *good* pictures require conscious awareness of the potential of a situation and the skill and patience to make the photograph happen. *Good* photographs also depend generally on the skillful and fortuitous combi-

RON NULL *Abandoned Home*
A full tonal range, strong underlying geometric design, and a sense of mystery combine to make this photograph one of my favorites. Many people enjoy this image because it is simultaneously effective on technical, graphic, and emotional levels.

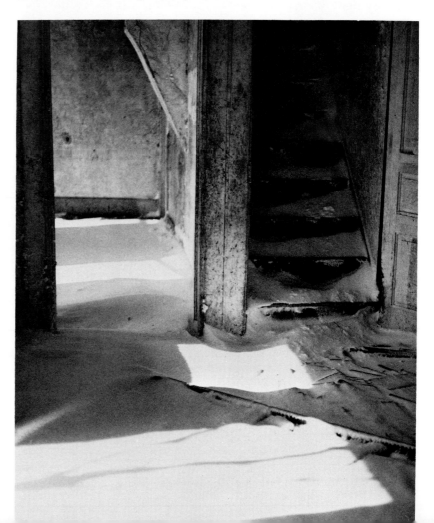

nation of subject matter with some of the elements of lighting, perspective, composition, and technique.

Although some photographs can be successful on the strength of subject matter alone, there has never been such a photograph that couldn't have had additional impact. *Great* photographs demand a conscious blending of all the elements of the photographer's visual vocabulary.

light

We can consider light in terms of tonality, contrast, and emphasis—in other words, what light does to and for the subject matter of the photograph.

TONALITY

We live among cultural clichés about color meanings and stereotypes about tonality. In the North American/European tradition, for example, lightness and brightness imply cleanliness, goodness, hope, and inspiration; darkness is often taken to mean the opposite: blackball, black death, blackguard, blacklist, blackmail, black market, black sheep, "a dark sky," "in the dark." The ancient oriental symbol of the eternal struggle between good and evil depicts the good as white and the evil as black or red. In Western movies, we all know who wears the white hats and who wears the black hats. Black, in the culture of the Western world, is the traditional symbol of death and mourning. Perhaps some of the roots of racial prejudice are traceable to ancient myths and taboos about darkness and blackness. Most people instinctively associate dark photographs with sadness, mystery, or ominousness. Lightness usually implies happiness, openness, innocence, and hope. Colors are stereotyped, too—reds, oranges, and yellows are traditionally warm, active, and advancing; whereas greens and blues are considered to be cool, passive, and retreating. Although these conventions are generally accepted, some interesting photographic paradoxes have been created by photographers who were bold enough to violate them.

Photography is the simultaneous recognition, in a fraction of a second, of the significance of an event, as well as the precise organization of forms which gives that event its proper expression.
Henri Cartier-Bresson

[When looking at a photograph] we experience a swift, intuitive response to the photograph as a whole—an emotional reaction that cannot be precisely verbalized—resulting from the interplay of shapes, forms, textures, lights, and darks. More or less simultaneously we try to find a rational meaning to the event or situation portrayed. Why is the photographer showing us this particular fragment of time and space? What meaning, if any, did it have for him and may it have for us?
Arthur Goldsmith

DAVID M. POSTHER
Splinters and Steel
What kinds of *contrasts* are evident
in this photograph? Can you imag-
ine an *audible* effect from this
image, in addition to the visual im-
pact?

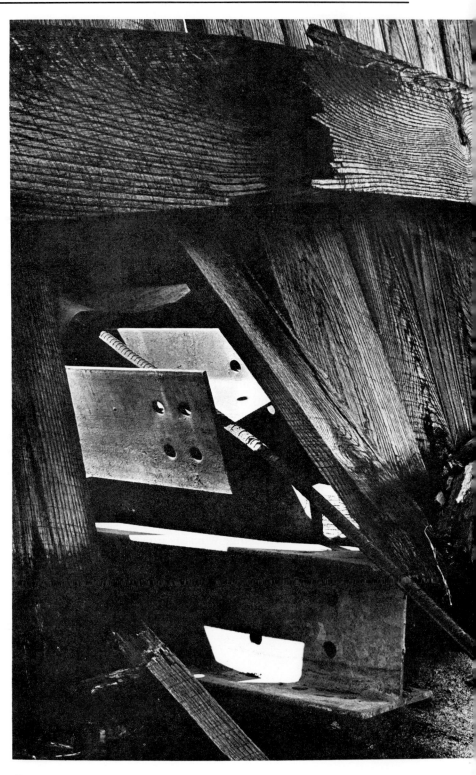

CONTRAST

Cartier-Bresson talked about conflict and contrast between
forms and objects, as well as between elements of light and dark
and conflicting colors: "Poetry is the essence of everything. It is

two elements which are suddenly in conflict. There is a spark between two elements. There are always two pulls and one cannot exist without the other one. It's these tensions I'm always moved by."*

Photography is possible because some objects and portions of objects reflect more light than others. Shadows, to put it most simply, are crucial. The term *contrast* refers to the relative brightness, or reflectivity, of various portions of the subject or of the photograph as a whole. Soft, low-contrast lighting, in which shadows are diffuse and luminous, often creates a mood of delicacy and softness, even femininity, especially when the image is predominately light in tone, or *high key*. Contrasts in lighting, on the other hand, tend to form harsh, dark shadows on and around the subject, emphasing texture and roughness. And remember what darkness may imply! If the predominant mood is extremely dark, there may be mystery (what evil lurks in those sinister shadows?) A photograph that consists mostly of dark areas is said to be *low key*.

Extreme lighting contrast is usually thought to be appropriate for enhancing the rugged appearance of masculine character subjects and for simulating the dramatic effect of stage lighting. As a spotlight singles out the principle performer on a stage, so the main or *key* light source draws the viewer's attention to the lightest portion of a photograph.

As you look at photographs, notice whether your eye is, indeed, drawn by the lightest area, and then whether this area is, in fact, the most significant point, or the center of interest. It's often distracting, for example, to allow a print to have very large white areas in the corners or bright areas in the background that compete for attention. The eye is drawn irresistibly away from the primary center of interest. You are usually able, of course, to control the direction and relative contrast of light and to choose which portions of a picture to illuminate.

Chiaroscuro is the term used by artists to describe the placing of

*Henri Cartier-Bresson, *The Decisive Moment*, sound/slide series (New York: Scholastic Magazines, Inc., 1973), frames 36 and 42.

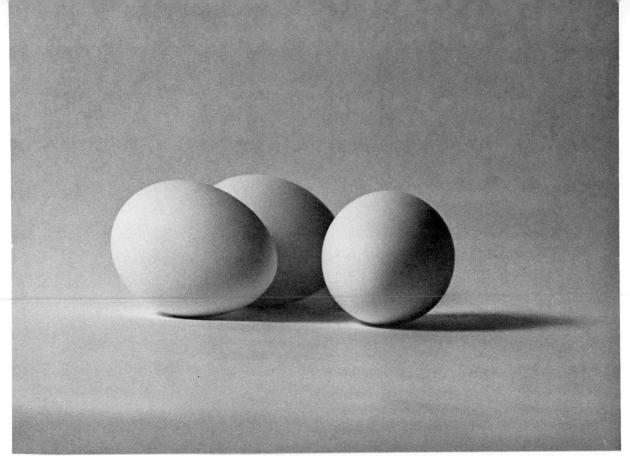

SALLY PUTNEY *High Key*
Notice that roundness and texture
are retained in the eggs, although
only relatively small shadow areas
have a value below Zone VI.

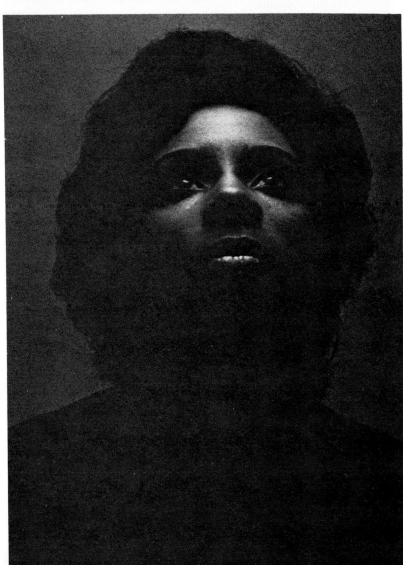

WALLACE KIRK *Low Key*
Notice that this portrait retains a
sparkle and feeling of quality al-
though composed almost entirely
of values below Zone V. Loss of
separation between the lower
zones seems relatively unimpor-
tant because attention is diverted
to highlights in the eyes and onto
the major planes of the face.

light against dark and dark against light, suppressing extraneous detail by placing it in the shadows. Balance is as important between light and dark tones as it is between various hues and intensities of color. Look for the chiaroscuro effect in nature and in works of art; try to employ it in your photographs.

Nothing exists in itself—it is the relationships between things which are important.
Henri Cartier-Bresson

perspective

In the broadest photographic sense, perspective means *point of view.* The term refers to the rendering of lines and surfaces on the flat film plane of the camera; it refers also to the effect of size relationships and camera angle to the viewer's interpretation of the photograph.

Should you correct a distorted rendering of perspective? Although our eyes see parallel lines as converging and straight lines as curved, an accepted convention in architectural and many other forms of photography is that parallels should be rendered parallel and that straight and perpendicular lines should be shown as being straight and perpendicular. With the right kind of equipment, we can either "correct" or deliberately distort perspective, depending on the effect we have in mind.

In size relationships, Biggest = Most Important. That's the general rule, exceptions being made by the skilful use of lighting and

The snapshot is a picture made with the eye only. The creative photograph, on the other hand, is made with the mind.
Wilson Hicks

BETH SHIRK *Black Angus* (*Perspective.*) Squint at this photograph. Do the cattle appear to be floating in space? Do their diminishing sizes give an illusion of depth and distance? Is the three-dimensional effect enhanced by the converging perspective of the rows of corn stubble?

JIM NIXON *Telephone Building*
Should this architectural photograph have been corrected to render the vertical lines parallel, or does the convergence add the feeling of soaring?

compositional balance to emphasize areas or objects that are smaller in size.

CAMERA ANGLE

When we look *up* at someone or something, that subject seems to increase in stature and significance, as a child's-eye view of an adult. Conversely, looking *down* tends by association to diminish or to de-emphasize. Notice the altered feeling of identification when you confront a child or a pet eye-to-eye. Sometimes a change in camera angle adds interest or drama to an ordinary scene.

JIM NIXON *Old Man Standing*
Does looking up at a subject increase its apparent stature? Do the hand and arm gestures in this example and *Old Man Sitting* contribute to the effects of enhancement and diminution?

JIM NIXON *Old Man Sitting*
What is the effect of viewpoint on psychological interpretation? Is diminution the result of looking down on a subject, as we are accustomed to looking down on a child?

composition

The camera is dumb!
Garry Winogrand

The contemplation of things as they are, without error or confusion, without substitution or imposture, is in itself a nobler thing than a whole harvest of invention.
Francis Bacon

The junkyard proved to me that there are things to photograph everywhere . . . and until I shot that assignment I didn't believe it.
A student

Abstraction releases everyday forms from their everyday associations—allows them to take on new and symbolic meanings.
Norman F. Carver, Jr.

In [my pictures] you have the object, but you have in the object—or superimposed on it what I call the *image,* which contains my idea. These two things are present at one and the same time. There is, therefore, a conflict, a tension. The meaning is partly the object's meaning, but mostly *my* meaning. . . . I feel the anthropormorphic qualities of shapes very strongly at times. I don't feel them as animals or because they resemble something, but as force or energy.
Aaron Siskind

J. H. Troup, Jr. observed that, "The camera allows the photographer to select and save rectangular bits and pieces of the all-encompassing, ever-changing reality in which we exist. . . . The photographer . . . applies the camera's frame to nature to include, to exclude, to associate, to disassociate, to isolate designs, and to show significance." In this quotation Troup distills the essence of the difference between the work of the painter and that of the photographer. While the painter starts with simple space (a blank canvas), and then adds basic lines and forms, concluding finally with the complex elements of texture and color, the photographer must do exactly the reverse: the photographer must work from the complex to the simple. From the bewildering array of visual stimuli confronting him, the photographer must *isolate* and *select*, including the significant elements within the space bounded by the edges of his ground glass or viewfinder, and excluding the extraneous.

A camera, correctly adjusted, will record an image of everything within its field of view. The camera's eye merely records facts. It is the eye and brain of the photographer that must determine which facts are worth recording and in what way.

Obviously, the biggest challenge in taking pictures in a junkyard is the discipline of searching for pleasing designs and patterns among unrecognizable subject matter. Unburdened by considerations of "What is it?", the viewer can share the photographer's joy of discovery.

Some modern painters and photographers try to produce abstract images by leaving out all real objects. Interestingly, this is the kind of image that a perceptive photographer can find in nature.

John Whiting has said, "More has been written about composition than should have been."* What Whiting means is that ironclad rules have been set down pontifically through the years by art

*John R. Whiting, *Photography Is a Language* (New York, Ziff-Davis Publishing Co., 1946), p. 51.

critics, professors, and salon judges. They have used these rules as inflexible criteria for measuring the value of photographs as art. Many of these so-called rules have become so a part of traditional criticism that perhaps the majority of people tend to accept them as gospel and to summarily reject images that fail to follow the formulas. But in the same way that photographs should not be rejected or ridiculed solely because they don't meet certain accepted compositional criteria, neither should empty and meaningless pictures be accepted and praised solely because they do.

Compositional "rules" are worth studying, however, because more often than not they will help you to produce stronger and more successful images. Once you've become familiar with the rules, you can feel free to break them with impunity—but not out of *ignorance*. Break the rules only when breaking them makes your statement stronger.

Photojournalist William Albert Allard has explained that, "When I make what I think is going to be a fine photograph, I feel it. I can feel it in my stomach. And I'd like someone else to feel that also."* Part of what Allard means is that he has an innate "feeling" for design, order, and balance—a feeling that says deep inside him: "Move the camera a few inches to the left . . ." or "This is it . . . shoot!" By studying other people's photographs, as well as your own, you'll see when the following "rules" have strengthened a picture and when the photographer was right in daring to break them.

*William Albert Allard, *A Sense of Place*. sound/slide series (New York: Scholastic Magazines, Inc., 1973) frame 13.

Compositional rules are nothing more than the experience of others that has become accepted. To accept and follow the rules uncritically means to accept other peoples' experience and not to allow yourself to experiment.
Gerhard Bakker

We live
In a demanding and confusing world.
With my camera
I try to pluck moments of beauty,
Of grace
And of tenderness,
So that they may
Become things for the eye
As well as the heart.
Russ Pfeiffer

MEL TEAGUE *Conversation*
Do the signs, poles, wheels, fence texture, and other details provide essential supporting information in this photograph or are they distractions?

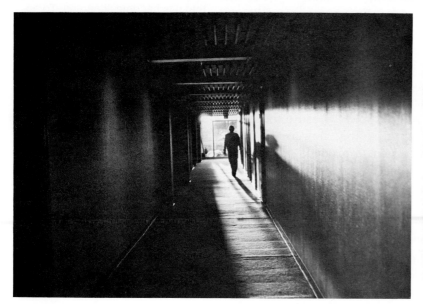
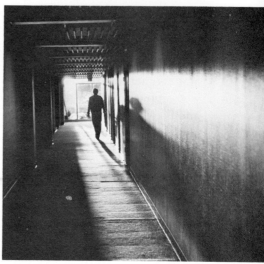

PAT GREEN *Corridor*
Which cropping do you prefer?
The version on the right conforms
to the widely stated rule that the
center of interest should be placed
approximately one third of the dis-
tance from either top or bottom of
the frame and also about one third
the distance from either left or
right. This "rule of thirds" pro-
vides for a more dynamic composi-
tion, but do you feel that there
might be exceptions? Do you get a
different feeling of space and
movement from the uncropped
photograph?

SOME "RULES" OF COMPOSITION:

1. Have a single, *dominant* center of interest.

2. Place the center of interest away from the center of the pic-
ture. Follow the "rule of thirds."

3. Keep the horizon level, placing it according to the rule of
thirds. Don't cut a picture into two equal parts either horizontally
or vertically.

4. Don't allow important tones and textures in your main sub-
ject to merge with the background.

5. Fill the frame. Do most of your cropping in the camera
viewfinder instead of in the darkroom.

6. Keep extraneous details out of the picture.

7. Don't amputate parts of your main subject at awkward
places.

8. Avoid distracting shapes at the very edges of the photo-
graph.

9. Have the main subject facing or moving *into* the frame,
rather than out of it.

10. Frame the principal subject with a complementary fore-
ground object.

11. Concentrate attention with leading lines, such as con-
vergence and S curves.

12. Employ strong *diagonal* lines to imply action or conflict.

13. Compose *vertically* to emphasize height and dignity.

14. Compose *horizontally* to suggest peace and rest.

David Knoblauch *Cyclist*
Does it make any difference to you whether the cyclist appears to be moving into the frame or out of it? In the photograph below, does he seem to be coming to a screeching halt?

JAMES M. RHODES *Drainpipe*
Does this combination of vertical format and jagged diagonals strongly imply both height and action? Besides strong graphic elements, this print contains fine textures and unusual spatial relationships.

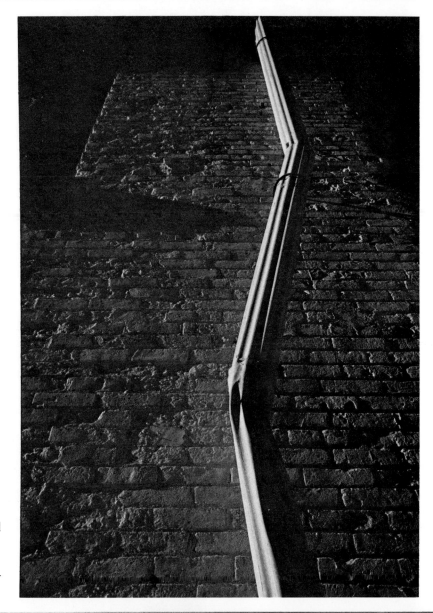

JIM NIXON *Snowscape*
The sensuous S curve, peaceful horizontal format, and restful tonal values of this quiet landscape contrast mightily with the violent jaggedness of James Rhodes' *Drainpipe*.

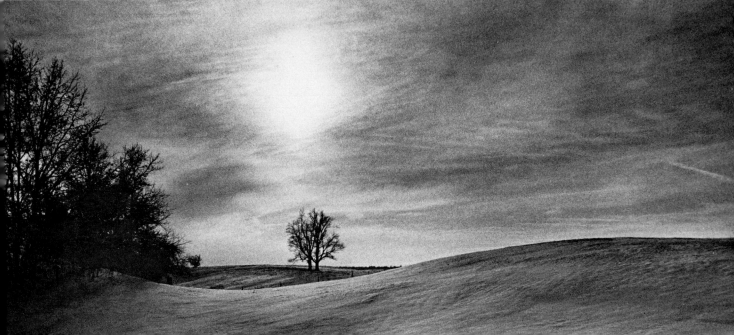

By following these rules you'll be able to make pictures that will sell and that will achieve other kinds of recognition. By totally ignoring the rules you risk failure; but sometimes, by deliberately violating them, you may audaciously achieve a fantastically successful photograph. It depends on what *besides* composition you've managed to put into your photograph.

Elements of Composition

Fundamental to effective composition are the artist's elements of form, line, tone, space, texture, and rhythm.

Form is the basic underlying shape of a composition. When evi-

> When simple forms are repeated they bring to the eye the kind of pleasure that music brings to the ear.
>
> *Victor B. Scheffer*

KENNETH ZELNIS *Milkweed Pod* (*Form.*) Concentric repetitions of the oval shape of hand and pod are subsequently repeated in the fingers, resulting in an image of refreshing simplicity and harmony.

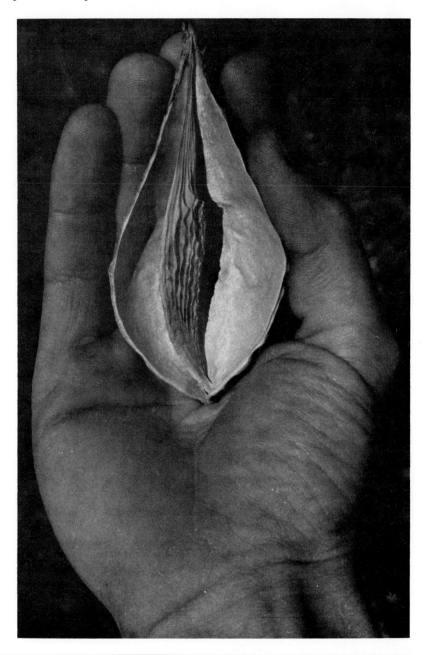

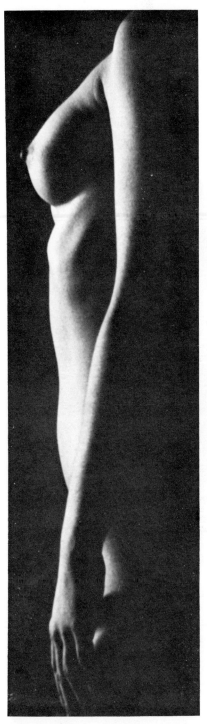

JAMES M. RHODES *Wall and Chimney*
(*Tone.*) Much of the interest in this strong, yet simple design derives from subtle variations in value from black to white and in areas of tone from tiny to relatively immense.

OMAR MANGRUM *Torso*
(*Line.*) Sensuous, undulating lines create the essence of this photograph, together with subtle variations in tone. Notice that the black background (negative space), forms an interesting shape of its own.

dent to the viewer, and especially when repeated with variation, form can become highly significant.

Line outlines, delineates, and defines form and space within the frame. Strong single or repeated lines may themselves be important elements in the composition. Because the eye and brain tend to connect and to group perceived objects, lines that are implied, although they are not actually present, may tend to connect forms and serve as vectors, giving direction for eye movement within the composition.

Tone is the relative value or reflectiveness of a given area within the image, or the overall lightness or darkness of the entire photograph. Whether in shades of gray or color values, tones can be contrasted, harmonized, or merged, depending on the effect you want to achieve.

Space is the field or background surrounding objects within the

frame. Whether the background remains in the background, in what is sometimes referred to as negative space, depends in part on the relative tonal values present in the image. If the main subject merges with the background, both form and space may be poorly defined. On the other hand, contrast of either line or tone can be used deliberately to separate the subject from the back-

JAMES M. RHODES *Passageway*
(*Space.*) Dark on light, or light on dark? Which is foreground and which is background? If the large white rectangle is a window or a doorway, whence does it lead—into someplace, or out? The mystery and drama seem heightened by visual contrast and by delicate graphic balance.

You can think of [texture] as form on a smaller scale. It describes the finer parts of a pattern. When you see a spider web at a distance you think of its texture, but when you look closely at one you think of its form. . . . As you bring your eye closer to the bark of a tree you gradually lose the feeling of texture and begin to see bold lines and curves. Now you see how form and texture are related by scale.
Victor B. Scheffer

Whenever I can feel a Bach fugue in my work I know I have arrived.
Edward Weston

Architecture is frozen music.
Goethe

ground (form from space or, in psychological terms, figure from ground).

Texture is another element of beauty and interest. Texture in a photograph is roughness or smoothness that you can "feel" with your eyes: tree bark, sand, or skin that your mind vicariously can caress and explore.

Rhythm and repetition are everywhere—in music, in architecture, in the human body, in nature. Form is the basic thematic statement of the composition. Form is the basic plan. Everything else is either support, repetition, or embellishment. In music, *syncopation* is the term used to describe unexpected interruptions in rhythm. The principle of syncopation applies also to the visual arts, as a form of repetition with variation. Rhythmic, repeated patterns of line and form can be interesting in themselves; but repetition can be more exciting if the pattern is varied by one single

F. L. Feick *Wheel*
(*Texture.*) Although other elements are important in this photograph, we expect to be able to "feel" the textures of rusty iron and weathered wood. Oblique sunlight and good photographic technique yield an image that does not disappoint us.

WILLIAM BEVERLY *Rhythms*
I hear music when I examine these
three photographs. Do you? With
one I can hear a strident march,
with another a waltz, and with the
third I hear jazz.

Opposites will always be present in any photo, but in the bad photo they will be at war with each other and not working as a team. For example, background objects will interfere with the foreground, highlights will blast while shadows are impenetrable.

Nat Herz

Creativity is the ability to relate previously unrelated things.

Paul Smith

The greatest joy for me is geometry. That means a structure. . . . It is a sensuous pleasure, an intellectual pleasure at the same time, to have everything in the right place.

Henri Cartier-Bresson

item being different from the rest—contrasting in size, shape, value, texture, or direction. As in musical composition, repetition with variation is usually a strong basis for an interesting visual composition.

Contrast—Conflict and Contradiction

Finally, let's consider another meaning of the term *contrast:* contrast between subject elements; or we could use the term *opposites,* meaning conflicts, or contradictions. Dynamic balance is a compositional way of placing unlike elements into equilibrium. Strong photographs often are filled with opposites—not only light versus dark, large versus small, rough versus smooth, but opposing and contradictory elements: flesh and steel, high and low, youth and age, birth and death, growth and decay, joy versus sadness, sun versus ice, rectangle versus circle, straight versus curved. Visualize in terms of contrasts and contradictions. Deliberately build your images around them.

When you repeat form and line with variation, the variation can be slight irregularity or it can be gross distortion, depending on how subtle you want to be.

Jim Nixon *Norm with Mask*
Is this photograph merely a bit of slapstick comedy or could it have deeper significance? What *contrasts* are evident? Is it important that the image is of superb technical quality?

ELAINE LOGIE *A Friend*
(*Repetition with variation.*) Notice in this portrait that the subject's face and cap are repeated, with variation, both in the painting and in the shadow on the wall.

Think in terms of contrasts in size, shape, tone, texture, direction, mood, color, and content. Composition is the sum total of all the elements we've described, put together not mechanically or ritualistically, but assembled with a real feeling for the effect you want to achieve.

Many photographers look consciously for compositional elements and many abstract photographs depend solely on these elements

I get a greater joy from finding things in nature, already composed, than I do from my finest personal arrangements. . . .
Edward Weston

Photographs come from that moment in the process of cognition *before* the mind has analyzed meaning or the eyes design and at which the experience and the person experiencing are fully, intuitively, existentially *there.* Such images look like photographs, not paintings.
Charles Harbutt

to photograph a rock, to have it look like a rock, yet more than a rock. . . .
Edward Weston

Photographic design is more related to jazz than to formal, classical composition. It is . . . spontaneous, instinctive, even subconscious. . . .
Charles Harbutt

I don't know any formal rules of composition. . . . Composition is simply the strongest way of seeing.
Edward Weston

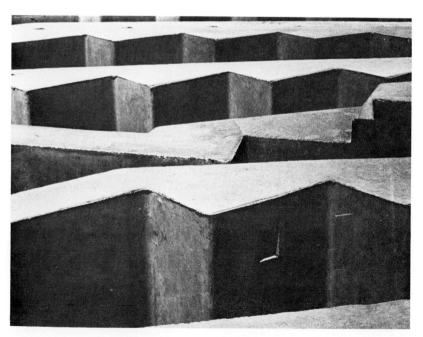

JACK URBAN *Precast*
This photograph contains all the elements of form, line, tone, space, texture, rhythm, and contrast. Do you find it interesting from a graphic point of view? Is it also a bit mysterious, as a visual puzzle of unknown scale? Does it surprise you to learn that these are edges of precast concrete steps lying on their sides?

SELECTING SUBJECT MATTER **45**

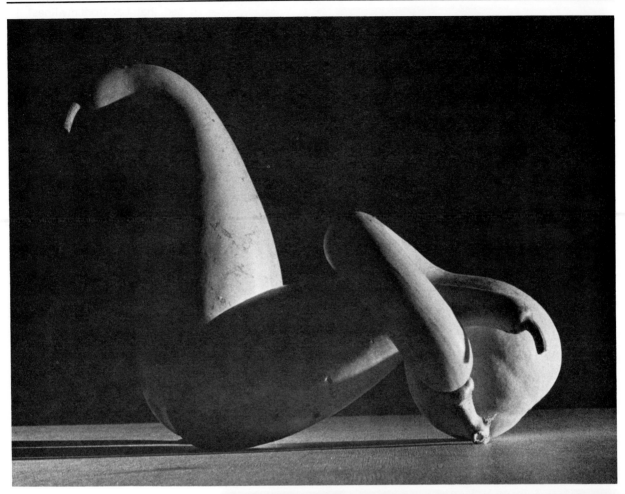

JACK SIZER *Gourds*
(*Visual analogy.*) Although these
two forms are far from identical in
form, texture, and size, are they
not visually very closely synony-
mous?

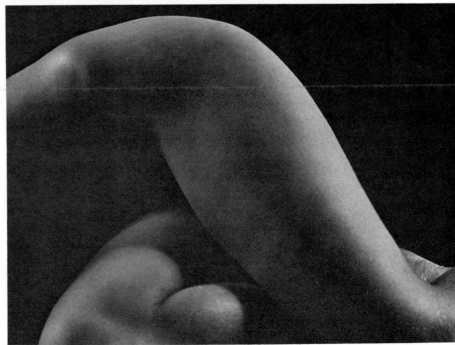

JOHN STITES *Figure*

as their reason for being. Cartier-Bresson said, however, that although he was always intuitively aware of geometric structure "you can't go shooting for shapes, for patterns. . . ."* But in order to make successful images of the kind Cartier-Bresson makes of people and events, you must always be subconsciously aware of compositional elements and ready to trip the shutter at "the decisive moment" when subject matter and compositional elements are in appropriate harmony or conflict. Therein lies the greatest element of skill in photography and the one aspect that it is most difficult to teach. Only by studying thousands of photographs and by making countless photographs yourself, both on film and in your mind's eye, can you teach yourself to be a really superb photographic communicator.

*Henri Cartier-Bresson, op cit, frame 11.

The camera is at once an expedient to communication and a barrier to expression. This paradox is explained by the fact that while many people recognize the camera as an indispensable tool for recording and preserving impressions of the world, others consider it to be an intruder—an obstacle—a contraption that mechanizes and dehumanizes the act of "creating" a picture. This contradiction illustrates one of the most charming characteristics of humanity, however: that people are pleased and satisfied by different things, methods, approaches, and results. Because cameras have certain characteristics that make photography unique among media, I can assume that you have more than a casual interest in what cameras can do for you, or you wouldn't have read this far.

The camera is an instrument that teaches people how to see without a camera.

Dorothea Lange

the basic camera

All types of cameras have the same basic parts:

1. Light-tight box

2. Holder and transport system for light-sensitive film

3. Lens to form an image on the film

4. Diaphragm, or aperture, to control the amount of light passing through the lens

5. Shutter to control how long the film is exposed to light

6. Viewfinder for aiming the camera

All cameras except the very least expensive have a means for moving the lens forward or backward to adjust for sharpest focus, variable shutter speeds, and a diaphragm with an adjustable aperture to allow more or less light through the lens.

The question "Which is the best camera for me?" can only be answered by asking further: "What kinds of pictures are you going to take?" and "How will your pictures be used?"

The camera need not be a cold mechanical device. Like the pen, it is as good as the man who uses it. It can be the extension of mind and heart.

John Steinbeck

contemporary cameras

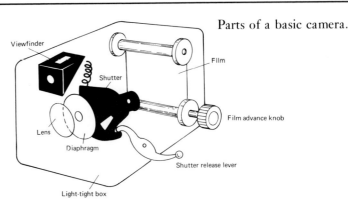

Parts of a basic camera.

Viewfinder
Film
Shutter
Film advance knob
Lens
Diaphragm
Shutter release lever
Light-tight box

No one camera can do all photographic jobs equally well. Although one of the popular pocket-sized automatic cameras may suffice for family snapshots, you'll need to know about the various types of advanced or "professional" cameras and the kinds of work each type does best. Let's examine the advantages and disadvantages of the five major types of professional quality cameras.

POPULAR FORMATS

1. *Rangefinder Camera, 35mm*

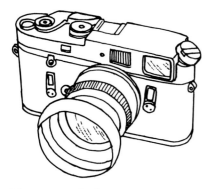

35mm rangefinder camera.

> *Advantages:* Very light and portable, cameras such as the famous Leicas and their lower-priced descendants are easy to handle rapidly and easy to focus in dim light. Their film magazines hold up to 36 exposures at a cost of only a few cents per frame for black and white. Interchangeable lenses of excellent quality allow shooting by existing light in many situations. A relatively quiet shutter simplifies unobtrusive "candid" shooting.
>
> *Disadvantages:* As with all 35mm cameras, the tiny negatives scratch easily, so they must be handled with special care. Extreme enlargement tends to make the grain of the film visible and to increase trouble from dust and scratches and to make more objectionable the blur resulting from camera movement. Different viewpoints of lens and viewfinder (parallax) make it difficult to frame and focus accurately when working closer than two or three feet from the subject, unless special attachments are used.

2. *Single-Lens Reflex Camera (SLR), 35mm*

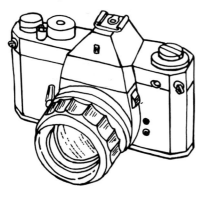

35mm single-lens reflex camera.

> *Advantages:* A very popular convenient and versatile camera, especially when equipped with prism viewfinder and automatic diaphragm (both features are standard on most models). SLRs such as Nikon, Pentax, Canon, Minolta, and Olympus, are similar in operation to rangefinder cameras, but the large, bright reflex viewing screen simplifies focusing and accurate framing under most conditions, especially when shooting extreme close-ups and when using telephoto

lenses. The ability to focus and view the subject through the lens is the most important advantage of the SLR. This feature allows predetermination of depth of field and selective focus effects and makes possible the use of extensive "systems" of lenses of various focal lengths and many special-purpose accessories.

Disadvantages: Negatives must be handled very carefully because scratches, dust, and grain are a problem with all 35mm films. Most SLRs are somewhat heavier and bulkier than most rangefinder cameras. Certain cameras are hard to focus with some lenses, in dim light and when following action, although many SLRs provide a bright-prism or split-image focusing system in the center of the ground-glass viewing screen. A relatively noisy mirror and shutter tend to call attention to the photographer at quiet events such as concerts and weddings, and movement of the mirror may shake the camera during long exposures. Momentary "image blackout" is a problem when shooting rapid action and flash, because you can't see through the viewfinder at the very instant of exposure. Lenses without an automatic opening and closing diaphragm often give trouble because people forget to set the lens opening each time before shooting.

3. *Single-Lens Reflex Camera (SLR), (6 x 7, 6 x 6, or 6 x 4.5 cm)*

Advantages: 120-size roll film requires less enlargement than 35mm, lessening the problems of grain, dust and scratches, and camera movement. The larger ground-glass viewing area of medium-format cameras such as Hasselblad, Bronica, Rollei, Mamiya, and Pentax, simplifies focusing and allows predetermination of depth of field and selective focus effects. Extensive accessory "systems" are available, including replaceable backs that permit changing film type in midroll and use of Polaroid film.

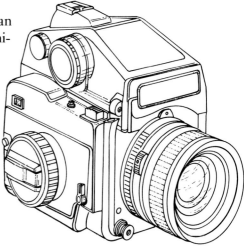

6 x 4.5 cm. single-lens reflex camera.

Disadvantages: Noisier and considerably more bulky than 35mm SLRs. Film for this type of camera is economi-

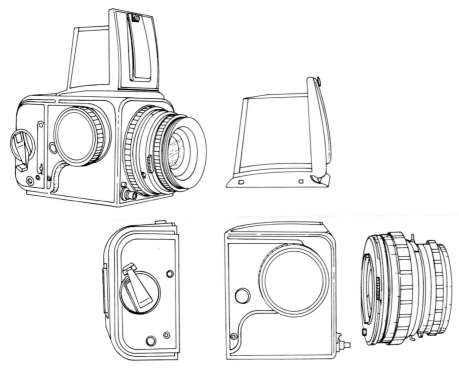

Many of the medium-format SLR cameras are modular—they have interchangeable lenses, film backs, and focusing screens or prisms.

6 x 6 cm. twin-lens reflex camera.

cal, although somewhat more expensive per frame than for 35mm. Camera and accessories are generally extremely expensive to purchase, to insure, and to maintain.

4. *Twin-Lens Reflex Camera (6 x 6 cm)*

Advantages: Convenient and rapid in operation, with the advantage of 120-size roll film negatives, several models of Rollei, Yashica and Mamiya cameras are available at a relatively moderate cost.

Disadvantages: These cameras are somewhat bulky. Most models do not accept interchangeable lenses, and few accessories are available. Unless an auxiliary prism is attached, focusing below eye level is required and this point of view may not always be desirable. Twin-lens reflex cameras are not convenient for copying or extreme close-ups.

5. *View Camera, 4 x 5 and larger*

Advantages: A Sinar, Deardorff, Calumet, or other view camera can be an ideal studio camera and an excellent field camera when negative quality is the most important objective. Long focal-length lenses can be used for portraiture and commercial subjects and wide-angle lenses for architectural photography. Swing, tilt, rise, and shift adjustments of both front and back can be used in combination to correct perspective distortion and to maximize depth of field. View cameras are good for copying and graphic arts work

View camera.

because of the large negative size (4 x 5, 5 x 7, or 8 x 10 inches or larger) and the wide variety of specialized film types available. Large sheet film negatives allow retouching, if desired, and permit great enlargement or fine quality contact prints. The large ground-glass screen on the camera back simplifies careful composition and focusing.

View camera adjustments can be used to correct or alter perspective and to maximize depth-of-field.

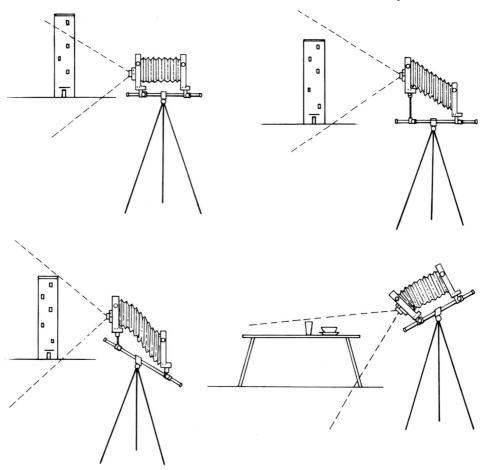

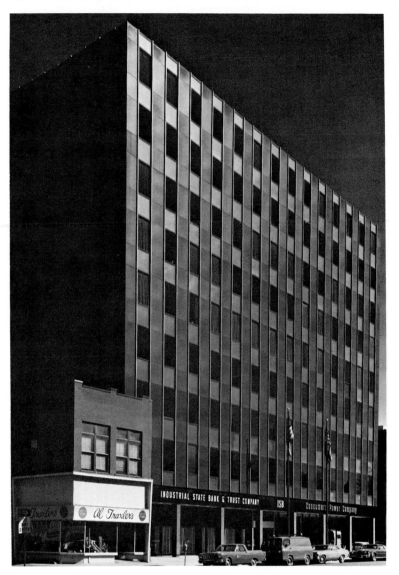

D. CURL *Al Traxler's*
View-camera adjustments have been used to render all vertical lines parallel. This was achieved by placing the planes of both the back and the front of the camera exactly vertical. An orange filter darkened the sky, allowing the large building to come forward.

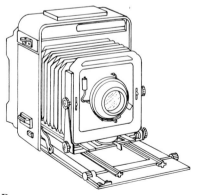

Press camera.

Disadvantages: View cameras are not very portable; they must always be set up on a tripod or studio stand. View camera lenses are slower and have less depth of field than comparable lenses for smaller cameras. Rapid shooting is difficult because several things must be done by hand before and after making each exposure. Sheet film is expensive, and film holders are awkward to handle. The holders must always be loaded in darkroom or light-tight changing bag and kept protected from bright light. Although many of the world's finest photographers have used view cameras extensively, this bulky instrument is not suitable when the photographer is in a hurry or has to travel light. A press camera such as the classic Speed Graphic is a more or less obsolete variety of the view camera with many view-camera features; the press camera, however, has some ad-

vantages that allow hand use, such as rangefinder focusing and synchronized flash.

specialized cameras

You might want to own one or more special-purpose cameras in addition to your regular equipment. A Polaroid camera, for example, or an accessory Polaroid film back, can be very useful for checking lighting arrangements or composition before exposing other film.

Polaroid instant prints offer an unusual spontaneity in portraiture—photographer and sitter can critique the expression, pose, and lighting and establish rapport. Some Polaroid films even yield instant negatives that later can be enlarged conventionally.

Half-frame 35mm cameras such as the Olympus Pen series were introduced mainly for reasons of film economy, but some teachers and others found the half-frame single-lens reflex to be ideal for making filmstrips (the frame format is compatible with standard filmstrip projectors). Like the negatives from 110-size Pocket Instamatics and 16mm Minox, Minolta, and other subminiatures, enlargements from the tiny negatives yielded by a half-frame camera are severely limited by the sharpness, grain, dust, and scratching problems that plague all users of miniature and subminiature formats.

The panoramic camera with a pivoting lens dates back to the nineteenth century, and it's returning today in roll-film format. Producing an extremely long, narrow image, the novelty of a panoramic camera such as the Widelux appeals to imaginative landscape and experiment-minded photographers.

Although waterproof underwater housings can be bought or built for many cameras, the popularity of scuba diving and other water-related sports (such as canoeing and water skiing) has caused

There was a time when I lived behind the camera, hiding behind it. There was only this huge camera walking around. My legs were wrapped around the base. My arms were sort of up on top and would reach to click the shutter. It was that big a thing. Now the camera is so small, it's like it's not even there.

Brian Lanker

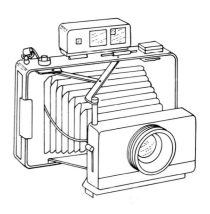

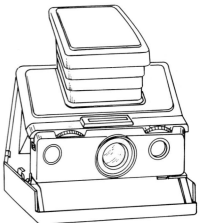

Polaroid cameras.

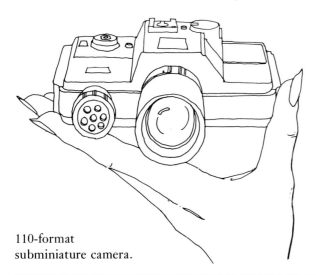

110-format
subminiature camera.

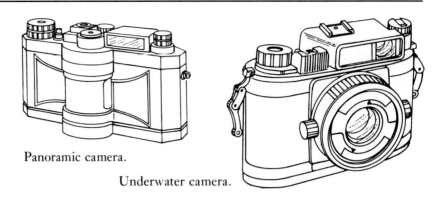

Panoramic camera.

Underwater camera.

the introduction of the Nikonos underwater camera to simplify underwater photography and to lessen the risk of dunking a conventional camera.

Sometimes it's fun to own and use an oddball camera or to actively collect antique, classic, or unusual cameras. Organizations catering to such collectors publish newsletters and sponsor exhibits and auctions.

There are times that I would like my cameras to be a complete and true extension of myself.
William Albert Allard

choosing a camera

After becoming familiar with the various types of cameras and deciding on the format you prefer, you have to face the dilemma of choosing a particular make and model from the many quality cameras available. That's not so easy, because investing in a camera is a lot like buying a car—the conscientiousness of the dealer you buy from may be more important in the long run than the brand of camera you purchase or the price you pay. As almost any kind of car will get you where you want to go, so there are literally dozens of cameras, each of which will make excellent photographs if intelligently used. Personal preference is very important in choosing a camera, so it's important that you work with a dealer who will let you handle, dry shoot, and perhaps even borrow a potential purchase over a weekend to get the feel of it. Different models employ different focusing systems, for example, and the viewfinder images vary significantly in brightness, relative size of the image, and ease of focusing. Placement of the controls may be much more convenient for you on one camera than on

Each of the major camera manufacturers offers a "system" of lenses of various focal lengths, close-up devices, and accessories that greatly extend the versatility of that particular camera, but that may not be adaptable to cameras made by competitors. Choose your camera system carefully because it can represent a major investment.

another; you'll find, if you handle several, that you simply prefer the feel of one model over another.

If you're thinking of going seriously into photography, your dealer can advise you on which camera manufacturers offer systems of lenses and accessories that are likely to be available as your interests, needs, and financial resources grow. And your dealer should be the kind who will see to it that you receive prompt and proper service when you need it and perhaps even a loaner camera in an emergency. Although price isn't everything, many of the better home-town camera dealers will actually meet the advertised prices of mail-order and discount competitors—they know that if you're satisfied you'll come back to buy accessories, supplies, and services. If you're considering the purchase of a used camera, be sure to study "How to Test Your Equipment" in Chapter Four.

exposure controls

Successful photographers such as Eisenstaedt and Cartier-Bresson know that there isn't time to agonize over the mechanics and calculations in photography every time you want to take a picture. Like driving a car or riding a bicycle, the technical processes have to become second nature, so you can concentrate all your psychic and emotional energy on perceiving and selecting the right arrangement and the right moment to record. The most difficult and confusing aspect of photography for most beginners is exposure.

The total amount of light reaching the film is controlled by both the size of the lens aperture (called f/stop) and the length of time the shutter is allowed to remain open (shutter speed).

The larger the lens opening, the more light that gets through. The numbered apertures (f/stops) on most lenses are spaced so that moving from one full f/stop to the next will result in either doubling or halving the amount of light passing through, depending on whether the aperture is opened up (made larger) or stopped down (to a smaller opening). Although the entire range of numbers from f/1 to f/64 will never appear on any one lens, you

Technology doesn't mean.
It is means.
Robert Rauschenberg

A photographer needs a short-circuit between his brain and his fingertips.
Alfred Eisenstaedt

In photography you've got to be quick, quick, quick, quick. Like an animal and a prey.
Henri Cartier-Bresson

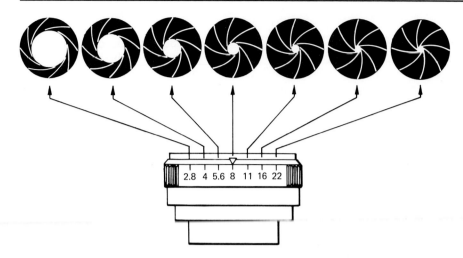

You should memorize these basic f/stops. Your lens may be faster than f/2.8, hence f/2 or even f/1.4 may appear on the aperture scale.

should memorize at least the basic scale of f/stop numbers shown above. Don't be misled by half-stop "click" indentations on your camera—these are to make it easier for you to make *in-between* settings. The half-stops are *not* part of the regular scale for calculating exposure.

Notice that an easy way to remember the stops is that the numbers are cut in half (or doubled) *every other* number. But don't try to use the same arithmetic in calculating exposure. The amount of exposure increases or decreases *by a factor of 2* between every adjacent pair of full f/stops on the scale. Very few lenses stop down to f/64 or f/45, although many go as far as f/22 or f/32. Many lenses for small cameras do not stop down to an aperture smaller than f/16.

If the maximum aperture on your lens shows an odd number, such as f/1.8, f/3.5, f/4.5, or f/6.3, for example, this number will *not* be a full stop larger than the next smaller f/stop of the regular series. Because the speed of a lens is expressed in terms of its largest f/stop (largest opening = smallest number), manufacturers like to impress people with a slightly lower f/number (larger aperture) than the competition. These irregular apertures, however, are only slightly larger than the next whole f/stop, and for practical purposes the difference can be ignored. An f/1.8 lens, for ex-

The speed of a lens (maximum f/number) is determined by dividing the focal length of the lens by the diameter of the maximum aperture. Focal length is the distance from the optical center of the lens to the focal plane (film surface) when the lens is focused on infinity.

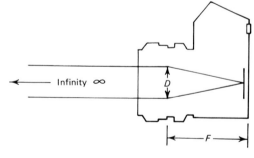

Speed of a Lens or f/number $= \dfrac{F}{D}$

ample, is only negligibly faster than an f/2 lens. An f/2 lens, incidentally, is considered to be a fast or high-speed lens, whereas a lens with a maximum aperture of only f/4.5 would be comparatively slow. Don't be misled into thinking that an f/1.2 or f/1.4 lens is significantly *better* than an f/2 lens. Although the f/1.4 lens will be a full stop faster than the f/2 (and it may be a little easier to focus in dim light), you will be paying for extra glass that you may seldom use and be sacrificing some sharpness at the wider apertures.

The other important variable in controlling exposure is the shutter speed. The shutter speeds shown below are the standard speeds found on the most versatile modern cameras. Each speed is expressed in terms of a fraction of a second. The shutter speeds affect exposure in the same way as the f/stops—that is, each change from any speed to the adjacent speed effectively *doubles* or *halves* the amount of exposure.

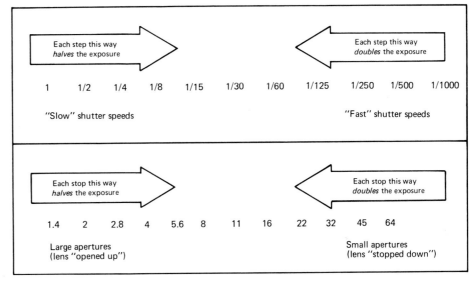

Each step this way *halves* the exposure

Each step this way *doubles* the exposure

| 1 | 1/2 | 1/4 | 1/8 | 1/15 | 1/30 | 1/60 | 1/125 | 1/250 | 1/500 | 1/1000 |

"Slow" shutter speeds

"Fast" shutter speeds

Each stop this way *halves* the exposure

Each stop this way *doubles* the exposure

| 1.4 | 2 | 2.8 | 4 | 5.6 | 8 | 11 | 16 | 22 | 32 | 45 | 64 |

Large apertures
(lens "opened up")

Small apertures
(lens "stopped down")

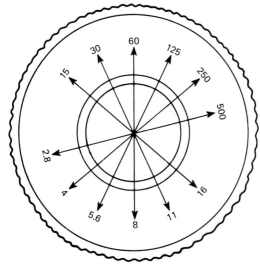

Any of the combinations of shutter speed and lens opening at left (e.g. 1/500 at f/2.8, 1/60 at f/8, or 1/15 at f/16) will result in the same amount of light reaching the film.

Many combinations of f/stop and shutter speed will admit the same amount of light, resulting in identical total exposures. The effect of using a slower speed, such as 1/60 of a second instead of 1/125, is to admit light for a longer time—in this case twice as long. This gives the same effect on exposure as opening up the lens aperture one full f/stop. Thus, an exposure of 1/30 at f/16 would produce the same density on the film as 1/60 at f/11. Although the length of exposure time has been cut in half, the amount of light passing through the aperture during that time has been doubled. Practice setting your camera until you can compensate easily for changes of several stops in either speed or aperture. You can set the lens between f/stops to make minor exposure adjustment (for example, halfway between f/5.6 and f/8). The shutter, however, on most cameras should not be set between marked speeds.

Some cameras are made so that once they are set correctly for prevailing light conditions, all the shutter speeds and f/stops are coupled. On these cameras, when either the speed or f/stop is changed, the other moves automatically for the same amount in the opposite direction—a great convenience under some working conditions, but a curse when you want deliberately to change the exposure. Usually there is also a way to set the controls separately when needed.

When set in automatic mode, cameras with automatic exposure control do all the calculating for you. On some automatic cameras you can't even tell what aperture or speed, you're going to get! The more desirable automatics, however, not only provide a visual readout of shutter speed and f/stop in the viewfinder, but they allow you manually to override the automatic settings at will.

If you're using an older camera marked with shutter speeds such as 1/400, 1/200, 1/100, 1/50, 1/25, 1/10, 1/5, and 1/2, the same rules apply. The effective difference between each of these speeds is still twice or half that of the next marked speed.

A few cameras are marked in the Exposure Value System (EVS). With EVS, a single number represents a given set of equal combinations of shutter speeds and f/stops. For example, EV 15 equals at least four possible combinations: 1/500 at f/8, 1/250 at

f/11, 1/125 at f/16, and 1/60 at f/22, all of which give exactly the same exposure to the film. You can see that these speed and aperture combinations could be carried in each direction as far as the camera is designed to go. Most cameras with EVS are marked also with standard shutter speed and f/stop scales for comparison.

the lens

Most camera lenses consist of three or more separate glass elements instead of a single piece. The sharpest and fastest lenses have many elements. Remember that lenses should never be taken apart except by an experienced camera repairman!

The lens projects a sharp image onto light-sensitive film in the back of the camera. Because film comes in different sizes, different types of lenses are needed. The size of the image projected by the lens and the distance the lens must be from the film to form a sharp image depend in part on the focal length of the lens. The focal length is usually engraved on the lens mount in millimeters and is a measure of the distance between the optical center of the lens and the film when the lens is focused on a distant object (infinity). There are approximately 25mm to one inch.

A so-called normal lens has a focal length about equal to, or slightly longer than, the diagonal of the image produced on the size film to be used in that camera. For example, a square negative made on 120-size roll film measures about 80mm diagonally from corner to corner. Therefore, the normal lens for a 6 x 6 cm reflex camera has a focal length of approximately 80mm. 35mm cameras are normally supplied with a lens of 50mm to 55mm focal length, slightly longer than the diagonal of the image. As you know, 35mm refers to the *width of the film* in a 35mm camera. A *35mm lens* would be a moderate wide-angle lens on a *35mm camera*.

The focal length of the lens determines how large the image will be on the film. An 80mm lens will always project the same sized image of a given object whether the lens is designed for use on a 35mm camera or on a 4 x 5. An 80mm lens will be a moderate

A camera has but one eye—the lens. It can record only a fragment of the visual world. The photographer carries with him the second eye. This is the eye of selection. The artist has a Third Eye, the eye of creative imagination. It is this Third Eye that can penetrate into our inner world.

Author unknown

A photographer should learn to work with the minimum amount of equipment. . . The camera should become an extension of your eye, nothing else.

Ernst Haas

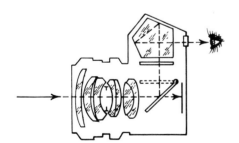

Light from the subject follows a devious path through the optical system of a single-lens reflex camera before it reaches your eye. Several lens elements, a front-surfaced mirror, and a five-sided prism are all part of the light-path. The mirror swings up and out of the way, of course, during the instant of exposure; then, in most SLR's, the mirror drops back down so you can again see through the lens.

Wide angle Normal Telephoto

"telephoto" if mounted on a 35mm camera, normal on a 6 x 6 cm camera, and wide-angle if its field of coverage is broad enough to cover 4 x 5. When the focal length is much shorter than the film diagonal, the lens is said to be wide-angle, projecting a smaller image of each object in its field but including a wider angle of view. When the focal length is longer than normal the lens is said to be a long-focus or telephoto* lens, and it will form a larger image covering a narrower angle of view. Image size is always directly proportional to focal length. That is, the image formed of a given object by a 100mm lens will be exactly twice the height of the image of the same object at the same distance formed by a 50mm lens, regardless of the size and format of the film and camera.

FOCUSING THE LENS

No lens is capable of recording all objects sharply at various distances within its view. Because of this, the lens must be adjusted (focused) within a certain range of distances so that all desired objects are sharp. On all except the simplest cameras, some adjustment of focus is possible. Simple snapshot or "box" cameras are permanently focused at about 15 feet, which gives acceptable, although not sharp, focus on everything within a range extending from about five or six feet from the camera out to infinity (as far as the eye can see).

Focusing is nothing more than moving the lens nearer or farther away from the film plane with a threaded or geared mechanism. Simple cameras have no provision for checking the accuracy of the focus, but coupled rangefinders and ground-glass focusing on better cameras make focusing quick and accurate.

Simple cameras do not permit the lens to be moved out far enough from the film plane to focus correctly on close-ups. View cameras and some reflexes have a flexible bellows connecting the lens mount with the body of the camera that can be extended for

*Although the terms *long focus* and *telephoto* are often used interchangeably by photographers, a true telephoto lens has been designed and constructed so that it fits into a compact mount while yielding an image size proportional to its focal length.

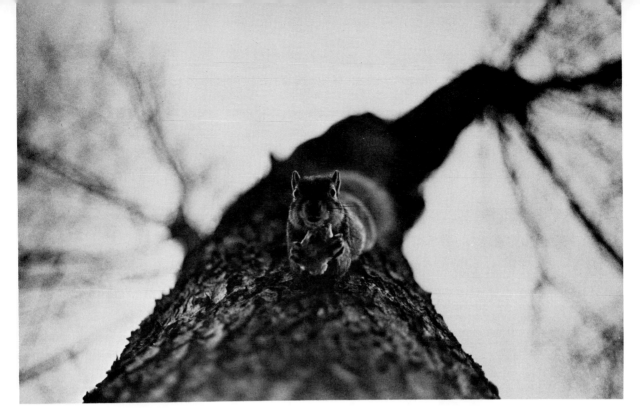

Nancy Miller *Squirrel*
(*Selective focus.*) The photographer
has not only concentrated attention
on her furry friend, instead of on
what would have been a very
"busy" and distracting background
of branches and bark texture, but
she has shown us the importance
of looking elsewhere for pictures
than straight ahead at eye level.

Split-image Focusing

Out of focus

In focus

Ground glass or Microprism focusing

Out of focus

In focus

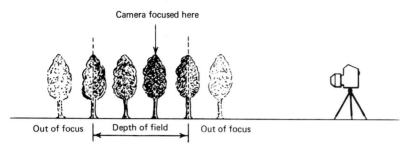

Camera focused here

Out of focus | Depth of field | Out of focus

Although the near and far boundaries of depth of field are indistinct, the acceptable limits can be determined for various lens openings and distance settings. Notice that depth of field extends almost twice as far *beyond* the plane upon which the camera is focused as it extends from the plane of focus *toward* the camera.

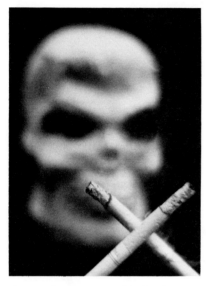

ABDEL ALSOLIMAN *No Smoking*
A large lens opening (f/2.8) and a close working distance resulted in very shallow depth of field in this allegorical image.

JIM NIXON *Windows*
It was necessary in this case to stop the lens down (f/16) and to focus between the plane of the windows and the reflection to keep all parts of the image in sharp focus.

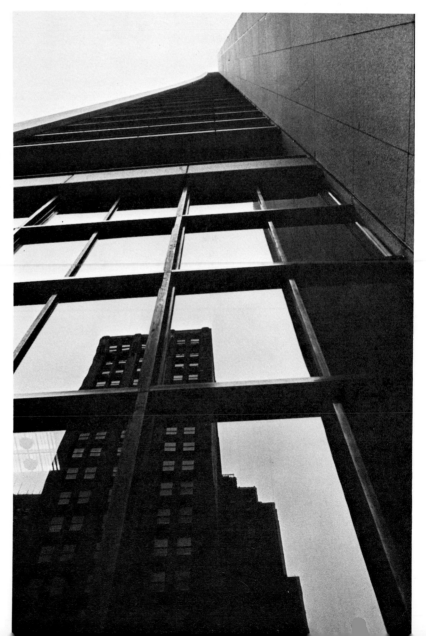

focusing on very near objects. Most 35mm cameras focus normally to as close as one and one-half to three feet, depending on the construction of the lens mount, but require extension tubes, bellows attachments, or supplementary close-up lenses that fit in front of the normal lens for photographing subjects closer than one and one-half to three feet. Although supplementary close-up lenses are often referred to as portrait attachments this term may be misleading, for most portraits do not require the use of such lenses; the close range the lenses allow tends to distort the shape of the subject's features. Extreme close-up attachments are best suited to copy work and to nature and scientific subjects.

depth of field

Depth of field is the distance between the subject distances nearest and farthest from the camera that will be acceptably sharp in the finished print. The extent of this area of sharp focus is very important; most of the time you'll probably want the greatest depth of field possible. Except when the background would be distracting and should be kept deliberately out of focus, sharp detail in both foreground and background usually improves the picture. Depth of field increases when smaller lens openings are used (that is, f/16 instead of f/8) or when the camera is moved farther from the subject.

Lenses of short focal length have proportionately greater depth of field than longer lenses. This is one advantage offered by 35mm cameras. View cameras have means of increasing depth of field by adjusting the angle between the lens mount of the camera and the principle planes of the subject.

Most cameras have a depth-of-field scale engraved on the focusing knob or lens mount. Using this scale makes it easy to predetermine whether certain subjects will be within the area of acceptably sharp focus when the picture is taken. View cameras and most single-lens reflex cameras have, in addition to the depth-of-field scale, provision for visually determining depth of field by viewing the subject with the lens stopped down.

Lens focused at 10 ft. Depth of field from about 9–12 ft. at f/4

Stopping lens down to f/8 increases depth of field to about 8–14½ ft.

At f/16 depth of field ranges from closer than 7 ft. to nearly 30 ft.

Depth of field, which is dependent upon both lens aperture and subject distance, can be determined by examining the depth-of-field scale engraved on the lens mount.

Hyperfocal focusing is a way to preset your camera for maximum depth of field as in general scenic photography.

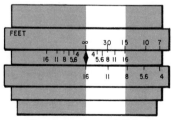

Focusing the lens on infinity (∞) wastes depth of field. Note near limit is 15 ft. when aperture is set at f/16.

By focusing at nearest limit of depth of field at infinity (hyperfocal distance)—in this example, 15 ft. at f/16—depth of field extends from about 8 ft. to infinity.

Parallax is a problem especially when close-focusing a twin-lens reflex, but it can cause cropping errors with any camera in which the viewfinder is separate from the taking lens.

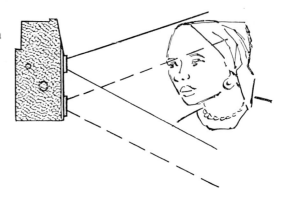

the viewfinder and parallax

With cameras other than single-lens reflex and view cameras, the lens that actually takes the picture doesn't "see" exactly the same area that the viewfinder sees.

This difference isn't very important on medium or distant shots, but when shooting close the difference becomes significant. You may find, for example, that, although your subject was perfectly framed in the viewfinder, the picture itself is cut off at the top or is off-center. This often happens in copying and in close-up portraits made with a rangefinder camera.

The difference between what is seen by the taking lens and by the viewfinder is called parallax. Some cameras have minimized the parallax problem by the use of adjustable viewfinders or movable masks. If you're using a twin-lens reflex for close-up photography, allowing for parallax may require measuring exactly how far the taking lens is below the viewing lens and raising the camera that distance before taking the picture. When using any camera at close range that does not have accurate parallax correction, you must compensate in some way for the different points of view or a part of subject may be cut off.

Although single-lens reflex viewing systems are free from the parallax problem, you may find, if you do much critical copy work or close-up photography, that the frame edges of your viewfinder are not precisely accurate. This may be true especially along the edge of the viewfinder corresponding to the bottom edge of the mirror; the problem may become more acute when using extra-long telephoto lenses. The only way to solve this is to run careful tests, measuring the error, and compensating slightly, as required.

the shutter

Photography's most unique characteristic is the ability of the camera to preserve eternally a moment out of time. It's the camera shutter that makes this possible, together with highly sensitive

film. We take these things for granted, but because of the handicaps of their primitive equipment and materials, early photographers were unable to photograph anything that moved. A portrait sitter had to hold himself unnaturally still or have his head clamped firmly to prevent movement during an interminable exposure time of from several seconds to several agonizing minutes. Have you wondered why there are so few very early photographs of young children, animals, sporting events, or battle scenes?

Modern equipment and materials give you a choice of whether to "freeze" motion for examination of minute detail or to attempt a subjective approach by deliberately allowing the moving subject to be blurred, thus preserving a feeling or interpretation of action, instead of stopping action coldly and objectively.

The goal of every artist is to stop movement, which is life, by artificial means and to maintain it fixed so that one hundred years later, when a stranger may gaze at it, it will once again move, because it is life.

William Faulkner

stopping motion

The choice of shutter speed is yours. A speed of 1/60 of a second will "stop" a person walking toward you at some distance, but it will take a higher speed, say 1/250, if the subject is closer to the camera or is walking directly past you across the field of the camera. Moving vehicles and fast-action sporting events usually call for 1/1,000 or 1/500 to freeze the action. If you're a nature photographer you may find that the wind will move blossoms and leaves so much that you can't get a sharp image.

SCOTT LAVACQUE *Contest*
A shutter speed of 1/125-second was fast enough to "stop" the action because the photographer waited for a moment when the combatants' positions implied movement that was not actually happening (note the slight blur of the left hand of the man on your right).

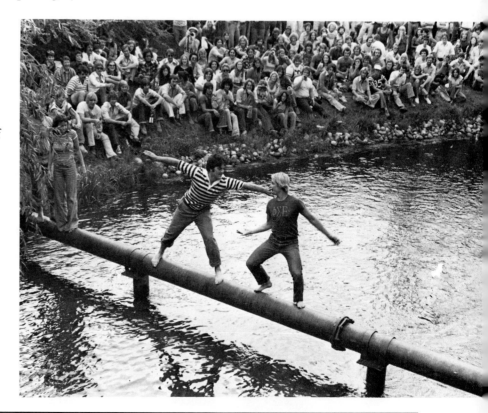

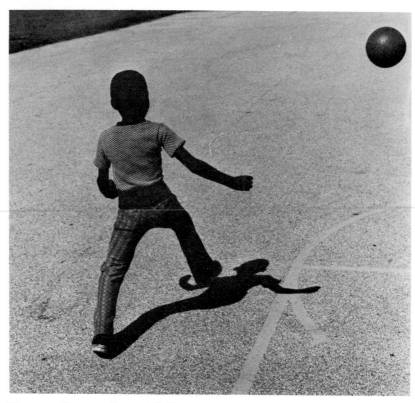

BARBARA BERGY *Boy and Ball*
A shutter speed of 1/1,000-second froze the movement of the boy, his
shadow, and the ball into a dynamic composition full of tension and
graphic contrast.

ANDREA RUBENSTEIN *Stairway*
Do you react differently to these two images of the same stairway? Do
the vertical format, the tilted angle, and the blur from camera movement
intensify the feeling—or fear—of falling?

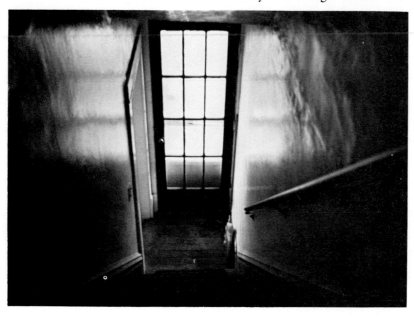

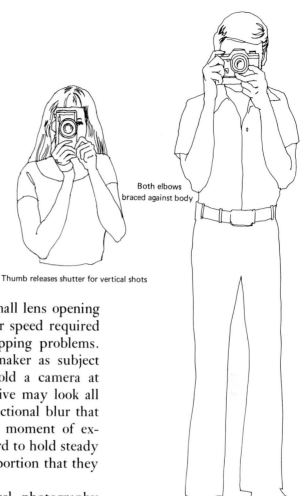

Thumb releases shutter for vertical shots

Both elbows
braced against body

Feet spread wide apart

Camera movement is by far the biggest cause of blurry pictures. Practice holding your camera steady and releasing the shutter gently.

Close-up photography often requires a very small lens opening to gain depth of field. The resulting slow shutter speed required for proper exposure can then cause motion-stopping problems. Camera movement can be as serious a troublemaker as subject movement. Most people are unable to hand hold a camera at speeds slower than 1/60 of a second. The negative may look all right, but enlargement will show the telltale directional blur that proves the camera wasn't steady enough at the moment of exposure. Long focal-length lenses are especially hard to hold steady because they magnify movement in the same proportion that they magnify the size of an image.

Hand holding a camera for street and travel photography requires the same steady nerves and concentration needed for accurate target shooting with a rifle. The camera strap can serve you as a steadying sling, as well as a carrying strap. An eye-level camera should be held firmly against your face, even if you're wearing glasses, and you should brace your elbows firmly against your body. Squeeze the shutter release smoothly—don't punch it or jab it!

Experiment with blurred, subjective action. Try shooting a rap-

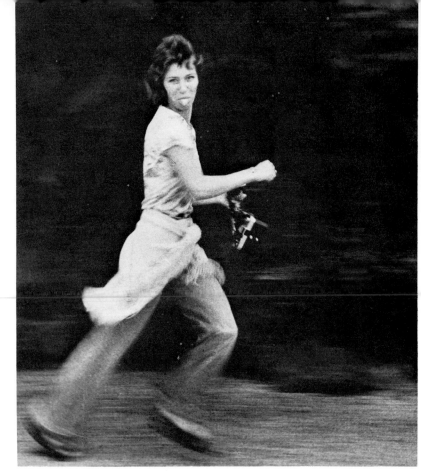

Mary Law *Running Girl*
A ¼-second exposure "stopped" the running girl, yet retained an illusion of motion. The secret? *Panning.* The photographer followed her subject through the viewfinder, moving the camera during the exposure. This is, of course, more difficult to do with a single-lens reflex camera because the mirror is up and blocking the viewfinder while the shutter is open.

David Knight *Waterfall*
Obviously, both the rocks and the camera remained motionless during this eight-second exposure, but the moving water has taken on a metallic, flowing quality.

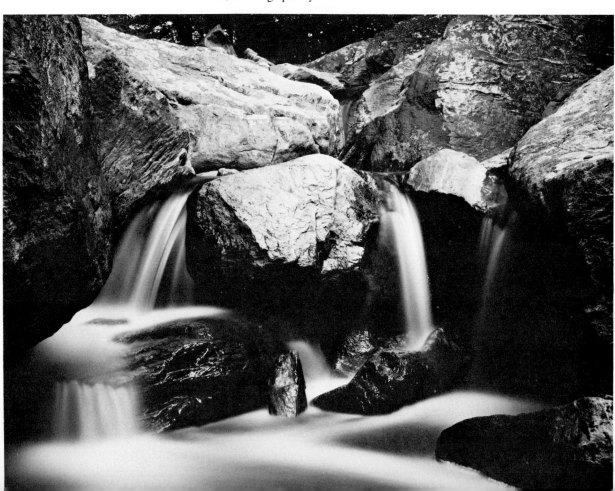

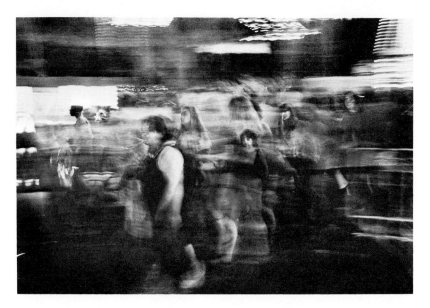

JIM NIXON *Turnstyle*
Do you get the feeling of a surging crowd of people? The effect was obtained by hand holding the camera at a shutter speed of one second and panning with the crowd of people as they burst through the turnstyle at the opening of a carnival.

idly moving subject using slow film at a very slow shutter speed—perhaps ⅛ of a second—and follow the action with the camera (panning), releasing the shutter while the camera is moving. Then mount your camera on a tripod and try photographing a moving subject at a very slow shutter speed. You may be surprised at the interesting illusions of motion.

Most modern 35mm single-lens reflex cameras have focal-plane shutters—so called because the shutter moves across the camera body directly in front of the film. You can interchange lenses more conveniently and less expensively on a camera with a focal-plane shutter because each lens need not contain a shutter. Most larger-format cameras and some 35's use between-the-lens shutters that have the advantage of not jarring the camera so much when the shutter is released; however, the cost is much higher because each lens must contain its own shutter. The highest speed on

DAVID KNIGHT *Dancer*
The dancer moved in front of the camera, which was mounted firmly on a tripod, during a one-second exposure. Notice that her brief pauses left sharp images connected by flowing lines, suggesting the grace of the dance.

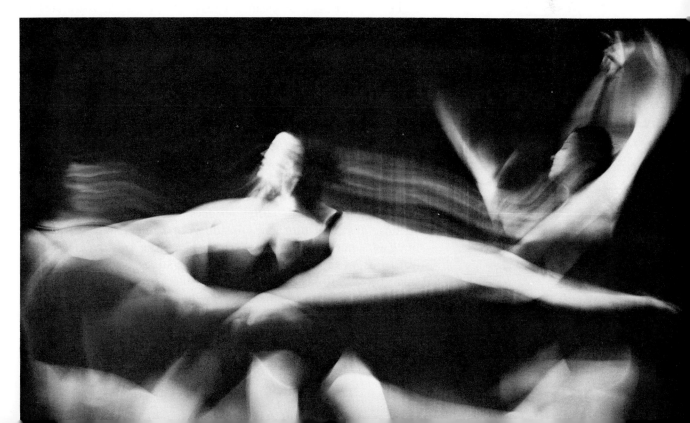

A clean lens is essential for clear pictures. Protect your lenses with lenscaps or clear glass filters, cleaning them only when necessary using the recommended procedure.

between-the-lens shutters is generally 1/500 of a second, whereas it may be 1/1,000 or even higher on focal-plane shutters. Some professionals prefer between-the-lens shutters because they will synchronize with electronic flash at all shutter speeds; the curtain of a focal-plane shutter is usually not fully open at speeds higher than 1/60, or possibly 1/125.

camera care

Your camera is a precision instrument that deserves good care not only to protect what may represent a sizable investment, but to ensure top-quality results.

Cleanliness is very important. A common misconception is that dust on the lens will cause spots on prints. This is not true—a thick layer of dust on the camera or enlarger lens will at most reduce the contrast of the image slightly, and it may degrade the sharpness. Dust, however, will cause permanent scratches if you're careless about how you clean the glass surfaces.

The proper way to clean a lens is first to blow away surface dust with canned compressed air or with your breath and then to brush away remaining dust with a very soft brush. Breathing on the lens, then gently wiping away the condensate with camera lens tissue will help to remove fingerprints and other spots, but a wad of lens tissue moistened with a drop or two of photographic lens cleaning fluid is the safest method for cleaning lenses. Swab the surface gently in a circular pattern, then wipe it dry with another wad of tissue. Never use the purplish silicone papers sold for cleaning eyeglasses, and don't try any solvent other than camera lens cleaning fluid because of possible damage to the anti-reflection coating on the surface of the lens.

Although dust on the outer surfaces of the lens may not be very serious, dust and film chips inside your camera may cause jamming of some part of the mechanism or the tiny particles may leave images of themselves on your negatives. Canned air and a small brush will keep these pesky problems to a minimum.

A durable leather camera case will protect your camera from

sun, water, dust, and rough handling; but few professionals use cases, preferring to have the camera unobtrusively ready under their coat or slung around their neck. A UV, Haze, or Skylight filter (practically colorless) kept over the lens at all times provides excellent protection against abrasion, dust, sand, and moisture. Opaque lens caps are a nuisance and, after all, it's a lot cheaper to replace a filter than to buy a new lens.

A few raindrops falling on your camera are not likely to cause permanent harm, although a good soaking or dunking certainly may. Salt water is an especially voracious enemy of lens coatings and metallic finishes, so a filter over the lens and even a plastic bag over the camera will help if you're going sailing or canoeing. If your camera should ever become thoroughly immersed, especially in salt water, rinse it out fast in a container of fresh water; then, if you can't get it to a repair shop immediately, while it's soaking, dry it out as rapidly as possible with warm air from a hair dryer or place the camera, with the back open and the lens removed, in a slightly warm (not hot) oven with the door left open. Operate the mechanism occasionally while it is drying to keep it freed up. Wet film can be saved if it can be processed within a few hours. Seal the film in a jar of fresh water until it can be processed.

Photographers who travel often run into vibration problems. The vibration from a plane, train, motorcycle, or car may eventually shake loose some vital screws, so retighten the visible screws periodically with a jeweler's screwdriver and plan to carry the camera around your neck or over your shoulder instead of having it travel in the baggage compartment. Another reason for carrying your camera is, aside from Customs difficulties and possible theft problems, that you can request a visual security inspection at the airport instead of having your loaded camera and film pass through a potentially harmful X-ray machine.

extreme heat and cold

The trunk and glove compartment and the ledge of the rear window of your car are among the poorest places to put a camera.

The intense heat within a closed automobile in the sun not only can fog the film in the camera or cause color shifts, but it may actually cause separation of the lens elements and do damage to batteries and photoelectric exposure meters. Tropical heat and humidity are especially troublesome, as fungus will grow rapidly on film and it will eat away some lens coatings and even etch itself into the glass. Don't leave film in the camera any longer than necessary under tropical conditions (this is a good idea anyway), and store your camera in an air-conditioned room or in a sealed box containing a desiccating agent such as silica gel to remove moisture from the air inside. An insulated carrying bag of the kind intended for keeping beer cool will protect your film (and your camera) against extreme temperatures for a few hours, even without ice.

Arctic conditions are a bit different. Professionals planning to spend a great deal of time taking pictures at subfreezing temperatures often have their equipment specially treated to remove lubricants that may freeze up. Carrying the camera under your coat, however, will allow your body heat to keep it warm enough to make occasional winter pictures without excessive trouble from a sticking shutter or condensation. At low temperatures and low relative humidity, static electricity is one of the biggest problems,

This negative is not a photograph of a thunderstorm, a nuclear missile, or a fireworks display. What you see is an actual example of a very bad case of static electricity. Encountered almost exclusively in very cold weather when the relative humidity is low, these ruinous static discharges can be avoided by advancing and rewinding film very slowly.

making lighteninglike imprints on your negatives. Defeat the static gremlin by always advancing and rewinding the film very slowly when the weather is extremely cold and dry.

loading film

Film-loading errors seem to cause most of the problems encountered with using an unfamiliar camera. Even though the film may not be transporting, most 35mm cameras will act mechanically as if everything is OK—even the exposure counter will register. When you load a 35mm camera, be sure the film leader is firmly attached to the take-up spool, that the film sprocket holes are engaged on both sides with the sprocket teeth, and that the film is flat and taut before closing the back of the camera. Wind the film-advance lever until it stops, and then turn the rewind knob in the direction of the arrow (as if you were rewinding the film after exposure) until you feel slight tension. Stop. Click the shutter and advance the film one more frame, watching the rewind knob as you turn the advance lever. The rewind knob should rotate in the direction opposite to the arrow, showing that the film is moving. Check this from time to time as you advance the film to avoid the embarrassment of making thirty-six exposures on the same frame. Most 120-size roll-film cameras have an arrow inside the film holder that must be lined up with an arrow printed near the beginning of the backing paper. Lining up these arrows sets the exposure-counter device.

Sheet-film handling creates a set of different problems, principally because most films must be handled in total darkness. Sheet-film holders must be blown or brushed clean before load-

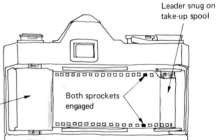

Leader snug on take-up spool

Film cartridge inserted correctly

Both sprockets engaged

Most problems with film loading are caused by being in too much of a hurry. Take your time. Don't short-cut the procedure. Check every step.

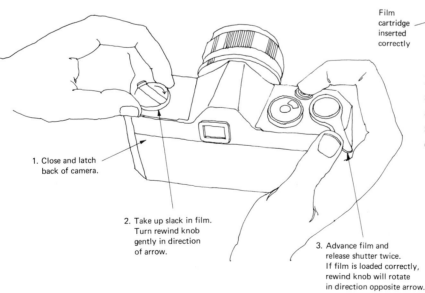

1. Close and latch back of camera.

2. Take up slack in film. Turn rewind knob gently in direction of arrow.

3. Advance film and release shutter twice. If film is loaded correctly, rewind knob will rotate in direction opposite arrow.

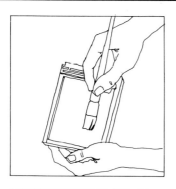

Sheet film holders must be kept free from dust. Each sheet of film is loaded separately beneath the retaining guides on one side of a holder. The dark slides should be inserted with the silver sides of the handles facing out to indicate unexposed film. After exposure, the slide should be reinserted with the black side of the handle facing out.

ing, and the dark slides must be positioned correctly. Nearly all sheet films are notched so that you can feel the notches with your right index finger if the film is held correctly for insertion into the holder. Guide the film under the retainers with your left hand; then fold over the hinged flap and insert the dark slide all the way, with the silver side out. Lock the latches. Don't forget to rewrap the leftover film and put it back into its light-tight box before turning on the lights!

Load and unload your camera in the shade or indoors, never in bright sunlight. Even sheet-film holders tend to leak light if the dark slides are removed and inserted in direct sun, so shade the camera if possible when this is done. Never force any of the adjustments or controls on any camera, and if film should jam for any reason, unload the camera in a darkroom or inside a changing bag.

care of batteries

The tiny mercury batteries used to power exposure meters are devilishly difficult because they seldom give warning of impending failure. Change the meter battery every six months or so, whether it's dead or not, and wipe the contact surfaces periodically with a cloth, especially before taking an extended trip. Alkaline flash batteries require frequent inspection to remove the white powdery crud that collects on the terminals and causes flash failure. A rough cloth will shine up the ends of the batteries; a pencil eraser or screwdriver may be needed to reach down inside the battery compartment to shine up the contact terminals there. Remove the batteries altogether if the flash unit isn't going to be used for a while.

Although the foregoing tips and suggestions won't ensure that all of your photographs will be significant and visually exciting, scrupulous avoidance of the mistakes made by others will help to increase the odds that the important images you do produce will not be lost because of malfunctioning equipment or careless error.

what to look for

Buying a camera is only the beginning. There are a lot of other ways to spend money on photographic accessories and gadgets. A few of these accessories are essential; some are worthwhile; and some others are merely toys.

TRIPOD

First and most important, you'll need a tripod. A sturdy tripod is essential for absolutely sharp pictures, although most beginning photographers aren't convinced that they need a tripod until they make their first *big* enlargements. Pick a tripod that won't wobble when you press down on the tripod head with your hand and twist it—and get a bigger tripod than you think you need. Although you may curse the weight of a bulky tripod when you're backpacking or photographing in the field, you'll bless the bloody monster when you finally compare your sharp negatives and prints with the fuzzy ones you used to get BT (before tripod). There are all kinds of gadgets that can substitute for a tripod in an emergency: a C-clamp, for example, equipped with a swivel tripod head, or a piece of lightweight chain or nylon rope fastened to a ¼ x 20 threaded eye bolt. But you'll need a substantial tripod eventually, so buy one as soon as you can afford it.

CABLE RELEASE

Then you'll need a cable release to trip the shutter without jarring the camera when it's on the tripod. A metal or cloth-covered cable release about ten inches long will screw into a threaded socket in or near the shutter-release button of your camera and permit you to squeeze the release much more gently than you can with your finger. For hand-held shooting, some people like the feel of a *soft release*, which makes it easier to squeeze off the shutter by extending and enlarging the shutter-release button.

LENS SHADE

A lens shade, or lens hood, is another essential accessory. Screwing directly into the threaded outer rim of your lens, the

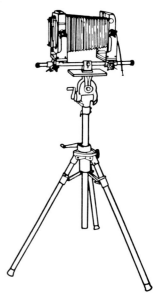

Essential when using a large-format camera, a tripod is desirable when using a 35mm camera especially at slower shutter speeds or when working with long focal length lenses.

camera accessories

Use of a cable release increases your chances of obtaining sharper pictures when the camera is used on a tripod or copy stand.

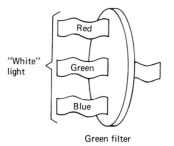

Green filter

A green filter transmits green, absorbing red and blue. In black and white photography, what effect would a green filter have on the image of a red apple among green leaves?

shade will help prevent stray light from entering the lens from just outside the field of view of the lens, causing flare spots or streaks on the negative. Either the rigid metal or collapsing rubber kind of shade is OK, but be sure that the threads are of exactly the right pitch and diameter to fit your lens (you may need to buy separate shades for different lenses); if you're not using a reflex camera, be sure that the shade doesn't obstruct the viewfinder or rangefinder window. You can't use a lens shade with some wide-angle lenses because the shade will cut off the corners of the image.

FILTERS

Filters are handy for special effects, but you won't need nearly as many as you'll be tempted to buy. A UV, Haze, or Skylight filter will be a good investment as a permanent transparent lens cap to protect each expensive and delicate lens from moisture and abrasion and to minimize the number of times you'll have to clean the lens surface. Cleaning a filter is easier and much less risky than cleaning the lens, and if the filter gets scratched you can simply throw it away and buy another.

Colored filters are used in black and white photography to darken or lighten a particular color as it will be reproduced in the final print.

To understand how a filter works you should know that visible white light is made up of all the colors in the visible spectrum, the primary colors of visible light being red, green, and blue. When you see a red object you are seeing red light that has been reflected from the object. The object has absorbed all the other colors, reflecting only red. If this red object is photographed through a red filter, red light is passed through to the film, but any green or blue light present is absorbed by the filter. Because the image is formed by red light, the red object photographed will appear dense on the negative and light on the print. Anything green or blue in the picture will not be recorded with much density on the film, and, hence, will print very dark.

Yellow light is made up of a combination of red and green light. If you put a yellow filter in front of your camera lens, the filter will pass red and green light easily, but it will hold back the blue.

The red and green light combine to form yellow light, which records the image. When a yellow, orange, or red filter is used, blue areas record as lower densities on the negative, thus appearing darker in the final print. A common use for a yellow, orange, or red filter is to darken a blue sky, giving added contrast between white clouds or buildings and blue sky.

A green filter yields just the opposite result of a red filter, lightening the greens and darkening reds and blues.

The effect of filters on black and white films is to lighten or darken colors. If you want to render a color lighter in the final print, select a filter the same color as the subject to be lightened or one that will pass the same color of light.

If you want an object to appear darker in the print, use a filter that will not pass that color. A filter will darken objects that are its complementary or opposite color. For example, if you want to make a red object appear darker, use a blue or a green filter. A red filter would make the red object photograph lighter than it actually appears; so would a yellow filter, although to a lesser degree.

Other important uses of filters in black and white photography include the improvement of contrast between colored lettering or lines and the background on signs, posters, or architectural drawings. Blue printing on a white background, for instance, won't show as much contrast in a photograph as the original appeared to the eye. Photographically copying the document with a red filter will darken the blue considerably, thus increasing the contrast and readability of the reproduction. Suppose that you want to copy a faded, yellowish-stained old document to make the writing (in black ink) more legible. What filter would you use? A yellow or an orange filter would record the yellow as white on the final print, increasing the contrast between the writing and the stained background. Remember the rule about filters transmitting their own and related colors and blocking opposite or complementary colors and you'll be able to determine whether a filter is called for to get the effect you want.

A polarizing filter may be used with black and white or color film. It removes detail-obscuring glare and reflections from non-metallic surfaces such as glass, water, and polished wood without

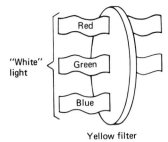

Yellow filter

A yellow filter is commonly used to darken skies in black and white photography because it absorbs blue light and transmits other colors. What is the visual effect of a yellow filter on a black and white *negative*—will the sky appear darker or lighter than if the filter had not been used?

A red filter transmits red light but does not pass other colors. Red objects will therefore be rendered very light in a black and white print, while objects that are predominately green or blue will appear considerably darker.

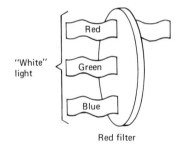

Red filter

affecting the relative intensities of colors. You simply rotate this grayish-looking filter until you see the effect you want. Because blue-sky light is polarized, the polarizing filter will also darken blue skies to some extent, depending on the angle between the sun and the camera-to-subject axis. A polarizer is the only way to darken blue skies when you're shooting with color film.

Because all filters absorb some of the light, except for the "transparent lens cap" type, you'll have to increase the exposure to compensate. Most cameras with through-the-lens exposure meters will automatically compensate for the density of the filter; however, if you're not using this kind of meter you'll have to increase the exposure by a factor as indicated on the film data sheet or in the following table. You can either open up the lens or slow the shutter speed by the number of stops indicated, or you can divide the ASA exposure index by the filter factor and set that lower ASA into your hand-held exposure meter.

The daylight filter factors for most black and white films and for the most commonly used filters are approximately as follows: (These factors should be verified from the film data sheet for individual types of film, especially when exposing with the filter under incandescent illumination).

Filter Color and Type	Factor	Number of Stops Increase
Yellow (#8 or K2)	2X	one stop
Orange (#15 or G)	3X	one and one-half stops
Green (#11 or X1)	4X	two stops
Red (#25 or A)	8X	three stops
Polarizing	3X	one and one-half stops

Camera filters intended solely for color photography fall into three categories: *compensating* filters (CC series), for making minor changes in the color balance of light used to expose color films and papers; *correction* filters (such as the 81 and 82 series), intended to improve the accurate reproduction of colors when the illumination present differs slightly from the color temperature for which the film was balanced; and finally, *conversion* filters (such as the 80 and

85 series), which enable the use of color film balanced either for daylight or incandescent illumination to be used in the other kind of light. Filter factors for color-compensating, color-correction, and the color-conversion filters are included in the manufacturer's exposure recommendations given on the film data sheet packed with each roll, cassette, or box of film. Because color emulsions vary occasionally from the norm in color balance—hence in the amount of filtration required—it is especially important to consult these recommendations. Although the most commonly used filters are available in either dyed or laminated glass for durability, each type is available also in a less costly but more delicate gelatin sheet form that is practical for studio use or for taping over the rear element of the lens, inside the camera, where it will be protected from scratching and handling. All filters either screw directly into the front of the lens mount or they slip into an adapter ring or holder. Be sure to get the right diameter and thread size to fit your lens.

Exposure Meter

If your camera has a built-in, through-the-lens exposure meter, it isn't as essential that you buy a separate meter. On the other hand, if you try to make very precise readings of small subject areas in order to place these areas in the proper exposure zones, you'll appreciate a precision hand-held meter with a relatively narrow angle of view. It's very desirable to be able to "spot" read the brightness of a small area from a distance. A spot meter with this feature is a worthwhile advanced accessory. An "incident light" meter is especially well suited to copy work and photography of very small objects because its design avoids false readings due to extraneous light sources and extremely light or dark backgrounds.

Wide-Angle and Telephoto Lenses

We've already discussed wide-angle and telephoto lenses, but it's worth repeating that you should wait to buy expensive lenses until you've had a chance to find out what your most comfortable shooting distances are. For street photography with a 35mm camera, for example, many photographers prefer the wide-angle cov-

The lens reveals more than the eye sees. . . .

Edward Weston

Filters, close-up lenses and lens shades can be purchased with screw threads to fit most lenses. Unthreaded and gelatin filters can be used with adapter rings and filter frame holders. Ask your photo dealer.

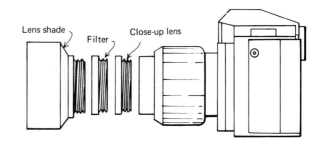

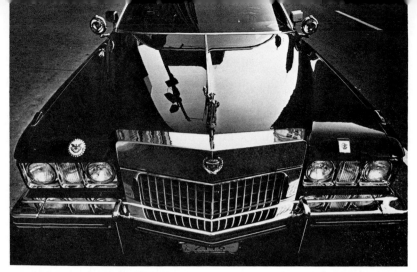

JIM NIXON *Limousine*
Wide-angle lenses tend to increase size differences between near and far objects, or between parts of the same object. In this case a 24mm lens has made the vehicle appear even more massive and sculptural than it actually is.

JIM NIXON *Chicago*
A moderately wide-angle lens makes street photography more convenient in crowded places.

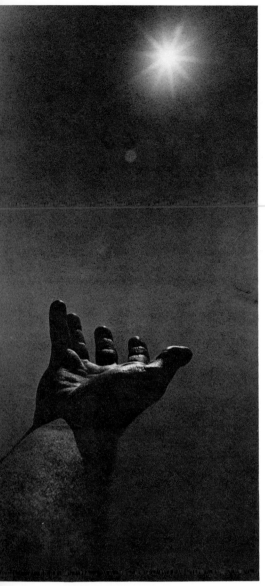

RAIMONDS ZIEMELIS
Hand and Sun
An extremely wide-angle lens (21mm) was necessary to allow the photographer to include his own right hand in the picture while holding the 35mm camera in his left hand.

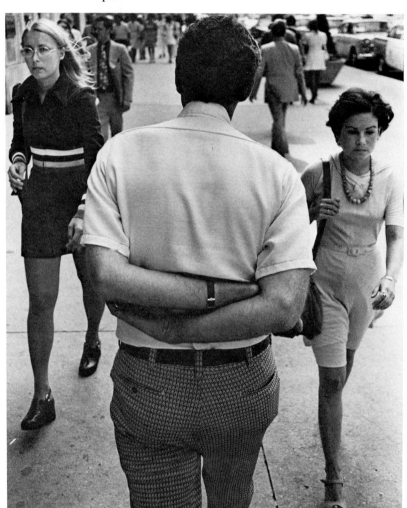

erage and great depth of field of a 35mm or 28mm lens because it allows them to work freely in the midst of a crowd of people without cutting off heads and feet. A wide-angle lens even allows shooting "from the hip" without putting the camera up to the eye. Other photographers feel more comfortable picking off their prey from a safe distance, hiding behind a 135mm or 200mm telephoto.

A focal length of about 105mm is very popular with portrait photographers who work with 35mm cameras because the 105mm lens yields a full head and shoulders image without the photographer having to be embarrassingly close to the subject. Shorter

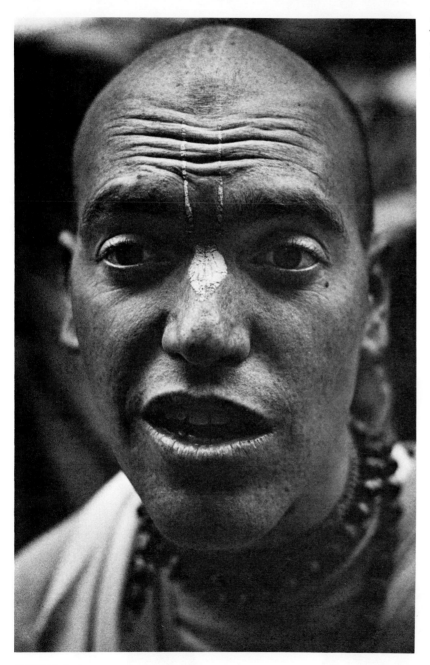

JIM NIXON *Hare Krishna*
A longer focal length lens allows close-ups of people without having to approach too close.

D. CURL *West "H" Avenue*
The cumulative compression of depth produced by telephoto lenses is especially apparent with extremely long focal lengths. More than a quarter mile of roadway is visible in this photograph made with a 400mm lens on a 35mm camera.

JIM NIXON *Self-portrait*
A "fish-eye" lens produced this unique image, which the photographer enhanced through the use of number 6 high-contrast paper and the Sabattier effect. The image is reversed because the final print (on the right) was printed by contact from a "solarized" paper positive print.

JIM NIXON *Self-portrait* (normal print)

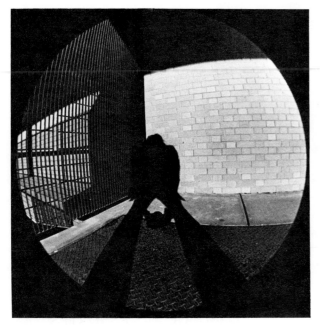

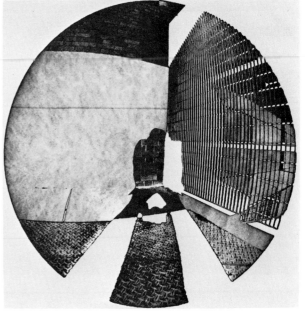

focal-length lenses tend to distort facial features on close-ups, whereas very long focal lengths flatten perspective and lose the feeling of roundness. Few photographers ever get their money's worth out of extreme telephotos (300mm and longer).

A *fish-eye* lens (extreme wide-angle) is an expensive toy for most photographers, distorting perspective so seriously that the effect is usable mostly as a novelty or for unusual architectural or recording requirements. Considering the amount you'll probably use it, a fish-eye lens probably should not be a high-priority item in your photographic budget.

Zoom Lens

A zoom lens is a somewhat luxurious convenience. Handy for the traveler who wishes to be prepared to record exotic street scenes, snatch unposed portraits, or follow the action of a bull-fight or football game without the bother of changing lenses, zoom-lens owners usually sacrifice maximum aperture and some corner-to-corner image sharpness in exchange for the convenience of carrying a single camera with only one lens. An alternative popular with professionals is to maintain separate camera bodies equipped with favorite focal-length lenses, switching rapidly between cameras rather than changing lenses or zooming.

Lens Extender

A lens extender is a relatively inexpensive way to make a long telephoto out of a shorter focal-length lens. The trouble is that you generally get what you pay for when you buy a lens. Aberrations present in an inexpensive extender will bring down the image quality of an expensive, high-quality lens to that of the lowest denominator—usually the extender. If you can afford it, it's a better investment to buy quality lenses of needed focal lengths (or a high-quality zoom lens) than to try to stretch a normal lens into something that it isn't.

Close-Focusing Attachments

There are many close-focusing attachments, the most common and least expensive being close-up lenses that screw like filters into

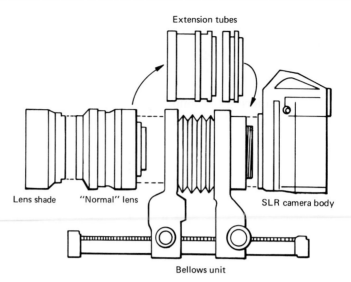

Extension tubes

Lens shade "Normal" lens SLR camera body

Bellows unit

Most single-lens reflex camera bodies will accept a system of interchangeable lenses and close-up accessories including extension tubes and/or focusing bellows.

the front of a regular lens. These lenses are available in various strengths—+1, +2, and +3 diopters—and they can be used singly or combined to allow you to focus on objects down to a few inches from the camera. Because the lens isn't physically moved out farther from the film, close-up lenses require no exposure correction. They do tend to cut down on the sharpness of the image, however, especially around the edges. Because of this problem, you should stop the lens down as far as possible, not only for sharpness, but because you'll need all the depth of field you can get when you're working that close to the subject. Framing close-ups is no problem with a single-lens reflex, but you'll have to measure the distance very carefully, according to the manufacturer's table, if you're using a rangefinder camera.

Table 4-1. *Approximate Exposure Correction for Close-up Photography with 35mm Cameras Using Extension Tubes or Bellows* *

Length of area photographed (in.)	12	6	3	2½	2	1½	1¼	1	¾	½	
Length of area photographed (cm)	30	15	7.6	6.5	5	3.8	3.2	2.5	2	1.2	
Open lens by (f/stops)		⅓	⅔	1	1⅓	1⅔	2	2⅓	2⅔	3	4
Or multiply time by factor of**		1.3	1.6	2	2.5	3.2	4	5	6.5	8	16

*These corrections may not be necessary if your through-the-lens exposure meter and automatic diaphragm mechanism are coupled with the close-up system you use. Certain macro lenses automatically adjust the diaphragm as the lens is focused. Check your instruction manual for verification.

**Note:* At exposure times of one second or longer, you will have to make additional correction for reciprocity departure. At one second, your corrected exposure will require opening one additional stop or lengthening the time to two seconds. Open up two additional stops at ten seconds or lengthen the time to 50 seconds. Interpolate or extrapolate as necessary.

Extension tubes are another way of getting a normal lens to focus close enough to the subject for *photomacrography* (the photographing of very small objects). Tubes of different lengths are available for the most single-lens reflex cameras, some of which actuate the automatic diaphragm mechanism (they are very desirable). Of course, the screw threads, or bayonet lugs, on the tubes have to line up perfectly with your particular camera. A *bellows* attachment is another solution, more flexible than extension tubes, that allows you to focus down to about 1:1 (where the image is the same size as the object). Both bellows and extension tubes require an increase in exposure the closer you get to the subject. Table 4-1 gives approximate exposure increase factors for 35mm cameras at various field sizes.

The ideal close-up device for most 35mm SLR cameras is a *macro lens*. Generally of normal focal length, the macro lens is especially corrected to give extremely sharp images at close focusing distances. Most macro lenses are designed to focus continuously from infinity to 1:1, or nearly so, without exposure compensation or other manual adjustment.

SELF-TIMER

A self-timer is a delayed-action gadget that lets you take your own picture. If your camera doesn't have a self-timer built in, you can buy one that screws into the cable release socket, mechanically tripping the shutter after a preset delay of ten seconds or so—long enough for you to run into the scene and pose. Narcissistic? Maybe, but handy sometimes. Another use for the self-timer is to trip the shutter gently at slow shutter speeds when you might not have a cable release with you.

MOTOR DRIVE

The battery powered motor drive is gaining in popularity even though it adds considerably to the bulk and weight of the camera. Valuable especially for sports sequences, a motor-driven film winder can allow you to expose as many as four frames per second!

It has always been my belief that the true artist, like the true scientist, is a researcher of the world using materials and techniques to dig into the truth and meaning in which he himself lives; and what he creates, or better perhaps, brings back, are the objective results of his explorations. The measure of his talent—of his genius, if you will—is the richness he finds in such a life's voyage of discovery and the effectiveness with which he is able to embody it through his chosen medium.

Paul Strand

A 35mm SLR equipped with an electronic flash attachment. Although it would be very handy to have both the electronic flash unit and a battery-powered motor drive, there could be a temptation to make exposures more rapidly than permitted by the recycling delay of the flash.

JIM NIXON *Boxer*
Electronic flash is the only practical way to stop very fast action when there isn't enough existing natural light. Although a slower shutter speed, such as $^1/_{60}$-second, may be required to synchronize the flash (notice that some background illumination has been picked up), the duration of the flash itself—usually 1/1,000-second or faster—determines the actual exposure time. Because the flash was held a few feet from the camera, a feeling of roundness was retained in the subject and the lighting appears to be from natural sources.

FLASH ATTACHMENT

A flash attachment is another popular accessory because it allows you to make pictures in very poor light and to fill in excessively dark foreground shadows in bright sunlight. A flash unit mounted on the camera is hardly the ideal light source, as we'll discuss in Chapter 9, but it is a way of getting an image when there is no other light. Flashbulbs are becoming about as old fashioned as a folding bellows camera and flash cubes are mainly for use with simple snapshot cameras.

Electronic flash units have come down in price, so that anyone can afford one who can afford a camera. The cost of an electronic flash unit varies with the light output of the unit and depends on whether you purchase such desirable features as automatic exposure sensing and provision for bouncing the light off the ceiling to get a shadowless, more flattering quality of light. Most units without automatic exposure sensing have a dial mounted on them for calculating the correct f/stop *for your tests* at various distances, for films of the ASA number you set into the dial. Or you can make up your own flash guide number, determined by tests: sim-

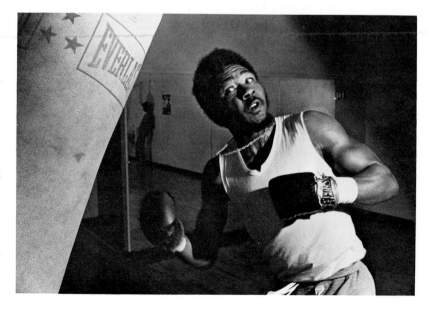

ply divide the Guide number by the distance from flash to subject to determine the f/stop. For example:

$$\frac{\text{Guide number}}{\text{Flash-to-subject distance}} = \text{f/stop}$$

Guide number = 110

Distance = 10 feet

$$\frac{110}{10} = 11$$

f/stop = f/11

Because light intensity depends directly on the distance between the flash unit and the subject, you can produce unprintable negatives if the flash unit is mounted on the camera and if there is a great deal of depth of field in the picture. Near objects will, of course receive most of the light, being grossly overexposed while the background is underexposed. Automatic flash units expose for the nearest surface, whether that is what you want to emphasize or not. Bounce flash generally requires about two stops more exposure than direct flash because of the absorption of light by the ceiling and because of the extra distance from flash to ceiling to subject. If your flash unit is not of the "hot shoe" type that makes its own direct connection to the camera, be sure to plug the flash cord into the X contact for electronic flash (M is for most types of flashbulbs) and use the shutter speed recommended in the instruction book—usually $^1/_{60}$ or $^1/_{125}$ second on 35mm single-lens reflexes.

Gadget Bag or Case

Now you need a badget bag or fitted case to hold all of your camera stuff. Only tourists seem to use the ubiquitous ever-ready (never-ready) case that's fitted to the shape of the camera. Although these cases do provide protection for the camera, most serious photographers find them a nuisance to work with, preferring to wear their camera(s) unadorned while shooting and to keep each camera body, lens, and accessory in its own leather or foam-lined compartment in a larger attaché-type case when it is not being used. Such cases can be purchased in light- and heat-reflecting aluminum or in humble black or gray. They are often lined with foam that you can custom cut to fit your equipment. If you

worry, however, about being the target of a camera thief, you may decide to use, instead of a regular camera case, a somewhat battered businessman-type case that doesn't shout "photographer" to the world.

how to test your equipment

You won't need to worry so much about testing if you've bought a new camera or accessory from a reputable dealer. He'll probably give you a free critique of your first few pictures and guarantee the equipment to your satisfaction. But after the warranty has expired, or if you're tempted to buy used equipment from someone's private ad, you ought to know what to look for.

Always suspect equipment that looks badly beat up. That usually means that the previous owner didn't take very good care of it and that there may be some internal problems, as well as the external defects that show. Most manufacturer's service centers charge a minimum fee for handling a camera, whether the problem is simple or not, although you may be able to find a congenial local repairman who will make minor adjustments for you without charging for a complete overhaul. Any way you look at it, though, major repairs may cost as much as a used camera is worth!

First check the lens for scratches. Reject the camera if these are severe, especially if scratches or dust seem to be inside the lens—an indication that the lens has been disassembled. A few tiny air bubbles in the glass will not cause trouble, however, and are a slight manufacturing defect that can usually be ignored. If the lens mount itself fits loosely and if the diaphragm setting ring or focusing ring either turns hard, grabs or grinds, or turns too loosely, suspect excessive wear or dirt in the mechanism.

Open the back of the camera and trip the shutter several times. Observe the automatic diaphragm at different f/stop settings. The diaphragm should stop down smartly when the shutter-release button is pressed and open right up again with no delay after each exposure.

Test the exposure meter by reading light and dark subjects in-

doors and out. Compare the indicated camera settings with a film data sheet for the outdoor exposures and with either an exposure table or another meter for the situations not covered by the film data sheet. Be sure the meter needle doesn't stick or move erratically—a sure sign of needed repair. Try each of the shutter speeds several times to see whether they are consistent and whether they seem to be proportional to the amount of time the shutter remains open. If in doubt about the shutter, have it checked by a camera repairman who has an electronic shutter tester. A shutter that sticks open at any of the speeds may need an expensive overhaul.

A newspaper classified ad page makes a suitable subject for a practical test of the sharpness and covering power of your lens at different apertures.

Check out the focusing system by focusing sharply through the camera eyepiece at objects at various distances; then compare readings on the lens distance scale with your measured or estimated distances. You can make an actual test of the coverage and resolving power of a lens simply by setting the camera on a sturdy tripod and photographing the classified ad page from a newspaper. Tape the newspaper up on a wall in strong, even light. Fill the entire negative with the image of the newspaper page, focus very carefully, and then make an exposure at each f/stop on the lens. You'll have to compensate by adjusting the shutter speed, of course, to maintain proper exposure. Keep a record so that you can tell which negative was exposed at each f/stop; then when you study the negatives with a hand magnifier you can tell easily whether you can read the printing out to the edges of the frame. You may find that your lens is like most others, in that the edges of the negative tend to be somewhat less sharp than the center of the field until you stop down to about f/4 or f/5.6, at which point the field becomes more uniformly sharp. Some lenses will show slight loss of sharpness at f/16 or f/22 because of diffraction.

Actually, shooting a roll of film in the camera will show you more than just the quality of the lens. If the frames overlap or show uneven spacing between frames, the film advance mechanism may require repair. If there are any light leaks you'll see dark streaks or spots. A scratch along the length of the film may indicate a rough spot either on the camera body aperture or on the film pressure plate.

An artist is not a special kind of person; every person is a special kind of artist.

Eric Gill

A man who works with his hands is a laborer; a man who works with his hands and head is a craftsman; and a man who works with his hands, head, and heart is an artist.

Author unknown

Electronic flash and camera synchronization can be tested by opening up the back of the camera, aiming the lens at a light-colored wall, and at the same time flashing a "picture." Don't forget to turn on the flash unit and let it charge up (there is usually a "ready" light that comes on). Set the camera for the proper shutter speed (probably $1/60$ or $1/125$). Be sure that the flash cord is plugged into the X outlet and that the lens is set to the widest aperture. You should see a brilliant flash through the lens at the exact instant that the shutter is wide open.

If you have any doubt about the condition of the equipment you own or intend to buy, be sure to get the advice of a responsible dealer, a repairman, your photo instructor, or an experienced photographer friend. If your equipment does need repair, be sure that it goes to a reliable repairman, and be sure to get an estimate—in writing.

Contemporary cameras are marvelous instruments. Care for yours lovingly and it will serve you well.

getting it on film

Although you'll discover later how to work some "magic" in the darkroom to improve the quality of your prints, you must remember that if detail isn't present in the negative, you can't print it. Photographic films have certain inherent limitations that have to be learned about and lived with. In this chapter you'll have a chance to experiment just enough to find out how far you can err in exposure and film development and what kinds of controls are possible.

characteristics of black and white films

There are many types of black and white film. Some, such as high-contrast copying and infrared films, are intended for specialized use, but there is a wide variety of general purpose films. One type of film is chosen instead of another for one or more of the following reasons:

SPEED

The ASA rating, or exposure index, is a measure of the film's relative sensitivity to light. A film rated ASA 400 by the manufacturer is assumed to be four times as sensitive as a film rated ASA 100. The slower film, therefore, would require four times as much exposure, or two f/stops more exposure than the faster film.

GRAIN

Grain is the extent to which the tiny silver particles forming the image tend to clump together and form a mottled, or spotty, effect. Generally speaking, the faster the film (the higher the ASA rating) the more tendency there is for grain to become visible upon enlargement of the negative.

COLOR SENSITIVITY

Film is either panchromatic (sensitive to all colors of visible light) or limited in sensitivity to only a portion of the spectrum.

5

It is in working within limits that the craftsman reveals himself.
Goethe

photographic films

ROBERT FLEMING
The Forum Building
Infrared film records familiar
things with an eerie difference.
This specially sensitized film must
be exposed through a deep red
filter to eliminate most visible
light.

I do not believe any tuition is a
better bargain than $100 worth of
film put to work in an attempt to
make each picture, each roll, bet-
ter than the last.

Wallace Hanson

Nearly all films today are panchromatic, except for special-pur-
pose process and copying films, some of which may be handled
and developed under a red or an orange safelight.

CONTRAST

Contrast is the relative differences in density between dark and
light tones in the negative image. Slower (lower ASA rating) films
tend to have more inherent contrast than the faster films. Gener-
ally, low speed, fine grain, and high contrast tend to go together
in some films, whereas high speed, more noticeable grain, and
lower contrast are common characteristics of others.

Until you've made a great many photographs, let me suggest
that you start with a single brand and type of film for most of
your work. A medium-speed film such as Kodak Plus-X Pan
(ASA 125) is a good compromise for most beginners, offering
enough speed for hand-held shooting, yet yielding images of fine
enough grain to allow considerable enlargement. Because of their
tendency to be more grainy, fast films (ASA 400 or higher) are
best used in situations in which action stopping is important and
where the light is dim, such as indoor pictures by window light or
existing artificial light. More and more photographers, however,
are standardizing on a fast film such as Kodak Tri-X Pan (ASA
400) to cover all possible lighting situations, often exposing it at
somewhat more or less than the manufacturer's suggested rating.
The quality of such negatives may surprise you! On pages 134–137
you will find a method for determining a "working" ASA rating

for your choice of film, exposed with your meter, in your camera, and developed following your own standardized procedure.

A very slow, fine-grained film such as Kodak Panatomic-X (ASA 32) is indicated when enormous display enlargements are to be made, when increased contrast is desirable, as in copying documents, or when you want to reproduce extremely fine detail and texture in the subject.

LATITUDE

Another important characteristic of film is latitude—that is, the amount the film can be underexposed or overexposed without serious loss of image quality. Although color films are quite limited in latitude, modern black and white films have a remarkable tolerance that compensates within certain limits for human and mechanical error. Most general-purpose black and white films may be underexposed or overexposed two or three stops and still produce a printable negative. Lower quality is the penalty for incorrect exposure; within one stop of optimum exposure, however, the difference in quality may be hard to detect in the finished print. Of course, you should expose exactly right whenever you can previsualize and measure the various values in the subject to be photographed. With a little knowledge and a lot of practice, you'll soon be able to produce negatives of excellent quality consistently.

characteristics of color films

SPEED, GRAIN, AND LATITUDE

Color negative films are generally of medium speed and relatively fine grain. Because the color balance of the final prints is affected by reciprocity departure, as well as by the color temperature of the light by which the negative was exposed, professional color negative films are balanced either for short exposures by daylight or electonic flash (type S film) or for longer exposures by 3200°K incandescent illumination (type L film).

Because the silver image is replaced by dyes during reversal

processing, color transparency films possess unusually fine grain. The image definition of slides made on the very high-speed color films does appear somewhat less crisp and lower in contrast, however, than on slides shot on a slower film such as Kodachrome 25. Mainly because of the problem of reproducing acceptable color balance, color films do not have the inherent latitude for exposure and development variation possible with black and white. Although some "pushing" from one and one-half to two stops or more is possible with user-processed color films such as Ektachrome 200 and 160, the quality deviates from the norm more than with an equivalent variation in black and white exposure and processing.

COLOR BALANCE

Color transparency (slide) films are manufactured specifically for exposure under predictable lighting conditions, either daylight or incandescent. Except for special effects, the colors of light should not be mixed. Fluorescent light is an example of misleading appearance—because of its overall bluish cast, it would seem to balance with daylight color film. But fluorescent light usually is extremely deficient in red, leaving an unpleasant surplus of green in the image, unless compensated for with a red or magenta filter.

Electronic flash illumination is very close in color to the light for which "daylight" color films are balanced. Incandescent lamps, on the other hand, appear quite a bit warmer, more toward the lower end of the Kelvin color temperature scale. A subject will appear an overall yellowish-orange if photographed under incandescent illumination on color film balanced for inherently bluish daylight or electronic flash. Conversely, moonlight effects can be obtained by slightly underexposing type B or type A color film that is balanced for incandescent illumination, in daylight, without the appropriate conversion filter.

Although nearly any kind of color film can be filtered for acceptable color balance under standard kinds of illumination, it's usually preferable to obtain the right kind of film in the first place, making any minor compensations in exposure or filtration according to the manufacturer's instructions packed with the film.

storing films

Whether the film is black and white or color, you'll do best to buy fresh film and store it in a cool, dry place. Factory sealed packages of film will keep well for two years or more in a refrigerator or freezer, even well past the expiration date. But to prevent moisture condensation, allow at least half an hour for refrigerated film to reach room temperature before unsealing the package. Frozen film should thaw for an hour or more before the seal is broken. A grayish overall fog or noticeable deterioration of color quality may appear on film that has been improperly stored under conditions of high heat and humidity; for this reason outdated film may be a poor bargain unless you're certain how it has been stored.

loading bulk film

Should you buy bulk film? The economy of purchasing 35mm film in 100-foot rolls is very appealing. If you shoot enough pictures to use the nearly 700 exposures you get from a 100-foot roll before it goes out of date, the cost per shot with bulk film is less than half what it costs you to buy factory loaded film magazines. But on the other hand, you have to invest in a bulk-film loader and a supply of empty, reloadable magazines. And bulk loading takes some time.

The most compelling reason for *not* using bulk film is the danger of scratches, fingerprints, or fog. With so-called daylight film loaders, the film may have to pass between felt light-trap pads four times instead of twice with commercially loaded film. Furthermore, there is more than twice the risk of an embedded speck of sand or grit gouging the entire length of a roll because the felt lips of the loaders and the reused magazine are less likely to be clean. Light fog will occur at both the head and tail ends of each roll (you have to be careful not to shoot right up to the very end—stop one or two exposures short), and there is always the possibil-

Nothing is as easy as it looks.
It will take longer than you think.
If anything *can* go wrong, it *will*.
 Murphy's law

ity that someone might inadvertently unscrew the lid of the loader and fog your entire bulk-film supply.

Some special films, however, must be bulk loaded because they're simply not available in twenty- or thirty-six-exposure magazines. It is convenient to be able to load short lengths of film for testing and for special processing. If you do load bulk film, be careful to handle the film only by the edges or by the very end; be sure to use strong enough tape (3/4-inch masking tape will do) so the film doesn't pull off the spool; inspect all felt light-trap lips for dirt; blow out dust from the magazines with canned air; and beware of fog. Be sure to insert the spool in the magazine shell so that the long end of the spool will point toward the bottom of the camera when loaded. Most cameras will require also that you trim the leader to fit the takeup spool.

determining exposure

A good exposure meter is indispensable. If your meter is working correctly, and if you use it intelligently, it will significantly increase your percentage of printable negatives and projectable slides. Although professional photographers often let experience be their guide in determining exposure, the pros nearly always use a meter to check the actual amount of light present and to verify their estimates. An accurate meter is an absolute must for obtaining the precise exposure needed to produce high-quality negatives from which fine prints can be made.

Although you can set your camera quite accurately for most ordinary outdoor shooting simply by following the manufacturer's recommendations printed on the data sheet packed with your film, that source is a generalization. It won't cover every situation, and it won't apply to subject matter of other than average brightness. A meter is especially useful for determining exposure indoors, in deep shade, in early morning or late afternoon, or whenever the subject is unusually light or unusually dark or has important shadow detail within an extreme range of brightness. Incidentally, if you ever find yourself stuck with neither meter

nor film data sheet, you can determine the average outdoor settings for bright sun by letting the ASA index be the shutter speed (for example, Plus-X, ASA 125 = 1/125 second) and setting the aperture at f/16. For hazy sun, open up to f/11. For light overcast, open up to f/8. If the sky is heavily overcast, or if your subject is in open shade on a sunny day, your basic settings for ASA 125 film will be about 1/125 at f/5.6. The same f/stops would apply for a film rated at ASA 64, but you would use 1/60 second instead of 1/125. ASA 400 film would require 1/400 (or 1/500,) and so on.

A built-in, through-the-lens exposure meter can be a great convenience when exposing color film and for shooting scenes of average brightness in black and white. Under such conditions, the built-in meter can be a pretty reliable guide. Most built-in meters read the entire field of view of the lens, averaging every part of the subject's brightness range. Such meters are designed with the assumption that the average photographer will be shooting subjects of average brightness. So-called center-weighted meters assume that you're going to place the most important area of your subject in the center of the viewfinder (the *magic circle* syndrome) and that you want that central portion reproduced as a middle gray.

Most exposure meters, including those built into many modern cameras, are of the *reflected light* type, and they are all subject to the same limitation: they want to convert everything they read into an average middle gray! This averaging feature simplifies exposure determination, especially for color, but it can also seriously mislead you if the subject itself is not of average brightness. With many types of subject matter, if you want to reproduce black and white with a full range of gray tones in between, you have to learn to *outsmart* the meter. Here's how you can do it:

using an exposure meter

First of all, hold the meter as close as you can to the part of the subject you're reading, but don't get so close that you read the shadow of the meter or your own shadow. Why get so close? Because if the background or adjacent areas are significantly

Overall

Center-weighted

Spot

If your camera has a through-the-lens exposure metering system, you should consult your instruction manual to determine just what portion of the viewfinder field is covered by the light-gathering cells. Zone system readings cannot be consistent if your meter is picking up light from the background.

A reflected-light meter with incident-light adapter.

A reflected-light spot meter.

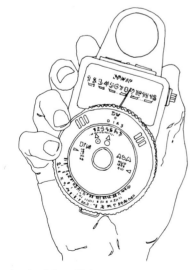

An incident-light meter.

brighter or darker than the area you want to expose for, the meter will indiscriminately include those areas, throwing off the accuracy of the reading. Spot meters, of course, are designed to read a very small area from a relatively greater distance. Cameras with built-in or attached meters should be handled, when making precise readings, as if the entire camera were the meter: move in very close for the reading, note the settings called for, and then back off to shoot from approximately the same angle at which you made the reading. If the meter needle changes position, ignore it. Leave the camera set as indicated when you made the close-up reading.

A built-in exposure meter, used as the camera manufacturer intended, can be helpful if you're shooting rapidly and if you can't take the time to make separate readings of significant high and low values in the subject. Actually, in such situations you might as well set your camera according to the instructions printed on the film manufacturer's data sheet. In any event, you should always confirm your meter readings with the film data sheet to protect yourself against possible meter malfunctioning.

A separate hand-held exposure meter, such as the types manufactured by Gossen, Weston, Honeywell, and Sekonic, will allow you to make extremely accurate readings of important low and high brightness values in your subject and to apply more conveniently the zone system that will be described in the balance of this chapter.

Many meters are equipped with incident light adapters. With the adapter in place, instead of reading light reflected from the subject, the meter is pointed toward the camera from the subject's position. Extreme highlight and shadow values, stray light, and background brightness have little effect on an incident light reading, so this technique is especially recommended for color photography, for copy work, and for situations in which the lighting is extremely uneven or when very small objects are being photographed against a contrasting background. A few types of exposure meters have been designed primarily to read incident light.

Because of their more limited exposure latitude, color films must usually be exposed very nearly according to the standard 18

per cent middle gray to which exposure meters are calibrated. Although the incident light method eliminates false readings from unwanted values, it does not read separately the important light and dark areas in the subject. These high and low values are very significant in black and white work because you can control the range of values in the brightness scale by manipulating exposure and development. The best way to get really superb black and white negatives is to use an accurate reflected light meter, following a procedure known as the zone system.

the zone system

Developed by Ansel Adams for his own use and written about by Adams and by other photographers, the zone system forces you to carefully previsualize your subject matter as you want it to appear in the final print. You must observe and compare the important tonal values in each scene you want to photograph, mentally placing each value at the desired place on a ten-step gray scale. Each step of the gray scale is referred to as a zone, according to Adams' analysis (see Table 5-1).

The zone system is really a quantified version of the ancient photographers' axiom, "Expose for the shadows and develop for the highlights." Photographers relied on this principle long before the invention of photoelectric exposure meters and panchromatic films. The old-timers judged exposure by examining the brightness of the shadow areas of the image as they appeared on the view camera ground glass, exposed according to experience, and then developed their glass plates or films by the light of a dim red bulb or lantern until the highlights appeared to be of the proper density. The same principle applies today, because shadow density in the negative is determined largely by *exposure*, more or less independently of development time, whereas highlight density increases very rapidly in proportion to *length of development*. If it weren't true that low and high negative densities responded differently to development, the zone system wouldn't work. Remember, the rule is to expose for the shadows (lower values—Zones I

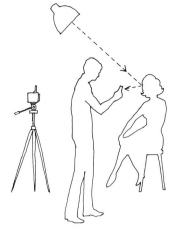

A reflected-light meter reads light reflected from the subject. The meter should be held so that it neither reads its own shadow nor is affected by background brightness.

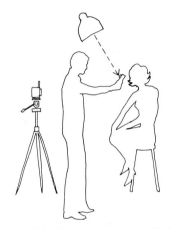

An incident-light meter reads light falling on the subject and is not affected by variations in reflectivity of the subject or brightness of the background.

> The photo-poet works within the discipline of the photographic process, with the greatest respect for the possibilities and limitations of his lens, shutter, film, and developer. He knows that the successful transformation of color tones into black and white values is as essential as image definition and the selection of his composition.
> *Thomas W. Leavitt*

Good photographs must show the
evidence of how they were made;
of the lens, shutter, and film, of the
unique ability . . . to "render" fine
detail in continuous tone.
 Charles Harbutt

Table 5-1. *Zones of Subject Brightness**

Low values	Zone 0 (five stops less)	Complete lack of density in the negative image, other than film base density plus fog. Total black in print.
	Zone I (four stops less)	Slight tonality, but no texture. Unlighted interiors through open doorways. Practically indistinguishable in print from total black.
	Zone II (three stops less)	First suggestion of texture. Deep tonalities representing the darkest part of the image in which some detail is required.
	Zone III (two stops less)	Dark, textured materials such as dark clothing, hair, and fur. Low values showing adequate texture in the print.
Middle values	Zone IV (one stop less)	Average dark foliage. Dark stone. Landscape shadow. Recommended shadow value for portraits in sunlight.
	Zone V (meter reading)	Clear north sky. Dark skin in sunlight. Gray stone. Average weathered wood. (*Note:* This is the 18 per cent middle gray for which exposure meters are calibrated.)
	Zone VI (one stop more)	Average Caucasion skin value. Light stone. Average sand. Shadows on snow in sunlight.
High values	Zone VII (two stops more)	Very light skin. Light-gray objects such as concrete walls and light-colored hair and fur. Average snow or light sand with acute side lighting.
	Zone VIII (three stops more)	Whites with textures and delicate values (not blank whites). Snow in full shade. White painted surfaces. Highlights on Caucasian skin.
	Zone IX (four stops more)	Glaring white surfaces. Snow in flat sunlight. White without texture. Light sources and reflections. Usually represented in the print by the maximum white of the paper surface.

*Adapted from Ansel Adams, *The Negative* (New York: Morgan & Morgan, 1948), p. 19.

through IV) and develop for the highlights (higher values—Zones
VI through IX). Ideally, you would read and place on the gray
scale each important zone appearing in the subject. However, if
you place even *one* zone correctly on the gray scale, all the other

zones will fall into their relative places within the limits of the film used and the development given.

placing brightness values

There are five different ways of determining exposure by using the zone system, the first four of which are timesaving shortcuts: the Darkest Important Shadow method, the Most Important Value method, the Substitute Reading method, the Standard Reading method (recommended for color), and the Brightness-Range method, which gives you control over negative contrast as well as density. When you understand the principle of the zone system and are able to previsualize the zones into which significant subject brightnesses should fall, you'll be able to choose the most expedient method for each situation.

1. DARKEST IMPORTANT SHADOW METHOD

This method is simple, yet it ensures against losing significant shadow detail in a subject such as a dark rock formation, dark

RON NULL *Snow Mountains*
This subject contains a full range of tonal values. Zone numbers have been placed in the photograph to indicate approximately what the corresponding steps would be on the ten-step gray scale used in the zone system. Each step, or zone, represents the equivalent of one f/stop difference in negative density.

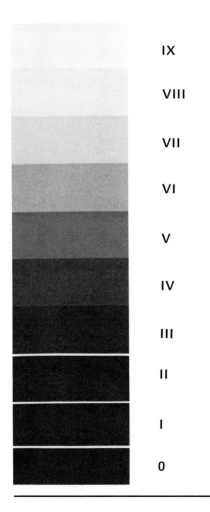

IX
VIII
VII
VI
V
IV
III
II
I
0

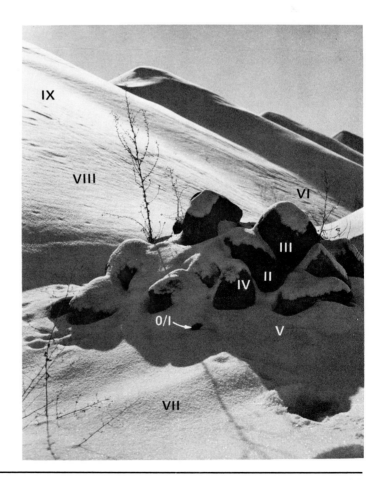

GARY CIALDELLA
White House with Picket Fence
The extreme brightness range of this subject calls for $N-$ development of the negative. Exposure should be based on Zone III to retain detail in the dark tree bark. The difference between reflected-light meter readings of the bark and the brightest portions of the white painted house indicated $N-2$ development to retain Zone VIII.

animal, or a woodland scene with spotty areas of sunlight and shade. If you previsualize the zone into which the darkest important values should fall (usually Zone III) and expose so that zone is placed correctly on the gray scale, you'll record the textures in those dark areas and the other zones will fall into place according to their relative brightness. Similarly, you can reduce or extend the development of future negatives if present prints fail to yield adequate textures in the high values, as well as in the low values. You should develop your negatives so that you can tell the difference in the final print between areas that you've previsualized as Zones VI, VII, VIII, and IX.

Remember, when making your close-up reading of the darkest

important shadow areas, your meter will give you a *Zone V* reading (middle gray). Unless you want those shadow areas to *be* Zone V, you'll have to convert your reading to the correct zone. The easiest way is to count zones as you stop down the lens. If your chosen shadow are should be Zone III, simply read the meter to determine the f/stop for making that area *Zone V;* then count "Zone IV" as you close down one stop and "Zone III" as you close down another stop. For example, a direct, reflected-light meter reading of a dark, textured area indicates an exposure of 1/30 at f/8. You know that this setting would be the correct exposure to render that area as Zone V, but you want to make that area Zone III. So as you stop down to f/11 you say to yourself, "Zone IV"; as you stop down one more stop to f/16 you say, "Zone III."

Remember, the rule is to *stop down* (give *less* exposure than the meter says) to place Zones I through IV. If you were basing exposure on higher values instead of lower values, you would *open up* (give *more* exposure than the meter indicates) to place Zones VI through IX. No change would be necessary if you wanted to place Zone V, because the meter reads directly for Zone V. And a reminder here is to count zones only on the numbered f/stops of the regular scale (that is, f/5.6, f/8, f/11, and so on). Don't make the mistake of counting the halfway click stops that may be on your lens.

2. MOST IMPORTANT VALUE method

Exactly the same as the Darkest Important Shadow method, except that, being based on higher values, you would choose this method when shadows are of less significance than skin tones, snow texture, or other middle and high values. What you do is to read the skin tone or other important value directly with your meter and then place that Zone-V reading on the chosen zone, as before. For example, in an outdoor portrait in full sunlight, the brightest side of the face reads 1/125 at f/16. You want the skin not to record as Zone V, but as Zone VI, so you *open up* the lens from f/16 to f/11, saying to yourself, "Zone VI" as you set the aperture. If, instead of a face, you've read "side-lighted, textured

When making a close-up reading of a face or any important value, be careful not to read your own shadow!

Hold the meter close, but do not cast a shadow!

snow," you would *open up two stops* from the direct, Zone V reading, to place the snow on Zone VII. If you've read the flank of a dark-colored Zone-III horse, you would *stop down two stops* to place the horse on Zone III. Of course, if you run to the end of your f-stop scale, you'll have to compensate with shutter speeds as well as f/stops. Just keep your wits about you and count zones as you change from one shutter speed to another in the same way as you would count zones when changing f/stops.

In some cases, you may be willing to sacrifice some background values in order to place the most important values in their proper zones; be careful, however, not to let your meter include those unwanted background areas in its reading. If you remember to read the *single most important value* (usually skin tones if people are in the picture) and place that value in the desired zone, you won't be misled by extraneous background values. Obviously, your exposure meter can't determine what the most vital part of the subject is, so it will dutifully average everything you allow it read into a Zone V middle gray.

3. Substitute Reading method

A variation of the Most Important Value method, a substitute reading is useful when it's impossible or inconvenient to approach the subject for a direct, close-up meter reading. You could read nearby snow to substitute for snow in similar light on a distant mountain peak. Or the trunk or foliage of a large nearby tree can substitute for trees on the other side of a river. Just be sure that the light conditions are the same, that you hold the meter properly to avoid false readings from contrasting background values, and that you count out the zones correctly as you open up or stop down the lens or change lens and shutter settings from those indicated by the meter for Zone V.

4. Standard Reading method

Appropriate for exposing color films of limited exposure latitude, the Standard Reading method is based on consistent Zone V readings from an 18 per cent gray card or incident-light meter or on reflected-light readings from some other standard value. Other

than a gray card, the most commonly used standard value is the back (or palm) of the photographer's hand. Caucasian skin being generally Zone VI in full light and Negro skin Zone V, this is a uniform standard that's always available.

Color films normally should be exposed for Zone V, allowing the higher and lower values to reproduce wherever they fall on each side. As with a black and white portrait, you would *open up one stop* in color if you've read Zone VI skin instead of a Zone V gray card. You would do this because the meter has read the skin not as Zone VI, but as Zone V middle gray. Color films ordinarily do not have enough exposure latitude to place zones more than about one stop away from "normal"—although there might be exceptional circumstances requiring placement of extremely dark or bright subject matter, realizing that other areas may turn out to be severely over or underexposed. Intelligent bracketing, although it may not be very scientific, is a good idea when you have to make such compromise decisions. Bracketing means making one exposure at exactly what your meter reading and calculations indicate and then simply making another exposure at one-half stop, one stop, or more additional exposure and another at the same amount less exposure. Bracketing is a very sensible practice when your experience doesn't allow you to completely previsualize the result.

An 18% neutral test card (gray card) is the standard to which exposure meters are calibrated. Because the gray card represents Zone V it can be used as a standard reference in practically any situation. When you determine exposure from reading a gray card, place the card so it receives exactly the same amount of light as the principal subject. Move in close with your meter—or your entire camera if using a through-the-lens meter. Be careful not to read the area beyond the gray card or to read your own shadow!

Using the Standard Reading method with black and white film, you would proceed from your standard reading in the same way as in the Most Important Value method; that is, you determine how many zones the most important values are from your standard and count zones as you either open up or stop down. The only exception would be that if you make your standard reading with an incident-light exposure meter or incident-light adapter, the indicated settings will already have been compensated for other zones (the incident-light meter reads Zone V as a true Zone V). When you base your exposure on an incident reading, you don't have to place the various zones; all you have to be sure of is that no significant zones fall outside the normal latitude of the film. Unfortunately, an incident reading can't give you this information. For this reason, an incident-light meter is convenient

Your hand can serve as a "gray card" if you place the reading on the appropriate zone.

when exposing color films of limited latitude or in controlled lighting situations in which the brightness range is not excessive. You need an accurate reflected-light meter, preferably a "spot" meter, for precise zone-system readings.

5. BRIGHTNESS RANGE METHOD

The Brightness-Range method gives you greatest control over all of the zones of subject brightness. At its most complex, the Brightness-Range method calls for reading each subject area separately and plotting these readings on a gray scale so that the brightness of each part of the subject is matched to the optimum zone. If the subject brightness scale doesn't match the scale of zones, then plus or minus development is indicated.

At its simplest, the Brightness-Range method calls for reading only the lowest and highest significant values (these frequently are Zones III and VII) and averaging the two readings. You might choose, for example, to read both a Zone III tree trunk and Zone VII side-lighted snow. Reading from the tree trunk, the meter indicates 1/125 at f/5.6, while the snow indicates 1/125 at f/22. Remember that these exposures would render both the high and low values as Zone V middle gray. The difference between the readings is exactly four stops (four zones), which it should be, and a satisfactory compromise exposure of 1/125 at f/11 would place both the tree trunk and the snow within the limits of the film and reproduce all values in between. You would set your camera at the halfway, or average, setting of 1/125 at f/11, exactly the same setting you would have obtained had you placed separately either Zone III or Zone VII or based the exposure on a Zone V gray card reading.

Averaging the highest and lowest readings is a timesaving technique when both high and low values are the same number of zones above and below Zone V middle gray; averaging doesn't work however, if all or most of the zones are skewed to either side of Zone V. In a very low-key subject, for example, the values may range from Zone II through Zone V, with nothing registering higher than Zone V, except perhaps a tiny catchlight or reflection that isn't measured by the meter. In this case, the exposure

should be set for the *Zone V* reading, to place all of the low values properly. An average exposure would place the Zone V value between Zones III and IV, adding unnecessary density to the entire negative. Similarly, a high-key subject with a tonal range extending from Zone VI through Zone IX may not contain any low values, or the low values may be so small as to be insignificant in determining exposure. An average setting halfway between Zones VI and IX would result in an undesirably thin negative, so the exposure should be anchored to Zone VI.

With many subjects, reading the highest and lowest important values and setting the exposure halfway between will result in a

JOHN GRIFFIOEN *Pine Board*
Do you see, in this photograph, a board or a baboon? Or is the image, for you, composed solely of textures and convoluted lines? With nearly all the values Zone IV and darker, this is an excellent example of the kind of subject matter that requires *N +* development.

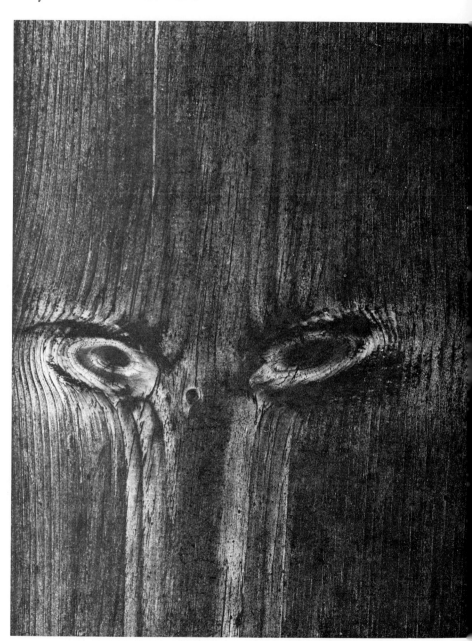

Zone V average, the same as a single overall reading of the entire subject, or an incident-light reading. With other subjects, however, the averaging method may lead you astray either because the significant zones don't fall equally on both sides of Zone V or because the brightness range from highlight to shadow may be greater than the film can adequately record. This may result in an unsatisfactory compromise of underexposure at the shadow end of the scale and overexposure of the highest values.

adjusting contrast by development

Black and white film will reproduce at best a range of only eight zones with detail from deepest shadow to brightest high value (Zone VIII can be no more than 128 times the brightness of Zone I). If you detect a greater brightness range than eight zones, or 128:1, you won't be able to record the entire gray scale properly unless you reduce the subject contrast. You can do this either by artificially increasing the amount of light in the shadows, by decreasing the brightness of the highlights by shading them somehow, or by developing the negative for less than the normal time.

COMPRESSION

Let's take an example in which the development time should be reduced. Suppose the Zone III tree trunk reads 1/125 at f/5.6, while the Zone VII snow actually reads 1/125 at f/32. That's now a *five*-zone difference instead of the desired four zones. In this case, normal *minus one Zone* (N − 1) development is indicated. If the tree trunk and the snow were *six* zones apart when they should be only four zones apart, correct development would call for normal *minus two zones* (N − 2).

EXPANSION

But supposing you want to *extend*, instead of compress, the placement of the highest values. For example, you're shooting the scene just described, but on a very dull and cloudy day. The Zone III tree trunk reads 1/30 at f/4, while the snow reads 1/30 at

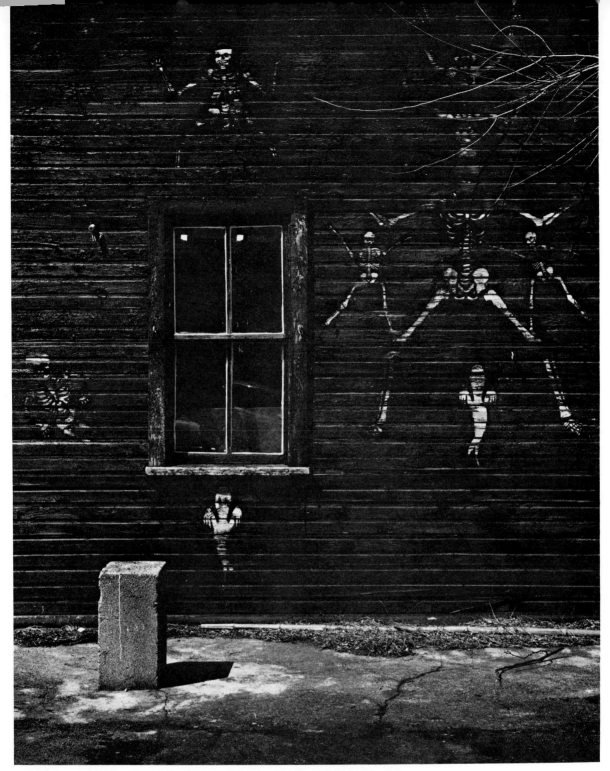

D. Curl *Abbott's*
Nearly all the texture of this bizarre building was in the weatherbeaten
Zone III black paint. Careful placement of the wooden siding on Zone
III was necessary to avoid underexposure. Extended development
(N + 3) increased the density of the white painted figures, enabling them
to print as Zones VII and VIII and the tiny white areas around the
window panes as Zone IX.

f/11. The difference between Zone III and Zone VII is, therefore, only *three* stops, instead of the desired four. Normal development *plus one zone* (N + 1) would be indicated. If you wanted the snow to be rendered as Zone VIII (snow in shade), you'd want to extend development to normal *plus two zones* (N + 2) to bring the high values up to where they belong. Otherwise, your print would seem gray and flat.

In practice, the brightness-range method is very convenient for determining exposure if you're using sheet film and can develop single sheets according to whether you want to expand the brightness range (N plus) or compress it (N minus). Advanced photographers who work with roll film and who can afford to own extra camera bodies or extra roll-film backs, often load one camera or one back with film to be developed normally, reserving and marking another body or back for either minus or plus development. You'll find much more about zone-system development in Chapter Six.

problems with exposure

A sensitive and accurate exposure meter is indispensable for making fine-quality photographs under varied lighting conditions. But the meter won't solve all of your problems. Your meter may not be entirely accurate; it may read consistently high or low. If the shutter speeds of your camera are slightly inaccurate in the same direction, you might find that your personal ASA rating for a given film is different from the rating indicated by the film manufacturer. Slight differences in processing technique may also affect the way you rate your film. If you have doubts about the calibration of your equipment or the quality of your results, ask your instructor or someone with a densitometer or an electronic shutter speed tester to examine your negatives and perhaps to test your camera.

Reciprocity departure is another problem that can surprise you by causing severe underexposure at exposure durations of one second or longer. A general rule is to open up one full stop at one

second (or expose for two seconds), open up two stops at ten seconds (or expose for 50 seconds) and open up three stops at an exposure of one minute (or increase the exposure to 12 minutes), but you should verify this procedure with information published by the film manufacturer.

Don't be lazy about taking notes and keeping records of your exposure settings, especially in unusual situations. There's nothing wrong with making a mistake the first time, but keeping careful records will save you the embarrassment and frustration of repeating errors. You'll soon learn to estimate the proper exposure in many situations, verifying it with your meter. And you'll learn to compensate by exposure or development for unusual lighting conditions.

The only way to become a skilled photographer is to make lots of photographs. Be prepared to use plenty of film, but expose it systematically. Follow careful meter readings or printed exposure guides, but keep accurate records of every frame you expose. When the film is developed, compare your negatives with the exposure data. Then you won't repeat your mistakes.

You'll be wise to use a single kind of film most of the time and to standardize on processing. To learn the most about what your camera can do, don't limit your photographic activities to average scenes on sunny days. Look for chances to make pictures indoors, in bad weather, and at those times when you are under pressure to get a picture. This additional experience will make you a much better photographer.

One should challenge accepted thinking, particularly one's own. . . .

Edward Weston

I believe in making the best pictures you can, even if nobody likes them. . . .

David Vestal

the negative

Film that has been exposed in the camera contains an invisible latent image made up of silver particles that have been changed by light. These exposed silver particles suspended in the film's emulsion layer turn dark during development and form a visible negative image. Light parts of the subject reflect more light onto the film, so those areas of the negative corresponding to the lighter values in the subject are filled with more opaque silver particles than the shadow areas of the negative that correspond to the darker values in the subject. The shadow areas remain more nearly transparent. The amount of silver deposited in a given area of the negative, then, determines the density, or opacity, of that portion of the negative image. A negative image is, therefore, reversed in tone: the dark areas of the original subject are light (more transparent) on the negative and the light areas of the subject appear darker (more opaque) on the negative.

After film has been developed, the silver grains that were not used to form the negative image are still sensitive to light. An acid-hardening fixing bath (hypo) is used to dissolve the unexposed silver, making the film safe to examine by ordinary light and more resistant to physical damage.

Although not absolutely necessary, an acetic acid stop bath or a water rinse is generally used between developer and fixer to stop development quickly and evenly and to make the fixer last longer.

Following the fixer, a bath in running water washes away chemicals remaining in the emulsion, so that the negative does not become stained or faded.

Most films must be handled in total darkness until after they have been through the developer and fixer. Processing may be carried out in ordinary room light if the film has first been loaded into a light-tight developing tank. The tank must be loaded in a completely dark room unless a changing bag or a special "daylight loading" tank is used.

Carelessness has no place in the darkroom. If you don't accurately control the temperature of the solutions and the length of time the film is in each solution, you can't come out consistently

There is a painful lapse [of time] between the . . . making of a photograph and looking at it. The proof of that is that every photographer wants to rush right into the darkroom and see what he has done.

Walker Evans

film development

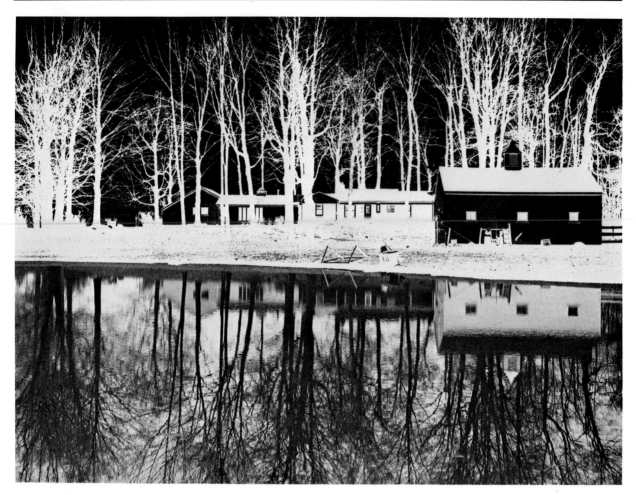

KEVIN MILLER *Lakeshore*
Both negative and positive images were cleverly juxtaposed in a single enlargement. The original negative was printed and then a film positive was printed on the same sheet of paper. An opaque paper mask was cut carefully to parallel the shoreline.

with good negatives. Nearly everyone now develops roll film in a tank, and many photographers prefer to develop sheet films in a tank, also, because tray processing is messy and hard to control and is more likely to result in scratches on the film. Most roll-film developing tanks are light-tight and have a hole in the cover through which solutions are poured in and out. Always follow the film manufacturer's instructions about development time and temperature, unless you're quite sure of your reasons for doing otherwise.

developing roll film

It's easy to develop roll film, either black and white or color. The hardest part is getting the film properly onto the metal or plastic reel that fits into the developing tank; but after a bit of practice, you'll feel confident of your skill. The following outline is presented as a sort of recipe to help guide you the first time or two through the black and white developing process. Because each color process is somewhat different from each of the others, it's

important to follow the manufacturer's instructions explicitly. You'll have few problems if you're careful. I suggest that you develop black and white film before you attempt color and that you go over the following steps "dry" several times until you feel fully acquainted with the procedure.

PROCEDURE FOR DEVELOPING BLACK AND WHITE ROLL FILM

1. *Have all chemicals and equipment ready for use*
You'll need all of the following:

Darkroom or changing bag

Darkroom with running water, or changing bag and kitchen or bathroom sink
Developing tank with reel and cover (a cap is required for some tanks and an agitating rod for others)
*Film loading guide (an aid in loading stainless steel reels)
Accurate photographic thermometer
Timer with sweep second hand
Graduated beaker, at least 16 ounces (0.5 liter)
*Deep tray or dishpan (for water bath if needed; keep solutions at the same temperature)
Funnel
*Rapid film washer
Scissors
Bottle opener or cassette opener (required for 35mm film)
Film clips or spring-type clothes pins
Drying line
Dry, clean towels
*Plastic apron (otherwise, wear old clothes)
Developer stock solution
*Stop bath concentrate (conserves fixer)
Fixer
*Washing agent (shortens washing time)
*Wetting agent (helps prevent water spots on negatives)
*Sponge or cotton balls (helps prevent spots on negatives)
Negative filing envelopes or transparent proof-file pages

*Items are optional, but recommended.

Sink with hot and cold mixing faucet

Plastic tank, reel, lid, agitator rod
or
Stainless steel tank, reel(s), lid, cap, lifting rod, loading guide

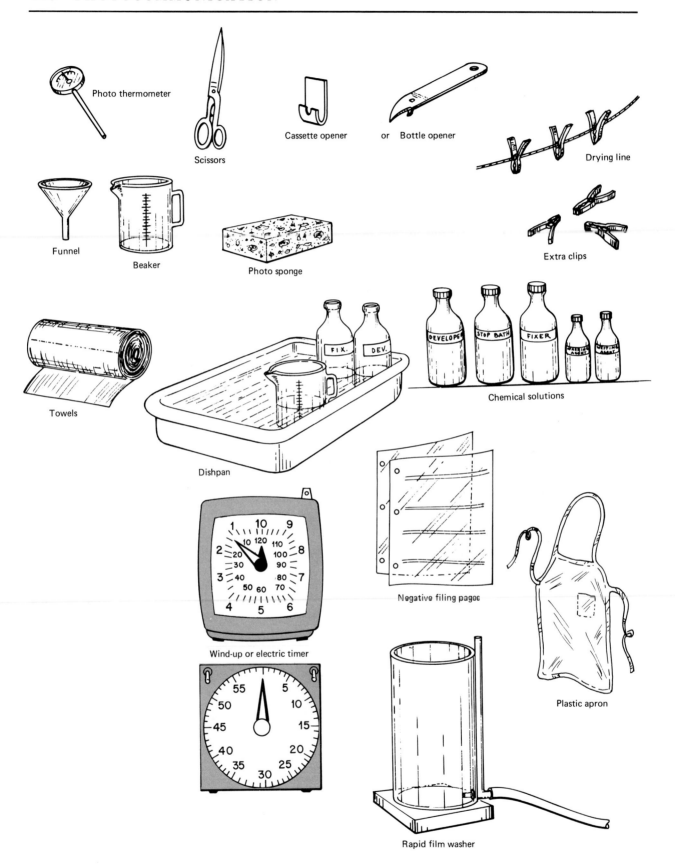

Photo thermometer

Scissors

Cassette opener or Bottle opener

Drying line

Funnel

Beaker

Photo sponge

Extra clips

Towels

Dishpan

Chemical solutions

Negative filing pages

Wind-up or electric timer

Plastic apron

Rapid film washer

You have to keep your wits about you, especially when working in the dark. That sinking, panicky feeling when you can't find the developing tank cover in the dark is unlikely to occur if you take the trouble to familiarize yourself with the entire processing procedure ahead of time and to lay everything out in advance where you can find it by feel.

Maintaining proper temperature is a major problem. Turn on the water and let it run into a beaker at a moderate rate until the temperature stabilizes. Adjust the hot and cold valves until the water is running at a steady 68°F (20°C). Keep the water running throughout the process if you can, but check it perodically, because other demands on the water supply may cause the pressure and temperature to change. Be sure to use a thermometer that has been tested for accuracy; even a degree or two of difference in the temperature of the developer can have significant effect on the quality of your negatives.

In hot weather if your tap water won't cool to 68° F you can use a somewhat higher temperature, if you compensate by shortening the development time according to the film manufacturer's instructions. All of the processing solutions should be within a degree or two of one another. The ideal temperature is 68°F, (20°C) and even in hot weather you can generally maintain that temperature by running water into a deep tray or plastic dishpan, allowing the water to circulate around the tank and solution bottles. If your cold water isn't cold enough, you can immerse a plastic bag full of ice cubes into the water, as needed, to keep the temperature down where it belongs. Don't put ice cubes directly into any of the solutions.

2. *Pour the developer into the tank*

For the same reason that you should stick with one type of film, I suggest that you start out with a standard developer formula and work with it until you're quite certain that you need to experiment with another formula. For convenience and economy, and especially to reduce the possibility of contamination, I recommend that you try a basic "one-shot" developer, such as Kodak HC-110 or D-76, that you can afford to dilute for use and then throw

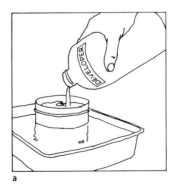

a

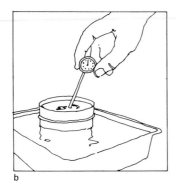

b

away. For either of these developers you mix a stock solution for storage from either concentrated liquid or powder. This stock solution is then usually diluted still further with water immediately before use, according to instructions on the film data sheet. For example, HC-110 stock solution is usually diluted 1:7 (100 ml of developer stock solution is added to 700 ml of water to make 800 ml of working solution). A common dilution for D-76 is 1:1.

Mix the stock solution with water of the appropriate temperature, and then verify the temperature before pouring it into the tank. Pour enough developer working solution into the tank to cover the reel(s), and then put the thermometer into the tank and double check the temperature. Although developing tanks are designed to be loaded dry and to have the developer poured in afterward with the lights on, you're more apt to avoid air bubbles and uneven development by pouring the developer in first, then loading the reel with film, and inserting the loaded reel into the tank in the dark—so that procedure is recommended here.

3. *Set the timer for recommended time*

Check the time-temperature-developer chart on the film data sheet. Beginning on page 128 we'll discuss varying the time for minus or plus development.

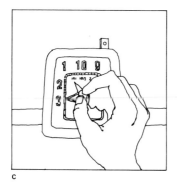

c

4. *Open the film roll or magazine* (in total darkness)

Roll Film: Break the seal with your thumbnail and separate the film from its backing paper. Let the paper hang down

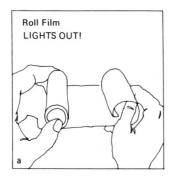

Roll Film
LIGHTS OUT!

a

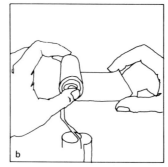

b

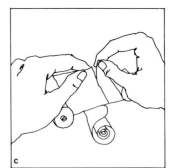

c

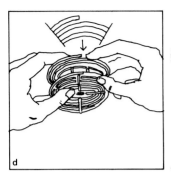
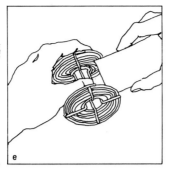
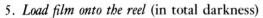

while the film rolls itself up in your hand. Handle the film by the edges only, except at the very end, when you have to tear off the tape. (If you tear the tape rapidly, you may see a flash of light—a harmless effect caused by static electricity).

35mm film: Unless you're using a reusable film magazine you have to pry off the flat end of the metal film magazine with a special opener or an ordinary bottle cap lifter. Pull out the plastic spool with the film wound around it. Cut the narrow leader end of the film off squarely.

Instamatic film, 126 and 110: Break open the cassette either in your hand, with a pair of pliers or with a cassette opener. Remove the spool of film and separate the film from its paper backing.

5. *Load film onto the reel* (in total darkness)

Be sure the reel is dry and held correctly. The emulsion side (dullest appearing and lighter colored—although you won't be able to see this in the dark), should be facing the center of the reel. You can tell how it should go in the dark because roll film naturally curls toward the emulsion side. Center the end of the film in the clip or slot at the hub of the reel; then rotate the reel, keeping the film curved slightly downward as it feeds onto the reel. With practice, you can feel if the film buckles and misses a turn. When this happens, go back and rewind this portion until it's going straight again. The film must not touch itself anywhere or undeveloped spots will result. Practice loading with a discarded film

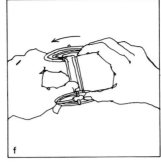

35 mm
LIGHTS OUT!

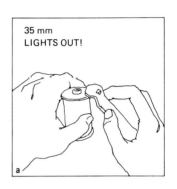

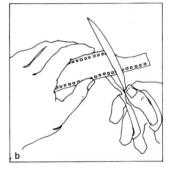

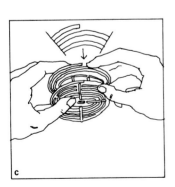
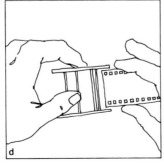
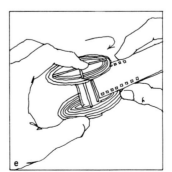
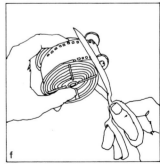

a

b

LIGHTS ON

c

d

until you can do it perfectly at least *fifty* times in the dark. Try not to touch the surface of the film or scratch it with your fingernails. Although plastic developing reels are easier for the beginner to load, they have several disadvantages: they require more solution per roll, many types limit you to developing only one roll at a time, they have to be absolutely bone dry or the film will stick during loading, they are more likely to harbor chemical residues, and they are subject to breakage.

6. *Place the loaded reel into the tank* (in total darkness)
Start the timer simultaneously
Bang the reel(s) against the bottom of the tank a couple of times to dislodge any air bubbles that may have formed on the film; then put the cover on the tank. Turn on the room lights now, so you can see what you're doing for the rest of the process.

7. *Agitate*
Gently turn the tank over and back several times during the first 15 seconds of development and then once or twice every 30 seconds thereafter, until the timer rings. DON'T FORGET: Tanks without a tight-fitting cover should be agitated with a circular motion. Don't agitate too vigorously or too frequently. Keep the tank in the sink or in the water bath between agitation so the temperature stays constant. Insufficient agitation may give you flat, mottled, unevenly developed negatives. Violent or too frequent agitation causes overdevelopment and possible density streaks.

8. *Check the developer temperature*
Be sure the temperature of the water bath hasn't drifted from where it should be. Don't hold the tank in your hand unnecessarily, or your body heat will raise the temperature of the developer.

9. *Prepare the stop bath or rinse*
Verify the water temperature to be sure it's no more than a degree or two away from the developer temperature. Many

photographers simply run tap water into the tank for a rinse. If you plan to use a stop bath, dilute it according to the manufacturer's instructions, usually the equivalent of about 30 ml stock solution per liter of working solution.

10. *Pour out the developer*

Anticipate the ringing of the timer so you can empty the developer from the tank as soon as the time is up. Diluted and used developer should be poured right into the sink drain and discarded. Although some working solutions are good for several rolls of film, the possibility of contamination and early exhaustion makes it penny wise and pound foolish to try to reuse developer. Although most developers are good for several rolls of film if used within a few weeks after mixing, and replenisher solutions are available to prolong the life of the developer for photographers who process film every day, many photographers prefer to use fresh developer for each roll, discarding the solution after use. Developer will lose its strength if kept for more than a few months or reused without adding replenisher.

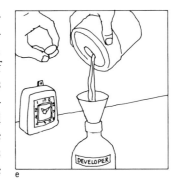
e

11. *Pour stop bath or rinse water into the tank*

The temperature of the stop bath and the developer should not differ more than one or two degrees. Hold the tank at an angle so the air escapes.

12. *Agitate the tank for about a minute*

13. *Pour out the stop or rinse bath*
Don't save this solution.

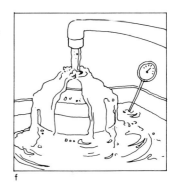
f

14. *Pour fixer into the tank*

(Dilute the fixer according to instructions if it is a concentrated or "rapid" type.) The temperature of the fixer should be very close to that of the developer and rinse or stop bath. Tip the tank so the air can escape while you're pouring the solution into the tank. Unless the instructions indicate a shorter time, set the timer for about ten minutes; set it longer if the fixer is not fresh.

a

b

c

d

15. *Agitate occasionally*

It's usually safe to inspect the film after about two or three minutes, but be careful not to splash fixer around—it dries to a messy white powder and contaminates everything it touches! Note how long it takes for all milkiness to disappear from the portion of the film at the outside end of the reel. Allow twice this time for total fixing.

e

16. *Pour out the fixer*

The same fixer can be reused for as many as twenty rolls per liter, so store it in a bottle until it begins to take longer than 5 or 6 minutes for the milky-white look to disappear from the film.

17. *Rinse the film in running water*

You can run the water directly into the tank, but check the temperature again to be sure it's close to that of the processing solutions. Leave the film on the developing reel and let the water circulate around it briefly if a washing agent is to be used. Otherwise, the film should wash 20 to 30 minutes (see step 19), with occasional dumping of the tank to ensure removal of all the fixer.

f

18. *Soak the film in a washing agent* (optional)

This solution will reduce washing time, conserve water, and may increase the permanence of your negatives. A one-minute bath in the washing agent with occasional agitation usually is sufficient.

a

19. *Wash the film in running water*

Five minutes is long enough if a washing agent has been used; 20 to 30 minutes is required otherwise, unless a special rapid film washer is used (see step 17).

20. *Add a wetting agent*

Leave the film in the washing tank and add a few drops of a wetting agent, such as Kodak Photo-Flo, to help prevent water spots from forming on the film during drying. If you have trouble pouring just a few drops, try using an eyedropper. Too much wetting agent may cause oily streaks on the negatives.

b

21. *Hang the film to dry*

Dust is your enemy. If your darkroom isn't air conditioned, hang the film in the most dust-free place you can find; however, be sure it won't touch a wall or other rolls of film. If you don't have steel-jawed film clips, plastic spring clothespins are a good substitute. Put one clip at the bottom of each roll to keep the film hanging straight.

22. *Remove surface particles* (optional)

Examine the film carefully when you hang it up. If little pieces of dirt are sticking to the surface, gently swab them away with a cotton ball moistened in wetting agent or wipe it gently *once* with an immaculately clean sponge moistened in wetting agent or with a rubber squeegee blade. Unless you're careful, however, this procedure can do more harm than good by causing scratches.

c

23. *Place dry film in filing envelopes*

Your film should dry thoroughly in an hour or two, depending on the humidity. As soon as they're thoroughly dry, cut the negatives into strips (35mm into strips of five or six, 120 into strips of two or three) and slip them into negative envelopes or filing pages to protect them from scratches, dust, and fingerprints.

d

developing sheet film

Sheet films are developed according to the same general procedure outlined for roll films, except for the way the film itself is handled. When only a few sheets of film are to be processed, the tray method is expedient and offers excellent control of agitation and individualized development time. Some photographers are able to shuffle as many as a dozen sheets of film simultaneously in a tray—but the risk is great of scratching and gouging the soft emulsion of one sheet with a corner of another. Stainless steel developing hangers are frequently used by professional photographers, but with these hangers you have to agitate very gently by lifting the bunch of hangers and draining from alternate corners. Too vigorous agitation forces developer through the holes in the hangers, leaving streaks visible in the negatives and, subsequently, in the prints.

Sheet films can be developed either in a tank or in a tray, but great care must be taken to avoid damage to the emulsion while it is wet and soft.

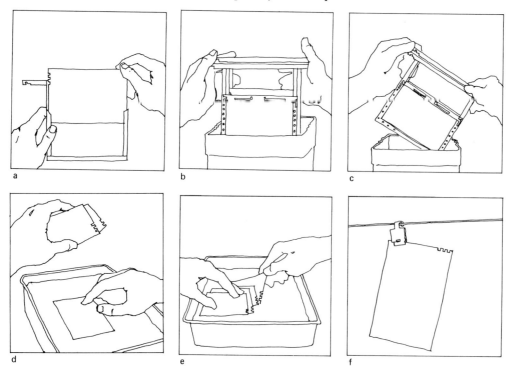

a b c

d e f

some hints for better film processing

1. Use clean water for mixing chemicals. City tap water is usually all right, but it should be filtered if it contains visible sediment. Well water often contains calcium, iron, and other impurities that cause spots and streaks on negatives. Wiping the film when it's hung to dry will help if you have these problems, as will mixing your final wetting agent bath with distilled water. In fact, if you have a source of low-cost distilled water, such as a dehumidifier, you might mix all of your chemicals with the purer stuff, using tap water only for the running-water washes.

2. Mix developer gently. Stir it according to directions and mix it at the proper temperature. Never shake the bottle vigorously or stir the solution violently because oxygen in the air bubbles that are formed will partially reduce the strength of the solution.

3. Label all chemical storage containers clearly. When pouring developer or fixer back into storage bottles, be sure you pour into the proper bottle. Either solution should be thrown out if any of the other is mixed with it. Clean glass bottles and most plastic containers are safe for photographic solutions, but developer should be stored in a dark brown or opaque container to protect it from light. Never reuse a household bleach bottle for developer.

4. Never touch the surface of film with your fingers or allow it to rub across a table top or along the bottom of a sink. The emulsion side is especially soft when wet, and it can be easily and permanently scratched.

5. Rinse everything every time, especially your hands. Make a habit of rinsing utensils whenever they are emptied, and rinse your hands every time you get any kind of solution on them. If you always rinse your hands in water before touching the towel, the towel will stay clean and prevent you from contaminating anything. Spilled chemicals may look like water when they're wet, but most of them leave a terrible mess when they dry. Sponge up any spills immediately and rinse out and clean up everything when you've finished working in the darkroom.

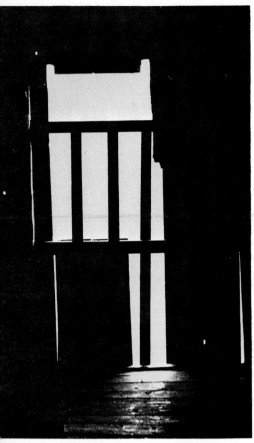

RENÉ POCH *Abandoned Barn*
(*Contrast.*) The visual impact of
this photograph depends on high
image contrast. High-contrast
treatment emphasizes the forms
themselves, without distraction
from any background texture or
additional detail.

controlling contrast through development

The old photographers' axiom that you should expose for the shadows and develop for the highlights was mentioned earlier. Half of the zone system is based on placing readings of the lower values in the scene in the appropriate zones (I through IV) by adjusting the exposure of the film. Now, in developing the negatives, we have a chance to expand or compress the placement of the higher values (Zones VI through IX) by increasing or decreasing that time of development. Obviously, you can't vary the high-value density of each separate negative on the same 35mm roll. The development control part of the zone system is ideal for black and white sheet film and for black and white roll film when the entire roll has been exposed with special development in mind. This process does not apply to color negatives or to color transparencies, because when you radically alter the time of the first developer you lose the ability to control color balance within normal tolerances. All the "rules" can be ignored, however, when you're experimenting with abstract and abnormal effects in color—a new frontier!

As exposure is placed on the proper low-value zone by adjusting f/stops—one stop adjustment equals one zone—so development time can be adjusted by increments of one zone in the higher values. If "normal" development, as recommended by the manufacturer and confirmed by your own tests, is represented by the letter N, then normal development plus one zone would be $N+1$; normal plus two zones would be $N+2$; and accordingly, normal minus one zone would be $N-1$, and so on. Table 6-1 gives approximate development factors as a basis for trial.

One problem with the zone system is that when you manipulate the developing time of black and white film to expand or compress the contrast range of the negatives, you also change the effective ASA rating of the film. If you don't compensate for this shift in ASA when you intend to give minus development, your negatives may not have sufficient shadow density (you may not be able to separate Zones I, II, and III). On the other hand, giving N-plus

Table 6-1. *Development Factors*

	Development Desired		Factor
To expand gray	$N+1$	Multiply	$N \times 1.4$
scale (increase	$N+2$		$N \times 2.2$
contrast)	$N+3$		$N \times 3.3$
To compress gray	$N-1$		$N \times 0.8$
scale (decrease	$N-2$		$N \times 0.65$
contrast)	$N-3$		$N \times 0.5$

Note: Sometimes a weaker developer dilution is required for $N-$ development to keep the development time within practical limits (see Table 6.2) or a one-minute water presoak may be used. Increase the developing time by one-half minute if a presoak is used. It takes the developer longer to replace water in the emulsion than to soak into dry emulsion.

development at normal ASA may result in unneeded density and excessive grain.

Lacking a densitometer, you may not be able to make precise tests of effective film speed. But you can and should make practical tests to verify both the effective ASA rating and development time for each of the various degrees of gray scale compression and expansion with which you choose to work. The accuracy of your camera shutter and exposure meter will affect these variables, as will your choice of film type, developer, developer dilution and temperature, and your method of agitation.

To get started, you can use the effective ASA ratings and development times indicated in Table 6-2. If you find that your experi-

DENNIS GRIFFIN *Hadley Hall*
An exposure of five minutes at f/16 permitted the lights of moving cars to trace their patterns without being overexposed. Notice that the nonmoving street lights have built up so much density on the negative that star patterns (halation) have been formed. *N*-2 development reduced the overall contrast.

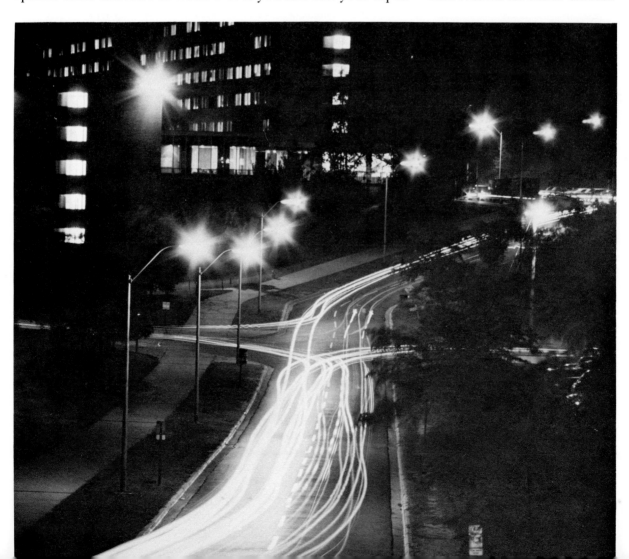

Table 6-2. *Suggested ASA Ratings and Developing Times in Minutes for Kodak Roll Films*

Developer: HC-110 Stock Solution Diluted 1:7 (Dilution "B") at 68° F (20° C)*

	Panatomic-X	ASA	Plus-X	ASA	Tri-X	ASA
Normal	4¾**	32	5	125	7½	320/400
N + 1	6	40	7	160	10½	400/500
N + 2	9¼	50	11	200	16½	500/650
N + 3	14	64	16½	250	Not Recommended	

Developer: HC-110 Stock Solution Diluted 1:15 at 68° F (20° C)*

	Panatomic-X	ASA	Plus-X	ASA	Tri-X	ASA
Normal	6	32	8	125	10	320/400
N − 1	5¼**	25	6½	100	8	250/320
N − 2	4½**	16	5	64	6½	200/250
N − 3	3½**	10	4½**	40	5	160/200

* First, dilute 16 ounces (473 milliliters) HC-110 concentrate in one half-gallon (2.0 liters) of water to make a stock solution; then, for use, dilute the stock solution further, as indicated.
**Time increased one-half minute to compensate for one minute presoak in water (recommended for development times of fewer than five minutes). *Maintain temperature accurately, using water bath around tank if necessary. Agitate gently and consistently every 30 seconds.*

ments verify mine, fine! Otherwise, don't hesitate to be independent and work up your own table of film speeds and developing times that are appropriate for your equipment and working methods.

Incidentally, giving *N*-plus development and compensating by exposing at a slightly higher ASA rating isn't exactly the same thing as "pushing" the film (see pages 186–187 for more on getting the maximum film speed possible under less-than-ideal exposure conditions).

evaluating your negatives

If you look at a group of negatives against the light, you'll probably notice that they differ from one another in several ways.

First, they will probably vary in overall density. Some may be nearly transparent all over because there was comparatively little silver deposited during exposure and development. Such a negative, low in density, transmitting a lot of light, is called a *thin* negative. Other negatives, appearing darker or denser because more silver was deposited, transmit less light and are called *dense* negatives. A negative of very high density transmits very little light and may be said to be almost opaque.

Besides differing in overall density, negatives vary from one to another in the relationship of dense and thin areas within each image. The highlights (high values), or brightest parts, of each

A *thin* negative appears to be relatively transparent overall. Especially if the result of underexposure, the negative may not have enough density and detail in the shadow areas to properly reproduce the darker values in the print.

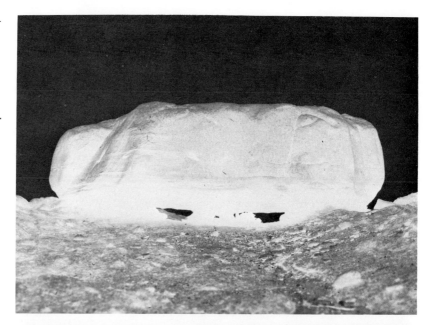

A *dense* negative is relatively opaque. Although plenty of detail will probably be visible in the shadow areas, there may not be enough separation of bright areas to ensure visible differences between high values in the print.

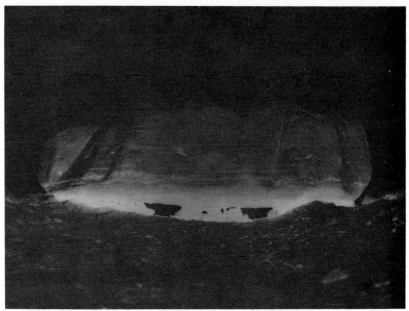

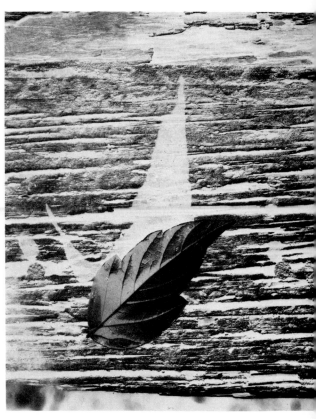

A *flat* negative may not necessarily be thin, but it lacks contrast. The density range of a flat negative is limited to relatively few adjacent values on a portion of the gray scale and may require expansion of the tonal range in printing.

A *contrasty* negative shows a wide range of densities. Although adequate shadow and highlight detail is visible in the negative, some dodging and burning-in may be required to retain separation within the highest and lowest values of the print.

original scene appear darkest in the negative, and the shadows, or darkest areas (low values), of the subject appear thinner or more transparent. The relative differences in density between the darkest and lightest important values within a single image is referred to as contrast. In a *contrasty* negative there is a great deal of difference in density between the high values (highlights) and the low values (shadows.) In a *flat* negative there may be very little density difference between high and low values. You must learn to judge the density and contrast of all kinds of negatives before you can expect to make good prints from them.

the ideal negative

The best prints are made from negatives that are neither too thin nor too dense; neither too contrasty nor too flat; neither smudged, nor stained, nor scratched. Although you can burn and dodge and work minor miracles in the darkroom, the best prints

will be made from so-called *normal* negatives. You can be sure that most of your negatives will print well if you're always careful to give correct exposure in the camera, use fresh chemicals to process your film, and develop for the optimum time and at the proper temperature.

Dense negatives are usually the result of overexposure. If an overexposed film is also overdeveloped—that is, developed too long or at too high a temperature or with too much agitation—the resulting negative may be so dense in the highlight areas that it cannot be printed. What happens is that Zones VII, VIII, and IX tend to merge, making it impossible to distinguish in the print subtle differences between such high values as white clothing, pale flesh tones, and blonde hair. Such a negative is said to be *blocked up*. There is a direct relationship between density and grain. Overexposure and overdevelopment combined can give skies and skin tones the texture of a concrete sidewalk. Unless you want this effect, don't let excessive grain occur as a result of negligence.

Thin, or extremely transparent, negatives may be caused by underexposure or by underdevelopment, or both. Underdevelopment is a result of not leaving the film in the developer for a long enough time, not agitating sufficiently, or of using developer that is old and weak, contaminated with fixer or stop bath, or too cold. Thin negatives usually fail to record some of the lowest values (Zones I, II, and III) at all, leaving clear film base where there should have been shadow detail. These areas without density print either totally black or lifelessly gray. Very thin negatives are usually *flat* or low in contrast, also.

Negative contrast depends mostly on the relative brightness values of important parts of the subject photographed, although contrast is affected, and controlled to some degree, by development. If your negatives always have too much contrast, you can try shortening your normal developing time or try diluting the developer with an equal amount of water. Correctly exposed, but consistently flat, negatives are usually the result of underdevelopment. Be sure that your agitation procedure is standardized: over and back gently for no more than five seconds every thirty

Either insufficient or excessive agitation during development can result in streaks like these or in a mottled unevenness in the negatives. Agitation problems are most apparent in smooth areas of even middle tones such as skin and sky.

seconds. Overagitation increases contrast unevenly; underagitation decreases contrast, leaving a mottled, uneven appearance.

determining exposure index

Are your negatives *consistently* too thin or too dense? If you've been controlling everything—previsualizing zones appropriately, making accurate exposure meter readings, compensating ASA for minus or plus development, developing in the proper solution at the recommended time, temperature, and agitation—and yet your negatives seem always to lack shadow detail (suggesting underexposure) or always to be excessively dense (implying overexposure), you may need to determine your own "personal ASA" exposure index. Although the manufacturer's ratings are scientifically determined and they are usually quite accurate, all kinds of problems may affect your own personal film speed rating for a given film. The shutter in your camera may be consistently fast or slow; your meter may read consistently high or low; or your film-processing procedure may produce differences from the norm established in the manufacturer's film tests. Occasionally, such errors are in the same direction and the cumulative effect is enough to prevent optimum negative quality.

In black and white negatives, Zone I density should be barely distinguishable from the clear film (film-base density plus inherent fog) between frames and around the edges of the negative. By making the following test you can determine which ASA rating

yields the proper Zone I density, hence deriving a "working" ASA for that particular film and processing combination with your own equipment and method of working.

The film-speed test involves shooting a standard 18 per cent gray card at various exposures:

1. Place the gray card in even, but not intense light, preferably outdoors in deep shade or on an overcast day. Adjust the angle of the card so there is no glare.

2. Set your camera on a tripod and focus the lens at infinity (you want the gray card to be out of focus—you're testing for negative density, not for detail). Move the camera close enough to fill the negative completely with the image of the gray card. Remember that your camera probably includes a little more than the viewfinder shows. Move in a little closer to allow for this. Be sure there are neither shadows nor glare on the gray card.

3. Read the gray card directly with your reflected-light exposure meter. This reading will give you the exposure for Zone V. Be sure to hold the meter (or your camera) close enough to the card so that you're not reading any background, but not so close that you read your own shadow.

4. Adjust your exposure reading from Zone V to Zone I. Do this simply by stopping down (closing) the lens four f/stops. Count zones to yourself as you stop down. For example:

Meter reading (Zone V) 1/250 @ f/4
Minus one stop (Zone IV) 1/250 @ f/5.6
Minus two stops (Zone III) 1/250 @ f/8
Minus three stops (Zone II) 1/250 @ f/11
Minus four stops (Zone I) 1/250 @ f/16

Of course you can use any combination of shutter speed and lens opening that gives an equivalent exposure, but avoid using the fastest speeds (1/1,000 and 1/500) because they tend not to be as accurate as the other speeds. If you can't stop down far enough,

place the gray card in a darker location and make a new Zone V reading.

5. Make an exposure at the manufacturer's ASA rating for Zone I placement (1/250 @ f/16 in the preceding example); then repeat the test at 25 per cent, 50 per cent, 75 per cent, 100 per cent (a duplicate of your first exposure), 150 per cent, and finally 200 per cent of the film manufacturer's recommended ASA rating. For example, in testing a film rated by the manufacturer at ASA 400, you would set your exposure meter at ASA 100, 200, 300, 400, 600, and 800. A test of film rated at ASA 125 would include meter settings of ASA 32, 64, 100, 125, 200, and 250. ASA 32 film would be tested at ASA 8, 16, 25, 32, 50, and 64. For each different ASA setting, calculate the exposure for Zone I placement. Keep very careful records of the sequence of frames. If you have some frames left over on the roll after finishing your test exposures, either repeat the tests once more or make pictures to finish up the roll. This is so that the developer will have a normal amount of silver to work on and not skew the results of your tests.

6. After normal processing, read each of the test negatives with a densitometer. In most cases, the Zone I negative closest to a densitometer reading of 0.10 above film-base density plus inherent fog will have been exposed at the correct ASA rating for that type of film and your particular combination of camera, exposure meter, and processing procedure. For this test to have any meaning, however, you have to keep very careful records. You also have to standardize your developing procedure.

If a densitometer isn't available, you can make a very practical test that will indicate your working ASA rating. Photograph a subject containing large, very dark areas with detail that would fall into Zone II. Dark, textured tree bark would be a good subject, or rough black soil or stone. Shoot at the various ASA ratings indicated for the densitometer test, deliberately placing the dark, textured surface on Zone II (three stops less than the Zone V meter reading of the dark subject). Again, keep very careful

records; after the negatives are processed, examine them through a magnifier, selecting the least-dense negative that seems to contain printable detail. The ASA rating used to expose that frame is your working ASA for that film.

negative faults

If you see negatives that have noticeable gray density extending beyond the picture area into the margins of the film, you can suspect that the film was unintentionally exposed to some light before or after exposure or during processing. Or it could have been outdated film, or film that has been stored at too-high temperature or humidity, or both. Dark streaks on negatives mean that some light probably got to the film either when it was in the camera—opening up the camera back or a light leak—or while the film was being loaded or unloaded in bright light. Color transparency films, of course, show fog and light leaks not as gray or black but as white or yellow.

Don't be alarmed if you notice a slight bluish or purplish cast to your negatives. This is the effect of antihalation dyes and is normal on many kinds of black and white film. An orange or buff appearance is to be expected of color negatives, the coloration being caused by a contrast masking layer built into the film during manufacture.

Mysterious gray blotches or "fireworks" effects on negatives may be the static electricity fog that occurs in cold weather and low humidity when roll film is advanced or rewound too rapidly or the dark slide on a sheet-film holder is withdrawn or inserted too quickly. Sometimes finger marks and scratches from careless handling of undeveloped film will show up as dark spots or lines on the finished negatives. Dark crescent-shaped marks result from pinching the film too tightly while loading the developing reel. Processing problems are usually caused by carelessness; these include agitation streaks and air bells. Most of the common negative problems that you are likely to encounter are described in Table 6-3. With care, most of them can be avoided.

Success is not permanent;
The same is also true of failure.
Author unknown

Table 6-3. *Trouble-shooting Chart for Negative Defects*

Problem	Cause	Prevention or Correction
Images pale and light (negatives very thin and transparent), but frame numbers dark and legible. Shadow areas lack detail.	Underexposure	Print on hard paper or use high-numbered filter. Shorten printing exposure. Reshoot if possible.
Images *and* frame numbers thin and weak.	Underdevelopment	Print as above. Reshoot if possible. Mix fresh developer. Verify dilution, time, and temperature. Chemically intensify negatives if reshooting is impossible.
Images very dark, dense, and grainy, but frame numbers appear normal.	Overexposure	Increase print exposure time. Reshoot, if possible.
Images quite dense and contrasty; highlight areas opaque. Frame numbers extremely dense.	Overdevelopment	Print on soft paper or use low-numbered filter. Reshoot if possible. Verify developer dilution, time, and temperature.
Film overall gray or dark streaked (fogged) outside of image area.	Film exposed to light during loading or unloading of camera or during processing or bulk loading	Load camera in shade. Check cassettes, film holders, and dark room for light leaks.
Image area overall gray or dark-streaked (fogged), but area outside and between frames is clear.	Light leak in camera—probably shutter, lens mount, or bellows	Refer to camera repairman.
Clear, or less dense, round areas with denser edges.	Air bubbles clinging to emulsion during development	Don't pour developer into tank containing dry film. Rap reel or hanger sharply when placing into tank.
Tiny clear pinhole spots.	Dust on emulsion during exposure	Blow and brush dust from inside camera and film holders before loading.
Dense streaks in even areas of image such as skies, especially near sprocket holes in 35mm film.	Excessive or too-vigorous agitation	Agitate gently and consistently.
Mottled or uneven density or streaking from densest areas.	Insufficient agitation	Agitate gently and consistently.
Milky translucency to all or portions of film.	Insufficient fixing	Return to fresh fixer; rewash.
Purplish-gray, opaque areas within image area of otherwise normal roll.	Film stuck together during processing	Next time load reel more carefully.
Purplish-gray, opaque areas along edges of film, but outside image area.	Film stuck to flanges of developing reel during processing	This is normal. Ignore it.
Slimy or crystalline scum on negatives.	Insufficient washing	Use washing agent; rewash; use fresh wetting agent.
Rounded spots or streaks dried on film (usually on base side).	Deposits left by impurities in wash water or wetting agent	Remove spots with Kodak lens cleaning fluid and cotton swab. Mix wetting agent with distilled water.
"Dirt" particles embedded in emulsion.	Impurities in wash water or wetting agent	Soak film in washing agent and re-wash. Bathe film in distilled water and wetting agent solution. Wipe film gently with clean, moist sponge or squeegee. Filter water supply if problem persists.
Emulsion blistered, frilled, or reticulated.	Extreme temperature variation during processing	Monitor temperature, especially during rinse or wash to avoid surges of hot water.
Dark, crescent-shaped marks.	Film bent or crimped during loading of reel	Handle film carefully.

Problem	Cause	Prevention or Correction
Forked, branched, or lightninglike dark lines or blotches (in cold, dry weather).	Static electricity	Advance and rewind film with slow, steady strokes. Withdraw and insert dark slides slowly.
Corners of image less dense than center (or corners rounded off entirely).	Lens not covering film size; lens shade or other attachment cutting into field of view	Use proper lens and attachments.
Dark lines (scratches) parallel with edges of roll.	Scratching before development	Check camera back, film magazines, and bulk loader for burrs or embedded particles of sand or dirt. Never cinch film (pull it tight on roll).
Light lines (scratches).	Cinching roll or other rough handling after processing	Cut roll film negatives into short strips. File all negatives in individual sleeves or envolopes.
Excessive curling or brittleness.	Too-rapid drying	Rewash and redry. Air dry without heat.
Hazy, diffused, indistinct images.	Lens or filter may be severely smudged or very dirty	Inspect and clean with lens-cleaning fluid and lens tissue.
Entire image blurred equally.	Camera movement	Hold camera steadier. Use tripod at shutter speeds slower than 1/125, whenever possible.
Moving subject blurred.	Shutter speed too slow	Use faster shutter speed; pan camera to follow subject movement.
One plane of subject in sharp focus, remainder out of focus.	Too-large lens opening or lens focused incorrectly	Focus on principal plane of subject. Stop down lens for desired depth of field.
Corners of image unsharp, especially at wide apertures.	Poor-quality camera lens; or supplementary close-up lens or extender used at too-wide aperture	Use smallest lens opening possible (e.g., f/16).
One side of image or irregular area consistently unsharp.	Lens or film pressure plate out of alignment	Refer to camera repairman.
Multiple or overlapped images.	Accidental double-exposure; camera loaded incorrectly; or film transport malfunction	Check shooting and loading procedure. If problem persists, refer to camera repairman.
Uneven spacing between frames.	Film transport malfunction	Have camera repaired.
Part of image normal; part totally unexposed or underexposed.	With flash: improper synchronization—probably either too-fast shutter speed used or flash cord plugged into wrong connector. Without flash: camera case, coat collar, strap, part of hand, etc. in front of lens	Most 35mm cameras synchronize electronic flash at 1/60 second and X setting—see your camera instruction manual. Be careful how you hold the camera.
Film completely blank (clear) except for frame numbers and edge printing.	Film not exposed. Camera probably not loaded correctly or dark slide not withdrawn	Load film carefully. Be sure sprocket holes are engaged in 35mm camera. Don't forget dark slide if used.
Film completely blank (clear) with no frame numbers or edge printing visible.	Film probably "developed" accidently in water, stop bath, or fixer	Check your procedures. Label all solution containers.
Film completely opaque with no evidence of image.	Film totally exposed to light before development	Be careful.
Film heavily fogged, but with traces of image.	Film exposed to light or radiation before or during development	Be careful.

You can't make fine-quality prints unless you have properly ex posed and developed negatives to work from. You can always make a print over again if it doesn't please you, but with negatives and color transparencies you have but a single chance. You have to do everything right the first time!

the print as a performance

The print usually is the end product of photography. The print you make is the final revelation of what you saw, thought, and felt when you were in the presence of the subject matter. Ansel Adams, a trained musician, a photographer whose awe-inspiring landscape prints are acknowledged to be among the finest in photography, has drawn from music his famous analogy that "The negative is comparable to the composer's score: the print to its performance."* It's at this final stage that you bring to bear everything you know about communication and about technique to make the print speak for you as eloquently as possible. Esthetically, printing is alchemy: chemicals are magically converted into images. Technically, however, a print is made by exposing light-sensitive paper to light passing through a negative. A corresponding positive image is formed on the paper, the image appearing upon development. To make the image permanent, the print must then be fixed, washed, and dried.

Photographers who work with view cameras that produce very large negatives often print by contact. Their prints are the same size as the negatives and they are made by sandwiching the negative between a sheet of photographic paper and a piece of glass. The great photographic artist Edward Weston worked in this way, most of his work being contact printed from 8 x 10-inch negatives. Smaller-format cameras, however, require that the negatives be enlarged. An enlarger, or projection printer, is required.

Besides the spectacular effect of making big pictures from little negatives, the enlarging process allows many controls with which you can improve on a somewhat less-than-perfect negative. With these controls you can lighten or darken areas, alter the scale of values, modify perspective, soften or strengthen lines, combine images, or print only a selected portion of a single image.

Although color printing from both color negatives and transparencies is becoming much simpler and less costly—and, hence,

> I have been asked many times, "What is a great photograph?" I can answer best by showing a great photograph, not by talking or writing about one.
> **Ansel Adams**

*Ansel Adams, *Ansel Adams Images 1923–1974* (Boston: New York Graphic Society Ltd., 1974) p. 5.

making fine prints

D. Curl *Celery*

Michael Sarnacki
Water Lilies

much more popular than formerly—the process of producing fine black and white prints for exhibition and reproduction will be emphasized here. If you master the equipment and controls required for quality black and white printing, you will certainly be able to follow the manufacturer's instructions for whatever color printing process you may choose to attempt later on.

the enlarger

The two most common types of enlargers are the condenser enlarger and the diffusion enlarger. Some enlargers are actually a combination of both types, having a relatively large diffused light

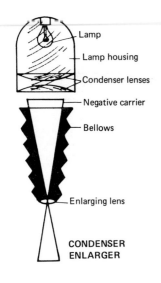

Lamp

Lamp housing

Condenser lenses

Negative carrier

Bellows

Enlarging lens

CONDENSER
ENLARGER

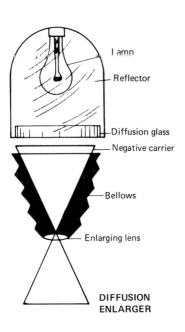

Lamp

Reflector

Diffusion glass

Negative carrier

Bellows

Enlarging lens

DIFFUSION
ENLARGER

source plus one or two condensing lenses above the negative to collimate the light. In comparing the two types of enlargers, we find that the condenser enlarger will yield prints of comparatively higher contrast than those made with a diffusion enlarger; but the condensing lenses, unfortunately, have a tendency to emphasize all the defects in the negative, such as grain, scratches, and dust. Some people claim that condenser enlargers yield sharper images, but the appearance of sharpness is only the effect of higher relative contrast. Assuming a sharp negative, the actual sharpness of the print depends on the quality of the enlarging lens and has little to do with the type of illumination. Modern color enlargers with dichroic filters are generally of the diffusion type, with the advantage that you can dial variable contrast paper filtration without the use of separate filters. Your determination of standard negative development time will depend on the kind of enlarger you use. While $N - 1$ might be appropriate development for negatives to be printed with a condenser enlarger, $N + 1$ might be the normal development for negatives to print with grade 2 paper or a number 2 filter on a diffusion enlarger. Some photographers working with a dichroic color enlarger or other diffusion-type enlarger use grade 3 paper as their standard instead of the normal grade 2.

Most enlargers are designed to accept more than one negative size. You must use a negative carrier (film holder) of the right size, and you must choose the proper enlarging lens and condenser lenses (or condenser lens setting if the condensers are adjustable) to match the negative size to be printed. If condenser lenses are used, they must be large enough to completely cover the negative area; the condenser focal length should be matched to the focal length of the enlarging lens; and the enlarging lens should be of at least the normal focal length for the negative size. If either condensers or enlarging lens fail to "cover" the negative, the edges of the enlargement will receive less exposure than the center, leaving a "hot spot" in the middle of the print and light corners. Remember that the normal focal length for 35mm negatives is 50 mm; for 6 x 6 cm, 75mm to 80mm; and for 4 x 5-inch negatives, the focal length of the enlarging lens should be at least 135mm.

the darkroom

In addition to the enlarger, you'll also need the following items:

Enlarger timer (automatic resetting type desirable)
Adjustable easel for the largest-sized prints you'll be making
*Focusing magnifier
*Filters for variable-contrast paper (not needed for regular papers)
Safelight(s) type "OC" yellowish orange
Negative brush
*Canned, compressed air
Paper cutter or scissors
Wall clock with sweep second hand
Four trays (slightly larger than the biggest print you want to make)
Graduated beaker at least 1 liter
Accurate photographic thermometer
*Print tongs
Dry, clean towels
*Plastic apron (or wear old clothes)
Print developer stock solution
Stop bath concentrate
Fixer
*Clearing agent (shortens washing time and saves water)
Sponge or squeegee
*Print washer (a tray will do if you have a tray siphon or if you dump and refill the wash water frequently)
Print dryer (drum, screen frames, blotters, towels on which to spread resin-coated (RC) prints, or clothespins to hang them from)

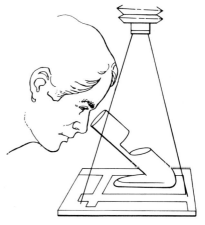

A focusing magnifier or "grain focuser" may make it easier for you to focus the image precisely on the enlarging easel. Be sure to re-check the focus before making your final print, however, because the negative may buckle slightly in the enlarger, throwing the image slightly out of focus.

types of papers

Because there are so many brands, types, and surfaces, your choice of enlarging paper will be influenced by availability and

*These items are optional, but recommended.

dictated by personal preference. A good beginning choice for prints up to 8 x 10 is a single-weight, variable-contrast paper with a smooth semimatte surface, or glossy surface paper dried semi-matte.

RC papers are a distinct advantage when time is short, although they present some limitations and problems when you're going to be printing for several hours. Because water-resistant paper shouldn't be allowed to soak for more than half an hour or so, prints on RC papers should be "batch" processed. Gather up your RC prints periodically, wash them (only four minutes is required—with no washing agent) and spread them out to dry face up on screen frames. Then you can return to the darkroom and print up another batch. RC paper is very convenient for photo class assignments because it saves so much processing time. RC paper is especially handy to have around for making contact proof sheets and for meeting deadlines. But as long as a choice of papers is available, you might prefer to print your finest-quality work at your leisure on conventional paper of your choice.

RC papers are on a relatively stiff base, but there's less danger of conventional prints being creased or cracked during processing if you use double-weight paper for prints 11 x 14 inches and larger. A smooth, semimatte surface is a popular choice for prints that are to be mounted and displayed. The blacks tend to appear disappointingly gray on very dull, matte-surfaced papers, whereas a high-gloss *ferrotyped* surface is difficult to achieve (except on certain RC papers) and the gloss tends to be annoyingly reflective. Ask your photo dealer to show you samples of enlarging papers of varied weight, surface texture, and image tone from different manufacturers. Most color papers are supplied with a glossy finish on an RC base. Matte spray is a popular alternative to high gloss for color prints that are to be displayed. Not only does the spray reduce reflections and obscure any hand spotting or retouching, but it protects the surface of the print from abrasion and soiling.

Dust is the biggest problem in the printing darkroom. If your darkroom is air conditioned so that filtered temperature- and humidity-controlled air is blown *into* the darkroom, you'll have much less trouble with dust. In any event, good housekeeping is

vital. Vacuum away the dust regularly, but do this *after* a printing session rather than immediately before, to give the dust a chance to settle elsewhere than on your negatives. Dried chemicals produce dust, so don't splash chemicals around. Mop up any spills immediately, because chemical dust leaves horrible spots on sensitized materials. For this reason it's not a bad idea either to purchase concentrated liquid chemicals or to mix from powders *outside* the darkroom. You'll probably notice the worst dust problems during dry weather when the air is heated and the humidity is unusually low.

enlarging procedure in brief

The processing of prints is not very different from the procedure for developing film. The chemical solutions may be mixed from different formulas, but they perform the same functions as they do with film. The process will be briefly outlined, and then you can go into the darkroom and follow the detailed instructions on pages 148–155.

Your first print should be a test. Cut a strip of grade 2 paper or use variable contrast paper without a filter and make a series of exposures. You'll soon learn to judge approximately what the length of exposure should be for negatives of different densities. Prints are usually made with the emulsion (light-sensitive) side of the paper facing the emulsion side of the negative, whether the negative and paper are in contact or not.

Slip the exposed paper face up in the developer and agitate it by gently rocking the tray, making sure the print stays immersed all the time. The image should begin to appear after about 15 seconds, and development should be complete in about 90 seconds with most papers. Rinse the print for a few seconds in a stop bath and then place it in the fixer and rock the tray. You can inspect the print briefly by white light after it has been in the fixer for about 30 seconds. Return the print to the fixer for a total time of about ten minutes. Agitate the tray occasionally. Don't let the prints stick together.

> I have never lost that initial thrill of watching an image surface in the developer. . . .
> *Jerry N. Uelsmann*

1

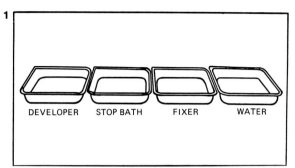

Arrange four clean trays in a row. Use trays that are slightly larger than the largest print you plan to make.

2

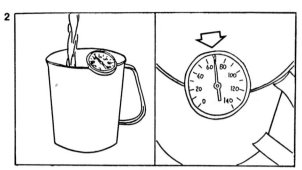

Adjust the tap water to about 68°F (20°C). In hot weather, if you cannot maintain 75°F (24°C) or below, you can use a plastic bag full of ice cubes to keep the developer temperature down.

3

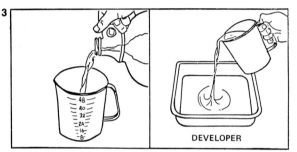

Mix print developer stock solution with approximately 68°F (20°C) water according to the manufacturer's instructions. A common dilution is one part stock solution to two parts water. Since one quart (1.1 ltr.) of working solution is enough for an 8 x 10 tray, a 1:2 dilution would call for approximately 10 1/2 ounces (315 ml) of print developer stock solution. Pour developer into the FIRST tray. Rinse the beaker with water.

4

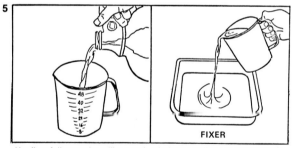

Dilute Stop Bath stock solution with water. The usual dilution is one ounce (30 ml.) to make a quart (1.1 ltr.). Pour Stop Bath into the SECOND tray. Rinse the beaker.

5

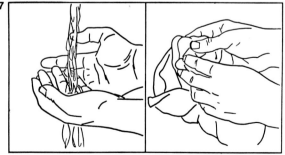

Use fixer full strength or dilute stock solution according to manufacturer's instructions. Pour fixer into the THIRD tray. Rinse the beaker.

6

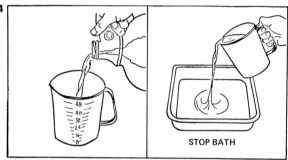

Fill the FOURTH tray about half full of water as a holding bath.

7

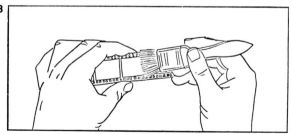

Rinse and dry your hands thoroughly.

8

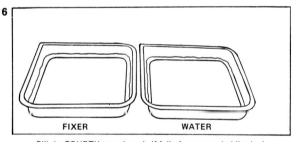

Select a negative to enlarge—hold the film by the edges and gently remove dust from both sides with a soft brush.

9

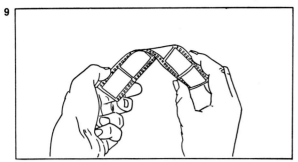

The emulsion side of the film is the *dull* side.

10

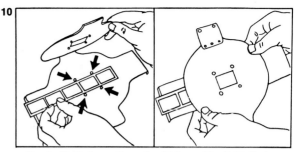

Place the film in the negative carrier with the emulsion (dull) side *down* and the negative centered between the pins—close the carrier.

11

Hold the negative carrier toward the light to see if the negative is centered. Don't move the film without opening the carrier.

12

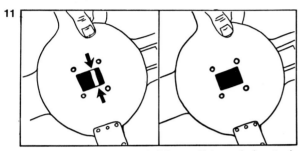

Raise the enlarger lamp housing and insert the negative carrier so the emulsion side of the film faces *down* toward the baseboard. Leave the lamp housing raised.

13

Turn on the enlarger lamp (timer switch to *focus* on many enlargers) and look for dust on the surface of the negative. Blow off dust particles with a blast of canned air or pick them off with the tip of a small watercolor brush.

14

Lower lamp housing. Turn on darkroom safelight and turn off room lights if you've not already done this.

15

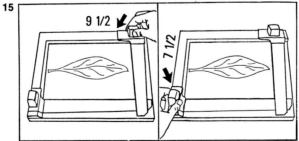

Adjust the easel to the size desired—for an 8" x 10" print with 1/4" borders, slide the side adjustment to 9 1/2" and the bottom adjustment to 7 1/2".

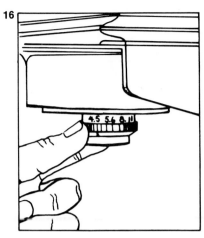

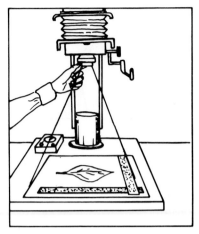

Rotate the aperture ring on the enlarger lens so that the brightest image is projected onto the easel.

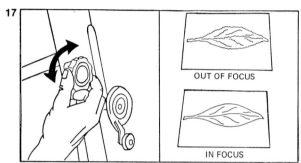

OUT OF FOCUS

IN FOCUS

Focus the image on the easel by turning the focusing knob.

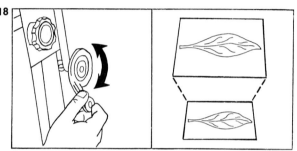

Increase or decrease the size of the image on the easel by raising or lowering the enlarger head.

Rotate the aperture ring on the enlarger lens to decrease the brightness of the projected image by two click stops (stop down to f/8 or f/11)—turn off the enlarger lamp.

Remove a sheet of photographic paper from the box—handle the paper only by the edges—REPLACE THE BOX COVER.

The *emulsion* side of paper usually is the *shiny* side—the opposite of film.

Cut the sheet of photographic paper into strips 1 to 2 inches wide—return the strips to the box—REPLACE THE BOX COVER.

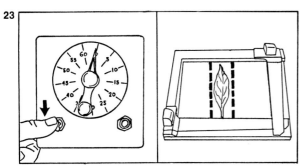

23 Turn on the enlarger lamp—find an area of important detail with high values in the projected image.

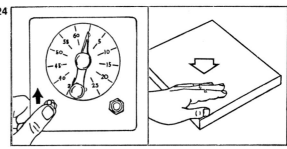

24 Turn off the enlarger lamp—remove one of the strips of photographic paper from the box—REPLACE THE BOX COVER.

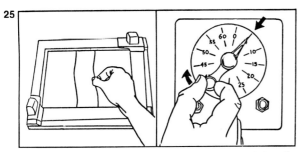

25 Place the strip with the emulsion side (shiny side) <u>up</u> on the easel where the important detail will be projected—set the pointer on timer at 5 seconds. (2 seconds for fast papers such as Kodak Polycontrast Rapid RC)

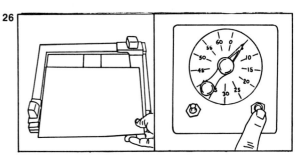

26 Cover 3/4 of the strip by holding a piece of cardboard slightly above it but not touching the paper—push and release the timer button to make a 5-second (or 2-second) exposure.

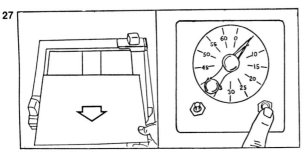

27 Move the cardboard to uncover another 1/4 of the strip of photographic paper, but don't touch the strip and make it move—push and release the timer button to make another 5-second (or 2-second) exposure.

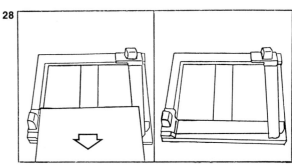

28 Continue until you have made four exposures of 5-seconds or 2-seconds each. If the first section of the strip was exposed for 5 seconds—when you exposed the second section you also exposed the first section for another 5 seconds, and so on. After developing, you will have a test strip with four exposures: 20, 15, 10, and 5 seconds. (2-second exposures will result in a test strip with exposures of 8, 6, 4 and 2 seconds.)

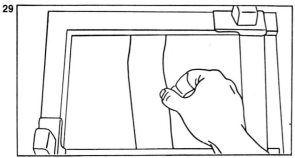

29 Remove the test strip from the easel

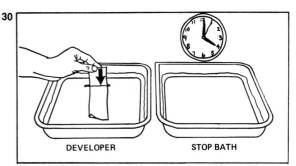

30 Slide the strip into the DEVELOPER so that the solution covers the entire strip—note your starting time.

31

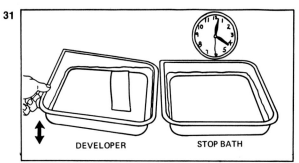

Constantly agitate the developer solution by gently rocking the tray. After 1 1/2 minutes . . .

32

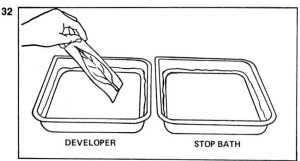

. . . lift the test strip by one corner and drain into the DEVELOPER tray for a few seconds . . .

33

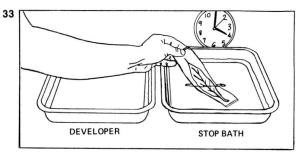

. . . then slide the test strip into the STOP BATH so that the solution covers the entire strip. Agitate. After about 10 seconds . . .

34

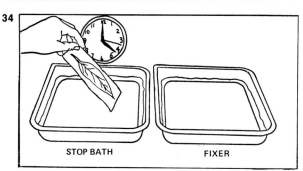

. . . lift the test strip by one corner and drain into the STOP BATH tray for a few seconds . . .

35

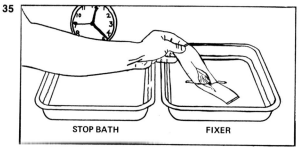

. . . then slide the test strip into the FIXER so that the solution covers the entire strip. Agitate. After about 30 seconds . . .

36

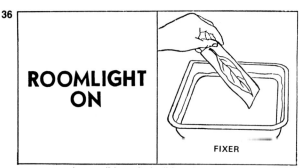

ROOMLIGHT ON

. . . turn on the room light or viewing light and examine the test strip.

37

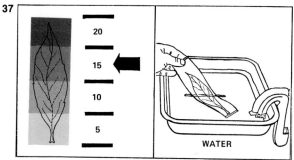

Determine the best exposure from the test strip and note the time. If the best time appears to be between two of the test sections, use an intermediate time.

38

Rinse and dry your hands thoroughly. If no section of the test strip looks right, see the following three frames . . .

39

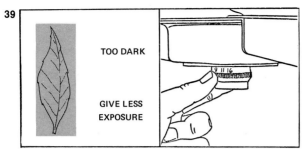

TOO DARK

GIVE LESS EXPOSURE

If the entire test strip is too *dark*, make another strip at the same times as before, but decrease the brightness of the image by one more click stop (e.g. f/11 instead of f/8).

40

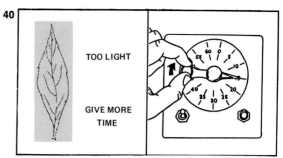

TOO LIGHT

GIVE MORE TIME

If the entire test strip is too *light*, make another strip giving twice the time for each step.

41

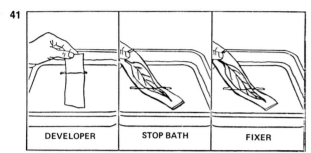

DEVELOPER STOP BATH FIXER

Develop, stop, and fix the test strip as before. Turn on the room light and examine the test strip. Rinse and dry your hands thoroughly.

42

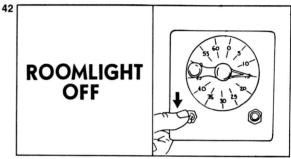

ROOMLIGHT OFF

Now make a full-sized print—turn off the room light—turn on the enlarger lamp.

43

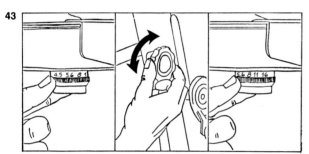

Rotate the aperture ring to project the brightest image—REFOCUS—decrease the brightness of the image by stopping down the number of click stops determined by the test strip.

44

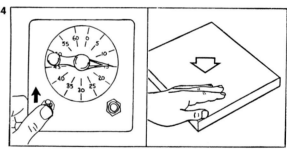

Turn off the enlarger lamp—remove a full sheet of photographic paper from the box—handle by the edges—REPLACE THE BOX COVER.

45

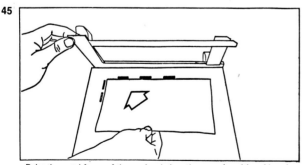

Raise the metal frame of the easel and place the paper (emulsion side up)— against the guides—lower the frame.

46

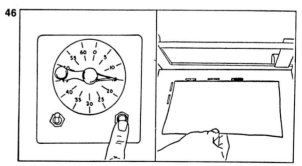

Expose the paper for the time determined by your test strip—remove the sheet from the easel.

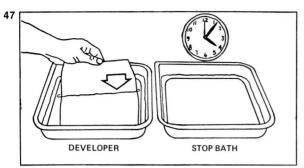

Slide the paper into the DEVELOPER so that the solution covers the entire sheet—note your starting time.

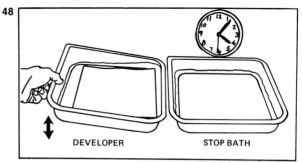

Constantly agitate the developer solution by gently rocking the tray—after 1 1/2 minutes . . .

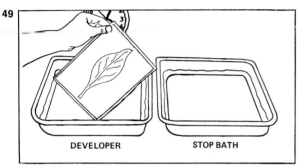

. . . lift the print by one corner and drain into the DEVELOPER tray for a few seconds . . .

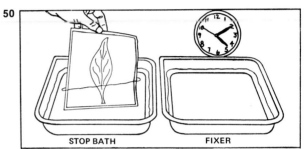

. . . then slide the print into the STOP BATH so that the solution covers the entire print. Agitate the tray. After about 10 seconds . . .

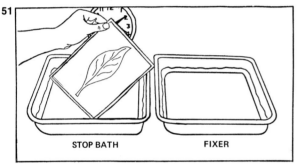

. . . lift the print by one corner and drain into the STOP BATH tray for a few seconds . . .

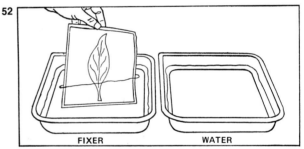

. . . then slide the print into the FIXER so that the solution covers the entire print. Agitate the tray. After about one minute inspect the print in white light.

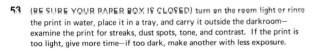
(BE SURE YOUR PAPER BOX IS CLOSED) turn on the room light or rinse the print in water, place it in a tray, and carry it outside the darkroom—examine the print for streaks, dust spots, tone, and contrast. If the print is too light, give more time—if too dark, make another with less exposure.

If your print is dull-looking and the deepest shadows are gray instead of black, make another print using filter #3 or #4 or use a "harder" paper (contrast grade 3, 4, or 5)—more exposure will probably be required—make a new test strip.

If your print has chalky highlights and black shadows without detail, make another print using filter #1 or a "soft" paper (contrast grade 1)—determine exposure by making a new test strip.

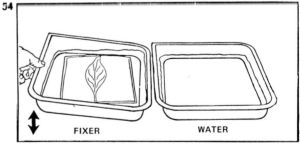

When you get a good print, let it remain in the FIXER for about 10 minutes (RC paper 2 minutes). Agitate the print occasionally by rocking the tray so that the print always is covered by the solution—if several prints are in the tray, don't let them stick together. After fixing . . .

If you're using variable contrast paper, filters can be used to alter the contrast of the print. Otherwise you will need paper of different grades of contrast.

55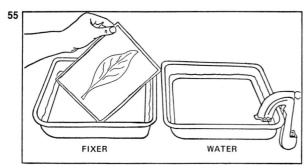

. . . lift the print by one corner and drain into the FIXER tray for a few seconds . . .

56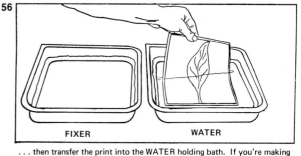

. . . then transfer the print into the WATER holding bath. If you're making several prints, let them accumulate in the holding bath, dumping and refilling the tray occasionally with fresh water. RC prints should not remain more than half an hour in the holding bath or the edges of the emulsion may begin to "frill."

57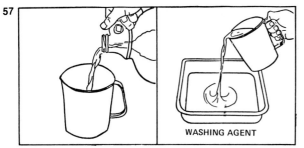

When you've finished printing, dilute washing agent stock solution with water (usually 1 part stock to 4 parts water) and pour into a clean tray. You can skip the washing agent if your prints are all on RC paper.

58

Transfer your prints to the WASHING AGENT—separate the prints and agitate the tray so that each print gets covered entirely. After 2 minutes . . .

59

. . . lift each print by one corner and drain into the WASHING AGENT tray for a few seconds, then place prints into the WASH for 10 minutes (RC paper 4 minutes). Washing time starts when the last print goes into the water. The wash water should be roughly 68°F (20°C) if possible and the water should be running rapidly or be dumped and drained every minute or so— (the tray siphon shown is convenient and inexpensive). While prints are washing, discard all solutions and rinse and drain all trays and accessories. After washing . . .

60

. . .drain the prints in a clean tray. If prints are to be dried with a matte finish, carefully blot or squeegee excess water from both sides and place prints face down on plastic screen frames (RC prints, black and white or color, should be placed face up on the screen frames.)

61

Matte prints may also be dried in a photo blotter roll. If a heated electric dryer is used, matte prints should be placed on the canvas dryer apron with the picture side away from the polished metal surface. NOTE: Regardless of the surface, RC (resin coated) paper should be air dried—place RC prints on screen frames or hang with clothespins.

62

If prints are to be dried glossy (not RC paper), soak them in glossing solution for about 5 minutes, drain, then place each print on the dryer apron face up so that the wet emulsion makes contact with the polished surface of the dryer drum.

exposure control

After you've made a good print from one negative, try working with other negatives of different density and contrast. You'll find out that although a normal negative may have made a good print when the exposure was, say, ten seconds, a very dense negative may require as much exposure as 30 or 40 seconds. On the other hand, a thin negative may need only one or two seconds to avoid coming up too dark in the developer. A group of so-called normal negatives, however, will all print at about the same time. That's one of the advantages of using the zone system: your negatives will be much easier to print because they'll be more uniform in overall density and contrast.

Although "expose for the shadows" is the rule for *negatives*, you'll discover that exposing *a print* for the *high values* will give you better control. Once your tests show satisfactory tone and detail in the lightest important areas of the print (skin tones, snow, and so on), you can adjust the relative contrast of the lower values in the print by choice of printing filter or paper grade and you can lighten shadow areas that print too dark by dodging. Incidentally, you'll have to increase the exposure time if you raise the enlarger head to make a larger print or if you change contrast filters or use a different grade or type of paper. Each time you change something, make a new test strip or calculate the exposure required from published data such as the *Kodak Master Darkroom Dataguide*.

development control

When you develop a print, you'll notice that the longer the print stays in the developer, the darker it becomes. This is a useful print control up to a point, but a print developed for the recommended time (usually one and one-half to two minutes) will have the best quality. Overexposed prints pulled from the developer after less than a minute because they were getting too dark may look all right under the safelight, but chances are the prints

will look mottled and gray or even brownish all over when examined under white light. Prints can be made slightly darker and given a bit more contrast by developing longer than the one and one-half to two-minute normal developing time, but stains or fog may result if development is extended beyond three or four minutes.

You'll soon discover, incidentally, that prints always look slightly darker under the safelight than they do when viewed under white light. So be sure to remember this when evaluating your prints: let each print develop out for the full recommended time, even though the print may appear slightly dark. Then examine it under white light.

However, this isn't the end of the story. Your print will dry down somewhat darker and flatter than it looked while wet. Some very particular photographers actually sponge or blot off surface water from a print to get a preview of what it will look like when it's dry. Another useful alternative is a trick often used by portrait photographers. In order to be sure that the skin tones match perfectly from one batch of prints to another, rewet a print that has dried to your satisfaction and keep it in a tray of water as a sample to match similar values in the prints you're going to make later. If you take a print out of the fixer to be viewed, rinse it off in water first to keep from contaminating the darkroom. But if you're going to keep that print, don't forget to put it back into the fixer for the required 10 minutes (2–4 minutes for RC papers).

washing and drying

After developing and fixing, prints on regular paper base should be washed in a rapid flow of water for at least one hour unless a washing agent is used. Prints should be agitated frequently and kept separated while washing. The use of a washing agent will greatly speed up the removal of fixer and silver salts from the print and shorten the washing time to 20 minutes or less.

Where water is scarce, an alternative method is to use a washing

A screen-frame dryer is best for matte prints when you're not in a hurry and for prints made on resin-coated papers. Prints on conventional papers should ordinarily be placed *face down* on the screens, while RC prints should be dried *face up.*

An electrically-heated print dryer is the conventional way of obtaining a glossy surface on certain types of photographic papers. Matte prints should be dried with the emulsion facing *away* from the metal drum or platen of the dryer. Resin-coated papers will not ordinarily stand the high temperature of this kind of dryer.

agent and then soak prints for a minute or two in each of six or more changes of water. Agitate the prints often and drain them well at each change. RC paper is a real time and water saver, requiring only a four-minute wash, even without a washing agent.

Stains and fading are the result either of insufficient fixing or of not washing prints long enough. This effect may not be noticeable until several months, or even years, later. When permanence of the print is not very important, thorough washing is not necessary from the standpoint of the print itself; a serious side effect, however, of insufficient washing is contamination of blotters, drying racks, or the canvas belt of a print dryer. Fixer left in prints by incomplete washing is transferred to such materials, and soon even properly washed prints become contaminated by the drying equipment. Don't let this happen!

Glossy prints on regular (not RC) paper can be dried on a chromed ferrotype plate or on an electrically heated dryer. Squeegee the emulsion into contact with the chromed surface and be sure that no air bubbles remain between the print and the drying surface. Prints will stick to the metal surface until they're dry and then peel off easily if the chromed surface is clean and the print has been correctly processed. Don't force-dry prints with high heat or try to pull them away from the dryer surface before they're dry—you'll get a poor gloss. Presoaking prints in a glossing solution will help to give a smoother surface to glossy prints and prevent them from sticking to the dryer drum. Drain prints well before putting them face up on the canvas dryer belt, and be sure the emulsion surface is evenly damp with glossing solution.

Matte, or nonglossy, papers may be dried between blotters, on fiberglass or plastic screening stretched on wooden or aluminum frames, or in an electric print dryer with the emulsion facing *away* from the chromed surface. Drain matte prints well and squeegee or blot away excess moisture before drying them. Prints on RC paper will not tolerate the heat of an electric print dryer. RC prints are best dried on screen frames or blotters; or they can be hung up with clothespins. Prints that for any reason have dried unsatisfactorily may usually be dried again after a thorough soaking in water or a glossing solution.

paper contrast

If you could use the zone system on every picture, controlling the entire process exactly, you could print every negative at a standard exposure time on grade 2 paper. That would be ideal; but in reality you're going to have quite a few negatives that aren't quite perfect, and it's helpful to have the additional degree of control offered by the printing paper.

Photographic paper is manufactured in different grades of contrast to make it possible to correct for negatives that may print too flat or with too much contrast on normal grade 2 paper. Variable contrast papers are also available that permit variations of contrast through the use of different filters on the enlarger. They allow you to maintain a single box of paper instead of several different grades. If a negative has too much contrast, a "soft" paper, such as grade 1, or a number 1 filter with variable contrast paper can be used to reduce contrast. A flat, low-contrast negative should be printed on a "hard" paper such as grade 3 or 4, or the corresponding filter should be used on variable contrast paper. Grade 2 paper or the number 2 or 2½ filter is considered normal for most enlargers, although the type of enlarger light source does influence the contrast. Variable contrast paper without a filter is generally equivalent to normal contrast.

Although some degree of contrast correction is possible in printing to compensate primarily for deficiencies in negative development, poor negatives will seldom yield satisfactory prints on any kind of paper. Very flat negatives that lack detail in the lower values (Zones I, II, and III) will make grayish-looking prints even on grade 4 or 5 paper. "Blocked up" negatives with extreme contrast will still lack highlight detail even when printed on grade 1 paper. Detail will be lost in the high values (Zones VII, VIII, and IX won't be separated). When you're shooting roll film, it's impossible to give the appropriate degree of minus or plus development to each individual negative. Paper contrast lets you compensate for this somewhat, grade 1 paper or a number 1 filter giving approximately the effect of $N-1$ development; grade 2 or no filter being normal; grade 3 being equivalent to $N+1$; and grade 4 paper or

Which of these prints do you prefer? The same negative was used to produce the two versions on variable-contrast paper, the only variation being in exposure time and contrast filter (filters No. 1 and No. 4 were used).

number 4 filter equating approximately to $N + 2$. Paper grades 5 and 6 appear to have limited tonal range; hence, they are most useful to achieve extremely high-contrast "poster" effects (see Chapter Ten).

paper weight, surface, and image tone

Double-weight paper is the most resistant to creasing and cracking in processing, especially in sizes larger than 8 x 10 inches. But single-weight paper usually costs less. RC paper has a very stiff, medium-weight base that takes all kinds of abuse, but it is so tough that its own sharp corners may tend to gouge the emulsion of other prints being processed in the same batch.

Although "silk" and other rough-textured prints are fashionable with photofinishers and their customers, most professional and serious amateur photographers prefer a smooth, semimatte surface on their prints. Paper with a smooth, semimatte surface reveals all the texture and detail in the photograph without introducing additional texture of its own. A high gloss may create disturbing reflections in a print to be displayed. A glossy print with a full range of tones, however, reproduces well in magazines and newspapers and is usually preferred by editors and photo engravers. Papers with a very dull matte surface subdue reflections effectively and allow some pencil retouching; however, they tend to flatten the range of tones by at least one full contrast grade, with the result that blacks seldom appear deep and rich.

Different brands and types of papers also vary widely in image tone, and you can modify the inherent image tone of most papers with chemical toner solutions. For general work, many contemporary photographers prefer a neutral black tone. Warmer, brownish tones seem suitable for some portraits and "earth" scenes, whereas cold, bluish-blacks may be appropriate for some snow scenes and metallic subjects. Your photo dealer has sample swatches of various paper weights, surfaces, and tones. You can examine his samples or buy a booklet such as the *Kodak Darkroom Dataguide*

There never seems to be enough time to do the things you want to do—Once you find them.

Jim Croce

Work expands so as to fill the time available for its completion.

J. Northcote Parkinson

I strongly believe that everything within the photograph, every element is there for the viewer to consider, and so if it's there I want them to deal with it. . . . If I think it's something that destroys the objective or the point or the essence of the situation I want to try to delete it in some way. Because . . . extraneous things get into photographs that you really have to weed out.

Brian Lanker

that contains examples, plus a lot of other useful information (see the selected references).

printing controls

Cropping is the most basic control in projection printing. Although some of the most highly respected photographers—including Edward Weston and Henri Cartier-Bresson—apparently have never cropped any of their images, there is considerable justification for the kind of postvisualization that allows us who are less severely self-disciplined to improve on perception that may have been too narrowly focused by excitement at the moment of exposure. Cropping is a way we can correct mistakes in framing, lighting, and perspective. Don't be afraid to crop; hindsight is a lot better than lack of sight. We learn by making mistakes, recognizing them, and correcting them. Just don't blow up a tiny portion of a 35mm negative and expect to have print quality equal to what you would have achieved had you printed the entire negative.

Although you may have tried to previsualize a photograph and match proper exposure and negative development to the brightness range of the subject, uneven lighting may cause parts of a scene to photograph lighter or darker than you wanted them. Sometimes the range of tones in the subject itself may be so great that the film can't record each zone properly, even with compensating development. Certain printing controls can help you to improve such photographs by allowing you to selectively lighten or darken portions of the print; others affect the image itself by straightening distorted lines or softening the image. Some of the most commonly used controls are described here.

DODGING

Dodging is the lightening of an area by covering part of the projected image for part of the total exposure time. Dodging can be done with your hands or with a piece of opaque paper fastened

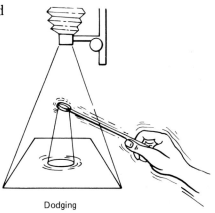

Dodging

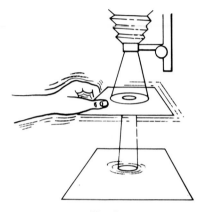

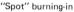

"Spot" burning-in

Burning-in or flashing edges

to the end of a length of thin, stiff wire. The dodging device must be held well above the paper and kept moving to avoid a noticeable line between dodged and undodged areas. To find out how much dodging is needed, try making a separate test strip for each area to be dodged.

BURNING-IN

Burning-in is the opposite of dodging. Certain parts of the print are given more exposure, in addition to the basic exposure time for the entire enlargement. This can be done by shaping your hands to cover all of the picture except the part to be darkened. Perhaps the best way is to give the extra exposure through a hole cut into a sheet of opaque paper large enough to cover the entire print. Keep the paper with the hole in it well above the enlarging paper; keep it moving so the effect isn't called attention to by a sharp edge. Pictures with light sky or a bright background are often improved by darkening the corners or edges by burning-in, using the edge of a large sheet of black paper or cardboard. Be careful not to overdo either burning-in or dodging because the result may look artificial.

FLASHING

Flashing is burning-in with raw, white light to darken distracting highlights in a print. Either remove the negative and use the enlarger as a light source, or use a small flashlight with a paper or foil snoot to selectively darken small, light areas. Like dodging and burning-in, the flashed area must be blended smoothly into the rest of the image to avoid an artificial appearance.

VARYING CONTRAST

Varying contrast in a single print is done with variable contrast paper by exposing part of the print through a high-contrast filter (meanwhile masking the other areas) and then exposing the remainder of the print through a low-contrast filter while covering the area previously exposed. This technique is useful when a negative contains large areas of both high- and low-contrast subject matter, such as a scene partly in the sun and partly in the shade.

D. Curl *Wheels*
Without flashing. Notice that light areas of contrasting shape and texture tend to compete for attention with the repeated oval forms of the wheels.

D. Curl *Wheels*
Flashing with a small flashlight locally darkened distracting light areas around the edges of this photograph. A red filter under the enlarging lens allowed the image to be visible so that the exact places needing flashing could be located.

Making separate test strips for both areas will help you to balance the different exposure times that will be required.

VIGNETTING

Vignetting (pronounced *vin-yet-ting*) simply means burning-in the portion of the image that you want, while totally dodging out the rest. A commercially made adjustable plastic vignetter can be purchased, or you can make your own by tearing out an opening of the shape you want from a piece of black construction paper. Make the edges of the opening saw-toothed or tear them raggedly; hold the vignetter well above the enlarging paper and keep it moving, to avoid leaving a distinct edge.

DISTORTION CONTROL

Distortion control is possible when the vertical or horizontal lines of a subject have been distorted in taking the picture. The most common example of this problem is when the camera has been tilted upward to photograph a tall building. This makes the sides of the building seem to converge toward the top. You can correct this by tilting the easel, supporting the easel with a book or other support when the image looks right. You should focus about one third of the distance down from the highest point of the image and then stop down the lens far enough to bring the entire negative into sharp focus. Some enlargers have a tilting lensboard that makes it much easier to keep everything sharp. If you can't get the image sharp enough by stopping down, try tilting the negative carrier by blocking it with a couple of pencils or strips of cardboard. Refocus carefully if you do this, and wrap a cloth around the negative carrier to block stray light from fogging your paper.

DIFFUSION

Diffusion is the deliberate softening of an image. It is not the same as having the image out of focus. Diffusion makes dust, scratches, blemishes, retouching, and grain much less noticeable, so it is a favorite trick used by some portrait photographers to make their subjects appear more youthful and glamorous. There

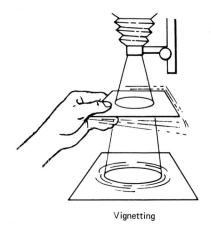

Vignetting

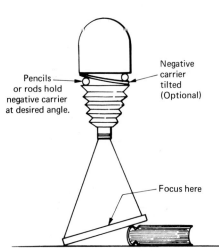

Pencils or rods hold negative carrier at desired angle.

Negative carrier tilted (Optional)

Focus here

Correcting distortion
(wrap opaque cloth around bottom
of lamphouse to block stray light)

D. Morenz *Imp*
Is this not a case where the lack of
sharp definition actually contrib-
utes to a sense of motion and
fun—a feeling of impish intimacy?

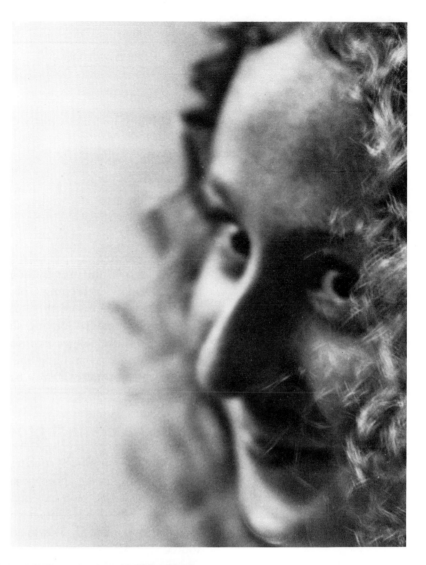

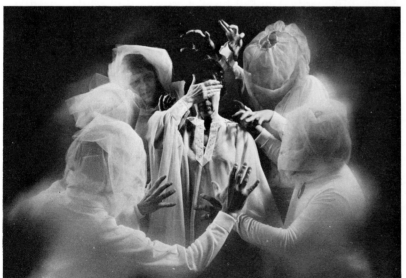

D. Curl *Ellie's Dream*
Diffusion is a technique rarely em-
ployed today, except by some pro-
fessional portrait photographers.
The desired dreamlike quality was
given to this photograph, however,
by placing a ring of petroleum jelly
around the outside surface of a UV
(haze) filter, leaving only the center
clear.

Both negatives and photographic paper normally tend to curl toward the emulsion side. RC papers, however, may sometimes fool you and curl backwards. Learn to tell the emulsion side of the RC paper you use either by the gloss of the surface or by the printing on the back.

are optical diffusion discs sold for this purpose, but you can easily make your own diffuser by holding a piece of nylon stocking, fine metal window screening, or cellophane (crumpled and then smoothed out) between the enlarging lens and the paper. The diffuser should be kept moving slightly during the exposure, and its use may require longer exposure. You can get more or less of a diffusion effect by holding the diffuser under the lens for only a portion of the total exposure time.

making a contact proof sheet

Many photographers routinely print contact proofs to simplify filing their negatives and to make it easier to choose the best negative from a series. You can make a contact proof sheet very easily if you have a large contact printer or printing frame available; the simplest method, however, is to use the enlarger as a light source. A commercially made "proofer" with hinged glass simplifies the process, or you can make a sandwich of paper, negatives, and glass on the enlarger baseboard. You'll have to experiment

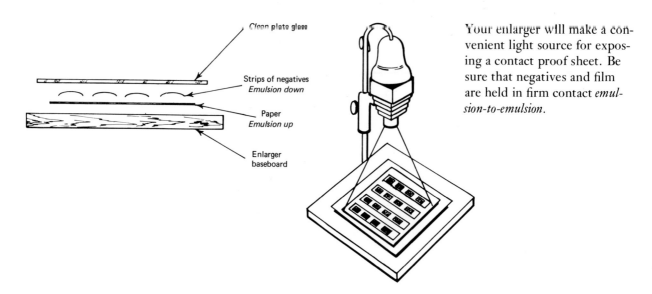

Clean plate glass

Strips of negatives
Emulsion down

Paper
Emulsion up

Enlarger
baseboard

Your enlarger will make a convenient light source for exposing a contact proof sheet. Be sure that negatives and film are held in firm contact *emulsion-to-emulsion*.

with exposure time—enlargers differ in brightness and your negatives will vary in density—but you'll find that a proof sheet is very helpful in deciding which negatives to print. Examine the proof sheet with a magnifying glass to check sharpness, facial expression, and so on, and mark cropping directly onto the proof sheet with a marker, wax pencil, or ball-point pen.

darkroom precautions and tips

1. Don't handle equipment or sensitized materials with wet or damp hands. To avoid constantly having to rinse and dry your hands while making prints, you may prefer to use print tongs. Some photographers like to keep one hand dry all the time for handling negatives, paper, and equipment, using the other hand for carrying prints through the solutions. Rinse your "wet" hand or tongs in water between processing steps.

2. Avoid dripping chemicals onto the darkroom floor or getting any chemicals on equipment. Your carelessness becomes evident after the spilled solutions dry, leaving stains, corrosion, and airborne dust. If you want to take a print out of the fixer to inspect it, rinse it in water and place it in an empty tray before carrying it around. Hypo (fixer) is the greatest contaminator in photography. Always wash it off your hands before touching anything, even the towel. Don't let it splash around the darkroom.

3. Don't turn on the white light in a processing area unless you check first to be sure all sensitized materials are covered. Ask permission of anyone else working in the darkroom before turning on the lights.

4. A paper cutter is dangerous in the darkroom. Always watch what you're doing and never cut a wet print.

5. Handle equipment gently. Learn where the adjusting and locking knobs are on the enlarger and don't use brute force on them. Timer levers and switches will last years longer if operated with care.

Do not be afraid of the practical and mundane aspects of the medium; they will strengthen your technique and discipline and give you a broader perspective of the world we live in.

Ansel Adams

6. Read the printed data sheets supplied with films, papers, and developers. File a copy of each for future reference or tape them to your darkroom wall.

7. Handle negatives and printing paper by the edges only. Most fingerprints are permanent, and they are almost certain to occur if you handle film or paper with damp hands.

8. Wear either an apron or old clothes when you're working in the darkroom. Developer leaves a brown stain that won't come out of clothing.

9. Developer is easily contaminated. Never put a print back into the developer after it has been in stop bath or fixer. Always rinse your fingers or tongs before putting them back into the developer after the fixer or stop bath. Some photographers who use print tongs reserve one pair of tongs for the developer and a separate pair for the stop bath and fixer.

10. Take only one sheet of sensitized paper from the package at a time and then *close the package*. Even under safelights, photographic paper will fog if left out too long or kept too close to the light. Lifting the head of your enlarger with the lamp on to insert a negative or to check for dust will fog any paper that's sitting out. Accidentally turning on the room lights with the lid off a full box of paper will be a memorable and expensive experience!

11. Open each new package of photographic paper carefully so that it can be resealed. Cut off a few strips of paper from one sheet for test exposures; then put the strips in the top of the package, where they'll be handy when you need them.

12. Refocus the enlarger before exposing each print. During the interval between the test strip and the final print, heat from the enlarger lamp may cause the negative to buckle enough to throw your print annoyingly out of focus. Try using a focusing magnifier—this device makes it easier to focus sharply on the grain of the negative. Don't forget to stop the lens down again after focusing!

13. Don't waste time trying to salvage a technically bad negative through the use of extreme paper-contrast grades, chemical reducers or intensifiers, and so on. If possible, correct your error by shooting another negative.

14. Beware of chemical solutions in unmarked containers. The best practice is not to use any solution if its identity or age is in doubt.

15. A filter will change the focus of the enlarger slightly. Refocus if you're using variable contrast paper and switch from no filter to a filter or vice versa. The same is true of a diffuser.

16. A few people are allergic to developer. If you're plagued with this problem, rinse your hands in stop bath immediately after the developer, or in water anytime. If the skin on your hands does become irritated, you'll either have to use print tongs or wear latex or polyethylene gloves.

17. Print washing time starts when the last print is put from the fixer or washing agent into the wash water. Another print will contaminate the batch if added to others already washing.

18. Don't keep solutions too long. Developer and stop bath should be dumped after every printing session, even though only a few prints were made. Penny pinchers may want to reuse fixer and washing agent, although none of the four solutions should be used for processing more than about twenty 8 x 10 prints or the equivalent per liter of working solution. Developer turns brown with exhaustion; some types of stop bath turn purple. Worn-out fixer may appear frothy, but by then it's too late. Keep track of the number of prints processed. The best motto to follow is, "If in doubt, throw it out!"

Table 7-1. *Trouble-shooting Chart for Print Defects*

Problem	Cause	Prevention or Correction
Image already too dark after one-minute development.	Overexposure	Make another print, exposing less time.
Image still faint after two- or three-minute development.	Underexposure	Make another print, exposing longer time.
Print developed for one and one-half to two minutes, but image is gray and dull.	Too flat	Make another print on harder paper (grade 3 or 4) or use higher-numbered filter.
Image dark enough overall, but lacks detail in highlights, shadows, or both.	Too much contrast	Make another print using softer paper (grade 1) or lower-numbered filter.
Corners of print very light; center appears normal.	Vignetting	Check lens focal length—50mm or longer for 35mm negatives; 75–80mm or longer for 6 x 6 cm; at least 135mm for 4 x 5. See whether condenser lenses in lamphouse are in proper position. Check for filter holder cutting off part of light.
One side of print very light, rest of print normal.	Partial vignetting	Straighten negative carrier; insert correctly. Inspect alignment of enlarger and filter holder.
Highlights of print gray, but margins pure white.	Light fog	Check for light leak in enlarger: around filter holder, negative carrier, or lens mount.
Print overall gray, including margins.	Light or chemical fog	Be sure paper isn't outdated. Inspect darkroom for light leaks. Check safelights for proper filter and bulb (usually 15 watts). Be sure developer is fresh and not excessively warm.
Black streaks on edges or corners of prints.	Paper exposed to light	Be sure lid is on paper box or inner envelope is sealed before turning on white light.
Thin white line in same place on all prints from same negative.	Small scratch on negative	Handle negatives carefully. Apply ''no-scratch'' solution to negative.
Thin black line in same place on all prints from same negative.	Deep scratch on negative	Handle negatives carefully.
Short, dark random lines on faces of prints.	Abrasion	Handle prints gently in developer. If using tongs, grip print only by one corner. Don't use tongs to ''stir'' prints.
Muddy-looking, mottled print.	Uneven development or under-development	Insert print in developer quickly and completely. Develop full time, agitating tray constantly.
Small white spots and ''snakes'' in sharp focus.	Dust and lint on negative	Blow and/or brush off dust.
Fuzzy, unsharp light patches on print.	Dirt on enlarger lens, filter, or condensers, or obstruction in lamphouse	Clean lens and filters; inspect condensers and inside of lamphouse for dirt.
Print fuzzy and diffused over all, but in focus.	Extremely dirty enlarger lens or filter	Clean lens and filters.

Problem	Cause	Prevention or Correction
Print partially out of focus.	Negative buckled or negative carrier out of alignment	Refocus. Check enlarger alignment.
Double-image effect.	Vibration	Don't bump enlarger during exposure.
Brownish or purplish stain on face of print.	Excessive handling	Keep your hands off the print while it's developing.
Brownish or purplish stain appears when print is dried.	Insufficient fixing	Fix for proper time. Don't let prints stick together in fixer or float on surface.
Brown or yellow stains on back of dried print.	Fixer contamination	Wash prints fully. Change print dryer apron or replace blotter roll.
Cracks in emulsion.	Wrinkling or folding	Handle prints gently. Don't let prints get bent sharply or tumbled roughly in washing. Watch prints as they go into dryer.
Scratches or gouges on face of print.	Abrasion	Don't use sharp-edged tongs. Trim long fingernails. Don't develop too many prints at the same time.
Emulsion frilled around edges of print.	Wash water too hot, or soaked too long in water or washing agent	Don't let prints remain wet for more than a few hours. Solution temperatures shouldn't be above 75° F (24° C). RC paper shouldn't stay wet for more than about half an hour.
Uneven surface on glossy print.	Poor adherance to dryer surface	Use glossing solution as directed. Be sure dryer drum surface is clean and smooth. Dampen face of print with glossing solution just before it makes contact with the dryer drum.
Prints stick to dryer.	Drum surface too hot, too cold, or too dirty	Check items above and be sure dryer temperature is correct. RC paper ordinarily should not be dried on a heated drum.
Dried prints curl excessively.	Low humidity	Flatten in a dry mounting press or under a stack of books, or moisten backs of prints slightly and place in blotter roll.

archival processing

Making a quality print is only part of the process. You probably want to show your prints to people and you want your work to look its best—permanently. That means mounting, and/or matting and framing, and effective display. It may mean toning. And you may be one who is concerned with archival processing so that your photographs can be enjoyed by future generations without danger of stains and fading.

Actually, most photographic materials will last for many years without apparent deterioration if they are processed carefully in fresh solutions, according to manufacturer's instructions, and stored with reasonable care. So unless you're producing prints for a museum collection, you might not have to worry too much about archival processing. If you are concerned, here are some major points to consider:

1. Fix prints in two successive baths of fresh fixer, four to five minutes, or half the manufacturer's total recommended time in each bath. Use a water holding bath—don't allow prints to accumulate in the fixer. Change the water in the holding bath every half hour.

2. Tone in gold-protective or selenium toner, according to the manufacturer's instructions. An economical and satisfactory short-cut procedure is to transfer prints directly from the final fixing bath into a solution of selenium toner and clearing agent:

Kodak Hypo Clearing Agent,* working solution 1 gallon (4.0 liters)

Kodak Rapid Selenium Toner, concentrate 3½ ounces (100.0 milliliters)

Kodalk Balanced Alkali 2½ ounces (75.0 grams)

Agitate prints constantly while they are in the toner solution, watching for any noticeable shift in image tone. Three minutes is

* Other brands of washing agent can probably be substituted, although I have not tested them.

Pictures are no mere decoration. . . . They represent the primary channel of all human understanding. . . . They are indispensable.

Rudolf Arnheim

print finishing and display

enough time for protective toning. With some papers, a longer time in the toner solution will intensify the blacks (desirable) and may give a warm effect to the image. Discard the solution after about ten 8 x 10 prints, or the equivalent, have been treated per liter.

3. Wash prints in a washer that allows *complete* separation of prints, or dump the wash water every five minutes and manually separate the prints, placing a different print on top each time. A total washing time of 30 minutes at 68°–75°F (20°–24°C) is probably adequate, although maximum permanence is attained by using a bath of Hypo Eliminator (Kodak HE-1 formula), followed by an additional 20-minute wash.

4. Squeegee or sponge excess moisture from both the front and back of each print. Use only a clean squeegee or sponge for this purpose, and lay the print on a smooth, nonabsorbant surface such as a stainless steel plate or a sheet of glass or plexiglass. The bottom of a plastic photo tray should not be used, as it may harbor chemical residue.

5. Air dry prints on thoroughly clean, inert fiberglass screening stretched onto frames. Place prints on regular papers face down against the screening; RC black and white and color prints should be dried face up.

6. Mount prints only with dry-mounting tissue and only on 100 per cent rag or other sulfite-free board. If an overmat is to be used, it too should be cut from sulfite-free board.

mounting and matting prints

Dry mounting is the most universally used of all mounting methods. Carefully dry-mounted prints are neat, flat, and permanent. If you have access to a dry-mounting press, set the temperature control to 225°–250°F for mounting prints on conventional papers with regular mounting tissue (180°–200°F for resin-coated

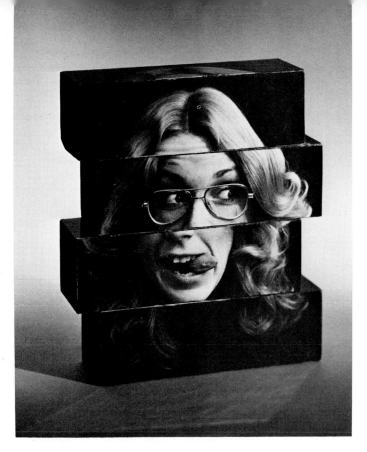

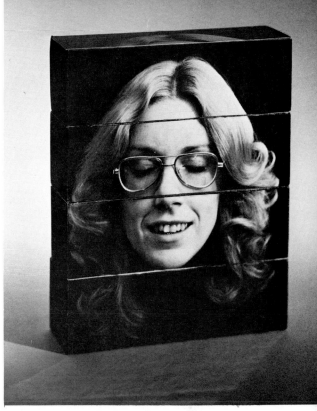

papers and special mounting tissue) and let the press warm up for half an hour. Plug in a tacking iron and set it for medium temperature. A preferred dry-mounting process for photographs is described and shown in the accompanying diagrams.

1. Pre-dry both the mounting board and the print for 30 to 60 seconds between sheets of clean Kraft paper or thin acid-free mounting board. This helps to drive out excessive moisture. The press should be closed but not locked.

2. Attach a sheet of dry mounting tissue to the back of the print by tracing a short line with the *tip* of the tacking iron *through* a small piece of teflon release paper. Be sure there are no particles of dust or grit between the print and the tissue.

BETSY HORNBECK *Self-portrait*
Only two of the many combinations of this entertaining, three-dimensional self-portrait are shown here. The photographer cut enlargements of four different poses into four equal-sized strips, mounting each strip on one side of a wooden block.

3. Trim to approximate size (this may be sufficient trimming if print is to be overmatted).

4. Place materials in the press in this order starting from the bottom (next to the sponge/felt pad): (1) clean, pre-dried Kraft paper or acid-free board, (2) print, *face down* on the Kraft paper or board, with tissue tacked to its back, (3) teflon release paper covering the exposed mounting tissue, (4) laminated cover sheet or heavy paper over release paper.

5. Lock press closed for 15 to 30 seconds to bond tissue to print.

6. Cool under weight. Place all the sheets from the press immediately under weight for a minute or so until cool. After cooling, examine the tissue bond by carefully flexing the print. If the bond is inadequate, place the entire sandwich back into the press for additional time. Trim the edges of the print if necessary.

7. Tack the print to the mounting board by tracing a short line with the *tip* of the tacking iron *through* a piece of teflon release paper along one edge of the print. Be sure there are no particles of dust or grit between the tissue and the mounting board.

8. Place materials in the press in this order starting from the bottom: (1) Kraft paper or acid-free board, (2) mounting board with attached print *face up*, being sure there are no particles of dust or grit on the surface, (3) laminated cover sheet.

9. Lock press closed for 15 to 60 seconds as needed for a good bond.

10. Cool under weight. After cooling inspect the bond.

A clean hand iron can be used instead of a dry-mounting press, but an iron will not be as convenient, and there is some care required to apply heat and pressure evenly over the entire surface

of the print. Set the iron's thermostat at "synthetic fibers" (between silk and wool) and use the tip of the iron for tacking. If you use a steam iron, don't put water in it; keep the iron moving so it doesn't leave impressions from the steam holes in the sole plate.

Both color and black and white RC papers require extra care in dry mounting because the plastic base tends to bubble and melt under the high temperature usually required. Special tissues are available, however, that are formulated specifically for low-temperature use with RC papers. It's extremely important that your press or iron not be too hot. For RC papers, an alternative to dry mounting is a two-part mat with the print simply taped between mat and backing board.

When the tone of parts of the image tends to merge with the mounting board, you might want to add a sophisticated thin, black line around the photograph. A few purists insist on filing the inner edges of their negative carriers to achieve the black-edge look on every print. Of course this means that you have to print the entire frame of every negative without benefit of any cropping whatsoever. A more flexible approach is to add the black line by flashing the edges when the print is made. Other alternatives

A hinged two-part mat provides quick and temporary display for a print to be shown in class or exhibited for a short time and then filed.

BRIAN KUEHN
Some photographers use an oversized negative carrier to obtain thin black borders around their prints. But this means that the entire negative must be printed. A popular alternative method which permits cropping, is to flash the edges of the image with a raw white light after the exposure has been made, masking the picture area with an opaque sheet of cardboard or thin sheet of metal.

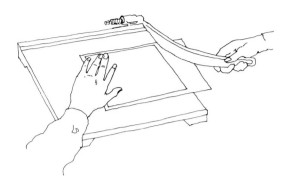

You'll get better results from the ordinary guillotine-type trimmer if you cover the surface of the print with a sheet of plain paper to protect it from your fingerprints, then press down firmly on the print or board being cut with your left hand while pressing downward and inward (toward the left) with the blade. Never count on the squareness of the ruler or grid of a trimmer, but measure and mark each cut.

include offset mounting (double mounting) or judicious use of black charting tape or india ink and a ruling pen after the print finally has been mounted. Ink can smear and tape may peel off after a while, but either method can be a satisfactory expedient.

There are some good guillotine-type paper cutters, but they are hard to find—most of them being either dull or out of square. The type of trimmer with a rotary cutting wheel is excellent for photographic use and is much safer to use in the darkroom. However, such a cutter can be dulled or sprung out of shape if you attempt to cut heavy mounting board. The kind of heavy-duty trimmer found in printing shops is ideal for cutting mounting board, although you can do very well in your own studio with a razor-sharp, stout-bladed utility knife and a steel carpenter's square. When cutting with a knife and metal square, be sure to cover the work surface with a piece of old cardboard or building board and make several straight, decisive cuts until the knife cuts clear through. A few circular swipes on a pocket carborundum hone will keep your knife blade sharp and lessen the chance of leaving ragged edges. Be sure to cut *away* from the "good" part of the mounting board so you won't damage that part if the knife slips.

An overmat is a sign of professionalism that adds a measure of elegance to a print, especially if the print is to be framed. A mat also serves to separate the print emulsion from the glass, lessening the possibility of moisture condensation and fungus growth inside. But many photographers don't bother with mats, either because they think they're hard to make or because they're unwilling to pay the high price charged by a professional picture framer to cut good mats. Actually, anyone can cut a mat because only the corners are difficult. Sharp, square corners require patience, dexterity, a good mat knife, a single-edge razor blade, a smooth (and expendable) cutting surface, and hours of practice.

cutting a mat

Because the cut-out opening of the mat has to be absolutely square with its outside edges, some careful measuring is required.

Here are directions for using an X-Acto mat cutter to overmat an 11 x 14 print mounted on 16 x 20 board:

1. Determine the desired width of the mat opening (27 cm).

2. Subtract the width of the opening (27 cm) from the total width of the overmat (40.6 cm). $40.6 - 27.0 = 13.6$ cm. Then divide by 2 to determine the width of the side and top margins. $13.6 \div 2 = 6.8$ cm.

3. On the back of the mat board, pencil mark the margin widths for the top and sides of the opening. Use a carefully aligned T-square.

4. Determine the desired height of the mat opening (35 cm).

5. Add the width of the top margin to the height of the opening. $35.0 + 6.8 = 41.8$ cm). Pencil mark the bottom of the opening on the back of the mat board.

6. Insert a new or sharpened blade into the mat knife. Place the knife into the proper slot for either a straight or beveled cut.

7. Hold your body against the base of the T-square and press down firmly on the end of the T-square with one hand. Being careful not to let the mat board slip, cut each of the marked lines in turn, from the back of the board, cutting barely into each of the corners but not beyond them.

8. Finish the corners, if necessary, with a new single-edge razor blade. Be careful to maintain the angle of the cut, and don't cut too far.

9. Line up the finished mat with the mounting board and insert the print so that it is centered properly within the opening in the mat. Lift the mat and mark the corners where the print should be mounted.

10. Dry mount the print as usual; you don't have to be too careful about trimming the edges because they won't show.

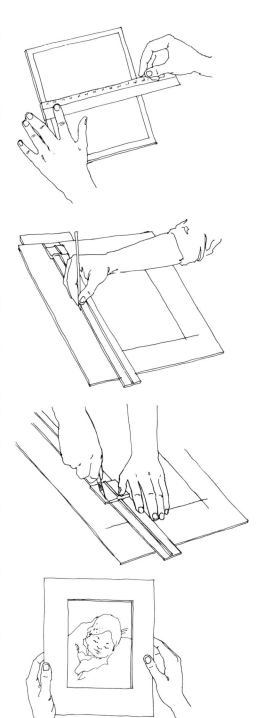

11. Hinge the mat to the backing board with a nonbleeding, nondrying tape made for library or office use. (A hinge isn't needed if the print is to be framed.)

A mat can be cut from almost any kind of board, but it usually looks better if all layers of the mat board are of the same color and texture, especially if the edges of the mat opening are to be beveled. Of course sulfite-free board should be used for both mat and backing if archival permanence is important.

What about colored mats and mounts? In photography, the general rule is to use white unless there is a very strong reason not to. Some prints do look better with a gray or buff mat, and a few prints—very few—require black. Sometimes color prints can be matted effectively with a harmonizing color, but this is a matter of taste. Generally speaking, the photograph should be complete within its own borders and not need the mat to complete the graphic balance or to enhance the tonal range of the print. A colored or textured mat seems more often to compete with, rather than to complement, most photographs.

spotting

Besides mounting, spotting is another factor that sets apart professional quality prints from amateurish efforts. You're going to have some dust on the negative no matter how carefully you brush and blow before enlarging. A very fine (00), high-quality red sable watercolor brush and spotting dyes are the tools you need to camouflage the spots. If you buy Spotone dye, the number 3 color is a neutral black that will match the most commonly used enlarging papers. But if you like to experiment, you might want to buy a kit that contains number 1 (bluish black) and number 0 or 2 (brownish black), as well as the number 3. It's possible to mix the solutions to obtain intermediate shades, but you'll probably find it easier to work directly from the bottle. Some workers like to prepare a palette of various Spotone dilutions to work from, but if you have only a few prints to spot it may be easier to work from the bottle cap following this procedure:

1. Be sure the cap is on tight; invert the bottle and then right it again. Unscrew the cap and leave it on the worktable. Put the uncapped bottle someplace where it won't get knocked over! Allow the dye in the bottle cap to dry for a few minutes.

2. Moisten your brush enough to point it, and draw the tip of the brush over the dried dye in the bottle cap. Although it might not seem very genteel, the tip of your finger moistened with saliva makes an excellent pallette for moistening and pointing your brush. Or you can use a little water in a shot glass or beaker and a paper towel or tissue to wipe the brush on.

3. If you're spotting within a dark area, apply the full-strength dye directly to the spot with the very tip of the brush. Don't try to paint on the dye, but build up the spot with several tiny touches of the tip of the brush, working from the center of the white spot outward to blend the edges with the background.

4. You'll have to dilute the dye to blend with lighter backgrounds. Use more water or saliva on the brush when you pick up the dye; then draw the tip of the brush across the end of your finger or the paper towel to get a lighter color and dryer brush before touching the brush tip to the print. Keep your brush almost dry, and always dilute the dye more than you think necessary; then go back and add more. If you put on too much dye, it's permanent—you make another print! Scratches and hair lines can be obliterated with spotting dye, too. The procedure is to draw the tip of the brush very slowly and very lightly along the length of the white line to be covered, going back several times to make the blend undetectable. With patience, practice, and a strong light you can do it!

Spotone will take care of white spots on a print, but it won't do anything about black spots. Black spots can be removed by etching or bleaching, but the cure may be worse than the malady. Etching nearly always mars the surface, although tiny spots can be worked down with the tip of a very sharp razor knife. The idea is actually to shave away the emulsion a layer at a time, stopping before you remove everything down to the white paper base. Po-

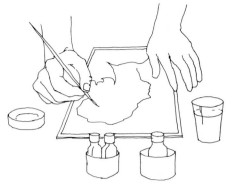

Spotting a print requires practice. Always work with a quality brush that will hold its point. Work with the brush nearly dry and build up density in each spot by stippling instead of trying to paint on the dye.

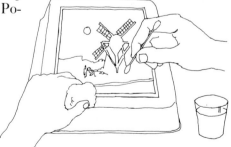

You can locally reduce or lighten small areas of a print with Farmer's Reducer. Do the bleaching very carefully while the print is damp, standing by with a sponge or paper towel to blot away any excess bleach before it spreads. Bleach and blot several times until you get the desired result, then re-fix and wash the print.

Although, as with every rule, there are variations and exceptions, photographs are most often hung for exhibition at eye level with the tops of the frames or mounts at precisely the same height.

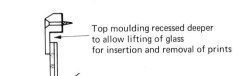

Top moulding recessed deeper to allow lifting of glass for insertion and removal of prints

Glass — Mounted print

This cross-section shows how wooden picture molding and sheets of glass or plexiglass can be used to make a slip-in wall display.

A true photograph need not be explained, nor can it be contained in words. My photographs are presented as ends in themselves, images of the endless moments of the world.

Ansel Adams

tassium ferricyanide bleach (Farmer's Reducer) can be applied to a black spot with a tiny brush, but this should be done while the print is damp from being washed and before the print is dried. Bleaching may leave a yellowish stain that you can usually get rid of by refixing and rewashing the print.

displaying your photographs

For permanent display, a neat frame adds the final touch of elegance. (How can it be art without a frame?) Don't gild the lily: ornate frames are definitely *out* for photographs, but a tasteful, narrow-edged black, bronze, or silver-colored frame can add a lot to the appeal of a print, as well as keep it flat and protect the corners. Glass, of course, protects the surface of the print from airborne substances and inquisitive fingers. Ordinary single-strength window glass or plexiglass seems to be most acceptable for photographs, although some purists dislike the reflections that appear in the glass. If it bothers you to have people combing their hair in front of your photographs, you could try the so-called nonglare glass. Nonglare glass is significantly more expensive, however, than regular glass, and its semimatte surface tends to gray out the appearance of the deepest low values in the print by about one zone. The choice of glass must be a compromise. Perhaps the best solution is ordinary glass with careful lighting of the prints so that reflections are subdued. Gallery walls shouldn't directly face opposite windows, anyway, or other nearby walls that are light in tone.

If you're preparing a gallery of your own, try lining one or more walls with either dark cork or soft building board (Celotex or Homosote) covered with rough, loosely woven material such as monk's cloth. Either of these surfaces will accept pushpins readily for temporary display of unframed prints. An excellent semipermanent display can be made from two strips of wood molding screwed to the wall. If the strips are positioned properly, the prints and their cover glass can be slipped in and out quite easily.

light

Light, in photography, is everything! Light is the force that illuminates subjects so we can photograph them. Light reveals form and texture to us. If you're going to make successful photographs of people and objects, you must first learn to observe light as it falls naturally on shapes and surfaces; then you must learn how to control the quality, direction, and intensity of light, so that your subjects are most significantly revealed.

Observe the effect of light on human faces. Notice how light can envelop a subject softly and gently, or harshly highlight irregularities. The way we see texture depends on whether light floods the surface with a general illumination or whether light skims the surface, creating shadows that emphasize and strengthen the natural feeling of roughness or roundness.

Light that's bright and all-encompassing can give a feeling of airy openness, space, and happiness. Lightness may also be associated with innocence or femininity. Absence of light, on the other hand, creates mysterious shadows that may appear ominous and threatening—or deep tones that may imply drama, dignity, or strength.

Whether you're photographing people, pets, or products; machinery, buildings, or boxes; rivers or rocks; snow or sand, the same general lighting principles apply: always determine first the quality, direction, and intensity of the *main* or *key* source of light. Study the intended, or possibly unintended, effects of this light on the subject and on the exposure and development required to reproduce the subject naturally. Then decide how you will alter the light or the effects of the light to get the image you want.

Because we're accustomed to seeing the world bathed in various degrees of sunlight, "natural" photography of most subjects usually means reproducing the general feeling of sunlight coming from above. Any other illumination may seem to be somewhat contrived. When working with any type of light source, then, usually the aim is not to call attention to the lighting by deviating from effects that appear natural. A single *main* or *key* light source

Camera lens, film, developer and printing paper have but one purpose: to capture and present light. Yet for all its place of importance in the photographic scheme, light is too often unknown, unstudied, and abused by photographers. . . .
Edward Weston

Become aware of distance, become aware of direction, become aware of bounce, become aware of the absence of light, become aware of reflectiveness. . . .
W. Eugene Smith

Light is never stable and never the same a second time. . . . Light makes each succeeding minute of every environment a new experience, and gives each situation the potential for aesthetic discovery.
Charles Swedlund

photographing people and things

184 PHOTOCOMMUNICATION

> The camera is an exquisite tool, for it captures the light pattern which the eye can see but which the brain cannot retain. Of all the beautiful tools of man, only the camera can mirror reality in an instant.
>
> *John Schulze*

should appear to come from somewhere above and to one side, directed to emphasize the form and texture of the subject.

existing light

Some people still believe that the only way pictures can be taken indoors is either with a flash on the camera or with heavy studio lights. Actually, very excellent and realistic photographs can be made indoors with "fast" films if the existing room light is used properly. Instead of moving the light to the subject, as in a portrait studio, you must move your existing-light subjects so they are properly lighted. People should generally have plenty of flattering light on their faces. If you're shooting a group activity,

WILLIAM BEVERLY *Kris*
Soft "wraparound" lighting from large classroom windows gave a soft effect, similar to umbrellas or bounce light, yet retained directionality of the light and imparted roundness to the features. A chalkboard provided a conveniently contrasting background. Notice the vitality obtained by having the subject turn her head at an angle to her shoulders.

R. VANDER ZWART *Easy Book*
An open book makes an excellent reflector to counteract the extreme brightness range caused by strong backlighting by direct sunlight from a window.

LARRY ALLEN *Boo!*
Lighting from underneath seems mysterious, even sinister, as the head appears to be floating in space. Reserve this technique for special effects.

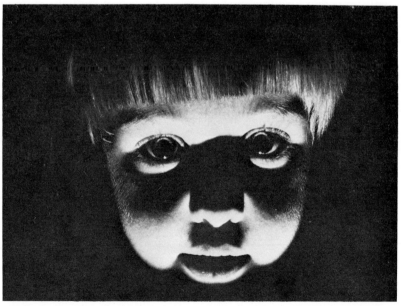

MIKE DEINES *Couple*
This informal portrait illustrates use of a single light source to provide uniform short key lighting on both faces. Enough light is scattered around the room from light-colored walls to provide fill.

for example, arrange everyone so that each person faces a light source, whether that source is a window, a lamp, or a fireplace fire. Arranging people doesn't necessarily mean posing them stiffly. You can group people informally and direct them to go ahead with some natural activity such as talking, working, playing a game, or examining an object.

Make plenty of exposures and people will soon lose their self-consciousness. Before your subjects are in place, if possible, use your exposure meter to determine a basic overall exposure setting, but be extra careful not to let the meter pick up any stray light that might affect the reading. Move some people nearer to the light source, if necessary, so that all important parts of the picture are receiving about the same amount of light.

Evenly lighted rooms pose few problems for existing light photography, except perhaps that the light may be perfect for uniform exposure, yet uninteresting. If the light is strong from windows along one wall and two or three stops darker on the other

Mary Cain *Silhouettes*
Is this silhouette perhaps more provocative than the same photograph might be if it had a full tonal range? What serious problem of exposure determination exists when photographing directly into a light source such as this large window wall?

side of the room, you can often obtain a very dramatic effect by backlighting your subject. There is a danger in such situations, however, of underexposing shadow detail, so either make incident-light readings or meter the shadow areas. As in other situations of extreme subject brightness range, the lowest important values should be placed in the proper zones. Another solution is to reduce the range of brightness. A reflector may introduce enough light to supplement the shadows, or you can try bouncing light from the ceiling or walls. The bounce technique works well with either flash or flood, yet allows you to preserve the effect of natural illumination.

Don't forget to carry a tripod with you for shooting interiors. The extra trouble will pay off when you need more depth of field and you're forced to shoot at a slow shutter speed, such as ½ second. Some interiors are just too dark to allow shooting with a hand-held camera.

"pushing" film

There is a body of photographic folklore pertaining to exposing certain films at enormously inflated exposure indexes (for example, Tri-X at ASA 1600 to 3200). The secret is said to be the use of costly, secret-formula, high-energy developers that supposedly yield, also, miraculously fine grain.

The fact simply is that rating any film appreciably higher than its recommended ASA speed diminishes the potential quality of the negative. With your own equipment you may actually find that the ideal negative is exposed at a *lower* ASA rating than the manufacturer recommends (for example, Tri-X film at ASA 250 or 320, instead of 400). Film manufacturers build into their products a safety margin of about one stop, meaning that, if your equipment is correctly calibrated, you can rate most films at double their normal ASA rating and still get an "acceptable" rendering of average subject matter. The penalty you pay for minimizing exposure is the risk of loss of shadow detail. What you're doing by

doubling the ASA is, in effect, dropping the low values in the subject brightness range one full zone lower; for example, a dark, textured Zone III area photographed on Tri-X film (ASA 400) would be rendered as Zone II at ASA 800. Doubling the ASA again to ASA 1600 will place the Zone III area in totally textureless Zone I, losing all shadow detail below Zone III and resulting in an extremely thin negative.

Developing "pushed" negatives for extended time in high-energy developer merely increases the density of the higher values (Zones VI through IX). This increase in highlight density raises the effective printing contrast of the negative, but it is also very likely to "block up" the highlights, losing separation between the higher-value zones. High-energy developers often build up a false shadow density through overall fog, and they noticeably increase the tendency for grain to clump together and become visible.

Because of the loss of shadow detail, "pushing" is poor practice when the subject has an extended brightness range, such as people doing things in an unevenly lighted room. Pushing, on the other hand, is useful when you want to stop fast action in limited light and when the brightness range is so limited that you would want to give $N+$ development anyway. An example might be a sports event under an overcast sky or indoor activities in a light-walled room illuminated very evenly by banks of fluorescent tubes. Under such conditions there are no significant low values to lose; hence, an underexposure of one or two stops (rating ASA 400 film at 800 or 1600) and $N+1$ or $N+2$ development would be appropriate, yielding a thin negative of slightly increased graininess, but with a satisfactory tonal range and adequate printing contrast.

PAM VOGEL *Swimmer*
"Pushing" your film may be the only answer when there isn't enough light for adequate exposure at the manufacturer's ASA rating and when flash may be unavailable or undesirable. Exposing the film at a higher ASA rating and extending the development time may result in a grainy but satisfactory negative when the subject matter is of relatively low contrast such as this indoor swimming meet. Pushing is less successful when the subject matter reflects an extended brightness range containing important shadow values.

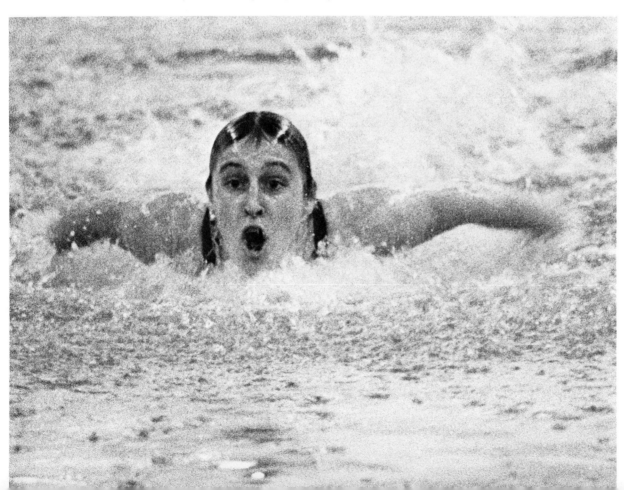

The attitudes of people are so different in front of a camera. Some are embarrassed. Some are ashamed. Some hate to be photographed and others are showing off. You feel people very quickly. You see people naked through the viewfinder . . . and it's sometimes very embarrassing.

Henri Cartier-Bresson

The good photographic portrait is a collaboration, a transaction between photographer and sitter . . . and it reveals the personalities of both photographer and person photographed. . . . The photographer and his human subject are connected by a thread that is delicate and tenuous. If the two establish rapport, the photograph will be a success. The subject will feel that the photographer has had the insight to see his best qualities, and the photographer will feel that he has perceived the essential human being. Thus, it is the photographer's responsibility to choose the particular fraction of a second by which the person would wish to be remembered.

Margery Mann

If you wait long enough and someone is looking at you—sooner or later you will see their soul, providing you don't talk too much.

Bruce Davidson

A portrait . . . if it's handled right . . . is the closest thing to climbing inside somebody's mind and experiencing what they are about.

Brian Lanker

LIN CHILDS *Jim*
Awareness, spontaneity, intimacy. An extreme close-up of a relaxed moment that seems to reveal something about the personality of the subject and about his relationship with the photographer.

portraiture

A portrait should emphasize the subject as a person. A good portrait can reveal much more about the subject than merely what he or she looks like; surroundings or background may contribute by indicating something about the person's home life, work, or interests. Careful selection of pose and lighting by the photographer can bring out grace, poise, dignity, and character, as well as emphasize or deemphasize certain features. The subject's eyes and facial expression will often reveal a great deal about your own relationship with your subject—tense and formal, casual and re-

JOHN WILLERTON *Two Faces*
Although the angle of the key light is slightly different, these two photographs of the same subject illustrate a difference in mood created by extremes of contrast. Do you react differently to the personality, as you imagine it, of the young man as he is represented in each photograph?

William T. O'Brien *Peggy*
Soft, existing room light was sufficient for this appealing portrait of a little girl's relationship with the photographer—her father.

laxed, amiable and intimate. You might be surprised to realize that your instinctive choice of camera angle, subject distance, and lighting will reveal something of your attitude toward the subject.

At one time, a 4 x 5-inch or even larger negative was thought to be necessary, for portraiture was believed always to require retouching and small negatives are difficult to retouch. But many excellent portraits are now being made with 35mm and 120-size roll-film cameras. Small negatives are difficult or impossible to retouch with pencil and an etching knife, but some of the demand for retouching has disappeared. Many portraits are made for publication, and reproduction processes suppress enough detail to effectively diminish many faults. Soft lighting and simple diffusion techniques either at the camera or in the darkroom can work wonders to soften the effects of wrinkles and facial blemishes when it's important to satisfy your subject.

Although you can make excellent informal portraits in natural light with a small hand-held camera, a tripod and controlled ar-

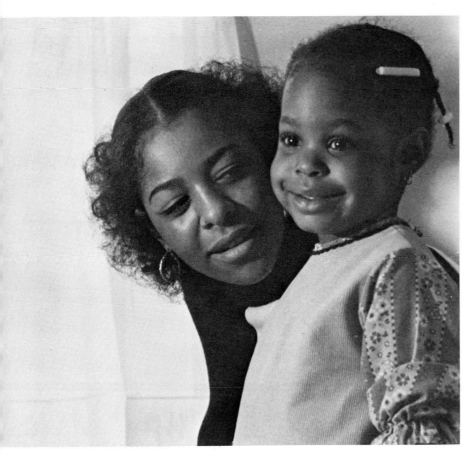

WALLACE KIRK
Mother and Daughter
A single key light plus fill provided sparkling short lighting to both faces in this informal home portrait.

tificial lighting are still important equipment for making "formal" portraits, together with some provision for a plain, neutral background. It's hard to converse with your subject and observe spontaneous expressions while looking through a viewfinder (it makes your subject uneasy); however, with a tripod and a long cable release, you can concentrate on the subject and forget about the camera, except to trip the shutter. If you have a choice of lenses, a lens about twice the normal focal length is ideal for portraiture. A shorter focal length lens at close range tends to make the subject uncomfortable and to distort facial features, making the nose, chin, or forehead appear unnaturally large.

Promote Visual Health . . . Photograph a Friend.

Walt Burton

The difference between a portrait and a snapshot is that the portrait is the person agreed to be photographed. It's not at all like somebody you see and catch on the street. . . .

Henri Cartier-Bresson

PROFESSIONAL PORTRAIT LIGHTING

Use variations of this system for lighting equipment illustrations,
how-to-do-it sequences, etc.

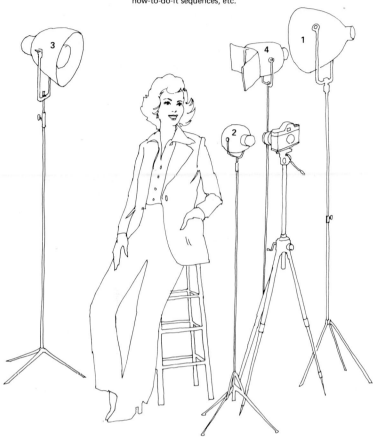

1. MAIN or KEY light — All shadows should appear to come from
 this light. Largely determines exposure. High and to one side (start at 45°).

2. FILL light — Less than half as bright as KEY. Close to lens axis.
 Softens shadows. Must cast no visible shadows of its own.
 A reflector is sometimes used instead of a lamp.

3. ACCENT or BACKLIGHT — Adds highlights on hair and shoulders.
 Should not strike camera lens or front of subject's face.

4. BACKGROUND light — Separates subject from background.
 Eliminates any shadows cast on background by FILL.
 Should not light subject.

studio lighting

Head and shoulders "studio" portraits usually require a minimum of two lights: the main or key light and a fill-in light, or one light source plus a reflector for fill. Although it's nice to have professional floodlights with telescoping stands, the inexpensive clamp-on lights with aluminum reflectors that are sold for a few dollars in photo, hardware, and discount stores will do. Equipped with 250-watt 3,200° K photo lamps or 150- or 200-watt household bulbs, these inexpensive lights will do an adequate job on a minimum budget. Clamp the key light on the edge of a door and the fill onto the back of a chair. Better still, purchase a couple of

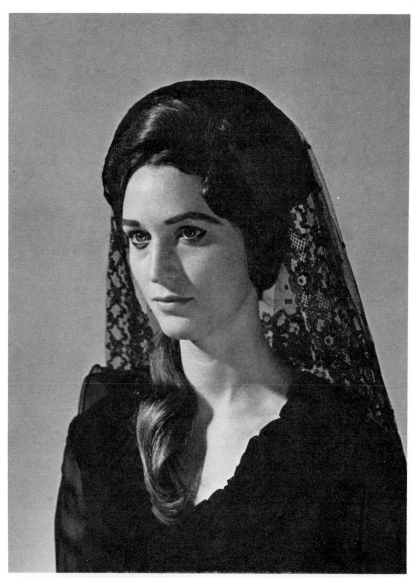

W. A. Moss *Satin and Lace*
Although posed very formally, the lighting of this portrait illustrates placement of the 45-degree key light, diffused fill light, and background light. Notice how the key light forms a triangle of light on the model's left cheek. This is what is referred to as short lighting, because the key is placed to illuminate the short or far side of the subject's face.

Notice the different emphasis of facial form when *Short* lighting is used (left); *Broad* lighting (center) and *Butterfly* lighting (right). The light source was the same in each example—a single quartz lamp bounced off a silvered umbrella. The only change was moving the light.

JOHNNY YEE *Maria*
"Broad" lighting was appropriate for this subject's face. The key light illuminates the broad, or near, side of the face and, in this case, is somewhat nearer to the camera than usual, so that no fill has been used. Notice that a strong accent or backlight adds sparkle and dimension to the hair and separates the shoulders from the background.

inexpensive light stands or make stands from lengths of electrical conduit or bamboo poles set into Christmas tree bases.

The *key* or *main* light is the strongest light and should cast the most prominent shadows, comparable to the sun's illumination outdoors. The best place for the key light is usually high enough so that the light falls on the subject's face from about 45 degrees above eye level, and to either the subject's right or left side, lighting the planes of the subject's face from about 45 degrees from the side.

The shadows cast by the key light alone usually are too dark for anything but a "stagey" dramatic effect; thus, you probably will want to add a *fill* light to reduce the subject contrast by lightening the shadows cast by the key light. Most beginners use too bright a fill, however, which washes out the effect of the key light and casts shadows of its own. The fill light should be only one half to one fourth as bright as the key, and it should be placed as near as possible to the camera. Experiment with the lighting ratio, remembering that for most human subjects there should be a two-zone difference between the bright side of the face and the shadow side. Ordinarily, caucasian skin in full light ought to be Zone VI and the shadow side of the face, Zone IV. Negro faces often reproduce well at Zones V and III. You can control the relative brightness of the fill by moving it toward or away from the subject or by "feathering" the lamp by turning the reflector to one side to control its brilliance. Other good techniques are to attach a white fiberglass diffuser over the fill light or to "bounce" the light from a convenient white wall or reflecting surface. Remember that

MARION GRZANOWSKI *The Afro*
Extremely strong backlight provided the halo effect, while a soft fill and some dodging of the print prevented the face from being lost.

a two-zone difference in brightness represents a 4:1 lighting ratio. You can verify this with your exposure meter, reading first the highlight side of the face and then the shadow side.

When dark-haired people are being photographed with only one or two lights, their hair sometimes blends into the background, or it lacks detail and sparkle. You can bring dark hair up to Zone III, improving its texture and adding some sparkling highlights, by using a third light, usually some kind of focusing spotlight. This third light, called an accent light or kicker, is placed high above and behind or to one side of the subject. Carefully aim the accent light at the area you want to lighten, being careful not to let any of the light spill over onto the subject's face or into the camera lens. When you add an accent light, it's generally a good idea to put a lens shade on your camera or to use "barn doors" or a "snoot" on the light to keep glare out of the lens.

If the background seems too dark, a fourth light can be placed behind the subject and directed onto the background. Move the subject farther away from the background if an objectionable shadow of the subject from the key or fill light falls on it. If the shadow is weak, the background light can eliminate it; if not, move the subject still farther from the background. A painted wall or plain drapes can serve as a portrait background if you don't have a roll of seamless paper or a painted canvas flat. A makeshift background rigged from a blanket or sheet usually shows wrinkles and looks fake. It is better to use a natural background. Try to avoid strong patterns and lines in the background unless you can use them as part of the composition. Strong background elements often distract by competing with the subject for the viewer's attention.

Most portraits of a seated subject look best if the camera height is near to the subject's eye level. Looking down on your subject can make the subject appear submissive (children are often photographed from an adult's eye-view), whereas looking up at a person either adds stature or a feeling of aloofness. If your camera is on a tripod, however, as it should be, direct your subject's eyes to the lens or to wherever you want the subject to look. Otherwise, in trying to get an animated expression, you might inadvertently

have the subject's eyes following you. If you're standing beside the camera, you might get a lot of "white of the eye," which looks unnatural. Usually, a head-on front view of a person (passport style) is unflattering or gives an unpleasant feeling of "confrontation." For most subjects, a three-quarter view is better. Turning the head in relation to the body gives a feeling of poised action. Don't hesitate to experiment with posing and lighting variations with a favorite model!

solving portrait problems

Professional portrait photographers have to lie a little—and sometimes a lot—in order to make a living. Very few people really are willing to be photographed the way they actually look, especially if they're paying for the pictures!

But you can be a portrait photographer and not resort to photographic sorcery or hand retouching to make your subject appear at his or her best. If you study your subject carefully, you'll see that camera angle, lighting, and choice of lens all can affect the subject's appearance for good or ill. Let's look at some examples of how to solve the most commonly encountered portrait problems:

Wrinkles. Wrinkles, crow's feet, and laugh lines are all signs of life, and everyone past the age of 20 has a few. A middle-aged or older person photographed without wrinkles would seem ridiculous (look at the window display at your neighborhood portrait studio). But nevertheless, when you photograph your mother, maiden aunt, or a favorite friend, the facial lines may seem a bit severe. Soft lighting will soften the lines. Diffusion can do the rest. Try using a diffusion filter made for the purpose, or make you own diffuser from a mesh window screen, a scrap of nylon stocking or pantyhose, or a piece of cellophane that has been wrinkled up and than flattened again. Try putting the diffuser over the camera lens, or try diffusing during enlargement. While enlarging you can control the amount of diffusion by holding the diffuser over the enlarging lens for only part of the exposure

As people grow older, there is written on their faces not only what life has brought to them but what they have brought to life.
John Mason Brown

After a certain age you've got the face you deserve, I think.
Henri Cartier-Bresson

One reason photographs don't look natural is that photographers always tell their subjects to look pleasant.
Author unknown

So many people dislike themselves so thoroughly that they never see any reproduction of themselves that suits. None of us is born with the right face. It's a tough job being a portrait photographer.
Imogen Cunningham

Have you wondered why portrait photographers nearly always use a longer-than-normal focal length lens? Compare the rendition of facial features, especially the nose and chin, in the photograph at the left, which was made with a 180mm lens on 6 x 7 cm format (equivalent to 105mm lens on a 35mm camera) with the version in the center made with the normal 90mm lens (equivalent to 55mm lens on a 35mm camera) and the result on the right in which a 65mm wide angle lens was used (equivalent to 35mm lens on a 35mm camera). The camera was moved closer when the shorter focal length lenses were used so that the head size would be the same on each negative.

time. Keep the diffuser moving. You can eliminate wrinkles on your subject's neck or conceal a double chin by "short" lighting the face and throwing the neck into shadow.

Distorted Facial Features. We suggested earlier that a longer-than-normal focal-length lens is best for most head and shoulders portraits. On close-ups of people, a normal focal-length or wide-angle lens tends to enlarge the nose or chin or whatever part of the face is closest to the camera. An extra-long telephoto lens tends to flatten out the features, giving a paper doll effect. The favorite focal length of most portrait photographers is 105 to 125mm for 35mm cameras, 150 to 180mm for 6cm cameras, and 210 to 360mm for 4 x 5. But suppose you have a subject for whom you want deliberately to emphasize or suppress a facial feature—a weak chin, for example. Choosing a relatively short focal length and a low camera angle will strengthen the chin in proportion to the rest of the face. Shooting slightly down on a person with a large forehead will emphasize the brain or egghead feeling. A long nose can be shortened by shooting from a slightly low camera angle.

A fat person tends to look heavier when photographed full-face. A heavy-set subject can be made to appear slimmer with a three-quarter pose and short lighting. Or you can add a few pounds to a thin-faced subject by use of broad or butterfly lighting.

Facial Blemishes. Look at your subject carefully to see whether you can conceal acne scars and other marks by choosing your subject's "best" side; then use short lighting to throw the offending areas into shadow. In severe cases, makeup may be needed; usually, however, diffused short lighting will do the trick. For extreme cases, the obvious solution is to throw the offending side of the face into total shadow—dramatic, but flattering to certain people.

Baldness. The rule here is simply to keep the light off the top of a bald man's head and not to emphasize his baldness with a high

camera angle. To save burning-in time in the darkroom, predodge a bald head by using barn doors on the lights or block some of the light with a head screen made from a piece of cardboard clamped to a stand. The same trick can be used to keep an ear or shoulder from being too light and distracting attention from the face.

Prominent Nose. A good look at your subject will tell you whether the nose requires special attention. Tilting the chin up will minimize a long nose, whereas meticulously controlled short lighting will straighten a crooked or an arched nose.

Glasses. If a person usually wears glasses, he or she often looks and feels strange without them. Leave the glasses on, but be extra careful about reflections, adjusting the lighting or positioning the subject's face so that shadows from the frames don't cut across the eyes. Tilting the face slightly down usually will get rid of reflections from the key and fill lights. With existing lamp or window light, the key is often reflected in the glasses; in the studio, the reflections are usually caused by the fill. Raising the bows (ear pieces) of the glasses or tipping the face down slightly will usually get rid of the objectionable reflections. Heavy frames are another problem, requiring careful placement of the key light to avoid shadows across the eyes. Watch out for secondary shadows from frames if the fill light is too bright or too far from the camera position.

Deep-set Eyes. Obviously, the problem here is to get enough light into the eye sockets. Either place the key light lower than normal, or lower the lighting ratio by moving the fill closer or using a reflector to bounce light into the eyes.

By taking the time to really study your subject intelligently and perceptively, you can capture your subject's likeness, as well as some of his or her essence and spirit, and avoid the "mortician's ideal" (the heavily retouched portrait) that's unfortunately still in vogue among many people. Good posing, lighting, and camera techniques will keep you from having to resort to handwork on the negatives or prints. With luck, you can make some money at portraiture as well, because the public is beginning to appreciate informal and more natural-looking portraits.

CARMEN ANDERSON *My Family*
Snapshot or portrait? How does one decide? Can a single image be both a personal recall picture and an image of broader significance?

full-length and group portraiture

A group portrait really should be a number of individual portraits taken at the same time. Be sure each face and figure is properly lighted to bring out the form and best features of each subject. But in group photography, the whole is actually greater than the sum of the parts because the total effect must be compositionally interesting, as well as technically well-lighted and photographed.

Avoid deadly, static, row-on-row groupings. Use enough imagination to arrange the people you're going to photograph in a unified and varied way. When people agree to be photographed, they'll look to you, the photographer, for guidance and direction. Tell them what to do, whether you merely want them to look toward the camera and "Smile, please," or pretend to be doing something. You have a chance to be a stage director when photographing groups of people, and the most successful method for arranging group pictures is often the *posed-unposed* technique. First you decide how to arrange people, props, and background the way you want them in relation to the lighting, and then you determine exposure and focus. After you've solved all your technical problems, you direct the people either to continue with what they would normally be doing (working on machines, examining an object, or talking informally with one another) or you give directions: "Joe, please hold up the trophy like this, with both hands

and be telling about how you won it; Mary and Jim, you'll be looking right at Joe"; or "Pick up the phone, Sally, and pretend that you're having a pleasant conversation with your boyfriend"; or "Be adjusting the horse's bridle with both hands, then turn and look directly at me . . . now smile!"

Full-length portraits require much greater attention to background detail and to the pose, especially if you're photographing outdoors. Obvious caveats include avoiding poles and branches growing out of people's heads, eliminating excessively bright or "busy" areas that might distract from the main subject(s), and not allowing awkward placement or amputation of arms, hands, legs, and feet. Body grace is especially important in fashion and figure photography because an awkward pose and crude lighting can make a beautiful person appear to be an ugly duckling. The cam-

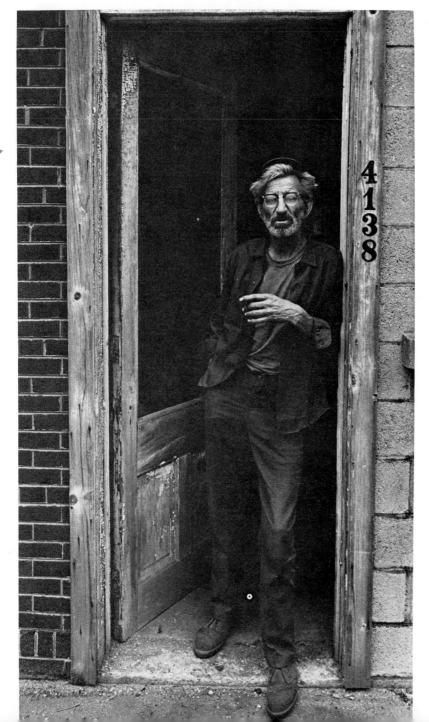

JIM NIXON *Man in Doorway*
A full-length portrait—straight-forward and eye to eye.

201

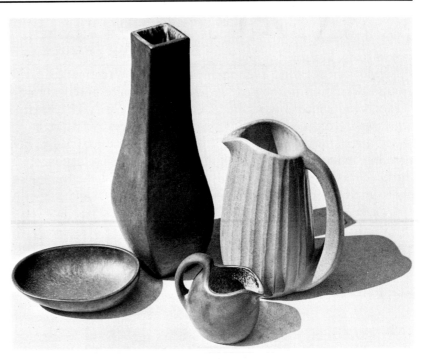

RICHARD STRADER *Ceramics*
Photographing objects requires the same care and attention to arrangement and lighting as making portraits of people. A single source of shadows (key light) is usually mandatory, plus sufficient fill light to retain adequate texture in the shadows. Still-life subjects often are most effectively lighted with the key light coming from behind or strongly from one side.

era angle should generally be lower for a full-length figure. Eye level is usually right for a head-and-shoulders portrait, but a chest- or even a waist-high camera position often lends grace and dignity to a standing figure.

The nude figure is the most difficult of all to photograph. A beautiful nude is seldom a portrait of a specific person unclothed—ideally it should be an impression of an anonymously senuous, esthetically satisfying form.

photographing inanimate objects

Most of the same principles that apply to portraits of people, not surprisingly, apply to the photographing of a structure, a sculpture, or a cereal box. The lighting principles are similar (key, fill, accent, background), and so are the elements of perspective and composition. Always think first in terms of reproducing the shape or form and texture of any subject; and then you'll be able to work out the details of lighting, lens choice, camera position, and so on, one problem at a time.

flash photography

Electronic flash, as mentioned earlier in Chapter Four on cameras and accessories, is a handy way to get a picture when it's inconvenient to set up lighting equipment or when there isn't enough existing light for satisfactory exposure. Many professional portrait and commercial studio photographers use electronic flash

To make a photograph of the human body express something more than mere physical nakedness or suggestive sex, one has to look for qualities that make the human body a natural and beautiful part of nature. The nakedness of a body is as natural as the nakedness of a tree.

Wynn Bullock

almost exclusively for their work because of its uniform quality, predictable intensity, incredible motion-stopping ability, and lack of uncomfortable heat and glare for the subject—whether the subject is a person, an animal, or an ice cream sundae. But professionals use costly, heavy-duty multiple studio-lighting units.

Effective lighting with flash, like good lighting with any other source, is the result of previsualizing the effect you want to achieve. Do you want shadows to be harsh, soft, or nonexistent? Do you want to emphasize texture or accent a certain part of the subject? Do you want to use light to separate the subject from the background? All of these questions should be answered before photographing any subject with flash or with any kind of light. The common method of using flash—with the flash unit attached to the top of the camera or held by a bracket to one side of the camera and aimed directly at the subject—violates all the principles of good lighting. Use a direct flash-on-camera only as a fill-in to illuminate harsh shadows cast by the sun as a key light, for personal "snapshooting," and as the sole light source only when absolutely necessary.

When flash is the only light source, calculate exposure either from the distance and f/stop guide supplied with the flash unit, or use the guide number method described below. Outdoors at night or in a large gymnasium or auditorium, where there aren't any nearby light-colored walls or ceiling to reflect light, you'll probably have to open up one or two full f/stops more than indicated by the calculator or guide number. Bounce flash also usually requires one or two additional stops because of the light absorbed by the ceiling or wall being used as a reflector. Outdoors, experiment a bit with flash as fill light. Start with setting the camera for normal exposure for the existing sunlight and then determine the distance from flash to subject required to balance out the light at the chosen f/stop. For example: Exposure required for sunlight exposure: $1/60$ at f/22.

> Flash guide number: 220
> $$220 \div 22 = 10 \text{ feet}$$
> Distance from flash to subject: 10 feet

Onlookers may wonder what you're doing, but holding your flash unit off-camera high and to one side will give better form and modeling to nearby subjects. A flexible coiled-cord simplifies off-camera and bounce flash.

In this example, if the flash is attached to the camera and you're closer to the subject than 10 feet, the flash fill will be too intense, overpowering the sunlight key. The solution here would be to put a thickness of white handkerchief over the flash unit for each f/stop you need to reduce the intensity. Taking the same example again, if you wanted to be seven feet away from the subject instead of ten feet:

$$\text{Guide number } 220 \div 7 = 32$$
$$\text{f/ stop required: f/32}$$

So you have two choices: either cover the flash with one thickness of white handkerchief to reduce its intensity by one stop, or change the basic exposure from $^1/_{60}$ @ f/22 to $^1/_{30}$ @ f/32.* Remember that cameras with focal-plane shutters (this includes nearly all 35mm single-lens reflex cameras) cannot synchronize electronic flash at the higher shutter speeds. With many SLRs you have to use $^1/_{60}$ or slower, which can cause a "ghost image" problem when you try to shoot fast action with an electronic flash fill when there is a lot of ambient light.

As a sole light source, a flash on the camera gives flat, uninteresting lighting, which, if combined with overexposure, can produce an image seriously lacking in detail. But by placing the flash unit to the side or above the camera, shadows are cast on the subject more from the ideal 45 degree key-light position, giving a feeling of form, texture, and depth. At the same time, objectionable shadows on the background may be eliminated or hidden less conspicuously behind and below the subject. Pink-eye is another common problem with flash-on-camera lighting. The eyes of subjects looking toward the camera may reflect spots of light the way the eyes of animals on the road reflect a car's headlights. The solution to this problem is to get the light source away from the camera.

*The fill light would balance the sunlight in the example given, resulting in even, but rather flat lighting (ratio 1:1). An additional thickness of diffusing material would be needed to reduce the lighting ratio to 2:1, or two thicknesses for a ratio of 4:1.

An off-camera flash requires a cord sufficiently long to hold the flash at arm's length, or farther. Because the flash is ordinarily about the same distance to the subject as it would be if mounted on the camera, the same f/stop may be used as with on-the-camera exposures. Take care to hold the flash so that the reflector is aimed where you want it. It's easy to tilt the reflector unknowingly up or sideways, with uneven lighting as the result.

By aiming the flash reflector at the ceiling or at a nearby, light-colored wall, you can generally obtain shadowless, low-contrast lighting. Aiming the flash at the ceiling or wall is called bounce lighting; one or two f/stops more exposure is usually required because some of the light is absorbed before it reaches the subject. This may cause special problems when you use an automatic electronic flash unit, so be sure to run tests with your own equipment.

copying and closeups

The photographic reproduction of flat objects is known as copying, whether you're making a new negative from an old photographic print or reproducing a map, chart, or drawing.

Black and white material to be copied is usually divided into two categories: *line* and *continuous tone*. Line copy materials contain only black and white without gray tones. Examples of line copy are a printed or typewritten page, an ink drawing, or a screened halftone reproduction (the image being broken up into a pattern of black and white dots). Such materials are best photographed on special film such as Kodalith Ortho or High Contrast Copy film. If high-contrast film is not available, you can use ordinary panchromatic films for high-contrast copying, but you should reduce the exposure by one stop and give $N + 3$ development to increase the contrast. You will then have a contrasty negative that will print with clean whites and good blacks on hard paper.

Continuous-tone originals, on the other hand, contain many shades of gray between the lightest and darkest tones. A good print of an ordinary photograph fits into the continuous-tone cate-

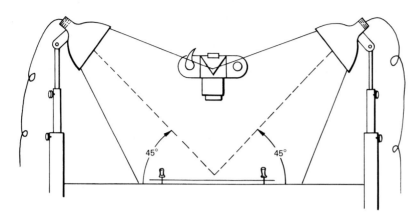

Flat artwork is most evenly lighted with a minimum of surface reflection when two identical lights are spaced evenly apart and placed at about 45° angles to the material to be copied. Polarizing filters over both lights and lens will subdue most remaining reflections if the problem persists.

"Feathering" the key light by aiming it at or slightly beyond the farthest object will enable you to light subjects more evenly when portions are at varying distances from the light source. Experiment with a gray card or incident light meter until the readings both near and far are approximately the same. The same principal applies to copy work when using only one light.

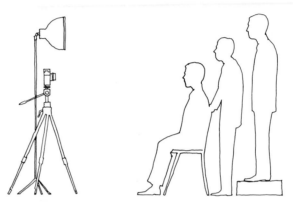

gory, as does a painting or drawing containing various shades of tone or different values and intensities of color. Slow, fine-grained panchromatic films are suitable for most continuous-tone copying. The highlights may tend to print with a grayish cast, however, and special copying films are available in sheet-film sizes that are designed to make reproductions that more exactly match the tonal values of the original.

The depth of field is very shallow in all close-up photography. For this reason, you'll want to stop the lens down as far as possible most of the time. A sturdy tripod or copy stand is absolutely necessary to hold the camera steady for copying and close-up photography and to ensure that the camera is held parallel to the original material.

Excellent copy negatives can be made by natural light as well as by artificial light if you take care to see that the lighting is even across the entire surface of the original print and that no reflections are present. Some photographers do all of their copy work in a shady spot outdoors. Unless you have a permanent set-up, flash is generally unsatisfactory for illuminating copy material because the results can't be visualized before the exposure and because calculating flash exposure is more difficult at short distances.

Two lights should be used to ensure even illumination when copying indoors. The lights—usually either photofloods or 3,200°K professional photo lamps in metal reflectors—should be

set at an angle of 45 degrees to the material to be copied and aimed so that they slightly overlap the center of the copy. Check with a hand-held exposure meter to be sure the light is even. A single light can be used in an emergency or if you want to emphasize surface texture or create shadows beneath objects such as 3D title letters. Adjust the height of the light to create the surface texture and shadows you want; then "feather" the light so it's aimed at the opposite side of the original material. Check the evenness of the light with a hand-held incident exposure meter, if possible, and readjust the angle of the light if necessary.

determining exposure for copying and close-ups

You should make and process a few trial exposures to serve as a guide for correct exposure with the equipment you're using. As long as conditions remain the same, it shouldn't be necessary to repeat your tests; however, if you alter the lighting, change to a different camera or meter, or use a different type of film or developer, you should once again expose and process a few test exposures to recalibrate.

Correct exposure can be determined most easily for copying and extreme close-up work by using a hand-held incident-light exposure meter or a reflected-light meter with incident-light attachment. If you're using a through-the-lens meter, you should make the reading not from the original subject, but from a neutral gray card of 18 per cent reflectance. The gray card represents an averaging of all brightnesses of an average original and is the equivalent of placing exposure settings on Zone V. If a standard 18 per cent gray card is not available, you can substitute a clean, smooth piece of matte white mounting board. Because the white board will reflect approximately five times as much light as the gray card, divide the ASA rating of the film by five, and then set this new ASA value into the meter before calculating the exposure.

With line copy, if the proper exposure has been determined by

reading either a gray card or a white card, it doesn't matter whether the original consists of black lines on a white background or white lines on a black background. An ordinary reflected-light meter reading from the actual subject would indicate very different exposures for those two extremes because of the tendency of the meter to expose the background as a Zone V middle gray. Whether you're exposing color or black and white film, the incident light or gray card method is recommended not only for copying, but for all kinds of small-object photography. In photographing small objects, it is difficult to read the brightness of each small area separately in order to place their values properly according to the zone system. If possible, develop a test exposure immediately, leaving the copying setup intact, so that you can return and make any necessary corrections as soon as you've examined the test negatives.

exposure increase factor

Additional exposure correction is necessary when photographing something that is closer to the camera than approximately eight times the focal length of the lens used. For example, if you are copying a small picture with a 35mm camera, using the normal 50mm lens, any work done with the subject closer to *the film plane* (inside the back of the camera) than 400mm or 16 inches would be subject to the correction. If you were using a 4 x 5 view camera with 200mm (8-inch) lens, the correction factor would apply at subject-to-film distances closer than 64 inches (1.6 meters). Note that the correction factor applies only when the lens is physically moved out beyond its usual focusing position and when exposure is *not* determined with a through-the-lens meter. If slip-on close-up lenses are used, the lens is not physically extended so the correction is not required. When a camera is closer to the subject than eight times the focal length of the lens, the bellows extension, or extension-tube length, to obtain a sharp focus is great enough to alter the f/stop values marked on the lens, resulting in underexposure unless a correction is made. Lens-to-film distance

should be measured from the optical center of the lens—usually at the aperture ring. A through-the-lens exposure meter automatically compensates for additional lens or bellows extension because light getting to the meter's photoelectric cell will already have traveled the same extra distance traveled by light reaching the film.

The easiest way to calculate the exposure increase factor when it is required is to refer to a table or guide designed for this purpose. There is such a calculator in the *Kodak Master Photoguide* (see the selected references) and a table for 35mm cameras with 50mm lenses appears on page 86 of this book (table 4-1).

There is a formula that you can apply if you're the precise, mathematical type:

$$X = \frac{B^2}{F^2}$$

$X = $ Number of times more exposure required

$B = $ Bellows extension (lens-to-film distance after focusing)

$F = $ Focal length of camera lens (read from the lens mount)

Example: $B = 10$ cm
$F = 5$ cm (50mm)

$$X = \frac{B^2}{F^2}$$

$$X = \frac{10^2}{5^2}$$

$$X = \frac{100}{25}$$

$$X = 4$$

This means that, in the example, the exposure indicated by the meter from the gray card or incident-light reading should be increased four times (4×) or the equivalent of two full f/stops. Example: $1/15$ at f/11, instead of $1/15$ at f/22; or $1/4$ at f/22, instead of $1/15$ at f/22.

If you're the happy-go-lucky nonmathematical type and you have neither the patience to use the formula nor the good fortune to have a table or calculator handy, you can probably get by with

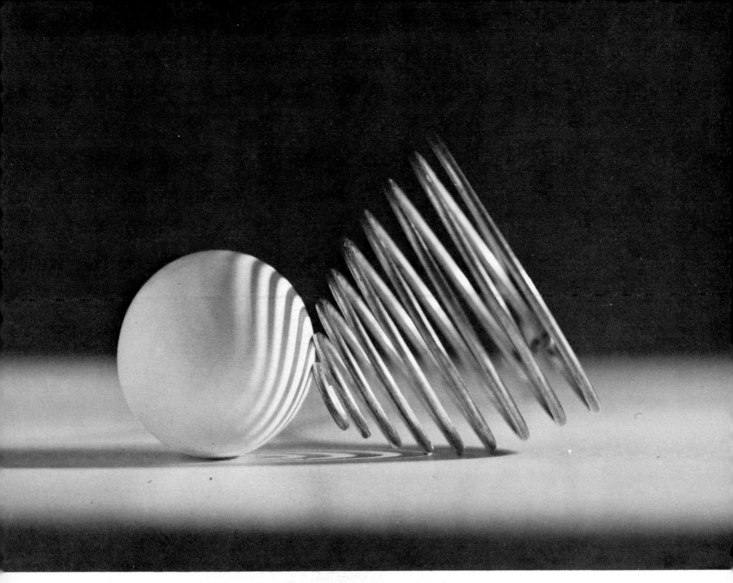

DOUG HAUK *Ball and Spring*
A commercial subject in which
imaginative use of lighting has em-
phasized and repeated the basic
forms.

the general rule that if the reproduction on the negative is the
same size as the original object (1:1 ratio), the increase factor is 4×
(two stops). If the image on the negative is half the size of the orig-
inal, the increase should be 2× (one stop). You can easily in-
terpolate these factors for intermediate reproduction ratios.

One final word of warning is that the exposure correction factor
for close-up photography has nothing to do with the zone system.
You must apply any needed correction factor *after* you've deter-
mined the optimum basic exposure. The correction factor is in ad-
dition to any other calculations for placing zones, compensating
for filter factors, or correcting for reciprocity departure.

photographing small objects

Most of what has been said about copying applies also to the
photographing of small objects—sometimes referred to as table-
top photography. Such photographs demand especially fine detail
and technical quality. The main problems encountered in photo-
graphing small objects are in obtaining adequate depth of field and

proper exposure at close working distances and in lighting the subject properly and getting an unobtrusive background.

Depth of field can be maximized by using the smallest lens opening available, by rearranging the objects to be photographed, and by getting no closer than absolutely necessary. View camera users, of course, have the additional advantage of being able to tilt or swing the front of the camera to increase depth of field.

Photographing small objects offers a fine opportunity for you to discover the effects of light placement. As you shift the lights about in your miniature "studio," you should notice the way the shadows fall and the way in which lighting angle can reveal and emphasize texture. Strong shadows may add to the effectiveness of close-up pictures, even to the point where the shadow may be more interesting than the object itself. Dramatic lighting can produce a three-dimensional effect, for the highlights tend to come forward and the shadow areas tend to recede.

Your choice of background will depend on the tone and texture of the subject. If the background is white or very light in color you can vary the contrast between it and the subject simply by using more or less light on the background. The background should be unbroken by seams, edges, or wrinkles. For small objects, a miniature stage can be improvised by curving and taping a large sheet of lightweight poster board or seamless paper along the top of a small table and part way up a wall. If your background is large enough to allow the subject to be placed well forward, the table can be pulled away from the wall far enough to allow you to place lights anywhere you want them. Instead of a plain paper background you might choose a material that can give added information about the subject if you're careful not to introduce too much additional texture or pattern. Native backgrounds such as stone, sand, cloth, woven matting, or tree bark can establish location and add character and realism to certain subjects.

Another good trick to remember in photographing very small objects is to show something relevant in the picture that will give

Artists . . . don't copy nature, and when they do record quite literally, the presentation is such as to arouse connotations quite apart from the subject matter.

Edward Weston

Improvise a table-top studio with a seamless background.

size comparison, unless you want deliberately to confuse or surprise your viewers. A human hand or finger can be used, or a pencil, or some other common object that everyone recognizes. For photographic records, simply placing a small ruler or metric scale near the subject may make the picture more valuable.

unexpected experiences

People believe in photographs. Most of us still subconsciously accept the old cliché that "the camera never lies"—hence, the enormous power of photography to shock us by twisting what we have quietly expected to be a faithful reproduction of reality into an unexpected experience.

Frequently there is a conflict between interesting subject matter and interesting photographs. Great photographs exist that are superb renditions of interesting subject matter, yet in other great photographs the subject matter is scarcely recognizable. Artists use the term *surrealism* to describe work that transcends reality; but unique to photography is the ability to produce an image that exists in a world of its own, halfway between the real and the imaginary.

Sometimes, because of subtly revealed textures and forms or bizarre juxtaposition of subject matter, a "straight" photograph may offer us a surrealistic surprise. But more often, such interesting images are the result of inspired manipulation.

Some photographic effects are good, clean fun. Some of the more obvious "tricks" that can make a visual joke (or sometimes sell a product) include multiple exposures of the literal type, such as adding clouds to a bald landscape.

Darkroom effects range from the obvious to the amazing, with many steps in between. Photographic effects are created in one of three ways: by accident, by trial and error, or by deliberate design (Uelsmann's *post*visualization). In this chapter are examples of several of the special effects techniques that my students have seemed most interested in trying, together with detailed instructions so that you can postvisualize some of your own images with a minimum of trial and error.

photograms

A cameraless shadow picture or photogram is the first assignment given by many teachers of photography. Because a pho-

Events that never happened—photographs of strange things and strange visions in strange places.

Peter Gold

It is possible to create any image one thinks of; this possibility, of course, is contingent on being able to think and create. The greatest potential source of photographic imagery is the mind.

Les Krims

The darkroom is capable of being, in the truest sense, a visual research lab; a place for discovery, observation, and meditation. . . . Let us not be afraid to allow for "postvisualization" . . . willingness on the part of the photographer to revisualize the final image at any point in the entire photographic process.

Jerry N. Uelsmann

My eyes see things that I don't know they see.

Ralph Gibson

The universe is full of magical things patiently waiting for our wits to grow sharper.

E. Phillpots

the surreal and the bizarre

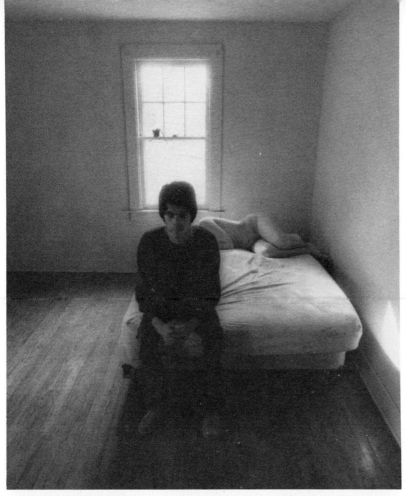

MICKEY HOWELL *Bedroom*
Are you puzzled and intrigued by
the bizarre lack of information in
this photograph? Why is the room
empty except for the bed and the
tiny plant in the window? Why are
the man and woman juxtaposed in
this manner?

WILLIAM BEVERLY *Junkyard*
Besides being what it is . . . what
else is it?

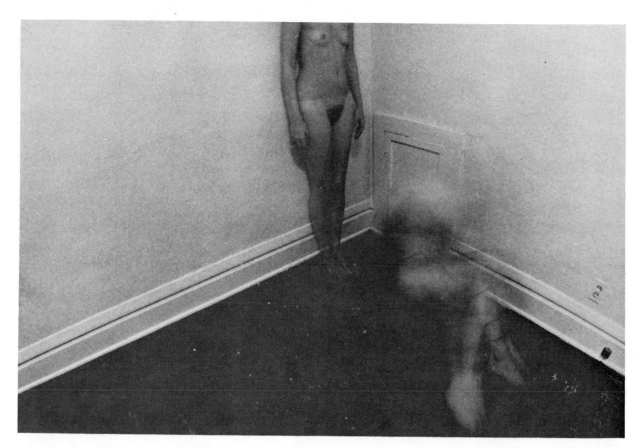

togram project requires no negative, it can be done on the first day of class; the experience with chemicals and an enlarger or other light source provides a beginner an excellent initiation into the mysterious rites of the darkroom. But making photograms can be more than an exercise. Exploring this simple process may challenge your imagination to find forms that will reproduce themselves in varied tones and to place them in graphically interesting patterns.

Any photographic paper will do for photograms—in fact, this is a good way to use up odd lots of outdated or surplus paper of any size, surface, weight, or contrast grade. Simply make a trial exposure to determine the deepest black you can get without pro-

Perhaps the biggest surprises will be found not in the far reaches of outer space, but rather in the near reaches of inner space—that special space where wonders are wondered, new worlds are imagined, and happenings are understood.
Bill Stonebarger

The most beautiful thing we can experience is the mysterious. It is the source of all true science and art.
Albert Einstein

Great photographs exist . . . in the electric tension between real and unreal.
Charles Harbutt

KURT OLDENBROOK *The Corner*
A photographic puzzle: What's going on here? Is this some sort of sado-masochistic ritual? Why is one figure bound and struggling on the floor while the other, decapitated, stands erect? Why is the action taking place in this stark corner? What is the significance of the small door in the wall?

You're looking at something that looks like something you know or something you don't know, and after a while of looking at it it begins to start taking shape for you and the back of your neck crawls a funny way and you know if you keep going it will start to make sense for you so you stay with it just a bit longer, changing yourself in a way somehow that suddenly makes it pop out clearly—just what you knew was there all the time.
Peter Gold

Jᴜᴍ Nɪxᴏɴ *Gable*

Dramatic clouds were needed to add dimensions of depth and mystery to the gable of this old house, but the sky was blank white that day. Double printing did the trick. First, the negative image of the gable was projected to the desired size on the enlarging easel and an outline of the gable traced with pencil onto black paper. Cut out precisely with scissors, the black paper mask then was used to cover the area where the gable was exposed, while printing in the clouds from another negative. A red filter under the enlarger lens was very helpful in aligning the mask and the second image. Careful spotting of the print will usually correct minor imperfections in registration.

ducing flare around the images of the objects you've placed on the paper.

prints from slides

A negative print? Of course. And such a negative print can be used as an intermediate paper negative to make a positive print on a second sheet of photographic paper. The contrast usually is greatly increased by this process, so you should begin with an

LOIS HENRY *Leaves*
The various tones of gray in this photogram were achieved by removing one leaf at a time during the exposure, leaving only the maple white.

JAMES ALVARO *Photogram*

AURELIA SPENGLER *Photogram*

217

DOUGLAS HAUK *Photogram*
Translucent objects often impart unique textures and varigated values of their own. This is a positive print made from a photogram on film.

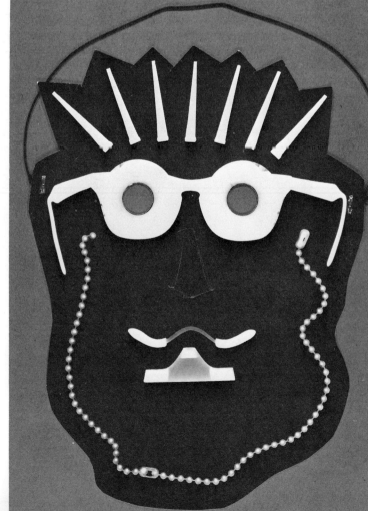

D. CURL *Photogram Mask*
A class Halloween party provided the occasion for students (and the teacher) to make and wear their own photogram masks.

LINDA CHICK *Motor Monster*
Here, positive and negative prints have been juxtaposed to create a mask-like image that bears little resemblance to the original subject matter.

STEVEN HUNT *Junked Truck*
You can produce a spectacular negative print by placing a positive transparency such as a color slide in the negative carrier of your enlarger. Another method, used for this photograph, is to use a conventional enlargement, preferably on single-weight paper, as a paper "negative." A vacuum, or pressure, easel is needed to keep the print and unexposed paper in firm emulsion-to-emulsion contact during exposure. This example was made, however, by squeegeeing the emulsion of the wet print into contact with the emulsion side of a sheet of unexposed enlarging paper that had been soaked in water for 30 seconds. Exposure was made through the back of the paper negative. The two sheets of photographic paper were then peeled apart and the negative print was developed normally.

D. CURL *Textured Figure*

POP solarization provides repeatable Sabattier effect images on a single sheet of number 6 paper. The process, adapted slightly from an article in *Peterson's Photographic Magazine,** is as follows:

1. Set the enlarger lens at f/5.6.

2. Focus a negative with good black/white separation onto a piece of plain white paper, using a sheet of glass as an easel.

3. Soak a sheet of Agfa Brovira number 6 paper in fresh print developer at normal dilution for at least one minute.

4. Place the wet paper, emulsion side up, on the glass and gently remove all of the developer from the surface. Wipe with a rubber squeegee blade or blot with a paper towel.

5. Place a red filter in the enlarger light path. Turn on the enlarger and position the glass so that the paper is in the desired area of the projected image.

6. Turn off the enlarger lamp, remove the red filter, and make the first exposure. Try four seconds at f/5.6 as a starting point. Don't move the glass or the paper after the exposure!

7. Watch the print develop under the enlarger for about 30 seconds. The print should appear very contrasty and somewhat light.

8. Make a second exposure at three times the first exposure (for example, 12 seconds if the first exposure was four seconds).

9. Return the print to the developer tray for at least 30 seconds to deepen the blacks.

10. Stop, fix, wash, and dry the print, as usual.

11. Clean up everything especially well. Be sure to wash the glass!

*Derryl G. Berry, "POP Solarization," *Petersen's Photographic Magazine*, vol. 4, No. 9, pp. 74–79 (Jan. 1976).

image that has strong lines or forms that will retain their separation from the background and from other elements in the image. For maximum sharpness, contact printing should be done emulsion to emulsion, in either a vacuum frame or a spring-backed glass printing frame. Lacking a vacuum or spring-back frame, you can achieve good emulsion-to-emulsion contact by wetting both the paper negative and the unexposed paper and pressing the two sheets together with a print roller or squeegee. After exposure, peel apart the two sheets and develop the final print normally.

solarization (the Sabattier effect)

Intriguing, partly negative, partly positive images are the result of exposing either film or paper to white light after development has been partially completed. The part of the image already developed acts as a mask, while the previously unexposed emulsion is being exposed to light. If the image has strong contrasts between light and dark areas, delicate white or black outlines, called Mackie lines, may be formed. Don't give up in despair if the first results aren't what you expected—part of the joy of the Sabattier effect is its unpredictability. You'll find that you can vary the effect if you experiment with the duration of the white light "flash" exposure and whether the exposure occurs when the print is only partially or almost fully developed. When you try the Sabattier effect on film, of course, you have only one chance—if the effect isn't right you have to make another negative. For this reason, I suggest you expose several duplicate negatives on sheet film or space your frames on roll film so you can cut the roll into perhaps

A special process offers me inestimable new understanding; I am able to return to straight work with new insight into both process and imagery.

Victor Landweber

D. CURL *Young Sassafras*
Solarization (the Sabattier effect) in the conventional manner. The very dark image on the right was exposed, on number 6 paper, from the original negative. After one minute of development, a 100-watt bulb in the darkroom ceiling was turned on and then immediately turned off. The print was allowed to develop, without agitation, for 30 additional seconds before being stopped, fixed, and rinsed in water. This dark print was then squeegeed face to face with an unexposed sheet of wet number 6 paper and the sandwich exposed to white light, through the back of the paper "negative," for about 10 seconds. The two sheets of paper were then peeled apart and the second sheet was processed normally, resulting in the print on the left.

JOHN STITES *The Oak*
Conventional print from Original continuous-tone negative.

SHIRLEY BALE *Brushes*
The Sabattier effect can be especially pleasing when the negative is solarized instead of the print. Be prepared to experiment, however, and use duplicate negatives!

LOWELL MCCOY *Self-portrait*
Double-exposure, paper-negative, and solarization (Sabattier effect) techniques were employed to create this unusual image.

High-contrast litho film can produce interesting positive and negative images and lends itself well to the Sabattier effect. Positive and negative images were made by contact on Kodalith Ortho Type 3 film from the original continuous-tone negative. Some of these negative and positive film images were exposed (solarized) for one second to the light of a 25-watt bulb four feet above the developing tray. The entire process can take place under illumination from a red Wratten series IA safelight.

Positive print made from Kodalith negative produced by contact from Kodalith positive.

Negative print made from Kodalith positive produced from original negative.

Negative print made from solarized Kodalith positive produced as follows:
 1. Normal contact printing exposure as determined by test
 2. 45-second development in Kodalith developer, in a tray, with constant agitation
 3. 15-second still development with no agitation
 4. Second exposure (one second, 25-watt bulb, four feet above tray)
 5. 1½-minute still development without agitation
 6. Normal stop, fix, and wash

Positive print made from Kodalith negative produced by contact from solarized Kodalith positive.

THERESE DOUVILLE *Vectors*
The high-contrast drop-out process eliminates all extraneous detail, focusing attention on the underlying graphic design. Notice in this example that the high-contrast technique provides a strong interplay between positive and negative space (foreground and background), without depending on inherent interest in the subject matter.

three sections for separate development and solarization. Kodalith Ortho, Kodak Commercial film, or Contrast Process Ortho are recommended when you want to make duplicate sheet-film positives or negatives for solarization, as these films can be developed by inspection under safelight illumination.

high-contrast drop-outs

Some photographs have more impact if the middle tones are "dropped out"; that is, if the image is reduced from a full scale of tones to only pure black and white. Obviously, this isn't an effect that you would use too often, because it would lose its novelty and defeat the purpose of striving for a rich tonal scale. A straight

enlargement on grade 5 or 6 paper will often yield a very satisfactory high-contrast print from a negative that already is a strong near-silhouette or that includes prominent light and dark elements. Additional tones can be dropped out by making an intermediate positive (or negative) on grade 5 or 6 paper or on Kodalith Ortho film. Kodalith is a photolithographer's film that is intended to yield completely clear lines against an opaque black background if exposed properly (ASA 3 to 6) and developed in Kodalith developer. Kodalith and other brands of litho films solarize beautifully, and they can be developed for somewhat lower contrast in ordinary print developer. A red (series IA) safelight lets you develop by inspection until you see the result you want. Kodalith Ortho film and Kodak High-Contrast Copy Film (panchromatic) can be obtained in 35mm rolls and exposed directly in the camera. The exposure is extremely critical, however, and it's much easier to control the results when you convert a normal negative or color slide to high contrast in the darkroom.

bas-relief

Combining a film positive with a negative of the same image can result in a dramatic low-relief effect. Commercial or Contrast Process Ortho film is convenient for making the positive, either by contrast or by projection, because it can be handled under a safelight. If you're starting with a 35mm negative and want to make the film positive by projection onto 4x5 film, then you should make from that positive a duplicate 4x5 negative by contact. The low-relief effect is strongest when the positive and negative match

JOHN STITES *Cycle*
This bas relief print was produced from a film positive and negative made on continuous-tone Commercial film instead of Kodalith. The densities of both negative and positive should be approximately the same.

JOHN STITES *Virginia*

Conventional print from original negative.

Appearance of shadow negative.

each other closely in density; however, experimentation with slight differences may yield very interesting results.

tone separation (posterization)

Another way to produce a strong graphic image, particularly of a portrait subject, is to make three or four high-contrast separation negatives on high-contrast litho film. Start with a fairly contrasty film positive and expose the duplicate negatives either by contact or by projection. You should deliberately underexpose one negative so that only the highlight areas are recorded. The intermediate negative(s) should receive somewhat more exposure, therefore the opaque areas will be larger. Finally, the negative receiving the most exposure will record the largest area of density and cover the deepest shadows that you'll be able to reproduce. The separation negatives must be printed in sequence of the most dense through the least dense, and they must be registered exactly with one another, similar to the way in which screen-process stencils are registered when printing with inks.

Appearance of midrange negative.

Appearance of highlight negative.

Posterization converts a conventional photographic image into something akin to a screen print. Instead of a full range of gray tones, the scale is limited to three or four values. This example was produced by the following procedure:

1. Three Kodalith positives were made by contact from the original continuous-tone negative. Exposures were 2.5, 5, and 10 seconds, as determined by test.

2. Three Kodalith negatives were made by contact from the Kodalith positives made in step 1 (same exposure for all three).

3. The final enlargement was made with three different exposures, from the three different Kodalith negatives, all on the same sheet of paper.

 a. Shadow negative (most dense): 35 seconds

 b. Midrange negative (middle density): 7 seconds

 c. Highlight negative (least dense): 4 seconds

Exposures were determined first by making separate test strips. Each negative was registered visually with a print made previously; then the enlarging paper was returned to the easel, in exactly the same position each time.

JOHN STITES *The Entertainer*

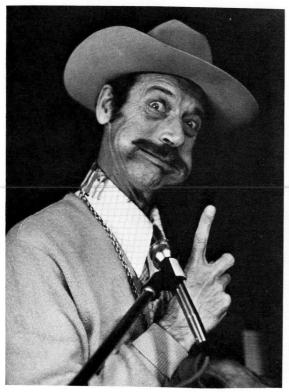

Conventional enlargement from the original continuous-tone negative.

Enlargement made from a high-contrast positive made by contact from the negative produced in step 5.

Enlargement made from the Tone-Line negative produced in step 5 below. The Tone-Line process can convert a continuous-tone photograph into an image resembling a pen and ink drawing. These examples were produced by the following procedure:

1. Conventional 35mm negative enlarged onto Kodalith film to make a high-contrast film positive.

2. Kodalith positive contact printed onto Kodalith film to make a high-contrast negative.

3. Kodalith negative opaqued to remove dust-spot pinholes.

4. High-contrast negative and positive taped together in register and placed into a pressure-back printing frame with a sheet of unexposed Kodalith film. Printing frame placed on turntable (see diagram).

5. Exposure with turntable rotating at 45 rpm was five seconds with a 60-watt bulb three feet from the turntable and at a 45-degree angle.

The *Tone-Line* or *Spin Drop-Out* process requires that positive and negative images be registered together for the exposure of the high-contrast litho film. Rotating this film sandwich during exposure should produce an outline image of sufficient continuity and density. Experiment with small strips of film until you find the best exposure time. Rotation does not have to be rapid, but it should be even. A kitchen "lazy Susan" will serve as a turntable if you don't have an old phonograph.

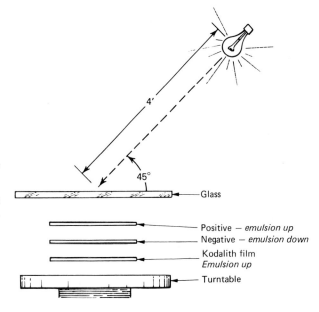

tone-line (spin drop-out)

A line-drawing treatment sometimes attributed to the Sabattier effect is achieved by registering positive and negative images and then printing this pair onto high-contrast litho film, exposing the film sandwich to an oblique light source while whirling it on a turntable! Although this seems to be a very weird process, the resulting detail and strength of line are well worth the effort involved. As with all special-effect processes, you'll have to experiment a bit to get the optimum exposure.

image distortion

The same technique that corrects for converging verticals and similar errors in perspective can be reversed to *produce* distortion in a normal image. Try going even further than tilting the easel: actually curving the paper, for example, can make a "stopper"

JIM SCHERRER *Volksface*
A curiously distorted, facelike image has been produced by holding the enlarging paper in a sharply curved position during exposure.

from an ordinary photograph. Another idea you might want to try is to aim your camera into a highly polished surface for distortion and then add to the effect by holding the paper out of square when printing.

multiple exposures

You've seen photographs of rapid action stopped in sequence by repeating electronic flash (strobe) units. Although most discotheque-type psychedelic strobes don't put out enough light for photography, you can simulate the multiple strobe effect by slowing down the action and firing a regular electronic flash repeatedly while the shutter is held open on "B." You must have a black background (or be outdoors at night), otherwise the light flashing repeatedly onto the background will build up too much density on the negative and obscure the image. Strong side light-

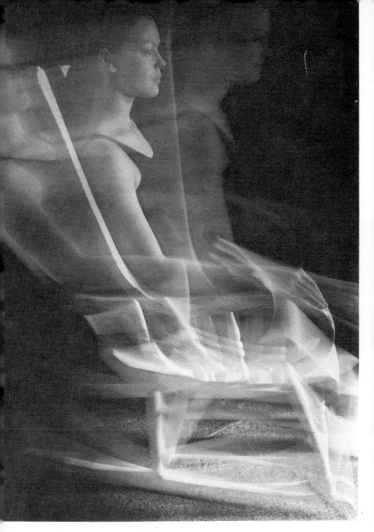
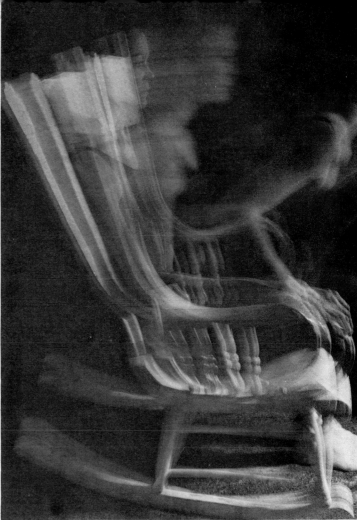

ing is best, and a few rehearsals will show you exactly where your model should be and when to fire the flash. The lens opening should be the same as for a normal flash picture. Combining sharp with blurred motion images is another interesting technique. You either combine electronic flash with enough incandescent illumination to register the moving subject, or, if you're using only floods, have your subject move, then hold; move, then hold; leaving sharp images connected by blurs to give the appearance of motion. Another variation on the multiple-exposure theme is to make

STEVE MCNUT *Rocking*
The model recorded sharp images of herself as she paused briefly, blurring as she moved during the brief time exposure (shutter set on B, cable release depressed for about five seconds).

The true magician can explain his trick, but the magic is still there.
Jerry N. Uelsmann

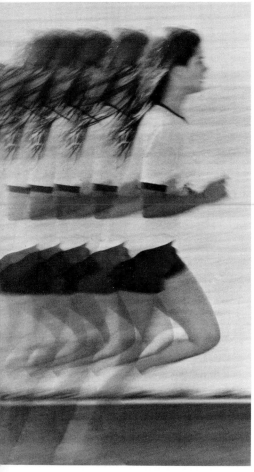

RENÉ POCH *Runner*
The illusion of motion in this photograph was achieved by making five separate exposures on the same sheet of enlarging paper, moving the easel a fraction of an inch each time. The white background enabled the runner's face and form to stand out because the paper remained virtually unexposed in those areas.

BERTA STAUFFENBERG *Mother*
A bizarre, ghostly effect was obtained by sandwiching two negatives together and printing them as one.

repeated exposures on the same sheet of enlarging paper, moving the easel a fraction of an inch between each exposure.

multiple printing

Sometimes it's effective, and often amusing, to print from more than one negative onto the same sheet of enlarging paper. There are actually three different ways of doing this so the images seem to form one, the choice of method depending on the relationships of the images and on the size of the negatives and whether their

JOHN BARTOCCI *Nude*
Although similar to the effect of a negative sandwich, this image is the result of a deliberate double exposure in the camera.

234

LOWELL MCCOY *Sunflowers*
A negative sandwich resulted in
this dramatic effect. Because the
sky portion of the sunflower nega-
tive was virtually opaque and the
foreground nearly transparent, the
bubble negative printed through
only the foreground.

DAN FETTERS *Self-portrait*
This photographer put himself on
TV by the simple expedient of ex-
posing the same sheet of enlarging
paper separately to two different
negatives. The cutout mask used
to separate the shoulders from the
frame of the TV set would have
been unnecessary if the entire por-
trait negative, except for the face,
had been white (opaque on the
negative).

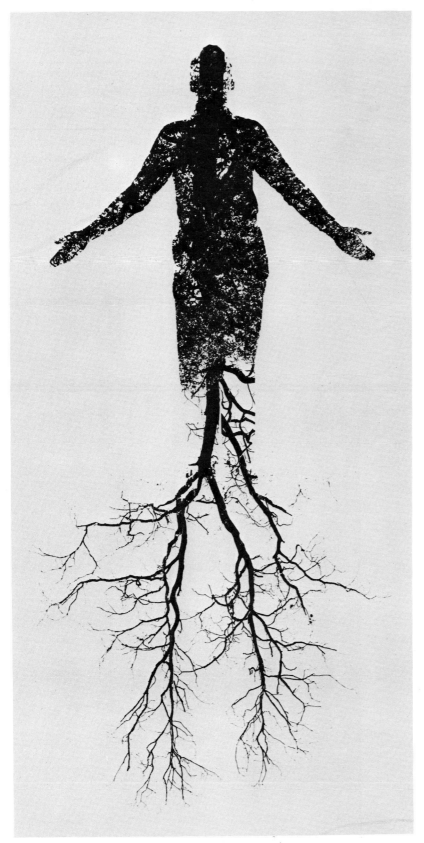

D. Curl *Roots*
Two negatives were sandwiched, one of them upside down, to produce a "roots" effect. The completely white background resulted because the backgrounds of both the tree and the silhouette figure negatives were very dense and overlapped when the two negatives were sandwiched for printing.

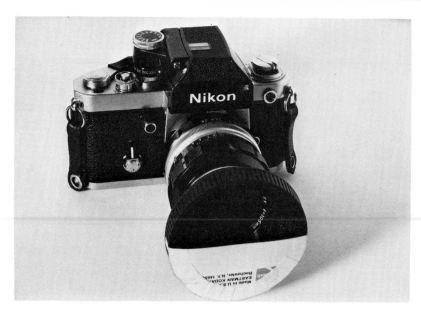

BRIAN KUEHN
Blends can be accomplished either in the camera or under the enlarger. A piece of matte black paper taped over half of the lens shade will do. (In the illustration, we have used a piece cut from an enlarging-paper envelope—yellow outside, black inside). If the blend line is too apparent, place the black paper mask inside the lens shade, closer to the lens, but be careful that it cuts the circle of light exactly in half. Try putting black paper in the enlarger filter holder beneath the lens and experimenting with placement of the blend line and lens opening until you get the effect you want.

D. CURL *Daymare*
This blend was achieved in the darkroom, using two separate negatives. First the top half was printed while the bottom half of the paper was covered with black paper in the filter holder. Then the negative was changed and the bottom portion of the photographic paper was exposed while the top was covered. A red filter under the enlarger lens allowed positioning of the blend line without removing the sensitized paper from the easel.

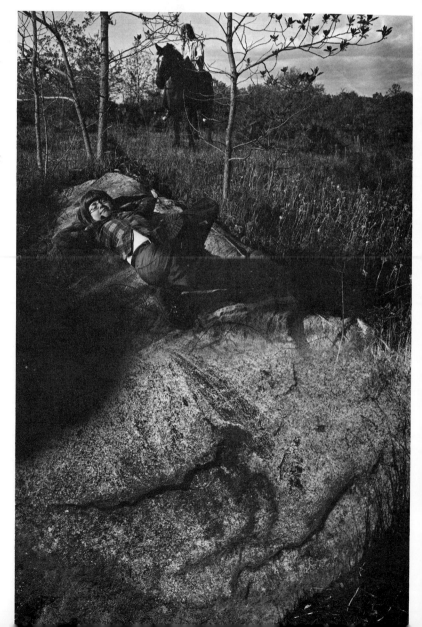

backgrounds are black (transparent on the negative) or light (dense on the negative). If you have a pair of negatives with transparent backgrounds, and if the subjects are in scale with each other, a simple negative sandwich in the enlarger will work. To see whether two negatives will sandwich effectively, simply hold them up to the light together and move them around to see whether they will register satisfactorily.

Negatives with dense backgrounds must be printed separately. The background of the second negative, if it is dense enough, will mask out all but the image you want to print, so as not to affect the image from the first negative already printed. Careful dodging or vignetting will be necessary if the backgrounds of the negatives are not dense enough.

Finally, and most difficult of all, is the blending of portions of two or more separate negatives to create what appears to be a single, unmanipulated image. Although a great deal of practice is required to make a blend line that doesn't show, the results can be strikingly surreal.

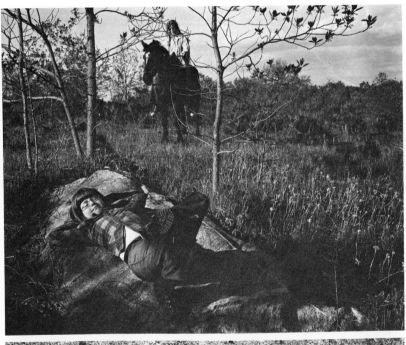

BRIAN KUEHN *My Cellar*
This image was blended entirely with light at the time the negative was exposed. A single 100-watt bulb in a reflector was used, first aimed downward, illuminating the lower half of the figure and leaving dark her upper body and the wall. The lens cap was put over the lens and the model stepped out of the picture. Then the light was aimed at the upper part of the wall for the remainder of the exposure.

induced grain

Although grain is something most photographers want to avoid, there are certain images that may benefit from the mystery, stress, or reverie that a strong grain texture can evoke. Grain, of course, is the result of several factors, including a very fast film, generous exposure, vigorous development, and a high degree of enlargement on a hard grade of paper. One system that you might want to try involves shooting Kodak High-Speed Recording Film 2475 at ASA 2,000, developing either in the recommended DK-50, in

HC-110 diluted 1:3, or in Dektol print developer diluted 1:1. A giant blowup of such a negative on very hard paper (grade 4, 5, or 6) can yield spectacular grain.

texture screens

Another way to superimpose an overall texture pattern onto a photograph is to print through a transparent material with the desired design. Texture screens can be purchased, or you can make your own by photographing a textured surface on high-contrast litho film. Zip-a-Tone and similar adhesive texture screens used by graphic artists can be reproduced on litho film also, and some materials such as lace, netting, or rice paper can be used directly as texture screens. The screen either can be sandwiched with the negative or placed over the enlarging paper when the print is made. Ordinarily, you should use a sheet of glass or a negative proofer to hold the texture screen and the paper in firm con-

MICKEY HOWELL *Ann*
Although grain is usually something to minimize, course grain occasionally strengthens the statement. This is an enlargement of a small portion of a 35mm negative made on Kodak 2475 Recording Film. This extremely fast film, inherently grainy, was somewhat overexposed and vigorously developed in print developer. All of these "mistakes" added up to increased impact.

J. SAVAGE *Old House*
Texture effects can be simulated by placing a transparent pattern in contact with either the negative or the paper and printing through the combination. This cobweb effect was obtained by sandwiching a sheet of lens cleaning tissue with the negative.

tact. A glass negative carrier may be needed in the enlarger, too, but usually stopping down the lens will keep both negative and screen in good focus.

halftones

Continuous-tone photographs must be printed through a kind of texture screen if they're to be reproduced in ink on a printed page, such as in a book or a magazine. The special screens used for this purpose break up the image into a regular pattern of black

DAN KLAASEN *Scarface*
The concentric circle pattern on the negative portrait resulted from a commercial texture screen being placed over the film positive when the enlargement was made.

A painting can be abstract from the beginning; a photograph, to be nonobjective, must either be selected with infinite care from a corner of nature or tortured out of all recognition in processing.
Thomas W. Leavitt

One must learn by doing the thing; for though you think you know it, you have no certainty until you try.
Sophocles

Constant creativity and innovation are essential to combat visual mediocrity.
Jerry N. Uelsmann

MARY KAY PAYNE *Reticulation* Sometimes the result of an accident during film processing, the textured effect known as reticulation is a wrinkling of the emulsion caused by rapid expansion and contraction of the gelatine. If you want to reticulate deliberately, immediately after the developer place the film into a rinse of hot water at least 140°F (60°C). Leave the film in the hot water for one minute, and then plunge it immediately into a bath of ice water for another minute before fixing and washing. Dry the film quickly with hot air.

and white dots of various sizes that, if the screen pattern is small enough, give the illusion of various tones of gray. You can get a sort of "pop-art" effect by superimposing a photolithographer's halftone screen on your negative and then enlarging it until the dot pattern becomes visible. A transparent contact screen can be placed tightly against the enlarging paper or sandwiched with the negative and then enlarged, or a duplicate negative can be made on Kodalith Autoscreen Ortho film. Autoscreen film has a built-in 133 lines-per-inch dot pattern that can be enlarged to the degree desired. Such a screened negative can be used to produce a screened positive on ordinary litho film, the first step in making photographic screen-process prints.

reticulation

One of my students "discovered" reticulation quite by accident. She came to me in tears, having "ruined" an entire roll of negatives. Luckily, however, the subject matter was enhanced by the neat pattern embossed onto the film by her "mistake." Deliberate reticulation can yield extremely interesting texture effects.

photo sketching

A final derivation involves eliminating the photographic image altogether, converting it into a line drawing by hand instead of by the tone-line process. Photo sketching is a controversial technique—purists insist that it's cheating, although many commercial artists use similar methods regularly, apparently without pangs of conscience. The most obvious and expedient method simply is to place a negative into the enlarger (or a slide into a slide projector) and trace the outline of the projected image with pencil, ink, or marker. Shading effects and other details can be added later. Another process involves making an underexposed enlargement on

grade 1 paper* so that the important parts of the image are barely visible without dark shadows (pull the print out of the developer prematurely if necessary). After fixing and an abbreviated wash,

*Kodak Polycontrast RC paper with number 1 filter works especially well because the image is easily bleached. The "sketching" can be done with pencil instead of India ink if "N" (matte) surface paper is used.

Photosketching is another procedure for converting a conventional photograph into a line drawing. This process is especially useful when you want to eliminate part of the subject matter or make changes by hand. Try the following steps:

1. Make an enlargement of the desired size. This print should be light and flat—just dark enough to discern the wanted detail (underexposure and underdevelopment will produce this kind of print).

2. Process and air dry the print. A long wash is not required.

3. Ink-in the detail you want, using a draftsman's "technical" pen and waterproof black india ink. Detail you don't want should be left un-inked. Shading can be done by stippling. Allow the ink to dry thoroughly.

4. Bleach away the silver image in a solution of Farmer's Reducer. You can buy packets of prepared powder or you can mix up a longer lasting two-solution bleach consisting of 25 gm. potassium ferricyanide crystals in 1 liter of water in the first tray and regular fixer in the second. Alternate the print between the two trays until the bleaching is complete. Another alternative bleaching solution may be made by dissolving 10 gm. potassium iodide and 1 gm. iodine crystals in 1 liter distilled water.

5. Agitate the print in ordinary fixer until the yellowish stain is gone. Wash, then air dry.

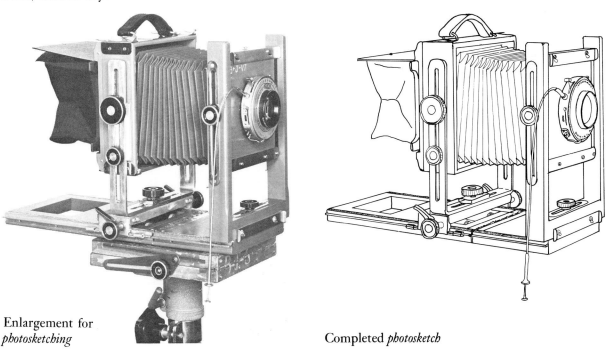

Enlargement for
photosketching

Completed *photosketch*

the print is dried. Then use a fine-tipped pen and waterproof black India ink to outline the areas you want to reproduce; add stippling or line shading effects. Simply leave out unwanted background details and strengthen any out-of-focus or merged areas with ink lines. Then bleach away the silver image. Whether or not you call it art, photo sketching is a useful technique of considerable commercial value.

creativity vs. craft

If you truly love photography, perhaps you should *not* become a professional photographer. On the other hand, the idea of being paid to do that which you most enjoy is an enormously appealing prospect. In spite of having squarely faced this dilemma for more than half my life, I haven't fully resolved the conflict between creativity and security; but then few photographers have resolved it, and in other media even fewer artists have. Nevertheless, students are constantly asking for advice on how to make a living in photography.

The crux of the paradox is creativity versus craft. Craft sells regularly and predictably; creativity sells sporadically. "Whoever pays the piper calls the tune" is not just a folk saying. It is equally true that whoever pays the photographer usually circumscribes the assignment. If you eventually become one of the few photographic artists who are so well known that buyers will give you blanket assignments and be delighted with whatever images are the result, you can measure your success by the size of your bank balance. To reach this exalted status, however, requires much more than the usual talent, plus an extraordinary knack for salesmanship and showmanship.

To earn a living as a professional photographer you have three choices open to you: (1) seek a salaried staff position, (2) be a freewheeling free lancer, or (3) set yourself up in business as an entrepreneur. A fourth option may lie on the periphery of the profession—in one of the allied fields related to photography or in a profession or trade that uses photography. Obviously, the prerequisites for success vary greatly depending on which road you decide to take.

the corporate photographer

For the most part, industrial firms, government agencies, and large photographic studios want to hire competent technicians. These big organizations already know the kinds of photographic

11

Work consists of the things you have to do that you dislike doing—everything else is either play or a labor of love.
Roger E. Greeley

The serious amateur photographer is not to be confused with the snapshooter. Nor is he hemmed in by assignments, as most professionals are. He uses photography wholly as a means of self-expression.
Joseph A. Bernstein

to be nobody-but-yourself in a world which is doing its best, night and day, to make you everybody else—means to fight the hardest battle which any human being can fight, and never stop fighting.
e. e. cummings

Wouldn't it be wonderful . . . if everyone knew who they were, where they were, what they wanted to do, and they could simply be allowed to do it.
William Albert Allard

photography as a profession

BERTA STAUFFENBERG
Kalamazoo Creamery Co.
Can a commercial subject be "art?" Here, repetition of forms with variation in size, texture, and value presents an interesting image of an industrial subject.

work they want done and they will buy the services of skilled craftspeople who will come to work in the morning, do the assigned job promptly and acceptably, and then go home in the evening (although overtime is all too frequent in photographic departments). Creativity? Yes, definitely—and you might eventually get praise—and a raise—if you can photograph an automobile, a milling machine, a stylish dress, or a bottle of beer so that the composition is subtly balanced and the lighting adds sparkle to the subject. But too often the corporate photographer is expected only to carry out the ideas of the "Creative People" in the advertising or pubic relations department. I remember how disillusioned I felt when I realized that the benevolent corporation I was working for actually sent out to a New York advertising agency all their jobs that called for imagination and originality. The agency then farmed out the photography to a commercial studio. It doesn't often occur to an executive that creative photography could be produced within his organization. Perhaps the greatest challenge facing you as a photographic employee is to sell yourself—raise your own stature, subtly, in the eyes of your employers.

But there are important trade-offs in corporate photography that help to compensate for the frustrations. When you sell your services to a large employer, you do so in exchange for relief from such problems as hustling to find clients, filling out endless regula-

tory and tax paperwork, and considering such anxiety-provoking issues as hospitalization and disability insurance for yourself and for your dependents. Most big corporations will also relieve you from the responsibility of putting aside money for your eventual retirement. That biweekly paycheck and employee benefit package look mighty big when you consider the alternatives.

Landing a staff photographer's job doesn't usually require a college degree, but getting—and holding—a staff job does demand mastery of the fundamental skills of photography and audiovisual production. Graduates of recognized technical schools and colleges and universities with highly regarded degree programs in photography generally have a portfolio and samples of other work to show. These fortunate men and women will have mastered certain job-hunting prerequisites such as how to write up a job application and résumé without making spelling errors. Some employers are wary, however, of college degree holders for technical positions. A master's degree could even be a handicap. Employers are often unwilling to pay the higher salary that an MFA would seem to demand, and they may actually be leery of the degree holder's creativity! Photographic experience plus a bachelor's degree in business administration seems to be a winning combination in many industries and organizations. "Here's a young person," goes the logic, "who can do a good technical job for us now, yet who may be potential management material."

Corporate photography can be a highly interesting way to make a living. Corporate photographers contribute significantly to the productivity of the organizations that employ them, but few of my colleagues who are "staff" photographers have kept photography as a hobby—they play golf or go sailing instead.

Daily and weekly newspapers still occasionally hire an ambitious young photographer, but usually to fill a vacancy left by a retiring former staff member. Many newspaper photographers find their jobs interesting because of a feeling of involvement in community happenings; but it soon becomes quite a challenge to keep coming up with fresh, new ways of handling the daily grind of routine assignments while meeting deadlines. Most of the magazines that once hired adventuresome and imaginative staff pho-

tojournalists are now either defunct, or they buy much of their nonroutine work from free lancers who work either independently, through agencies or cooperatives, or on contract to the publisher.

Television has changed forever the public's media habits. The *Evening News* and the various talk shows and specials have replaced, for most people, the daily newspaper and weekly or monthly magazines as major sources of current information and entertainment. As advertisers have shifted much of their money from print to television, so too have gone many of the most interesting career opportunities for photojournalists.

The production of documentary film for television is almost a totally different field from still photography. Although the "good eye" and human sensitivity of the still photojournalist are needed by the filmmaker, the still photographer making the switch to professional motion pictures finds it very difficult to finance and produce a film independently. Because of the enormous costs involved and the tremendous amount of work, film producers nearly always need either to work for a salary or to have a commercial sponsor. And one person rarely completes a film alone, a crew consisting of director, camera operator, and sound, lighting, and editing technicians usually is required. Electronic journalism certainly is the wave of the future, but to get to the top you will need specialized training, a long apprenticeship, and probably labor union affiliation.

how to sell yourself

There's a psychology to applying for a photographic job, as there is in any career field. First you have to do a good job of writing yourself up. Your résumé, or vita, ought to provide prospective employers with the basic facts about your personal status and educational background, plus a chronological listing of your previous work experience. Make this section of your vita brief, but emphasize those aspects of previous jobs that have a bearing on the position for which you're applying. For example, if you're applying for work as a photographic technician with an aerospace

firm, say so if you shot movies and stills of aircraft activities and tests while you were a photographer in the Navy. Remember that your résumé represents *you* to someone you haven't met. Try to impress the personnel office with your effectiveness and your neatness, if not with the depth of your experience.

Your portfolio shows what you have actually done photographically and implies the kind of work you can be expected to do without additional training. Just as you wouldn't show up for an employment interview wearing tattered jeans and unkempt hair, you shouldn't expect an employer to be impressed by dog-eared, unmounted, unspotted prints, no matter how good the content and technique. Don't try to show more than twenty or twenty-five prints unless you're asked for more, and do select prints that show you have an idea of the kind of work the company docs. You wouldn't include many (or any) "artsy" abstractions, nudes, or fashion illustrations, for example, in a portfolio intended to show how well you might handle a nuts-and-bolts industrial job. Your prospective employer will probably be looking for well-corrected view-camera illustrations, competently lighted product photos, and perhaps an example of your best "company magazine" style picture story feature. A prospective employer wants to hire someone who can do the kind of pictures he wants made.

The advertising game is a bit different, however, and an ad agency executive or picture editor may want to see your most imaginative work to determine whether he should take the risk of offering you a challenging assignment. The editor or advertising executive sees competent commercial photography every day. What he's looking for is someone who can do routine assignments in an unusual way. Generally speaking, 11 x 14 or 13 x 16 inches is a handy portfolio size; you can present smaller prints on this size mount for a neat, uniform appearance. Put your prints in a fiber case or in a vinyl or pressed-board folder with a hinged flap, and you will have an attractive presentation that will help you to sell yourself. A portfolio to be sent through the mail needs only to consist of unmounted 8 x 10 prints (RC paper is fine for this purpose because of its medium weight and resistance to creasing and

cracking). Pack your prints in a sturdy envelope with oversized corrugated cardboard stiffeners.

the free lance game

If you begin to feel restless in the security of corporate employment, you may soon begin to look longingly at the glamorous life of the free lance butterfly. The free lancer, it would seem, flits care free from client to client, sampling the nectar from only the choicest opportunities. Don't you believe it! Free lancing can be a killing grind. Free lancing is a fierce competition in which only the very fittest survive.

Nevertheless, the flame of free lancing attracts, like moths, thousands of aspiring young photographers every year. As a successful free lancer you can be an artist, but you also have to be a canny businessperson. Many free lancers choose to work through an agent, who relieves them of routine business matters in exchange for a percentage of each sale.

Free lancing, demanding and uncertain as it is, is, nevertheless,

BRIAN KUEHN *Orchestra*
Rather ordinary group photographs, such as this one, can be a ready source of income for anyone with a medium- or large-format camera, some patience, and lots of hustle. Every face must be recognizable. A wide-angle lens is very desirable, along with one or two large flash units to supplement uneven existing light.

a good way to make some good pocket money, especially if you're good at a speciality and if you research your specialized market carefully. Nearly every young professional starts out by free lancing or moonlighting (moonlighting is part-time free lancing). There will be more on how to break into free lancing a little later on in this chapter. Meanwhile let's look at some other career possibilities.

opening your own studio

There's always money to be made from portrait, wedding, and general commercial photography. Although the field is somewhat crowded, there seems to be room in almost any community for a *quality* studio. Usually there is an untapped market for photographic sales that cries for an enterprising entrepreneur to develop the market by advertising and to maintain sales by offering excellent service at a fair price. But if you want to be successful at establishing and operating a studio you have to have an insatiable drive for achievement. If you think this is your cup of tea, be aware that you (and your spouse or partner) must expect to work 16-hour days routinely for, at least for the first few years, a modest financial return. You have to enjoy running the business fully as much as you enjoy photography, perhaps more. And because human contact is such an important aspect of operating a studio, you had better have a friendly, open, somewhat extroverted personality. Like other businesspeople, contacts made through service clubs and community activities will pay off for you at the cash register. Like the florist, the real estate broker, and the neighborhood merchant, the successful studio owner becomes an integral part of his community as he goes about earning a living.

other careers in photography

Many careers related to photography are open to men and women who are interested in the field in some capacity other than

as a practicing photographer. Graphic arts, for example, encompasses the wide world of printing and duplicating. Offset lithography involves technical photographic processes for reproduction of photographs. Scientific and biomedical photography includes photomicrography, photogrammetry, spectroscopy, metallography, ballistics, and many other finely differentiated specialties in industry, medicine, and law enforcement. Photographic manufacturing and retailing is a multibillion-dollar industry in itself, employing scientists, managers, technicians, and salespeople, most of whom require considerable knowledge of at least certain aspects of photography. Although much of the photographic equipment sold in the United States is imported, the distributors of equipment and manufacturers and distributors of materials and supplies employ experienced photographers as technical representatives and salespeople. Photofinishing is another lucrative career field for those who have a technical bent and management ability. Custom laboratories produce work for professionals, and amateur finishing plants process and print the billions of images exposed each year by weekend snapshooters.

A high school diploma is the entry-level qualification for many jobs in the career fields mentioned here, with a two-year associate's degree in photography being a valuable credential for a technical job or a position as a working photographer or photographer's assistant. A bachelor's degree in photography is generally looked upon as a ticket to eventual management status in corporate photography or, if photography is combined with science or engineering, to a specialized technological position. The MFA (Master of Fine Arts) is considered by most colleges and universities as a terminal degree for the individual who will teach photography in a department of art, with the PhD being a credential for the academic administrator, researcher, or art historian. Teachers in secondary and elementary schools require a bachelor's degree and a teaching certificate. For permanent certification, most states require teachers to obtain further credits in education, leading eventually to a master's degree. Full-time teaching jobs in photography are rare, there being many more aspiring teachers than there are vacant positions. Part-time teaching, however, is pleas-

ant and relaxing for some working photographers; more of these opportunities are becoming available as public interest increases in photography as a leisure-time activity. For teaching evening or weekend courses, community colleges, art centers, and adult education programs often employ experienced professional photographers who have demonstrated their talent for teaching.

how to get started

Back, as promised, to free lancing. Nearly every professional photographer started out as a free lancer, often gaining experience and making pocket-money-plus while in high school or college. Here's advice on how to start:

1. *Specialize.* Become especially skillful at photographing certain types of subject matter that you particularly enjoy and have knowledge of. One of my former students, for example, is a model airplane buff; he submits regular how-to-do-it illustrated articles to the model-building magazines. He has become so well known in this field that now the editors send him assignments and he has sold a number of color covers. What is *your* hobby: horses, dogs or cats, wildlife, hunting and fishing, gardening, weaving, custom cars, spelunking, antique aircraft, stamp collecting? You name it—there are special interest publications, organizations, and individuals who will buy photographs. One girl was taking pictures of some of the animals she admired at a pet show. Some of the animals' owners asked her for prints and now she is "official" photographer for all of the cat and dog shows in her corner of the state—and she has all the reprint business she can handle. But this work wouldn't continue coming to her if she didn't keep after it. That brings us to point number two:

2. *Hustle.* Another student enjoys architectural photography. While he was in high school he made a series of construction progress pictures of a public building being erected in his home town. Putting these photos neatly into a ring-bound book format, this enterprising young photographer went to see the contractor on the job. The contractor, very impressed, bought the book on

RAIMONDS ZIEMELIS *Welders*
When you're making routine photographs, try also to visualize the subject matter in its most abstract or graphic form. The high-contrast drop-out technique simplified this construction photograph to a composition of forms in positive and negative space.

the spot and commissioned my young associate to shoot aerial and ground progress pictures at regular intervals of every subsequent project that his firm did it the area. Out of this contact grew sales to subcontractors, architects, and occupants of the buildings. But the photographer had to go around and see these people. They wouldn't have come to him.

If you study collections of old photographs made in the 1880s and 1890s, you find that itinerant photographers traveled about photographing families posing out in front of their houses or farms. Many of these old-time photos are technically excellent—sharply focused, well exposed, and obviously made with a properly adjusted view camera. But George Eastman's snapshot Kodak killed much of this business, convincing most people that they could take their own snapshots of their homes and families. Today, people still will buy photographs of themselves and their property, but not many people will call up a photographer and order the work done. Maybe door-to-door sales isn't your thing, but one neighbor does tell another, and if you can wangle a few jobs—even for free—other people will want photographs made if you're on the scene at the right time.

"Kidnapping" is another way to collect some cash (this term means *photographing* children, of course, not abducting them). In child and baby photography, you're competing with the established studios as well as with the "99-cent" shopping mall operators. It doesn't occur to many parents, however, to have their kids photographed around the home, or in a park, in natural childhood settings and typical activities. Even if the parents own an expensive camera, chances are their snapshots of the kids are stilted, too far away, and poorly exposed. Another of my former students, who now makes his living as an elementary school teacher, started out making informal portraits of the kids in his class. When the parents saw the pictures, they loved them. Parents told other parents. Now this teacher has a lucrative home portrait business every summer and on weekends to supplement his salary, without having to look for a humdrum summer job.

The quality free lancer cuts into the established professional's business less than you might imagine. The smart free lancer is

using imagination and hustle to profit from a largely untapped segment of his community's portrait and commercial photo market. Most studio operators depend on the formal and conventional walk-in and telephone trade, and they often make little effort to go out to the public. The part of the potential market that the pros overlook is *your* fair share! Then, after you gain enough experience, you, too, can become part of the established profession—if you choose.

3. *Be Professional.* You *are* a professional if you're earning a substantial amount of money from photography. If you're operating as a professional, the public will expect you to be dependable, to produce quality work, and to price your work fairly but competitively. If photography is a moonlighting business for you, don't try to take work away from established studios, but try to mine the gold that they may be overlooking. Above all, don't compete unfairly on price. If your work is as good as the studio operator's, your price should be very nearly competitive. The established pro has overhead expenses that you don't have, so you can charge less—right? Wrong! People often tend to value services according to what they have to pay for them. Not only does a competitive price make your work appear to be of higher quality, but if your costs actually are less than the studio's, you can pocket the profit without feeling that you're taking away someone else's livelihood by undercutting his prices.

Weddings are a case in point. With so many automated color-processing and printing laboratories providing a complete wedding package at a very low price, the wedding photographer can spend all of his time shooting and selling, spending no time at all in the darkroom. If you're a moonlighter and you like to shoot weddings, leave the formal bridals to those who do the job best and concentrate on providing a uniquely personal type of candid wedding coverage tailored to the desires (and the financial resources) of the bride and groom and their parents. Through friends and satisfied customers you could create a demand for quality custom wedding coverage that might actually increase business for some of the better studios, as well as give you a comfortable extra income. But weddings usually are once in a lifetime, and you have

to deliver like a professional or your budding business will evaporate overnight! Plan ahead of time with the bridal couple, be punctual and polite, be neat and courteous, yet boldly competent, don't goof up technically. These rules apply not only to weddings, but to any assignment you may undertake. The professional is competent and confident, dresses like a business person, and behaves maturely.

4. *Keep trying!* If you're determined to make money at photography, you've got to keep at it until you develop a reputation for quality and dependability. It may take a while before the work begins to come to you, instead of your having to go out after it all the time. This is especially true of sales to publications, as all free lance writers know. In publications work you'll be dealing with many of the same markets as the free lance writer, and you can expect to collect rejection slips and polite letters at about the same rate. There are excellent references (some listed in the Selected References at the back of this book) that can give you up-to-date information about publishers and agencies and how they should be approached.

If you're selling directly to publications or to commercial and advertising markets, it's very important to have prices that are fair and competitive because you're competing directly against full-time professionals. Find out what the going rates are. Many publications specify the rates they will pay; this and other valuable information can be found in some of the guides, such as *Writer's Market*. Assignment work should be priced at current rates, as listed in the *ASMP Guide to Business Practice* and in other references available through the Professional Photographers of America, Inc., and state and local professional photographers' organizations. You should consider joining one or more of these organizations. The membership benefits usually far outweigh the cost.

working with an agent

When you first start out as a free lancer you should try to sell some pictures directly to publishers, especially if you have a

strong specialty. You might be lucky with sales, and if you can establish a name for yourself, your chances of having work accepted by a stock-photo agency are greater than if you've never had anything published. Agencies work on a 40 to 50 per cent commission, but an active agent will show your pictures to markets that you might have never imagined existed or had the time to send work to. Barbara Van Cleve, an agent specializing in travel and textbook markets, recently offered my students some pretty sound advice:

"Young photographers," she said, "usually have an inflated sense of their ability and a naive knowledge of the market, which makes them very impatient should sales not be forthcoming immediately. They need to know that their work is competing with the work of famous professionals who market on their own to all kinds of clients, with whom we also deal. Further, . . . to be really involved in this business they ought to be sending us at least fifty new shots per month, until they build up a file of around 1,000 shots with us. These should cover a wide range of subjects in order to be best salable."

The advice offered by Ms. Van Cleve to aspiring young photographers is to "look at a lot of pictures as they appear in ads, textbooks, and magazines, make assignments to themselves to shoot these assignments, do a lot of highly selective shooting, edit their work carefully, send it to us . . . and be patient. All sales through an agent should be considered 'gravy' or 'icing on the cake.' No one can live on stock-photograph sales alone, and no professional, even, does. Some work from very good photographers will sit in our files for a year before we can market it, because textbook publishers follow cycles in revision of their texts."

"If young photographers want to bypass a service such as ours," suggests Ms. Van Cleve, "they can use the *Writer's Market* as a guide . . . and send out letters of inquiry accompanied by some sort of inexpensively printed brochure as a sample of their work. When a buyer contacts them they can send out their work for review and take their chances. But they will soon learn the economics of postage!"

dealing with editors

Most editors like to receive unsolicited material they can use; but they detest being bombarded with photos and articles that are wildly inappropriate or of unsatisfactory quality. First study recent issues of the publication you aim for, then query the editor briefly by letter, enclosing a few representative samples of your work, if you're not known to him. Always enclose a self-addressed return envelope and sufficient postage (SASE) for return of any samples or other work that you want returned. Editors expect a SASE and most won't return your work unless you enclose one.

Publications pay for work accepted—sometimes upon receipt, more often upon publication. When you do sell photographs, be sure that there's a written understanding about whether the editor is buying full, exclusive rights to your material or only reproduction rights for one-time publication. Naturally, you're entitled to much more money when exclusive rights are involved. Rates vary widely for single photographs, from a pitiful low of $3 for a single black and white print, on up, with generally attractive package rates often applying to articles with pictures. A color transparency for a magazine cover generally brings at least $50, and frequently, much more.

Some editors, if they like an article idea that you've queried them about, will give you some suggestions as to how to make it more salable and then "assign" you to do the story. Unless you're a well-known pro, however, this kind of assignment is still on speculation, as far as both parties are concerned. The editor is not obligated to publish your material or to pay you for it if he doesn't think you did a good enough job. But on the other hand, the editor is ethically bound not to "steal" your idea and assign it to another photographer or writer until you've had a good crack at it. You're bound ethically, too, not to submit the same story idea or similar photographs to competing publications at the same time. You could, for instance, submit similar fishing photos to a sportsman's magazine and to a postcard publisher, but never to another hunting and fishing magazine, unless your material has already been rejected by the editor of the first magazine.

Some picture editors, particularly those who publish industrial stockholder and employee magazines and annual reports, may be willing to contract for your photographic services by the day, rather than by the picture or by the story. Day rates are individually negotiable, of course, but rates recommended by the ASMP (see the Selected References) for small publications begin at a minimum of $150 per day plus expenses. The photographer usually retains rights to the photographs, selling one-time reproduction rights to the publication, unless it is agreed in advance that all negatives and transparencies made while on that assignment belong to the client. In such cases you should negotiate a "job" rate that includes a specified number of prints or transparencies.

Advertising photos usually bring higher prices than those used editorially. Find out what other photographers are charging for similar work, and be sure your written agreement includes all the terms and prices, so that your invoice comes as no surprise. Being specific also protects you from the shock of being told: "Sorry, but that's not what we had in mind." Successful free lancer Fred Tonne suggests avoiding the "Never time to do it right; always time to do it over" syndrome by being sure at the outset that everyone concerned with a photo assignment knows what to expect of the other parties. "Get it in writing," Tonne advises, "unless you've worked before with the same client and you're sure you understand each other."

model releases

The model release is a necessary evil. Releases are such a nuisance that they're almost never obtained for routine editorial photography. Legally, a photographer or publisher is in little danger of a lawsuit, unless the subject of the photo is being held up for ridicule by miscaptioning or a clear invasion of privacy is evident. You wouldn't, for example, publish a telephoto picture of someone sunbathing nude by their backyard pool, but almost anything occuring in a public place is fair game if the facts and circum-

LARRY DALY *Henderson Castle*
An architectural subject with a bit of the unusual. Singular subject matter, extreme sharpness, higher than normal contrast, and intricate framing work together to create a pleasurable image with a bit of the mysterious.

PERMISSION TO USE PHOTOGRAPH

Release No. _____

Date _____

I am (am not) of legal age. For good and valuable consideration, the receipt of which is hereby acknowledged, I hereby authorize _____

to take photographs of me and/or my property and authorize him and his assigns and transferees to use and publish the same (including use and publication with my name, no name, or a fictitious name, use in the form taken or with intentional or unintentional alterations, and use for the purpose of publicity, illustration, commercial art, and in the advertising of any product or services).

Signed_____

Address _____

Witness _____

Parent or guardian (if not legal age)

Assignment: Date _____

For value received I assign full rights in this release to _____

_____ for purposes covered in Order No. _____

or as follows _____

Photographer

Release No. _____

Date _____

Subject _____

Consideration _____

Check No. _____

Photographs taken on this
release _____

Model release forms, although a nuisance, are good business if you plan to use your photographs for purposes other than non-commercial exhibition or editorial publication. (Release form courtesy of Professional Photographers of America, Inc.)

stances are not misrepresented. For travel pictures, for example, you are seldom able to get a release, and a release is seldom required for editorial use.

Advertising use of pictures of recognizable people is another story. Most clients won't consider buying a picture for advertising use unless you can provide a signed model release. Exhibition of a photograph in a gallery or display, however, is not usually held to be advertising, unless a product is being promoted. You're usually quite safe if you exhibit nonderogatory photos of people in a public park, at a school, gallery, art fair, or camera club. If prints are sold, however, and the subject finds out about it, you might have to share the proceeds with him or her or remove the offending prints from display. But if prints are going to be exhibited to promote the sale of a certain brand of film or camera, for example, you should obtain a release. If you're on assignment for an advertiser, or if you're planning to sell stock pictures later, you'd be wise to get a signed release from anyone portrayed prominently in the pictures. Always get a routine release from anyone modeling for you, especially nudes. Without releases, picture agents' hands are tied. Many clients simply won't buy pictures without releases. Professional models who are being paid for posing expect to sign a release as a matter of course. A few free prints are usually compensation enough for most amateur models.

copyright

Copyrighting your photographs protects you from unauthorized publication, but almost no one bothers to actually copyright everything. What many free lancers do routinely is to stamp on the back of each print, "Copyright © John Photographer 19—," thus

giving notice of intent to copyright and securing what is, in effect, a common-law copyright.

Some photographers, in addition to the copyright notice and their address and telephone number, stamp an admonition such as: *Not to be reproduced without written permission.* The copyright notice should appear on the front, also, if the print is mounted or matted so that the back can't be seen.

Official, fully legal copyright can be secured by publishing the work (publication is defined as distributing prints or offering them for sale) with the prescribed notice of copyright on every print or on the mount of each transparency. Two prints of the photograph (or two prints of the entire contact sheet—or two duplicate transparencies should be mailed to the Register of Copyrights, Library of Congress, Washington, D.C. 20559, together with a "Form J" application and a $6 fee. An unpublished photograph or contact sheet may be copyrighted by following this procedure, except that only one print is required instead of two. But if the same photograph is later sold or offered for sale, you have to apply again on Form J, with $6 and two prints.

Once a photograph has been "published" without the required copyright notice, protection is lost permanently and cannot be regained. In other words, you can stamp a print or slide and offer it for sale before you send in the Form J, but you can't file for copyright afterward if you failed to put the notice on the first time you sent out the photographs. The Register of Copyrights will send you a detailed explanatory brochure and application forms if you write to the preceding address.

the picture story

Life and *Look* and other once-popular but now largely defunct picture magazines developed the still photography and text sequences that we call picture stories or photo essays to a high form of communicative art. Although now published mainly in smaller magazines and in photographic books, this format still

offers the imaginative photographer a great opportunity to communicate ideas and to comment on society.

The picture story usually follows some form of chronology or other continuity, employing words as captions or as supplementary text, either to provide background for the pictures or to explain their meaning. Strong photographs, ideally, require a minimum of words to explain them, if any at all; the words and pictures should complement one another. The photo essay, a highly refined form of picture story, deals, in the literary sense, with a selected topic from an interpretive, personal point of view.

There's a strong temptation to overshoot on a picture story assignment. Beginners often photograph everything that moves in the hope of later discovering great image sequences on the content sheets. This "shotgun" approach can work if you're covering a fast-breaking news or sporting event, but it's much better to plan ahead of time the kinds of shots you think you'll need to tell the story.

The script for a picture story or photo essay may consist merely of an outline listing each aspect of the subject to be covered. A simple checklist is often sufficient when you do your own planning.

If you prepare a detailed shooting script, each picture idea should be described in enough detail that its part in the sequence is clear and any special photographic techniques are noted. Simple sketches will help you to previsualize the format and composition you'll be looking for during shooting sessions.

Whether or not you prepare a detailed script, you ought to have in mind exactly what the purpose of your story is, who the intended audience will be, and just what kind of reaction you expect from your audience, or viewers: Do you want them to be amused, enlightened, saddened, angered, aroused? Do you want them to *buy* something or to *do* something. Or would it be sufficient if those who view your efforts shared your very personal feelings of concern, elation, appreciation, or nostalgia? If, as a communicator, you don't have a purpose clearly in mind, how can you expect your viewers to get the message you intend?

But don't be a slave to the script. If what you thought you

would find, or what you thought would happen, doesn't turn out as you expected, be flexible. Even while you're shooting, if you feel the need for a different approach, or if you encounter interesting aspects of the subject that you hadn't anticipated, don't hesitate to change. If you've thought out all aspects of your story, you can always change the script as you see fit. Without enough advance planning, however, you may discover, too late, that you have to go back and reshoot some key pictures that you missed. But unfortunately, reshooting isn't always possible.

One of the simplest types of picture story is the how-to-do-it series. The how-to-do-it is simple to produce because the continuity is already determined by the actual steps involved in whatever process you're photographing. All you have to do is to write down the sequence and decide how each step can best be photographed. An example of a how-to-do-it might be a story on the manufacture of a hand-tooled leather belt or the construction of a geodesic dome shelter. Imaginative treatment and interesting camera angles spell the difference between a mundane record of a process and an interesting and motivating experience for the viewer.

"A day in the life of . . ." has become a common picture story theme. A slight variation is the "What it's like to be a . . ." approach, in which you describe an unusual occupation, pastime, or way of life.

Another popular theme is to photograph similar subject matter, but in different locations. For example, a story on how people have restored historic houses may be told effectively by photographs made in several different towns. Or you might do an essay in depth on a singularly interesting and inviting old home in your community and about the people who are restoring it. A deeply personal essay on *being alone* or *daybreak* or *flight* or *the sea* might contain a number of evocatively related visual poems interwoven with free verse or prose. Such essays can be enormously rewarding, both for the sake of doing them and from the possibility of publication.

The starting point for any picture story or photo essay is the *idea*. Ideas may come easily to you if you've become an expert in a specialized field; or you may need to do quite a bit of research.

I do not believe in photography just to invade people's lives. I go into people's lives constantly, but only to make their motives, their ideas, understood.

Cornell Capa

I find no photographs superior to the decency of a man's feelings and his right to those feelings. When there is such a conflict, I by far prefer to put the camera down and take no pictures. I do not possess my subjects. I must honor them and their right and there's no excuse that I am a professional doing a job.

W. Eugene Smith

After the initial story idea, you need to learn as much about the subject as possible, taking notes for later copy and caption writing. You should ask—and answer—the journalist's traditional questions: Who? What? Why? When? Where? and How? You'll need to get to know the people involved and to become accepted by them. Virtually everyone will be friendly and cooperative if they think you care about them and if you're genuinely interested in what interests them. Get to know your subjects: observe how they talk and act. Listen to what they say and pay attention to their advice.

Experienced photojournalists can imagine what an image is going to look like as a finished photograph. You can train yourself to do this and to sense the exact instant when subject arrangement and action are "right." Henri Cartier-Bresson calls this *the decisive moment.* Preplanning can help you to recognize these important instants when they occur. Self-confidence and a good relationship with your subjects can make it easy to set up some significant situations in an unobtrusive "posed-unposed" manner. But unless you plan ahead, it's easy to lose purpose and direction and end up merely with a hodgepodge of routine pictures.

Every picture story needs a strong "lead" picture to engage the viewer's curiosity and interest and entice him to examine the rest of the story. Most stories, even photo essays that do not have rigid continuity, require a beginning, a climax, and a conclusion. Often, the lead picture is an overview or an introduction, or it may be the one most dramatic photograph, which sets the mood or establishes the locale. The lead is the picture that the editor often will run largest in his layout as an enticement to the reader.

Notice, in effective published picture-story page layouts, that seldom are the pictures the same size and shape; nor are they usually arranged in static rows. Editors and art directors want to avoid monotony in their layouts, so you'll be wise to include verticals as well as horizontals and shoot plenty of close-ups, as well as medium and long shots. Don't forget that magazine covers and book jackets usually are vertical in format. If you want to crack the lucrative cover market, your compositions have to be oriented

correctly and there must be enough space allowed for the name of the magazine or title of the book, as well as other copy.

Picture captions should be complete, containing all names (spelled correctly), plus all the other important data (who, what, why, when, where, and how). Captions should be neatly typewritten and attached to the prints in such a way that they can be read while the editor is looking at the print. This is done by attaching the caption to the bottom of the reverse side of the print with nonbleeding "magic mending" or library type and then folding the paper up over the face of the print to save space in handling and mailing.

conclusion

Here in this final chapter you've read a few suggestions about how to turn your interest in photography into income. Photography, even more than most professions, requires energy, talent, and persistence because of the very popularity of the medium. People who would never consider being their own doctor, lawyer, accountant, plumber, or farmer will believe that they can be their own photographer—until you educate them to see how your pictures are better than theirs. That's one of the problems faced by photographers everywhere. But you can be a successful professional photographer if you work hard enough at it and have confidence in your ability to learn, to produce, and to grow.

Talking about the future and talking to young photographers, I can only give this advice: Be as flexible as possible; learn everything; go into television; learn the camera; learn movie making . . . draw, paint, let yourself go. Become a universal visual man. And read, and listen, and live. . . .

Ernst Haas

One should never put off taking the picture if you see something. . . . Nothing is stationary. Nothing is permanent. Everything is changing.

Eliot Porter

You can make several great pictures in a single day—if you don't make that day *tomorrow!*

Author unknown

one: feelings about photographs

Locate several photographs that communicate something to you. Discuss them with friends and classmates. Explain how each photograph makes you feel. Try to imagine how the photographer must have felt at the moment of exposure. Do you think that your reactions to viewing each image are similar to those experienced by the photographer who was actually there? Identify any techniques that you think the photographers might have used, either deliberately or subconsciously, to influence the reactions of those who would later see the photographs.

two: emulation

Study the work of several photographers whose work you admire. Make at least one photograph of typical subject matter in the manner of each of these admired photographers. Try, for example, an "Edward Weston" vegetable or tree root; an "Ansel Adams" landscape; an "Aaron Siskind" wall; an "Arnold Newman" portrait; a "Bruce Davidson" portrait; an "Imogen Cunningham" portrait; and a "Cartier-Bresson" street photograph. *Note:* This work should be *emulation*, not imitation. Don't simply copy something that you've seen published, but try to react to the subject matter as you imagine that particular photographer would have reacted. Try to identify yourself with your chosen photographer, interpreting the subject matter, as well as you can, through his or her "eyes."

three: types of cameras

Arrange with your instructor, your friends, or a cooperative photo dealer to examine several different types of cameras. Obtain, if possible, one of each of the following types of cameras: 35mm single-lens reflex, 35mm rangefinder, 6 cm single-lens reflex, 6 cm twin-lens reflex, 4 x 5 or larger view camera.

self-assignments

With guidance from someone knowledgeable, practice handling each camera and adjusting the controls. Pretend to take pictures. Sight through the viewfinder. Focus. Operate the shutter at various speeds. Learn how to load each camera with film. Know the following information about each of the cameras you have available: (1) name of camera, (2) size of negative, (3) types of film used, (4) focal length of standard lens, (5) other lenses available, (6) largest f/stop, (7) smallest f/stop, (8) fastest shutter speed, (9) slowest shutter speed, (10) provision for Time and Bulb exposures, (11) provision for flash bulbs and/or electronic flash, (12) how the camera is focused, (13) provision for a self-timer (delayed action release), (14) provision for preventing accidental double exposures, (15) provision for *intentional* double exposure, (16) the kind of photography for which the camera is best suited, (17) any special precautions that must be exercised when using the camera, and (18) the camera's greatest limitations.

four: photogram

Exposing with light from an enlarger or overhead lamp, arrange opaque or translucent objects on a sheet of photographic paper to create an interesting design without the use of a camera.

five: the lens

Make a series of photographs comparing image size and perspective rendering with lenses of different focal lengths. Obtain a wide-angle lens of roughly half to two-thirds the standard focal length for your camera and a long-focus, or telephoto, lens of twice the standard focal length or more. For example, if you are using a 35mm camera, you should try using, in addition to the normal 50mm or 55mm lens, a 28mm or 35mm wide-angle and a 105mm to 135mm lens, or longer. If you have access to a variable focal length zoom lens, try it out over its entire range.

six: the aperture

Make a series of photographs comparing depth of field and overall sharpness achieved by using the same lens (probably your standard focal length) at apertures (f/stops) ranging from the widest (probably f/1.4 or f/2) to the smallest opening available on your lens (probably f/16 or f/22). Be sure to choose a subject that has a range of near and far objects or planes so that differences in depth of field will be apparent. Don't forget to compensate for correct exposure by adjusting to the appropriate shutter speed when you change f/stops.

seven: the shutter

Make a series of photographs comparing the effects of slow shutter speeds (perhaps 1 full second to ⅛ second) with the action-stopping ability of the higher shutter speeds (1/1,000 or 1/500 second). Try shooting subject matter moving at different rates of speed and at various angles to the camera. Move the camera itself (pan) during some of the slow exposures. If you have access to a zoom lens, try zooming during the exposure. You might want to expose for several seconds to allow a moving subject to trace itself on the film. Don't forget to compensate for correct exposure by adjusting to the appropriate aperture whenever you change the shutter speed.

eight: contrast filters

Photograph subjects that contrast strongly in color hue with the background. Choose filters that will exaggerate or diminish the separation of each subject from its background: a red apple, for example, against green leaves, or a building of light colored stone or concrete against blue sky. Another possibility is to eliminate contrast between colors, such as in copying a stained document or

old photograph, using a filter to remove or lessen the effect of the stain. If your exposure meter does not read through the lens with a filter attached, be sure to adjust exposure to compensate for the filter factor.

nine: flash techniques

Produce a series of photographs illustrating various uses of flash illumination. Include direct flash on camera; flash aimed directly at the subject, but at least at arm's length from the camera; flash bounced from ceiling or wall; and fill-in flash outdoors in bright sun. If you're using bulbs or a conventional electronic flash unit, make practical tests to determine your own exposure table or guide number. If you have an automatic electronic flash unit, first check the manufacturer's instruction manual and then test the unit under the preceding conditions to determine whether the sensor responds predictably.

ten: architectural forms

Photograph both the exterior and the interior of a building that interests you. Your photographs should indicate something of the function of the building, as well as its appearance. Experiment, if possible, with a wide-angle lens and with the perspective correction of a view camera, if you have one available.

eleven: close-ups and copying

1. Photograph a small sculpture, household object, or natural form so that its shape and texture are clearly shown. Use either natural or artificial light, but be sure to determine exposure and development with care, compensating, if necessary, for light loss due to lens extension.

2. Copy a small photographic print. Make a duplicate print the

same size as the original, trying to reproduce as accurately as possible the tonal values and contrast of the original print.

twelve: product illustration

Illustrate a familiar household product so that it becomes tempting to buy or to consume. A view camera, if available, may be desirable for this project because of its controls, but any format will do, if you conceive an interesting idea and compose and light the subject imaginatively.

thirteen: portraiture

1. Make several significant portraits of someone who is important to you. Photograph this person in various settings, under different conditions, and with both natural and studio lighting. Try to capture the "essence" of your subject—more than a mere likeness—and attempt to visualize the relationship between your subject and yourself.

2. Attempt a nonportrait of the same individual, indicating as much as you can about him or her without showing the subject's face.

3. Make a revealing portrait of yourself.

fourteen: the nude

Entice or employ a suitable model to pose for you, either indoors or outdoors. If you're interested in pin-ups, by all means shoot a few and get it out of your system. Then try to portray the sensuous grace, the line, form, texture, and symmetry in the human form that have made it a favorite subject of artists throughout history. Try to capture flowing movement as well as static poses.

fifteen: evidence of man

Without including any people in the photographs, show how man has changed his environment. Examples could range from an unmade bed or a half-eaten apple to a strip mine or a monument; but you should try to give viewers evidence enough to make inferences about the nature of the person or people who had been there.

sixteen: visual equivalents

Search for visual parallels or analogies:

1. Simile—something that reminds you of something else (for example, a vegetable that looks like an animal)

2. Metaphor—an object that symbolically represents another (for example, a lone tree symbolizing an individualistic person)

3. Equivalent—a natural arrangement of forms that evokes an esthetic sensation (for example, a pattern of leaves or clouds that elicits the feeling of having heard a musical chord)

seventeen: the real and the surreal

Photograph the same subject or theme in at least two different ways:

1. as literally and realistically as possible

2. in a highly unreal or surreal fashion

eighteen: visual paradox

Produce a photograph in which familiar subjects are juxtaposed or joined to communicate a new meaning. In other words, make a

"double-take" image, the meaning of which appears at first glance to be obvious, but which, on second examination, becomes something in addition to what it seems to be: i.e., a visual paradox or pun.

nineteen: the junkyard

Visit a junkyard, with permission from its owner, and photograph as many abstract compositions as you can discover among the jumbled, twisted, and corroded remnants of man's industry. Work close up with a single-lens reflex or view camera on a tripod, observing line, form, texture, and color.

twenty: your own back yard

Spend one or several days photographing only the subject matter you discover within the bounds of your own yard, farm, city block, or campus. Notice how many objects, shapes, surfaces, and relationships you may have passed by hundreds of times, yet may never have "seen" before.

twenty-one: a common theme

Decide on a kind of subject matter, such as rocking chairs, vans, windows, TV antennas, or an emotional state such as love, joy, despair, or death. Produce a series of photographs (a photo essay) that illustrates your choice of theme.

twenty-two: documenting an event

Photographically document an actual event or "happening," so that esentials of the occurrence can be understood or felt by viewers of the photographs.

twenty-three: a picture series

Produce a series, or sequence, of from four to ten photographs that, viewed either sequentially or simultaneously, elicit an emotional reaction or communicate information more effectively than would have been achieved with fewer images.

twenty-four: interviewing the pros

Identify several successful photographers and interview them. Study their work. Find out how they feel about photography as a profession and as an avocation. Find out whether they received formal education in photography or were self-taught. See whether you can learn some "tricks of the trade" from these professionals.

aberrations Inherent defects in a lens that cause the image to be unsharp, particularly around the edges.

accent light Usually a small spotlight directed at a subject from the side or back to add highlights and to separate the subject from the background. Sometimes referred to as a kicker.

acetic acid Used in diluted form to make stop bath and in fixer. Commonly available in 28 per cent dilution. Concentrated glacial acetic acid is corrosive and must be handled very carefully.

achromatic Color corrected. A lens designed to eliminate most chromatic aberrations.

acutance The inherent capability of a photographic emulsion to reproduce fine detail.

additive colors The red, green, and blue wave lengths of light that theoretically add up to make white light.

agitation Movement of the film or paper being processed, or movement of the processing solutions, to ensure uniformity.

air bells Bubbles of air causing transparent spots on negatives, resulting from insufficient agitation of film when first immersed in the developer.

airbrush A small, compressor-powered paint sprayer used to retouch or enhance such areas of prints as backgrounds, clothing, and skin tones that require an even tone and to add highlights or outlines.

analyzer An electronic device used to determine filtration and exposure for color printing.

anastigmat A lens corrected for astigmatism.

ANSI American National Standards Institute. Formerly American Standards Association (ASA).

aperture Lens opening, controlled by an iris diaphragm and expressed as an f/number.

apochromat A highly corrected lens with an extremely flat field. Used primarily for precise close-up work with a view camera and for graphic arts reproduction.

ASA A system for comparing light sensitivity of photographic emulsions. Named for American Standards Association (changed to *ANSI*).

astigmatism A lens aberration that prevents points of light in the image from being brought to a sharp focus.

available light The normal illumination that the photographer finds existing in the place where photographs are to be made.

B "Bulb" setting on a shutter. Not to be confused with flashbulbs. A shutter set on *B* will remain open as long as the release lever remains depressed (see *T*).

background light Light aimed at the background in order to silhouette the subject or to prevent the subject from visually merging with the background.

back lighting When the main source of illumination comes from behind the subject, in relation to the position of the camera.

barn doors Adjustable flaps on a studio light used to block the light from parts of the subject or background or to prevent the light from shining into the camera lens.

base The material on which light-sensitive emulsions are coated. Usually transparent acetate or polyester base is used for modern films, although paper, glass, metal, and cloth are also used.

baseboard The work surface beneath an enlarger, to which the enlarger column is usually attached and on which the enlarging easel is normally placed.

base-plus-fog The density of an unexposed area of a developed film.

bas-relief An apparent low-relief effect created by printing positive and negative images sandwiched slightly out of register.

bellows A flexible, light-tight connection between a camera lens and the body of the camera.

between-the-lens shutter A type of camera shutter

glossary of photographic terms

in which the leaves that open and close are located in the space between lens elements.

bleach A chemical treatment that lightens or removes the visible silver image (see *reducer*).

bleed An image printed or trimmed without a border.

blocked-up An extremely dense area in a negative that tends to print as white without texture; usually the result of overexposure and/or over-development.

blotter roll A strip of lintless blotter and cloth in which prints may be rolled for nongloss drying.

blowup An enlargement.

bounce light Light aimed at a ceiling, wall, or some other reflecting surface and reaching the subject indirectly.

bracketing Making exposures both over and under what the "normal" exposure has been determined to be.

brightness range The extent of the scale of values present in a subject, ranging from the deepest shadows to the most reflective highlights.

broad lighting In portraiture, when the main or key light fully illuminates the side of the subject's face that is turned toward the camera. The effect tends to broaden a thin or narrow face and to subdue textural blemishes.

bulb The *B* setting that allows the shutter to remain open as long as the release lever is depressed. (Photographers used to release their shutters with a rubber squeeze bulb and hose.)

bulk film 35mm film purchased in long rolls that must be cut into shorter lengths and loaded into cassettes for exposure in a camera.

burned out The result, on the print, of *blocked-up* highlights.

burning-in Giving additional exposure to darken relatively small areas, while shielding the rest of the print from light (see *dodging* and *flashing*).

butterfly lighting A portrait lighting technique sometimes employed for glamour portraits of young women. The main or key light is placed above and directly in front of the face, casting a symmetrical shadow directly beneath the nose.

C Celsius, or centigrade, temperature scale.

cable release A flexible attachment that allows the shutter release to be depressed smoothly from a short distance from the camera and without moving the camera.

camera Latin for *room*. A light-tight box fitted with an image-forming lens or pinhole that focuses its image onto a light-sensitive surface.

carrier The negative holder in an enlarger.

cartridge The metal or plastic container that 35 mm and smaller roll films are packaged in. Referred to also as a cassette or magazine.

cassette (see *cartridge*).

catchlights Tiny reflections of light in a subject's eyes.

CC filters Color Compensating filters that are used to balance the color of the light used to expose color films and papers. CC filters are available in six colors: additive primaries of red, green, and blue; subtractive primaries of cyan, magenta, and yellow; and in various densities.

CdS Cadmium sulfide cell. The light-sensitive receptor in exposure meters requiring batteries (see *selenium cell*).

center weighted A through-the-lens metering system that, in calculating exposure settings, automatically bases the exposure more on light reaching the center of the viewfinder area than light at the edges of the frame.

changing bag A flexible, opaque rubberized cloth container with light-tight openings that can be used for loading or processing photographic film when a darkroom is unavailable.

characteristic curve A graph depicting the response of a particular emulsion to exposure and development. Also referred to as the D Log E

curve because silver density is plotted against the logarithm of the exposure.

chromatic aberration Inability of a lens to focus all colors of light in a common plane. The result is a blurred image in black and white, or color fringing with color materials.

circle of confusion A tiny cluster of light rays that are slightly out of focus at the image plane. The size of acceptable circles of confusion determines the limits of depth of field.

clearing agent (see *hypo clearing agent*).

clearing time The length of time required by the fixer to remove all visible traces of undeveloped silver halides from the emulsion.

click stops Slight indentations that give positive indication of f/stop or shutter-speed settings. Some lenses have click stops between the marked f/stops; these half-stops should not be confused with whole f/stops when calculating exposure.

close-up A photograph made nearer to the subject than the normal focusing range of the camera; may require use of a close-up lens, supplementary bellows, or other attachments.

coating A chemical layer applied to lens surfaces to reduce flare caused by reflections within the lens.

cocking Tensioning the shutter mechanism before making an exposure.

cold tones Bluish or blue-black overall tinting in a black and white image, particularly in the darker areas; in color, the green-blue-violet portion of the spectrum.

color balance Apparent accuracy or naturalness of colors as reproduced in a color photograph.

color head An enlarger lamphouse providing either a slot or drawer for inserting color-printing filters or a system of dichroic filters by means of which the desired color balance can be achieved.

color sensitivity The effective response of an emulsion to different wavelengths of light. Orthochromatic films, for example, are not sensitive to red; panchromatic emulsions are sensitive to all visible colors; some special copy films and most printing papers are sensitive only to blue.

color separation The process of photographing a subject through three primary-color filters (red, green, and blue) to produce black and white separation negatives used in certain processes of color reproduction.

color temperature A system for measuring the color of light in terms of its relative warmth or coolness in degrees Kelvin. Daylight and electronic flash are relatively cool, or bluish white, whereas incandescent lamps are warm, or yellowish, by comparison.

coma A lens aberration that causes unsharpness around the edges of the image.

compensating developer A self-limiting formula that tends to develop shadow areas (low zones) fully, without overdeveloping or blocking up the higher values. Two-solution formulas are often effective. (For formulas and instructions, see Ansel Adams' book, *The Negative*.)

complementary colors Any two hues of light that combine, in the additive system, to reflect white; or, in the subtractive system, to absorb all wave lengths, resulting in black or gray.

composition Consciously assembling and arranging the visual elements of a photograph.

condenser enlarger An enlarger in which a system of large lenses collects light from the lamp and directs it uniformly through the negative.

contact printing A print made by placing the emulsion sides of the negative and the printing paper together under pressure and exposing them to light through the back of the negative.

contact screen A film screen containing halftone dots. When placed into contact with photographic materials during exposure, the resulting screened image may be reproduced by offset or screen-process printing.

contact sheet A contact print made from several negatives simultaneously on one sheet of paper; a proof sheet.

continuous tone A conventional image consisting of continuous gradations of gray values.

contraction Shortened development, resulting in an effective reduction of negative contrast.

contrast The range of difference in density between dark and light areas of the same image. Contrast may be described in terms of *contrast index* and plotted on graphs called characteristic curves.

contrast grade (see *paper grade*).

contrast index Numerical expression of the gradient of a straight line drawn between two points on a film *characteristic curve* that represent the highest and lowest useful densities.

conversion filters Colored filters enabling color film balanced either for daylight or for incandescent light to be exposed and balanced satisfactorily in the other kind of light.

convertible lens A lens that can be taken apart and the two major components used either together or separately at longer focal lengths.

correction filters Warm or cool colored filters used to improve the rendition of color when the illumination present differs significantly from the color temperature for which the film was balanced.

covering power The ability of a lens to produce a sharp image large enough to fill the format for which it was designed.

CP filters Acetate filters placed in the enlarger color head and intended to balance the color of the light source in color printing.

cropping Trimming or masking the borders of an image to improve the composition.

cross lighting More than one main light source appearing to come from opposite sides of the subject.

curvature of field An aberration causing the center of a lens to focus on a different plane than the edges.

cut film Sheet film.

darkroom A light-tight room for carrying out photographic processing.

dark slide The light-tight cover of a film holder that must be removed before making an exposure.

density The opacity, or light-stopping power, of a negative. A *dense* negative appears quite dark, or opaque, compared to a *thin* negative.

densitometer An instrument for measuring either the transmission or reflection densities of areas of a photographic image.

depth of field The distance between the nearest and farthest objects that appear to be in acceptable focus in a photograph.

depth of focus The shallow zone within which the plane of focus (the film) can be moved toward or away from a focused lens without a significant change in the focus of the image.

developer The solution that makes visible the latent image by converting exposed silver halides to black metallic silver.

developing tank A container, usually light-tight, into which film is placed for processing.

diaphragm An adjustable device, ordinarily, located between lens elements, that controls the size of the aperture allowing light into the camera.

diffraction The tendency for light rays to be bent around the edge of an opaque obstruction.

diffuser A special filter or material, such as mesh or wrinkled cellophane, that, when placed over a camera or enlarger lens during exposure, produces a soft-focus effect.

diffusion The scattering of light rays in random directions as they are reflected from a rough surface or transmitted through a translucent medium.

diffusion enlarger An enlarger using translucent glass instead of condenser lenses to even out the light that passes through the negative.

DIN Deutsche Industrie Norm. A film-speed comparison system commonly used in Europe.

diopter A measure of the relative magnification of a simple lens, such as a supplementary close-up lens. Such lenses are commonly provided in +1, +2, and +3 diopters, +3 being the "strongest."

discontinuous spectrum Light, such as that from fluorescent tubes, that does not include all wave lengths. Blue and green predominate in most fluorescent tubes, there being little, if any, red present.

dodging Shading part of the image from light during printing to make it appear lighter (see *burning-in*).

double exposure Two or more exposures made on the same frame of film, either intentionally or accidentally.

drop-out A high-contrast image from which the intermediate gray tones have been eliminated, leaving only black and white; also used to describe eliminating the background from around an object in a photograph by masking with opaque material.

drum A cylindrical plastic container for processing prints; generally employed for color printing because only a very small amount of each solution is required, but may also be used for black and white.

drum dryer A machine with a heated metal drum or cylinder and an endless canvas belt that holds prints in contact with the drum surface until they are dry.

dry mounting A permanent bonding process in which a sheet of thermoplastic material is placed between a print and a sheet of mounting board and then subjected to heat and pressure.

dye transfer A high-quality color printing process in which full-sized black and white separation matrices are dyed yellow, magenta, and cyan; the dye images are transferred in register onto a single sheet of prepared paper.

easel The paper holder, usually with adjustable masking strips, for use on the enlarger baseboard.

electronic flash A repeatable light source, producing a brilliant flash of light, usually less than 1/500 second in duration. Most often powered by replaceable or rechargeable dry batteries, electronic flash is often referred to inaccurately as "strobe" light.

element One of the glass components of a lens.

emulsion The gelatin coating on photographic films and papers in which are suspended light-sensitive silver salts.

enlarger A projection printer for making enlarged (or reduced) reproductions of a negative or transparency.

etching Removing areas of unwanted density from a photographic image by shaving away the emulsion with a very sharp blade.

EVS Exposure Value System. A simplified, but obsolete, system for combining f/stop and shutter speed into a single *EV* number, usually from 1 through 18.

expansion Extended development, resulting in an effective increase of negative contrast.

exposure The total amount of light allowed to reach photosensitive material. Exposure is the product of light intensity, as controlled by the aperture or iris diaphragm and the length of time the shutter is permitted to remain open.

exposure factor The amount by which exposure must be increased when using a filter or when extending the lens for extreme close-up photography. Usually stated, for example, as 4X, which means a four-time increase in time (four seconds instead of one second) or opening up the lens two stops (f/8 instead of f/16).

exposure index The ASA rating. A measure of the relative light sensitivity or "speed" of sensitized photographic materials.

exposure latitude The amount of over- or underexposure possible without the result being an unprintable negative or unacceptable transparency.

exposure meter An instrument for measuring the intensity of light either falling on or reflected from a subject for the purpose of determing exposure settings.

extension tubes Light-tight rings or tubes placed between the lens and the camera body to enable focusing on very close objects.

F Flash synchronization marking on some shutters to indicate the setting for obsolete fast-peak, gas-filled flashbulbs. Also the symbol engraved on some lenses of European manufacture, referring to focal length—for example, F = 135mm. Also refers to the Fahrenheit temperature scale—for example, 68° F means 68 degrees Fahrenheit.

Farmer's reducer A bleaching solution of potassium ferricyanide and sodium thiosulfate (fixer).

fast Film or paper that is extremely sensitive to light (high ASA number); also a lens with a relatively large maximum aperture—for example, f/1.2 or f/1.4.

feathering Evening out intensity of illumination by tilting a light source so that the brightest part of the beam is directed toward the more distant parts of the subject.

ferrotype Originally the name of the obsolete tin-type process. Now used to describe the process of drying glossy prints by squeegeeing them with the emulsion surface against a polished metal plate or drum.

fill light Light, usually diffused or reflected, directed into the shadow areas of the subject to reduce the brightness range or lower the lighting ratio.

film A strip or sheet of transparent acetate or polyester plastic, coated on one side with an emulsion consisting of light-sensitive silver salts suspended in gelatin and on the back side with a dyed gelatin layer to reduce curling and to minimize halation, or scattering of light.

film clip A special toothed, spring clamp or a spring clothespin used to suspend processed film during drying. Usually a second clip is put on the bottom of roll film as a weight to keep the film hanging straight.

film holder Device for holding two sheets of film, one on each side, for exposure in a view or press camera. Also, roll-film holders and film-pack adapters are available for most large-format cameras.

film magazine (see *cartridge*).

film pack A metal or plastic container holding several individual sheets of film. Each sheet is moved into place for exposure by pulling a paper tab.

film speed The relative sensitivity of film to light (*ASA*).

filter A piece of transparent gelatin, glass, or plastic material, usually colored, that will absorb selected wave lengths of light while transmitting others.

filter factor The number of times basic exposure must be multiplied (for example, 4 x = four times, or two stops) to compensate for light absorbed by a filter.

fisheye lens An extremely wide-angle lens usually capable of covering a field of view as wide as 180 degrees. The image on the film is often circular, with noticeable barrel distortion (rounding of straight lines) toward the edges.

fixer The processing solution that dissolves unexposed and undeveloped silver halides from the emulsion, making the film or paper no longer sensitive to light; also called hypo or fixing bath.

flare Extraneous light reflected from within the lens and/or camera and resulting in overall fog density, halo effects, or repeated patterns of density that often take the shape of the lens diaphragm. Flare is most noticeable when photographing subjects that are strongly backlighted or when light sources appear in the picture.

flash A brief, intense source of illumination from an electronic flash unit or from an expendable

flashbulb or flash cube that is usually synchronized with the opening of the camera shutter.

flashing Selective darkening of a portion of an enlargement by exposing part of the paper to raw light from the enlarger lamp with the negative removed or by local use of a small flashlight with a cone to restrict the coverage of the light; also, uniform exposure of film to light of low intensity for the purpose of increasing density in the shadow areas.

flash synchronization Adjustment of the timing of the firing of a flash light source so that the shutter is fully open at the time the flash is at peak intensity.

flat A photographic negative or print that is too low in contrast; also a large panel or screen used as a studio background, space divider, or reflector.

flood A light source designed to illuminate a relatively large area uniformly.

f/number, or f/stop Numerical expression of the diameter of the lens aperture in relation to the focal length:

$$f/ = \frac{\text{focal length}}{\text{diameter of aperture}}$$

focal distance The distance from the lens to the plane of focus. Usually measured from the diaphragm of the lens to the film plane.

focal length The focal distance when the lens is focused at infinity. Focal length is used as a comparative measure of lens image size and covering power.

focal plane The surface inside the camera where light rays come together to form a focused image.

focal plane shutter A curtain shutter located in the camera just ahead of the film, which exposes the film through a slit of adjustable width.

focus To adjust the relationship between lens, film plane, and subject, so that a sharply defined image is formed on the film.

focusing cloth An opaque drape used to shield the ground glass of a view camera from extraneous light while composing and focusing.

fog Overall density in a negative or print, not part of the normal image, resulting from extraneous light or chemical action.

forced development "Pushing" a film beyond its recommended ASA rating by prolonging development or by development in a highly concentrated solution to compensate for known underexposure.

format The size and proportions of the image area produced by a particular camera. 35mm cameras are considered to be of small format; 6 x 6 cm and 6 x 7 cm cameras of medium format; and 4 x 5 and larger cameras as large format.

FP Flash synchronization marking on some cameras to indicate the setting for long peak, wire- or foil-filled flashbulbs.

frame To compose; also a single negative or slide from a roll, or the useful picture area on the film.

fresnel A shallow, concentric lens used to focus the illumination from a studio spotlight.

frilling Loosening and detachment of emulsion from along the edges of film or paper during processing, usually caused by high temperatures and prolonged soaking.

gamma A numerical expression of image contrast as indicated on a characteristic (D/logE) curve. Superseded by *contrast index*.

gelatin A jellied animal protein substance used as the basic medium in which the light-sensitive silver salts in photographic emulsions are suspended.

glossing solution A bath in which glossy prints should be soaked briefly before being ferrotyped.

ghost image A blurred, secondary image of a moving subject recorded on the film by ambient light when electronic flash is used in daylight or in a brightly lighted interior; also a second image recorded out of register, caused by slight movement of the camera or enlarger during exposure.

glossy print A print with an extremely shiny surface, produced either by ferrotyping or by printing on glossy resin-coated paper.

gobo (see *scrim*).

gradation A scale of values or tones ranging from white, through gray, to black.

grain Particles or clumps of metallic silver forming a photographic image. Grain is not usually noticeable unless the image is enlarged.

grain magnifier An optical device resembling a miniature microscope that is used to aid in focusing the image from an enlarger.

gray card A standard, neutral test card of 18 per cent reflectance. Representing Zone V of the zone system, a gray card is the basis for determining average exposure and a neutral reference for determining color balance.

gray scale A standardized rendition of tonal values, usually in ten steps (Zones 0 through IX) arranged one stop apart in a sequence of increasing density.

ground glass The focusing surface in view and reflex cameras.

guide number The product of f/number and distance in feet from flash unit to subject. To calculate flash exposure, either the distance is divided into the guide number to find the required f/stop, or the f/stop is divided into the guide number to determine the required distance.

halation Blurred density surrounding densely exposed areas of an image where excess light has passed through the film and reflected back into the emulsion from the base.

halftone Printer's term for a continuous-tone image that has been broken up into a dot pattern for reproduction by offset or screen process, for example. Fineness of dot pattern is measured in terms of number of dots (lines) per inch, common halftones being 65, 85, 100, 120, and 133 lines.

halides Silver compounds that provide the light sensitive component of photographic emulsions.

H and D curve A graph depicting the response of a particular emulsion to exposure and development. Also referred to as a characteristic, or DlogE., curve.

hanger A frame, usually stainless steel, for tank processing of sheet films.

hard High contrast.

hardener A chemical solution, usually incorporated in the fixing bath, that toughens the emulsion, increasing its resistance to scratching, frilling, and reticulation.

high contrast Predominately black and white with few, if any, intermediate values of gray.

high key An image predominately light or white in overall tone, dark areas or bright color accents being very small, if present.

highlights The brightest areas, or highest values, in the image. These area are the most dense in the negative.

holder A film holder.

hot spot An undesirable concentration of light, usually toward the center of the beam of a studio light, enlarger, or projector.

hue Color; for example, red, blue, green, and so on.

hydroquinone A vigorous developing agent; a chemical component of many developer formulas.

hyperfocal distance The distance from the lens to the near limit of depth of field when the lens is focused on infinity.

hyperfocal focusing Focusing on the hyperfocal distance, which extends depth of field from half the hyperfocal distance to infinity.

hypo A fixing bath made from sodium thiosulfate or ammonium thiosulfate; also called fixer.

hypo clearing agent Washing agent. A bath used between fixing and washing to shorten washing time, while increasing permanence of the image.

image Photographic representation of the subject; the visible "picture."

incandescent light Light from a filament bulb as distinguished from fluorescent tubes or daylight.

incident light Light reaching, or falling on, the subject, as distinguished from light reflected by the subject.

incident meter An exposure meter designed or adapted for measuring the intensity of light falling on the subject.

infinity The distance, usually 50 to 100 feet from the camera, beyond which distant subjects will be in focus without further adjustment of the lens. Indicated by the symbol ∞.

infrared Invisible, long wave lengths of electromagnetic radiation that may be used to record images on especially sensitized film exposed through a deep red filter that blocks all or most visible light.

inspection Determining the extent of development by watching the image under dim safelight illumination.

intensifier A chemical solution for increasing image density and/or contrast; usually for making printable an underdeveloped negative.

interchangeable lens A lens that can be completely removed from the camera body and replaced by another.

inverse square law A fundamental principle of physics to the effect that intensity of illumination varies inversely with the square of the distance from the light source. In other words, if you double the distance between the light source and the subject, only one fourth as much light reaches the subject; so you have to open up the lens two stops to compensate.

iris The adjustable part of the diaphragm, controlling the size of the aperture admitting light through the lens.

Kelvin degrees A system related to the Celsius scale that is used for comparing the color temperature, or visual warmth or coolness, of photographic light sources 1.0 degree Celsius equals 273 degrees Kelvin (273° K). Sunlight averages approximately 5,400° K (cool), whereas most professional studio lamps are designed to operate at 3,200° K (warm).

key light (see *main light*).

kicker (see *accent light*).

Kodalith (see *litho film*).

lamp A light bulb or light source.

lamphouse The part of the head of an enlarger or projector that contains the light source.

latent image The invisible image produced by exposure of photosensitive material to light. The latent image must be made visible by development.

latitude (see *exposure latitude*).

leader A strip of film or paper provided at the beginning of a roll to aid in threading the material into a camera, processing machine, or projector.

leaf shutter An irislike series of overlapping metal leaves, usually placed between elements of the lens, that opens and closes to allow a predetermined amount of light to enter the camera.

lens The image-forming part of a camera, usually glass, the varying thickness of which causes light rays to be bent predictably as they pass through this denser medium, forming an image in a single plane.

lens barrel A metal tube in which lens elements are mounted, usually containing an iris diaphragm, but often without a shutter.

lens board A metal or wood panel on which an interchangeable lens is mounted for use on certain large-format cameras and enlargers.

lens cap An opaque protective cover placed over either the front or rear element of a lens. Many photographers use UV filters on each of their lenses for this purpose.

lens hood A tubular or rectangular attachment for shielding the front of a lens from extraneous light

that might cause undesirable flare in the image; also called a lens shade.

lens mount Both the part of the camera body that supports the lens, and, especially in 35mm cameras, the metal barrel that contains the lens elements, diaphragm, and focusing mechanism.

lens cleaner A special solvent that is effective in removing fingerprints, smudges, salt water, hard water, and wetting agent smears from lens and film surfaces.

lens shade (see *lens hood*).

lens tissue A special nonabrasive, lintless paper recommended for cleaning optical glass surfaces.

light Visible electromagnetic radiation; illumination.

lighting ratio A measure of the relative brightness of highlights and shadows; for example, a ratio of 4:1 means two stops difference.

light meter An exposure meter.

light-tight Capable of excluding all light, such as a camera, darkroom, or changing bag.

light trap A mazelike arrangement that excludes light, yet permits people to enter or leave a darkroom; or allows processing solutions to be poured into and out of a tank.

line copy A high-contrast image consisting only of black and white, without middle tones.

litho film An extremely high-contrast film intended primarily for line and halftone reproduction in graphic arts processes; referred to by manufacturer's trade names, such as Kodalith.

long lens A lens of greater than normal focal length for a particular format. Describes telephoto lenses, as well as long focal-length lenses of conventional construction.

low key An image predominately dark or black in overall tone, there being usually only relatively small white or brightly colored accents.

LVS Light Value System (see *EVS*).

M Flash synchronization marking on some shutters to indicate the setting for medium peak, wire-filled flashbulbs.

Mackie lines Thin outlines that appear around areas within a solarized image (see *Sabattier effect*).

macro lens A lens especially corrected for close-up work that has an extended focusing range allowing very close camera-to-subject distances without requiring accessory devices. Sometimes the term *micro* appears in the name of a macro lens.

macrophotography The making of very large photographs, such as posters or photomurals.

main light The key, or principal, light source in a studio lighting setup. The main light is the apparent source of directional illumination and shadows.

masking Blocking out portions of the image area, such as the background, with opaque paint or tape; also, the use of a low-contrast film positive in register with a negative, or a low-contrast black and white negative in register with a color transparency to reduce contrast in printing or duplicating.

mat A cut-out cardboard frame placed over the top of a print or transparency for presentation and display.

matrix A positive gelatin relief image used in dye transfer color printing.

matte Dull, nonreflective surface texture.

matte box A device similar to a large lens hood, into which are placed cutouts for making multiple-exposure photographs.

metol A relatively soft-working developing agent that is a chemical component of many developer formulas.

microphotography The making of very small photographs, such as the reproduction of images for microfilm or microfiche storage and retrieval systems.

microprism The structure of the focusing circle within the center of the viewing area in some single-lens reflex cameras.

mirror telephoto A lens, somewhat similar to a re-

flecting telescope, in which light rays are gathered by reflection from a curved mirror surface instead of by refraction through lens elements.

modeling light A term used by some photographers to describe the *key* or *main* light in a studio setup; also, an incandescent lamp placed within a studio electronic flash unit to allow visual placement of the light.

monobath A single processing solution that combines the functions of both developer and fixer.

MQ developer A formula containing both metol and hydroquinone developing agents.

multi-coated lens (see *coating*).

ND filter (see *neutral density filter*).

negative A photographic image in which the tones are reversed from the original subject—that is, shadows appear light or transparent while light areas in the subject appear dark or dense; opposite of a *positive* image.

negative carrier A frame for holding a negative in position for printing in an enlarger.

neutral-density filter A gray filter intended to reduce the intensity of light without changing its color.

nodal point The optical center of a lens from which measurement of focal length or focal distance is made. In practice, measurement from the lens diaphragm is usually accurate enough for most lenses, except for true telephoto and retrofocus designs.

normal lens A lens with a focal length approximately equal to the diagonal of the film frame the lens is designed to cover; also, the standard lens normally supplied with a camera.

notching code A system of notches cut into one edge of most sheet films to identify the type of film and to indicate the emulsion side when loading film holders.

one-shot developer A developer that is stored in highly concentrated stock solution, diluted for one-time use and then discarded.

opaque Incapable of transmitting light; also, a red or black paint that is used for blocking out or masking areas of a negative that are not to be printed.

open flash Method for taking flash pictures in which the camera is placed on a tripod, the shutter is set to *B* or *T* and opened, the flash is fired manually, and the shutter is closed.

opening up Increasing the size of the aperture of a lens. Using a smaller f/number—for example, opening up from f/8 to f/5.6.

ortho Orthochromatic: an emulsion sensitive to visible blue and green wave lengths of light, but not sensitive to red.

overexposure Too much light reaching photosensitive material, resulting either in an excessively dense negative, an unacceptably dark print, or a reversal transparency that is lacking in density and color saturation.

panchromatic An emulsion sensitive to all wave lengths of visible light.

panning Following a moving subject with the camera during exposure.

paper The sensitized paper used in making photographic prints.

paper grade Numbers that refer to relative contrast from 0 (very soft), 1 (soft), through 2 (normal), to 3, 4, and 5 (hard and very hard) to 6 (extreme contrast). Contact and enlarging papers are available graded in this way or as *variable-contrast* papers.

paper negative A negative image on photographic paper, either exposed directly in the camera or printed from a positive transparency; usually the paper negative is printed again, resulting in a positive print. If the paper negative is a final product, it properly would be referred to as a negative print.

parallax The difference in framing between the view seen through a camera viewfinder and that actually recorded by the lens.

PC filters Polycontrast filters for producing print contrast grades from 1 through 4 with Kodak Polycontrast paper. PC acetate filters are placed in the enlarger color head between the lamp and the negative. Plastic PC filters are optically clear enough to be placed below the enlarger lens.

pentaprism The five-sided prism in the viewfinding system of a single-lens reflex camera that turns the image right side up and orients it laterally.

perspective Two-dimensional representation of three-dimensional space; refers to relative size of objects, convergence of lines, variations of tone with distance, and camera viewpoint.

Photoflo Kodak trade name for a wetting agent commonly used as a final bath to aid in rapid and even drying of film.

photoflood An incandescent lamp bulb of high intensity but limited life, designed to burn at 3,400° K.

photogram A shadow picture made by placing objects on the sensitized surface of a sheet of photographic paper and exposing it to light.

photomacrography The making of extreme close-up photographs of subjects too small to be readily visible to the human eye, but without the use of a microscope.

photomicrography The making of photographs through a microscope, usually at relatively high magnification.

photosensitive Capable of chemical change from the effects of exposure to light.

pinhole A tiny, clear spot in a negative or reversal positive image resulting either from a speck of dust on the film during exposure or from an air bell during development; also, the image-forming aperture in a pinhole camera.

pinhole camera A simple camera that focuses light rays with a tiny pinhole aperture instead of a lens.

polarizing filter A neutral gray filter that, because of its structure, can reduce or eliminate glare reflected from some surfaces.

portrait attachment Inappropriate term for a close-up lens.

positive A photographic image in which the tones or colors are similar to those in the original subject; opposite of a negative.

posterization A high-contrast printing process in which the tonal scale usually is limited to two or three values or colors.

preset diaphragm An adjustment on some lenses to allow focusing at maximum aperture and then manual stopping down to a predetermined f/stop for exposure; accomplished automatically on most modern single-lens reflex cameras.

press camera An obsolete type of large-format camera with many features of a view camera but designed for hand use.

primary colors The basic hues, or colors, of light or pigment from which other colors may be blended.

print The final photographic image, usually a positive representation on paper.

printing frame A frame with glass and a pressure back used for holding negative and paper when making contact prints.

printing out A process of printing in which a visible image is produced by direct exposure to light, without development.

prism A solid, transparent optical form that bends light. Most single-lens reflex cameras use a prism to provide a large, bright viewfinder image that is right side up and laterally correct.

process To subject photographic materials to chemical treatment in sequence, such as development, stop bath, fixing, and washing.

process camera A large-format sheet-film camera, usually fitted with a highly corrected apochromatic lens, designed for line and halftone copying.

projection print An enlargement.

projector A camera in reverse; a machine with a

lens and self-contained light source that projects an image, usually greatly enlarged, from a small transparency, negative, or print.

proof A sample or test print.

proof sheet A contact print made from several negatives simultaneously on one sheet of paper; a *contact sheet*.

push To prolong film development time in an attempt to compensate for known underexposure (see *forced development*).

quartz light Also quartz-iodine or quartz-halogen light; highly efficient incandescent light sources characterized by relatively long life, consistent light intensity, and uniform color temperature.

rangefinder A system of prisms and lenses that aids focusing by presenting two images simultaneously. When the two images are made to coincide, the camera is in focus.

RC paper Resin-coated paper. Printing paper with a water-resistant base that allows for very rapid processing, short washing time, and quick drying.

ready light An indicator that the capacitor of an electronic flash unit has been recharged sufficiently for an exposure.

reciprocity law The principle that the amount of exposure varies directly in proportion to changes in light intensity or time. Reciprocity departure or failure occurs, however, at very long exposure times or with extremely short exposures with high-intensity illumination.

recycling time The time required for the capacitor of an electronic flash unit to recharge itself sufficiently for another exposure.

reducer A chemical solution that reduces the density of a negative or print by dissolving some of the silver that forms the image.

reducing agent Chemical term for a developing agent such as metol or hydroquinone.

reel A metal or plastic spiral-flanged spool on which roll film is wound for processing.

reflection The rebounding or redirection of light rays from a surface; also, an image that appears to be beyond or within a shiny surface such as water, a window, or a mirror.

reflector A surface, such as cardboard, fabric, or foil, used to redirect light onto a subject.

reflex camera A camera in which the viewfinder image is reflected by a mirror to a ground-glass surface for focusing.

refraction The bending of light rays as they pass from one transparent medium into another of different density.

register To superimpose one image over another so that their outlines coincide.

replenisher A concentrated additive placed into a used developer or other processing solution to maintain constant strength and to prolong the useful life of the working solution.

resolution Sharpness of the image. Resolution depends primarily on the resolving power of the lens and the acutance of the sensitized material used.

resolving power The inherent capability of a lens to reproduce fine detail.

reticulation A wrinkled emulsion surface usually caused by subjecting film to drastic temperature changes during processing.

retouching Hand alteration of a photographic negative or print by spotting, etching, painting, or air brushing in order to correct defects either in the photograph or in the subject.

retrofocus A type of wide-angle lens designed for single-lens reflex cameras that has greater distance behind the lens than its focal length to allow clearance for the camera mirror.

reversal Transformation of a negative image to a positive, or vice versa.

reversal film Transparency film intended to produce a positive image from first processing (direct positive). Actually, reversal film is first developed to a negative, which is bleached away during pro-

cessing; a positive image is formed from the silver not previously used to form the negative.

rim light Light coming from behind the subject that produces a bright outline, such as on a profile of a portrait subject.

rise and shift View-camera adjustments that allow some control over framing and perspective; generally used in conjunction with swings and tilts.

roll film Usually refers to rolls of film (for example, 120 or 220 size) that are supplied on a spool with paper backing and/or leader instead of in a metal or plastic cartridge or cassette, such as 35mm, 126, or 110.

Sabattier effect Partial reversal of image tones caused by exposure of the emulsion to light during development; commonly referred to as solarization.

safelight Darkroom illumination of a color that will not fog or expose certain sensitized materials during normal handling and processing.

saturation The intensity or relative brilliance of a color.

scoop A type of studio floodlight with a very large, deep reflector.

screen A surface on which images are projected for viewing; also, a sheet of glass or film containing a closely spaced pattern of dots or lines for producing a halftone image for reproduction or an overall texture effect in a print.

scrim A small piece of translucent or opaque material placed between a studio light source and the subject in order to locally dodge or lessen the intensity of the light; also called a gobo, flag, or head screen.

secondary colors Complementary colors; for example, cyan, magenta, and yellow are colors that each contain equal amounts of two of the primary colors of light.

selenium cell The light-sensitive receptor in some exposure meters.

self-timer A delayed-action device on some cameras that can be set to delay release of the shutter for several seconds, usually so that the photographer can become his own subject; indicated on some shutters by the symbol *V*.

sensitivity Susceptibility of an emulsion to formation of an image by the action of light.

sensitometry The measurement of the sensitivity characteristics of photographic materials.

sharpness Apparent clarity and crispness of definition in a photographic image.

sheet film Film supplied in individual sheets, rather than in rolls; also referred to as cut film.

short lens A lens of shorter than normal focal length; usually referred to as a wide-angle lens.

short lighting In portraiture, when the main or key light fully illuminates the side of the subject's face that is turned away from the camera. The effect is to narrow a broad face and to emphasize facial contours. When a weak fill light is used, the near side of the face and neck can be placed into shadows that tend to conceal blemishes and wrinkles.

shutter A mechanical device, sometimes electronically controlled, that determines the length of time light is allowed to enter the camera.

shutter speed The duration of exposure; usually indicated on the camera as the denominator of a fraction of a second—for example, $250 = \frac{1}{250}$ second.

single-lens reflex A reflex camera in which the viewfinder image is formed by the camera lens instead of by a separate viewfinder lens. A hinged mirror reflects the image up to a ground-glass focusing screen that is usually viewed through a prism.

skylight filter A pale pink filter intended to absorb ultraviolet and some visible blue light, giving a warmer-hued color image under hazy or overcast conditions.

slave A flash unit triggered remotely by the flash

from another unit synchronized to the camera shutter.

slide A transparency mounted in a cardboard, plastic, metal, or glass frame and viewed by projection on a screen; also the dark slide of a film holder.

slow An emulsion that has relatively low sensitivity to light; also, a lens that has a relatively small maximum aperture; also, a relatively long shutter speed.

SLR Abbreviation for single-lens reflex camera.

snoot An opaque tube placed over the front of a light, usually a studio spotlight, to provide a narrow and well-defined beam of light.

sodium thiosulfate A major component of fixer; also called hypo.

soft Low in contrast; also, lacking in sharpness.

soft focus Blurred, diffused, or slightly out of focus.

solarization Partial reversal of tones caused by extreme overexposure; often used somewhat inaccurately to describe the *Sabattier effect*.

spectrum The systematic arrangement of electromagnetic energy according to wave length. Visible light makes up a portion of the electromagnetic spectrum, which can be observed in the rainbow effect of a prism.

speed (see *fast* and *slow*).

spherical aberration A lens defect that permits light rays to form the image in a curved, rather than in a flat plane. Common in very fast lenses, this aberration results in a noticeable lack of sharpness, particularly around the edges of the frame.

spin drop-out The *tone-line* process.

spot meter An exposure meter especially suited for use with the zone system because it enables measurement of the reflected brightnesses of very small areas.

Spotone Trade name of a commonly used spotting dye.

spotting Dyeing, penciling, painting out, or bleaching small defects in a photographic print.

stabilization A rapid processing techique that yields prints of good quality but limited permanence.

stain A darkened or colored area within a photographic image, usually caused either by incomplete processing or by oxidation or chemical contamination.

step wedge A transparent gray scale used either for calculating print exposure times or for calibrating a densitometer.

stock solution A chemical solution stored in concentrated form but intended to be diluted into a working solution for use.

stop An f/stop or aperture setting; A change in exposure that doubles or halves the exposure resulting from the preceding setting; also, stop bath or shortstop, the acid rinse bath between the developer and the fixer.

stop bath A dilute solution of acetic acid used between the developer and the fixer to neutralize the alkalinity of the developer and help prolong the life of the fixer; also referred to as shortstop or, simply, stop.

stopping down Decreasing the size of the aperture of a lens; using a larger f/number—for example, stopping down from f/8 to f/11.

strobe An electronic flash unit capable of flashing repetitively several times per second. This term is often applied, inaccurately, to describe any electronic flash unit.

studio A room for making photographs; also, a photographic business.

subject A person, object, or view photographed. The term *object* generally is used to refer to an inanimate subject; however, the terms are considered interchangeable.

subtractive colors The secondary hues (cyan, magenta, and yellow) that are complementary to the

red, green, and blue light primaries. Cyan, magenta, and yellow are the basic colors used in photographic reproduction because each of the three colors subtracts from white light all wave lengths except that of the desired primary.

supplementary lens A simple lens or lens system intended to be attached to a camera lens for the purpose of altering effective focal length.

swing and tilt View-camera adjustments that allow control over framing and perspective and maximum use of depth of field; generally used in conjunction with rise and shift adjustments.

synchronization (see *flash synchronization*).

T Time; a marked speed on many shutters; similar to *B* (bulb), except that a shutter set on *T* will remain open until the shutter release is depressed a second time or, in some cameras, until the shutter is recocked.

tacking iron A small, electrically heated tool used to attach dry-mounting tissue to the back of a print or to mounting board before insertion into a dry-mounting press.

taking lens The lower lens of a twin-lens reflex camera; the lens that forms the image reaching the film.

tank (see *developing tank*).

telephoto A compact lens of relatively long focal length. A telephoto is designed to form a large image of a distant subject on smaller format film than a lens of similar focal length would ordinarily be expected to cover.

test strip A small test print made from a representative area of the negative. Usually exposed in segments at progressively increasing times, the developed test strip provides a range of print densities from which to estimate the exposure time required for the final print.

texture screen A pattern of lines, dots, or designs printed on film; the pattern is reproduced on a print from any negative projected through the screen.

thin A transparent image, usually a negative, of very low overall density.

through-the-lens meter An exposure meter with sensors placed inside the camera, often on the mirror of an SLR, so that reflected light readings are made of the light that has actually been transmitted through the lens. A *TTL* meter usually eliminates the need for compensating for lens extension and filter factors.

time and temperature The method for controlling film development by strict adherence to a predetermined development time at a carefully maintained temperature.

time exposure An exposure usually ranging from more than one second to as long as several minutes, the shutter generally being set either to *T* or to *B*.

TLR Abbreviation for twin-lens reflex camera.

tonality The range of gray values in a black and white photograph or the quality of color.

tone A value of gray (see *tonality* and *values*).

tone-line process A method for producing a high-contrast photographic image from a negative combined with a positive transparency. The negative and positive are sandwiched with unexposed high-contrast film and subjected to a narrow, slanting beam of white light while being rotated on a turntable; also referred to as a spin drop-out.

toning Deliberately changing the color of a photographic image, usually by immersing it in a chemical solution following the fixing bath.

translucent Describes material that diffuses light while transmitting it.

transparency A photographic image, usually a positive, that is intended to be viewed either directly by transmitted light or by projection.

transparent Capable of transmitting light without diffusing it.

tray A shallow, open, rectangular dish in which prints, and sometimes films, are processed.

tripod An adjustable three-legged stand for supporting a camera.

TTL Abbreviation for *through-the-lens* exposure meter.

tungsten Incandescent illumination at the warm end of the Kelvin color temperature scale.

twin-lens reflex A type of reflex camera that employs two similar, but separate, lenses: one for viewing and focusing and the other for taking the picture.

type A Color film balanced for exposure without filtration in incandescent illumination of 3,400° K.

type B Color film balanced for exposure without filtration in incandescent illumination of 3,200° K; also, a type of panchromatic black and white film with moderate red sensitivity.

ultraviolet A band of short, invisible electromagnetic wave lengths adjacent to the visible blue-violet, to which most photographic materials are highly sensitive.

underexposure Too little light reaching photosensitive material, resulting either in a thin negative, an unacceptably light print, or a reversal transparency with excessive density.

UV filter A clear glass or very pale yellowish filter intended to absorb some of the invisible ultraviolet wave lengths that may be recorded by ordinary photographic emulsions. Requiring no exposure factor and often referred to as a haze filter, the UV filter is used by many photographers as a protective lens cover.

values The relative intensities or brightnesses of gray or color comprising a photographic image.

variable-contrast paper Printing paper coated with two layers of emulsion sensitized, respectively, to yellow and to purple light. Exposure through numbered filters will yield print contrast approximately the equivalent of correspondingly numbered grades of conventional paper (see *PC filters*).

view camera A large-format, tripod-mounted camera used predominately for architectural and commercial illustration. The inverted image must be focused on a ground-glass screen at the back of the camera. In addition to a long bellows for copying and close-up work, most view cameras provide extensive adjustments, called *swings, tilts, rises and shifts* that allow for considerable control over image perspective and depth of field.

viewfinder A device for aiming and framing the image in a camera.

vignetting Isolating part of an image from the background by dodging around the desired area with a mask, usually oval in shape, called a vignetter. May be done at the camera or during enlargement of the negative (pronounced vin-nyet-ting).

warm tones Brownish or reddish overall tinting in a black and white image, particularly in the darker areas; in color, the red-orange-yellow portion of the spectrum as well as the brown or "earth" hues.

washed out A weak, pale, unsaturated image such as results from underexposure of a print from a negative or overexposure of a reversal transparency.

washing agent (see *hypo clearing agent*).

wave length The distinguishing characteristic of each portion of the visible electromagnetic spectrum that causes it to be perceived as a distinct color.

weight Thickness of photographic paper base or mounting board.

wet mounting Attaching a print to a surface with a liquid adhesive.

white light Illumination, usually consisting of a mixture of all wave lengths, to which photographic materials are normally exposed. The proportion of each wave length present determines the *color temperature* of the light.

wide-angle A short focal-length lens with an angular coverage substantially greater than that of a lens of normal focal length for a given format.

working solution Photographic chemicals properly mixed, diluted, and ready for use in processing.

X Flash-synchronization marking on some shutters to indicate the setting for electronic flash.

zone A value or tone of gray corresponding to one step in the ten-step gray scale that is the basis for the *zone system* of exposure and development control.

zone system A systematic exposure and development method for controlling the relationship between subject brightness range and negative contrast in black and white photography.

zoom lens A lens of continuously variable focal length.

The following titles represent a cross section of references that have been found to be most useful to me and to my students. They have been selected from the more than one thousand photographic publications currently in print.

ADAMS, ANSEL. *Camera and Lens*. Morgan & Morgan, Inc., 145 Palisade St., Dobbs Ferry, NY 10522, 1970, 304 pp. Reveals technical procedures recommended and followed by this master of large-format photography. *Camera and Lens* is a revision of the first book in a series of significant books that includes *The Negative, The Print, Natural-Light Photography*, and *Artificial-Light Photography*.

AHLERS, ARVEL W. *Where and How to Sell Your Photographs*, 7th ed. Amphoto, 750 Zeckendorf Blvd., Garden City, NY 11530, 1975, 191 pp. Market lists plus professional advice for the freelance photographer.

Artist's Market. Writer's Digest, 9933 Alliance Road, Cincinnati, OH 45242, revised periodically. A directory of buyers of photographs and other art, including galleries and agencies. Advice to the freelancer on selling and exhibiting.

ASMP Guide: Business Practices in Photography. ASMP—The Society of Photographers in Communications, Inc., 60 East 42nd St., New York, NY 10017, revised periodically. Describes pricing guidelines and contract procedures followed by many freelance professional photographers.

CRAIG, WALT. *Learning Photography: A Self-directing Introduction*, rev. ed. Grid, Inc., 4666 Indianola Ave., Columbus, OH 43214, 1975, 154 pp. A programmed book that takes the student, step by step, through the confusing world of f/stops, shutter speeds, lens and film characteristics, and darkroom procedures.

CRAIG, WALT. *Concepts in Color Photography: Color Temperature and Filters*. Grid, Inc., 4666 Indianola Ave., Columbus, OH 43214, 1973, 51 pp. A programmed booklet that helps the beginner learn to observe differences in color temperature as produced by various light sources and modified by the use of filters.

CRAVEN, GEORGE M. *Object and Image*. Prentice-Hall, Inc., Englewood Cliffs, NJ 07632, 1975, 280 pp. A uniquely organized text that considers fundamental techniques and processes within a historical and esthetic perspective.

Creative Darkroom Techniques. Eastman Kodak Co., Rochester, NY 14650, 1973, 292 pp. A compilation of special processes and formulas for improving print quality and creating photographic derivations in black and white and color.

DAVIS, PHIL. *Photography*, 2nd ed. Wm. C. Brown Co., 135 South Locust St., Dubuque, IA 52001, 1975, 354 pp. This well-balanced text includes a capsule history of the medium and covers, in short, modular chapters, much basic theory and technique.

DIXON, DWIGHT R., and PAUL B. DIXON. *Photography: Experiments and Projects*. Macmillan Publishing Co., Inc., 866 Third Ave., New York, NY 10022, 1976, 264 pp. A modular laboratory manual emphasizing physics and optics, including specific assignments, report forms, and quizzes.

HEDGECOE, JOHN. *The Book of Photography*. Alfred A. Knopf, Inc., 201 East 50th St., New York, NY 10022, 1976, 256 pp. A comprehensive basic text, uniquely illustrated, with an emphasis on illustrative and documentary photography in color.

HORRELL, C. W., and R. A. STEFFES. *Introductory and Publications Photography*, 3rd ed. Kenilworth Press, 421 West Grant Ave., Eau Claire, WI, 54701, 1972, 107 pp. This text, actually a work-

selected references

book including specific student assignments, is intended primarily for a photojournalism class at college or high school level.

Images of Man (slides or filmstrips with cassettes and teacher's guides). Scholastic Magazines, Inc., 50 West 44th St., New York, NY 10036. A series produced by Cornell Capa, Director of the International Center for Photography, in which concerned photographers comment upon their own photographs, motivations, and methods of working.

Index to Kodak Information, L-5. Eastman Kodak Company, 343 State St., Rochester, NY 14650, revised annually. This free publication describes the hundreds of books and pamphlets sold or distributed by Kodak on nearly every photographic topic. The titles listed below are among those that may be of greatest interest to students of professional or fine art photography.

A Survey of Motion Picture, Still Photography, and Graphic Arts Instruction, T-17. (Lists schools, colleges, and courses)
Copying, M-1
Filters and Lens Attachments for Black-and-White and Color Pictures, AB-1
Kodak B/W Photographic Papers, G-1
Kodak Color Dataguide, R-19
Kodak Color Films, E-77
Kodak Darkroom Dataguide, R-20
Kodak Neutral Test Card, R-27
Kodak Professional Black-and-White Films, F-5
Kodak Professional Photoguide, R-28
Printing Color Negatives, E-66
Printing Color Slides and Larger Transparencies, E-96
Professional Portrait Techniques, 0-4
Photography with Large-Format Cameras, 0-18
What is B/W Quality?, G-4

LEWIS, ELEANOR (ed.). *Darkroom*. Lustrum Press—Light Impressions Corp., Box 3012, Rochester,

NY 14614, 1977, 183 pp. Thirteen prominent American photographers describe in their own words the discoveries and the efforts that led to their own unmistakable photographic styles.

Life Library of Photography. Time-Life Books, Time-Life Building, Rockefeller Center, New York, NY 10020. An encyclopedic set consisting of seventeen volumes (1970–1972) plus annual supplements, each of which provides useful technical information with outstanding illustrations. Titles in the basic series include

The Art of Photography
The Camera
Caring for Photographs
Color
Documentary Photography
Frontiers of Photography
Great Photographers
The Great Themes
Light and Film
Photographing Children
Photographing Nature
Photography as a Tool
Photojournalism
The Print
Special Problems
The Studio
Travel Photography

LITZEL, OTTO. *Darkroom Magic*, 2nd ed. Amphoto, 750 Zeckendorf Blvd., Garden City, NY 11530, 1975, 143 pp. Describes processes for producing various kinds of print derivations.

LYONS, NATHAN, ed. *Photographers on Photography*. Prentice-Hall, Inc., Englewood Cliffs, NJ 07632, 1966, 190 pp. An anthology of essays by twenty-three historically significant photographers.

NEWHALL, BEAUMONT. *The History of Photography*. rev. ed. The Museum of Modern Art, 11 West 53 St., New York, NY 10019, 1972, 215 pp. A clas-

sic survey of practitioners and masters from the very beginnings of photography.

Petzold, Paul. *Effects and Experiments in Photography*. Amphoto, 750 Zeckendorf Blvd., Garden City, NY 11530, 1973, 160 pp. Detailed instructions for numerous special effects and processes.

Photographer's Market. Writer's Digest, 9933 Alliance Road, Cincinnati, OH 45242. Revised periodically. A directory of buyers of photographs, including agencies and galleries. Advice to the free lancer on exhibiting and selling.

Photography Market Place. R. R. Bowker Company, 1180 Avenue of the Americas, New York, NY 10036, revised periodically. A directory of picture buyers, sources of equipment and services, picture sources, publications, organizations, and schools.

Photo Market Survey. SMP/Books, 1500 Cardinal Dr., Little Falls, NJ 07424, revised periodically. A looseleaf binder with helpful articles for the aspiring freelance photographer, plus supplements listing publications, agencies, and other markets.

Picker, Fred. *The Zone VI Workshop*. Zone VI Studios, 147 Hillair Circle, White Plains, NY 10605, 1972, 122 pp. A handbook of exercises to aid in calibrating equipment and standardizing procedures for effective use of the zone system.

Rhode, Robert B., and Floyd H. McCall. *Introduction to Photography*, 3rd ed. Macmillan Publishing Co., Inc., 866 Third Ave., New York, NY 10022, 1976, 280 pp. A comprehensive text, primarily for photojournalism students, that goes fairly deeply into the technical aspects of photographic theory and processes.

Swedlund, Charles. *Photography—A Handbook of History, Materials, and Processes*. Holt, Rinehart and Winston, Inc., 383 Madison Ave., New York, NY 10017, 1974, 368 pp. A brief discussion of history and esthetics, followed by concise, well-illustrated coverage of fundamental processes and techniques, including color.

Szarkowski, John. *Looking at Photographs*. The Museum of Modern Art, 11 West 53 St., New York, NY 10019, 1973, 215 pp. Penetrating essays commenting on one hundred significant photographs selected from the collection of the Museum of Modern Art.

Szarkowski, John. *The Photographer's Eye*. The Museum of Modern Art, 11 West 53 St., New York, NY 10019, 1966. A collection of photographs classified as to The Thing Itself, The Detail, The Frame, Time, and Vantage Point.

The Family of Man. The Museum of Modern Art, 11 West 53 St., New York, NY 10019, 1955, 207 pp. With a prologue by Carl Sandburg, this book documents the most acclaimed photographic exhibition of all time; assembled by Edward Steichen at the Museum of Modern Art.

Todd, Hollis N., and Richard D. Zakia. *Photographic Sensitometry*. Morgan & Morgan, Inc. 145 Palisade St., Dobbs Ferry, NY 10522, 1969, 312 pp. A text and manual on the subject of the characteristics of light and the effects of light on sensitized materials.

Upton, Barbara, and John Upton. *Photography*. Little, Brown and Company, 34 Beacon St., Boston, MA 02106, 1976, 354 pp. A comprehensive text that includes mainly material extracted from the 17-volume *Life Library of Photography*. Illustrations include many how-to-do-it sequences.

Vestal, David. *The Craft of Photography*. Harper & Row Publishers, Inc., 10 East 53rd St., New York, NY 10022, 1975, 364 pp. A "personalized" course in photographic technique by a distinguished photographer, teacher, and writer.

Weston, Edward. *The Daybooks of Edward Weston: Volume 1—Mexico; Volume 11—California*. Horizon Press, 156 Fifth Ave., New York, NY 10010, 1966, 504 pp. Through his personal journals, Weston gives us extraordinary insight into the creative process.

WHITE, MINOR, RICHARD ZAKIA, and PETER LORENZ. *The New Zone System Manual.* Morgan & Morgan, Inc., 145 Palisade St., Dobbs Ferry, NY 10522, 1976, 139 pp. Revised and expanded from an earlier handbook by Minor White, this book presents a series of explanations and exercises designed to aid mastery of the zone system through previsualization, sensitometry, and calibration.

WILHELM, HENRY. *Preservation of Contemporary Photographic Materials.* East Street Gallery, 723 State St., Box 616, Grinnell, IA 50112, 1977, 320 pp.

An exhaustive treatment of processing procedures and storage conditions for archival permanence.

Writer's Market. Writer's Market, 9933 Alliance Rd., Cincinnati, OH 45242, revised annually. A directory of buyers of articles and illustrations with advice for the free lancer.

ZAKIA, RICHARD D., and HOLLIS N. TODD. *Color Primer 1 & 11.* Morgan & Morgan, Inc., 145 Palisade St., Dobbs Ferry, NY 10522, 1974, 152 pp. A programmed booklet for learning concepts of colored lights and colored pigments.

SOURCES OF PHOTOGRAPHIC BOOKS

Hundreds of fine photographic books are available to match every interest and level of taste. Some are monographs featuring the work of one photographer; others reproduce collections of photographs on a theme or catalog an exhibition, representing the work of several photographers. Some of these books can be found in local libraries, bookstores, museum stores, and photographic galleries. Among the firms publishing catalogs of books for sale by mail order are the following, which specialize in photographic books:

Amphoto—American Photographic Book Publishing Co., 750 Zeckendorf Blvd., Garden City, NY 11530

Aperture, Inc., Elm St., Millerton, NY 12546

International Museum of Photography at George Eastman House, 900 East Ave., Rochester, NY 14607

Laurel Photographic Books, 55 West 39th St., New York, NY 10018

Light Impressions Corp., P.O. Box 3012, Rochester, NY 14614

Morgan & Morgan, Inc., 145 Palisade St., Dobbs Ferry, NY 10522

PERIODICALS

No one has time to read *all* of the photographic magazines. If you examine an issue or two, however, of each of the following major periodicals at a library or newsstand, you should quickly form an impression of those that appeal most to you at your present level of interest. *Aperture, Industrial Photography, Pho-*

tomethods, *The Professional Photographer*, and *The Rangefinder* will probably have to be seen either in a library or in the collection of a friend, because they are available only by subscription.

Aperture (quarterly). Aperture, Inc., Elm St., Millerton, NY 12546

Camera (monthly). C. J. Bucher, Ltd., Lucerne, Switzerland. USA subscriptions c/o Ralph Baum, Modernage Photo Services, 319 East 44th St., New York, NY 10017

Camera 35 (monthly). Popular Publications, Inc., 420 Lexington Ave., New York, NY 10017. Subscriptions: P.O. Box 9500, Greenwich, CT 06830.

Industrial Photography (monthly). United Business Publications, Inc., 750 Third Ave., New York, NY 10017

Modern Photography (monthly). ABC Leisure Magazines, Inc., 130 East 59th St., New York, NY 10022. Subscriptions: 1 Picture Place, Marion OH 43302

Petersen's PhotoGraphic Magazine (monthly). Petersen Publishing Co., 8490 Sunset Blvd., Los Angeles, CA 90069.

Photomethods (monthly). Ziff-Davis Publishing Co., One Park Ave., New York, NY 10016

Popular Photography (monthly). Ziff-Davis Publishing Co., One Park Ave., New York, NY 10016. Subscriptions: P.O. Box 2775, Boulder, CO 80302.

The Professional Photographer (monthly). Professional Photographers of America, Inc., 1090 Executive Way, Des Plaines, IL 60018

The Rangefinder (monthly). The Rangefinder Publishing Co., Inc., P.O. Box 66925, 3511 Centinela Ave., Los Angeles, CA 90066

Page numbers in *italics* refer to photographs or quotations by the person named.

index